P9-CRZ-459

MASTERPIECES OF IMPRESSIONISM & POST-IMPRESSIONISM

THE ANNENBERG COLLECTION

MASTERPIECES OF

THE ANNENBERG

PHILADELPHIA

IMPRESSIONISM
& POST-IMPRESSIONISM

COLLECTION

COLIN B. BAILEY & JOSEPH J. RISHEL
& MARK ROSENTHAL
WITH THE ASSISTANCE OF VEERLE THIELEMANS

MUSEUM OF ART

THIS BOOK IS PUBLISHED ON THE OCCASION OF AN EXHIBITION AT THE
PHILADELPHIA MUSEUM OF ART, May 21–September 17, 1989.

Cover: Detail of *Vase of Roses* by Vincent Van Gogh (p. 108)
Edited by Jane Iandola Watkins, with the assistance of Molly B. C. Ruzicka and Mary Patton
Produced by the Publications Department of the Philadelphia Museum of Art
Photography by Graydon Wood
Designed by Joseph Bourke Del Valle
Composition by Cardinal Type, New York
Color separations and printing by A. Pizzi, Milan
Printed and bound in Italy

© Copyright 1989 by the
Philadelphia Museum of Art
26th Street and Benjamin Franklin Parkway, P.O. Box 7646
Philadelphia, Pennsylvania 19101
All rights reserved. No part of this publication may be reproduced, stored
in retrieval system, or transmitted in any form or by any means, electronic,
mechanical, photocopying, recording, or otherwise, without prior permission,
in writing, of the Philadelphia Museum of Art.

LIBRARY OF CONGRESS CATALOGING-IN-PUBLICATION DATA
Bailey, Colin B.
 Masterpieces of Impressionism & Post-Impressionism: The Annenberg
Collection/Colin B. Bailey & Joseph J. Rishel & Mark Rosenthal, with the assistance of Veerle Thielemans.
 216 pp.
 "This book is published on the occasion of an exhibition at the
Philadelphia Museum of Art, May 21—September 17, 1989"—T.p. verso.
 Includes bibliographical references.
 ISBN 0-87633-079-0 (pbk.)—ISBN 0-8109-1545-6 (Abrams)
 1. Impressionism (Art)—France—Exhibitions. 2. Post-
Impressionism (Art)—France—Exhibitions. 3. Art, French—
Exhibitions. 4. Art, Modern—19th Century—France—Exhibitions.
5. Art, Modern—20th Century—France—Exhibitions. 6. Annenberg,
Walter H., 1908– —Art collections—Exhibitions. 7. Annenberg,
Lee—Art collections—Exhibitions. 8. Art—Private collections—
California—Rancho Mirage—Exhibitions. I. Rishel, Joseph J.
II. Philadelphia Museum of Art. III. Title. IV. Title:
Masterpieces of Impressionism & Post-Impressionism.
N6847.5.I4B35 1989 89-3978
759.4′074′74811—dc20 CIP

THIS EXHIBITION, publication, and related programs
were supported by generous grants and contributions from

Pennsylvania Historical and Museum Commission
The Pew Charitable Trusts
The Florence Gould Foundation
The Bohen Foundation
CIGNA Foundation
Philip and Muriel Berman
Ed and Martha Snider
an anonymous donor
The Women's Committee of the Philadelphia Museum of Art

CONTENTS

AVANT-PROPOS

No ART LOVER can fail to be deeply impressed by Walter Annenberg's collection. His sense of quality has led him to acquire only works of major beauty and significance. These standards of excellence have enabled him, over the years, not only to collect works of great importance but to forge a coherent and homogeneous ensemble, where the quality of the whole is as high as that of the components.

Seeing the works in the paradise-like setting of Rancho Mirage, surrounded by the luscious beauty of the landscape, which Walter Annenberg has also created, is an experience not to be forgotten. But seeing them in the great Philadelphia Museum of Art, close to such a number of masterpieces, will be exhilarating: great works of art also like to be together!

May I add, as a Frenchman, that I am deeply moved by the interest in French art displayed by the Annenberg Collection. Nowhere will one have a better image than at this beautiful exhibition of what Impressionism and Post-Impressionism have brought to the world.

I am happy to think that so many art lovers will thus be able to enjoy some of the finest works created by French artists.

Merci, Monsieur Annenberg! And good luck to the paintings, which have found a haven in such worthy hands.

EMMANUEL DE MARGERIE
Ambassador of the French Republic

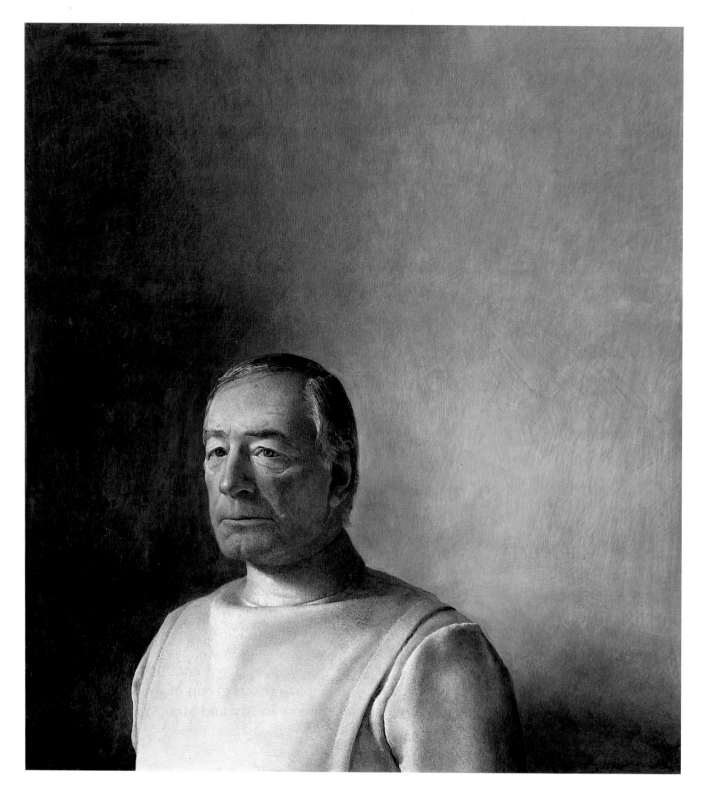

Andrew Wyeth (American, born 1917)
Walter H. Annenberg, 1978
Inscribed: 1978 Walter Annenberg by his friend Andrew Wyeth
Tempera on Masonite, 32³⁄₈ x 28¹⁄₂ inches

FOREWORD

IT IS A RARE opportunity and a distinct honor to present to the public in the United States for the first time a collection of works of art of such remarkably concentrated quality. Since their first acquisitions made in the early 1950s, Walter and Lee Annenberg have steadily and thoughtfully assembled a group of pictures that together give evidence of the achievement of the masters of Impressionism and Post-Impressionism equaled by very few collections in private hands today. The addition in 1983 of fifteen works from the distinguished collection of Mrs. Enid Annenberg Haupt brought new depth to the representation of each artist. The names are magisterial—Cézanne, Degas, Monet, Van Gogh, Gauguin— but the individual objects yet more telling. From the formidable grandeur of Van Gogh's *La Berceuse (Woman Rocking a Cradle)* to the irresistible charm of Renoir's *Daughters of Catulle Mendès,* from the broadly brushed immediacy of Monet's *Path through the Irises* to the subtly reasoned strokes of Cézanne's most panoramic view of *Mont Sainte-Victoire,* the Annenberg Collection provides virtually infinite opportunity for delight and contemplation. Thirteen of the works in this exhibition were shown at the Philadelphia Museum of Art in the summer of 1963, and thirty-two were the subject of a warmly received exhibition in 1969 at the Tate Gallery in London during Ambassador Annenberg's years at the Court of St. James's. The presentation of the collection in its current, astonishingly powerful form at the Philadelphia Museum of Art, together with the marvelous group of drawings by Cézanne from two sketchbooks given to the Museum by Mr. and Mrs. Annenberg, constitutes an occasion of great importance for the Museum and the public it serves.

It should be noted that the Annenbergs' keen interest in the field of art ranges from Chinese T'ang dynasty tomb figures to the sculpture of Auguste Rodin and Jean Arp, from superb portrait paintings of eighteenth-century America to the art of their friend Andrew Wyeth, whose grand and austere image of Walter Annenberg serves as frontispiece to this foreword. What is presented here, then, is but one aspect of a shared enthusiasm for beautiful and significant works of art.

This exhibition and the book that accompanies it are the result of extended collaborative effort on the part of many members of the staff of the Philadelphia Museum of Art. The project would not have been possible without the energetic enthusiasm and thorough scholarship of Joseph J. Rishel, Curator of European Painting and Sculpture before 1900, who oversaw its realization, and that of his colleague Colin B. Bailey, Assistant Curator in that department, who collaborated on every aspect. In the preparation of the exhibition and the writing of the catalogue, in which a number of very great works of art are given their first extended discussion, they have realized a remarkable achievement within a relatively short space of time. The many valuable contributions of scholars and institutions to the extensive research for this project are acknowledged by the authors elsewhere in this book, and their thanks are here most warmly seconded. Mark Rosenthal, former Curator of Twentieth-Century Art, contributed thoughtful entries on three modern paintings in the collection; and Veerle Thielemans provided skilled research assistance to the authors. The complex production of this handsome volume, designed by Joseph Del Valle, was overseen by George H. Marcus, Head of Publications, and Jane Watkins, Senior Editor, with their customary thoroughness and devotion to detail.

The myriad arrangements necessary to present these splendid works of art to the public were skillfully coordinated among the Museum's departments of the Registrar, Conservation, Installations, Packing, and Special Exhibitions. Sandra Horrocks, Head of Public Relations, and her staff were cheerfully indefatigable in their handling of a remarkable volume of publicity; and Natalie Peris, as coordinator of daily logistics during the run of the exhibition, contributed a welcome measure of order.

The presentation of this exhibition has been supported by an impressive group of public and private resources whose combined generosity has made such an ambitious undertaking possible. The Museum is deeply grateful to the Pennsylvania Historical and Museum Commission, The Pew Charitable Trusts, The Florence Gould Foundation, The Bohen Foundation, CIGNA Foundation, and The Women's Committee of the Philadelphia Museum of Art, as well as to Philip and Muriel Berman and an anonymous donor for their most welcome contributions. Ed and Martha Snider have underwritten the two-day symposium devoted to late nineteenth-century French art, a principal component of the related educational programs.

With this exhibition, above all, we celebrate the vision embodied in the adventure of forming a great collection and, together with Walter and Lee Annenberg, we celebrate in turn the extraordinary vision and mastery of two generations of Impressionist and Post-Impressionist painters in France.

ROBERT MONTGOMERY SCOTT
President

ANNE D'HARNONCOURT
The George D. Widener Director

CATALOGUE

CAMILLE COROT

FRENCH, 1796–1875

THE LITTLE CURIOUS GIRL, 1850–60

OIL ON BOARD, 16¼ X 11¼ INCHES

H E IS ALWAYS the strongest, he has foreseen everything." Degas's reaction to the paintings of Camille Corot at a sale of the artist's work in 1883[1] suggests the depth of admiration then felt by French progressive artists for the famous painter. Berthe Morisot and Camille Pissarro listed themselves as his pupils, while his impact on Gauguin, perhaps second only to that of Delacroix, continued well into Gauguin's Tahitian period. This profound admiration was based almost entirely on Corot's powers as a landscape painter, since the numerous figure subjects he did throughout his life were little known until the beginning of this century. Corot showed only two figure subjects during his lifetime: *A Monk* at the Salon of 1840 and *A Woman Reading* in 1869 (fig. 1),[2] preferring to keep such works in his studio or to give them away to his pupils and friends. The critic Théophile Gautier was perplexed by *A Woman Reading*, although he ultimately found it "pleasing for its naïveté and color in spite of the faulty drawing of the figure."[3] Others were more astute, including Degas (who owned seven paintings by Corot, including an early figure study)[4] when he gave this assessment in 1887: "I believe Corot painted a tree better than any of us, but still I find him superior in his figures."[5] Four figures (out of a total of forty-four works) were shown in Paris at the Exposition Universelle in 1889,[6] and an appreciation of this aspect of Corot's work slowly began to emerge. The American painter John La Farge (1835–1910) explained in 1908 to the students of the Art Institute of Chicago: "In the same way that the subtleness and completeness of his landscapes were not understood on account of their very existing, the extraordinary attainment of Corot in the painting of figures is scarcely understood to-day even by many of his admirers and most students. And yet the people he represents, and which he represents with the innocence of a Greek, have a quality which has skipped generations of painters."[7]

It was not until 1909, when a group of figure pieces was shown alone at the Salon d'Automne in Paris, that a broad critical understanding began to develop. The dealers who were taking up the cause of the new generation of painters pursued these Corots also, and sold them with the same conviction they held for Degas and Cézanne, Picasso and Braque.[8]

This enchanting painting at one time bore a label on the reverse reading "Given to my Friend M. Camus, fils. C. Corot, 24 February 1864."[9] (The picture is dated to the previous decade by Robaut.)[10] Camus was almost certainly the landscape painter George Camus, who first exhibited as a student of Corot in the Salon of 1869, where he was listed as living in Arras. Corot often visited and worked in Arras, drawn there by his closest friend, the lithographer and painter Constant Dutilleux (1805–1865). Camus, who does not seem to

have made much of a reputation for himself as a painter, owned at least three works by Corot, including two that were gifts from the artist.[11]

Within the category of paintings of children, numbering about forty—genre figures in the spirit of Chardin (fig. 2)—there is a particular charm that has suggested to some writers parallels between these works and qualities celebrated in Corot's own character: innocence, unquestioning goodwill, directness, and a nearly saintly purity. As early as 1845 Baudelaire had praised his naïveté, linking this quality with the ineloquent originality of his work.[12]

Whereas the older girls and women who posed for Corot were professional models, the children who appear in his works—except for street urchins painted on his trips to Italy—seem to have been part of his extended family, the offspring of close friends.[13] His children, as exemplified here, are knowingly alert, if slightly vulnerable; and as the title of this painting, *The Little Curious Girl*, suggests, they are part of an animated life that indicates a degree of human insight absent from his grander images of adolescents and young women (fig. 3). Yet, for all its expressive effectiveness, and in a decade that often took the readily exploitable charm of children to an extreme (fig. 4), this picture has neither the sentimentality nor the gentle melancholy that pervades nearly all his adult figures,[14] just because of the artist's even, solemn, and altogether tender presentation of this disarmingly mischievous child.

It is a picture created through a seemingly uncalculated, wondrously harmonious and rich means. The dark colors are applied densely and stand above the surface in slight relief, the gradation into the shadows as subtle and precise as the highlights on the skirt. The patch of light that falls under the girl's right arm holds with remarkable solidity to the plane of the ocher wall, beautifully worked within a fine harmony, as are the gently stippled strokes on the trees and sky beyond. Colors outside Corot's basic palette of ocher, blue, green, and flesh tones are introduced with great discretion, first logically, as in the lavender thistle and the dry, yellow bloom below, and then with harmonic independence, as in the four salmon strokes on the wall, three to the left, one to the right, with complete assurance of his coloristic control of the entire surface.

These are the qualities that Baudelaire understood better than any other early critic. In reviewing the landscape paintings at the Salon of 1859, he wrote that Corot "has the devil too seldom within him. However inadequate and even unjust this expression may be, I chose it as approximately giving the reason which prevents this serious artist from dazzling and astonishing us. He does astonish—I freely admit—but slowly; he does enchant—little by little; but you have to know how to penetrate into the science of his art, for with him there is no glaring brilliance, but everywhere an infallible strictness of harmony. More than that, he is one of the rare ones, the only one left, perhaps, who has retained a deep feeling for construction, who observes the proportional value of each detail within the whole, and (if I may be allowed to compare the composition of a landscape to that of the human frame) the only one who always knows where to place the bones and what dimensions to give them.... His eye, which is keen and judicious, is more concerned with what establishes harmony than with what emphasizes contrast."[15]

JJR

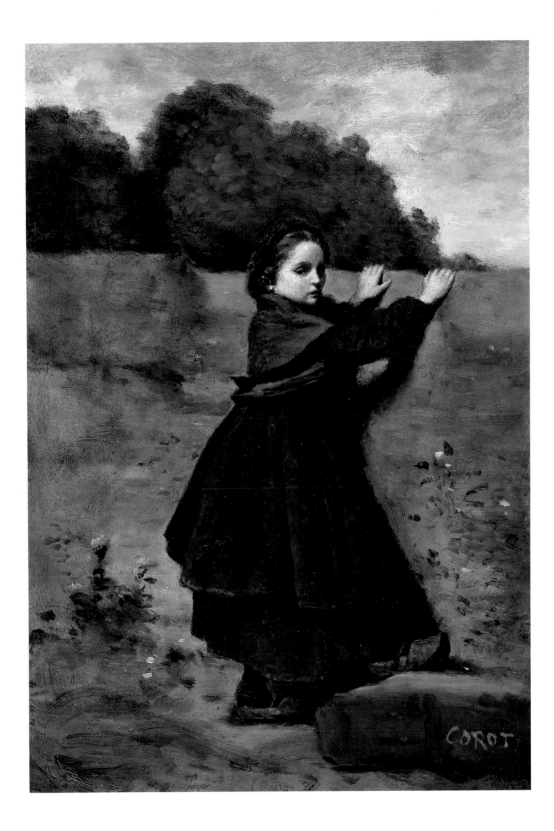

EUGÈNE BOUDIN

FRENCH, 1824–1898

ON THE BEACH, DIEPPE, 1864

OIL ON PANEL, 12½ X 11½ INCHES

O<small>N AND OFF AFTER</small> 1850, Eugène Boudin retained a studio in Paris during the winter months, where he developed into finished works the drawings, watercolors, and oil sketches he had done out of doors during more clement weather. Yet, for all his absorption with life in the capital and with the swift developments in painting that were taking place there, he often yearned for his native Le Havre and the surrounding area of Normandy, the source for much of his art. In June 1869, detained in Paris, he wrote to a family friend: "I daren't think of the sundrenched beaches and the stormy skies, and of the joy of painting them in the sea breezes."[1]

This deep desire to reabsorb himself in nature—particularly the Norman coast—points up the critical role Boudin would play in the history of French landscape painting. By working directly from nature and attempting to retain the freshness of spontaneous vision in his finished oils, he introduced a type of naturalistic painting from which there could be no retreat, as Baudelaire was among the first to note. That he generously shared this joy he took in his native region, and in painting it as directly as he knew how, first with Courbet and Whistler (fig. 5), and then, most critically, with the young Claude (then Oscar) Monet, gave him the distinction, in later criticism, of being the "precursor of Impressionism," a distinction that, while certainly just, tends to eclipse his essentially modest yet enchantingly fresh and vivid pictures.

Born near the harbor at Le Havre, Boudin developed as an artist with a strong sense of his own limitations, setting for himself the goal to do justice to nature in a way that he first learned from Constant Troyon (1810–1865), for whom he acted as a studio assistant, while closely heeding the works of Millet and Corot. By the late 1850s he had achieved a style of such individuality that Baudelaire, after a chance meeting in Le Havre while visiting his mother, wrote a last-minute insertion to his Salon review of 1859 praising the works he had seen in Boudin's studio: "On the margin of each of these studies, so rapidly and so faithfully sketched from the waves and the clouds (which are of all things the most inconstant and difficult to grasp, both in form and in colour), he has inscribed the date, the time and the wind.... If you have ever had the time to become acquainted with

these meteorological beauties, you will be able to verify by memory the accuracy of M. Boudin's observations. Cover the inscription with your hand, and you could guess the season, the time and the wind. I am not exaggerating. I have seen it. In the end, all these clouds, with their fantastic and luminous forms; these ferments of gloom; these immensities of green and pink, suspended and added one upon another; these gaping furnaces; these firmaments of black or purple satin, crumpled, rolled or torn; these horizons in mourning, or streaming with molten metal—in short, all these depths and all these splendours rose to my brain like a heady drink or like the eloquence of opium."[2]

Such full-blown praise did not immediately provide a substantial audience for Boudin's work, yet he persisted, while sustaining himself by working in a framing and stationery shop that often showed the work of local artists, including his, as well as those of the more famous figures who visited Normandy to paint. It was through this shop, which showed caricatures by the seventeen-year-old Monet, that these two artists met; and through this meeting the older artist set Monet on the path from which he would never veer. "Boudin, without hesitation, came up to me, complimented me in his gentle voice and said: 'I always look at your sketches with pleasure; they are amusing, clever, bright. You are gifted; one can see that at a glance. But I hope you are not going to stop there. It is all very well for a beginning, yet soon you will have had enough of caricaturing. Study, learn to see and to paint, draw, make landscapes. The sea and the sky, the animals, the people, and the trees are so beautiful, just as nature has made them, with their character, their genuineness, in the light, in the air, just as they are.'"[3] The boy resisted Boudin's invitation to come work with him, but finally that summer he acquiesced and joined with Boudin: "My eyes were finally opened and I really understood nature; I learned at the same time to love it."[4] Monet's greatest reciprocation to his mentor came years later when he was probably the means through which Boudin was asked to exhibit with the Impressionists in their first show, in 1874.

This love of nature, so effectively conveyed to the young Monet, sustained Boudin throughout his long and productive career. It is perhaps nowhere more obvious than in this small panel, which speaks so directly of a specific place and time, and of Boudin's pleasure in depicting it. The subject is the sea air itself, and how the sky, the sea, and the fashionably dressed crowd gathered on the beach are affected by it. And if there is irony in the foreground couple, attempting to carry on a conversation in the stiff breeze, it is gentle, so completely do they seem to partake in the artist's own stated pleasure at being there at that moment.

JJR

4

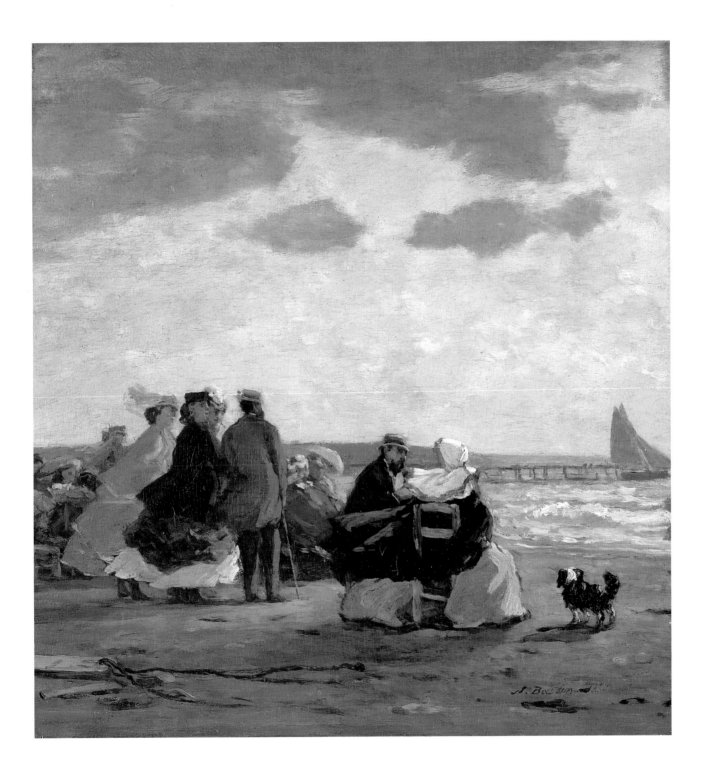

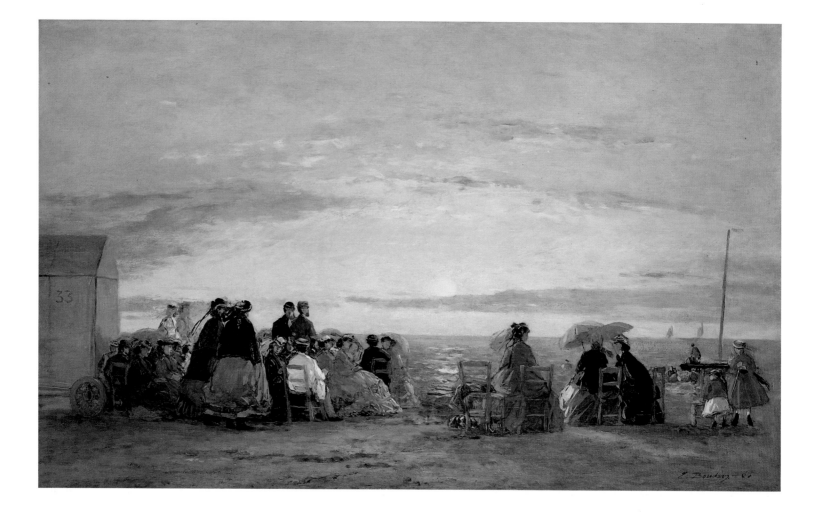

EUGÈNE BOUDIN

FRENCH, 1824–1898

ON THE BEACH, SUNSET, 1865

OIL ON PANEL, 14^{15}/$_{16}$ X 23^{1}/$_{16}$ INCHES

DURING THE SUMMER of 1865 Boudin worked on the Norman coast with Monet, Courbet, and Whistler. To what degree these encounters affected his new interest in painting on a horizontal format and, particularly, his absorption with the effects of the light of the setting sun, is an open question of influences and counter-influences. However, it was at this point that he began a series of pictures of fashionable beaches, which he continued with great effectiveness for the remainder of the decade, depicting well-dressed, upper-class holidaymakers gathered in the last light of day on the beach at Trouville or Deauville (fig. 6).[1] From about 1862, perhaps on the suggestion of Eugène Isabey,[2] he had done beach scenes of these fishing villages, which had become hugely popular, with their race track, casino, and what was thought to be the most lovely sands in France. Visits by the Empress Eugénie and her court only heightened the rage for these towns, a point not lost on Boudin, who commented in 1863: "They love my little ladies on the beach, and some people say that there's a thread of gold to exploit there."[3]

If he seems overly mercenary by this comment, it was a subject about which he was ambivalent. In August 1867, having just returned to the fashionable section of the coast, north of Le Havre, from the most isolated area—still the purview of pious peasants and fishermen—farther down the coast, he wrote: "I have a confession to make. When I came back to...the beach at Trouville, which I used to find so delightful, ...[it] seemed nothing more than a frightful masquerade. One would have to be a near-genius to make anything of

this troop of idle 'poseurs.' After spending a month among a breed of people doomed to the rough labour of the fields, to black bread and water, to see again this group of gilded parasites, with their haughty airs, makes me feel contempt and a degree of shame at painting such slothful idleness. Fortunately, dear friend, the Creator has spread a little of his splendid and warming light everywhere, and what I reproduce is not so much this world as the element that envelops it."[4] The following year he would temper his rage at social inequities: "The peasants have their painters, Millet, Jacque, Breton; and that is a good thing....Well and good: but, between you and me, the bourgeois, walking along the jetty towards the sunset, has just as much right to be caught on canvas, *to be brought to the light.*...They too are often resting after a day's hard work, these people who come out from their offices and from behind their desks. If there are a few parasites among them, aren't there also people who have carried out their allotted labour? There's a serious and irrefutable argument."[5]

Here, any conflicts of conscience he may have felt later are put aside by his love for an enveloping light. In this painting of 1865, a dense crowd is pulled up nearly to the water's edge at dusk. A few swimmers remain in the sea, although the bathing wagons are now pulled back from the tide. Two little girls play at the right, while the two women under parasols seem more caught up by their conversation than by the grand effect of the sky. But the crowd to the left, the man in profile setting the mood, seems to have fallen silent, staring out to the horizon as if in anticipation of the shift from yellow to red that is about to take place as the sun meets the sea—in an effect of temporal progress that, as Baudelaire noted in 1859, Boudin had mastered completely. It is a more harmoniously composed picture than the previous one, more contained and reserved in color and more blended in execution. The heroic boldness of Courbet and the tonal subtleties of Whistler are not seen here, nor are the brilliant bravura brushstrokes of the young Monet. It is calmer, more tempered, and—for all his railing against the participants—wondrously kind and sympathetic to a mutual participation in the moment. JJR

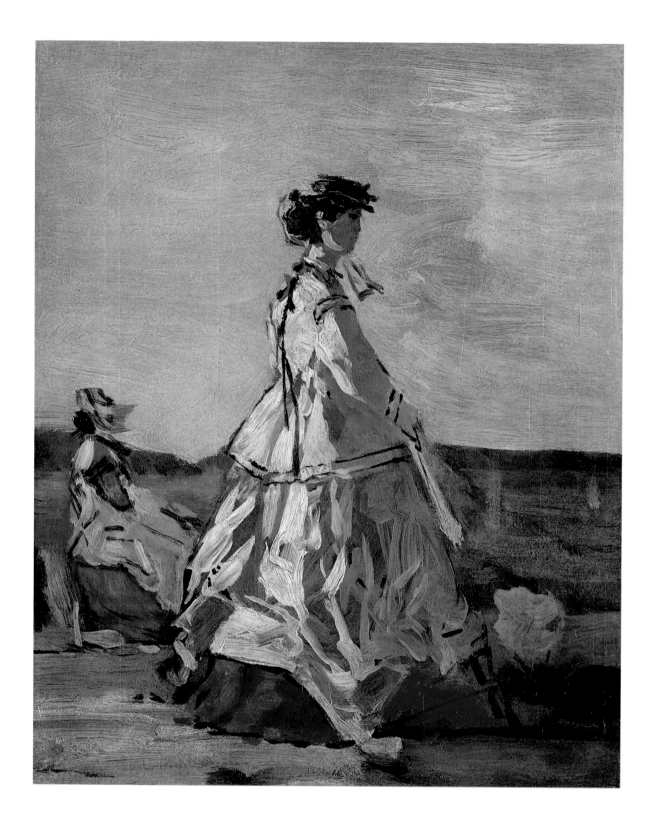

EUGÈNE BOUDIN

FRENCH, 1824–1898

PRINCESS METTERNICH ON THE BEACH,
c. 1865–67

OIL ON PAPERBOARD, MOUNTED ON PANEL, 11⁹⁄₁₆ X
9¼ INCHES

THIS LITTLE WORK is curiously unique, even in the context of Boudin's immense production. It is painted on a paper board that had been randomly scored, both horizontally and vertically, perhaps with a matt knife. Boudin took up this object, probably a studio scrap (only later mounted on panel), laid a thin coat of white gesso over the surface, and painted one of the most freshly spontaneous sketches of his entire career. The oil is applied with gouachelike directness. This work falls somewhere between his brilliant watercolors and his finished paintings, both of which often depict fashionable women on the beach, although rarely with such gusto. In its alert observation of high fashion and Parisian style it compares with the similar sketches of Constantin Guys (fig. 7). In the freedom of execution and continuous animation of surface it ranks nearly with the oil sketches of Manet. Within Boudin's work it stands alone and seems to have never been used for a larger or more finished work.[1]

The central figure has always been identified as Princess Metternich (1836–1921), wife of the Austrian ambassador to France and one of the more noteworthy women at the court of Napoleon III. Boudin certainly would have seen the princess often at the resorts on the Norman coast; she was frequently there, often in company of her close friend the empress. In comparison with contemporary photographs (fig. 8), this identity holds.

As the Goncourt brothers, who were not fond of the Empress Eugénie and her circle, caustically noted in their journal in 1864:

"Her, always, her! In the street, at the Casino, at Trouville, at Deauville, on foot, in a carriage, on the beach, at children's parties, at balls for important people, always and everywhere, this monster who is nothing and has nothing, who has neither grace nor spirit nor beneficence, who has only the elegance that she can buy from her dressmaker for one hundred thousand francs a year."[2] Part of their distaste for her came from the fact that the princess was small, very slight of build, and quite plain, with a face that they had earlier described as having a bluntly "turned-up nose, lips like a chamber pot, and the pallor of a figure from a Venetian masque."[3] Yet the princess was a woman of considerable style, wit, and self-knowledge —declaring herself to be the "best-dressed monkey in Paris"[4]—who contributed greatly to the diplomatic success of her husband, brought a kind of gaiety to the rather dreary formality of court life, and, at least on one occasion, championed against formidable odds the operas of Wagner, whom many critics condemned, immediately identifying them with the new, controversial movement in painting.

Her appearance, perhaps just because of its combination of homeliness and immense chic, attracted Degas in one of his strangest portraits (fig. 9), done after the fall of the Second Empire in 1870 and the departure of the Metternichs from Paris, from a photograph showing the princess with her husband in 1860.

Her attraction for Boudin could not have been more different. He has turned her blunted features in complete profile, reserving his perceptions for the billowing complexity of her dress and the way the back of her head takes the light, just as her companion's profile is observed as her veil is caught in the wind. The horizon, for once in Boudin, does not lie distant and still; its undulations seem to take part in the same current of air that pulls about the princess's dress; this, like the thinly suggested sailboat to the right, recalls the oil sketches of Whistler, although that much more aesthetic artist would never have taken such conspicuous pleasure in light and the laying on of paint.

JJR

9

Edouard Manet
French, 1832–1883
Mme Manet at Bellevue, 1880
Oil on canvas, 31¾ x 23¾ inches

INCAPACITATED BY severe rheumatism, Manet left Paris in the summer of 1880 for the neighboring suburb of Bellevue, renowned for its agreeable villas and for its waters.[1] He had first attended the hydropathic clinic there in September 1879, and in June 1880 rented a villa on the route des Gardes from the opera singer Emilie Ambre, "the neighboring prima donna and 'chatelaine,'" whose portrait he had started in September 1879 and would finish during this second, protracted stay.[2] Manet and his family remained at Bellevue until the beginning of November 1880, and in spite of an arduous regime of showers and massages—and Manet's marked distaste for country life—the stay was among the most productive of his last years.[3]

Manet confined his painting in these months to open-air studies made in the garden of his rented villa. In a letter to the engraver Henri Guérard, husband of his pupil Eva Gonzalès, he once complained that his day's work had been interrupted by the threat of a storm: "Therefore we had to put away the easels."[4] Nor is it clear that such a sustained period of painting in plein air entirely suited him. Toward the end of his time at Bellevue he wrote to Zola: "The Bellevue air has done me a world of good ... But, alas! naturalist painting is more in disfavor than ever."[5]

Indeed, *Mme Manet at Bellevue* exemplifies Manet's deep-seated ambivalence toward the aims and techniques of the Impressionist school he was widely credited to have fostered. Seated on a bentwood rocking chair, her hands resting on her lap, Suzanne Manet's gaze is hidden under the large brim of a straw hat and her face is covered by its veil. The paint is applied very freely: over the thin, gray-cream ground that makes up her dress, patches of white, gray, and blue are laid on in crisscross strokes to suggest the flickering of light over her ample form. By contrast, the foliage in the background is rendered in dense, oily patches of greens of varying intensity, and the serpentine line of the rocking chair is a passage of bravura impasto. Manet's touch changes again in the more delicate handling of Suzanne's face and hat: strokes of blue, peach, and white create the edge of the brim of her hat, and the flesh tones darken to model her chin and cheek. He is at pains to record certain effects of light: Suzanne's hands, in direct sunlight, appear almost orange compared to the plum-flesh tones of her protected face. Equally, there are touches of red in the background—against the edge of the garden chair, in the foliage above Suzanne's hat—to add vibration to the greens.

But in themselves the ambient effects of sunlight and the play of shadows are not of overwhelming interest to Manet. Nor are the particulars of this suburban site. The thick green bushes with the sunlight upon them are merely *background*—freely handled, but synoptic, and with few concessions to having been directly observed. In this the portrait resembles Manet's *Reading L'Illustré* (fig. 10), painted the previous year: the general flatness of the composition and the disjuncture between sitter and setting are common to both works.[6]

Yet, if Manet's handling is undeniably Impressionist, he arrived at the statuesque and immobile presence of his wife through several stages. Suzanne's profile first appears as a sketch illustrating Manet's letter to Henri Guérard (fig. 11).[7] The pose is repeated, almost identically, in a black wash drawing on graph paper (fig. 12),[8] while a third drawing, in ink (fig. 13), has Suzanne's face turned directly to the right, the pose she assumes in the finished painting.[9] Lastly, an unfinished oil sketch for the painting (fig. 14), which was photographed in 1883 and has subsequently disappeared, demonstrates how Manet worked out this composition, building up the elements from the left: only Suzanne's hat and the back of her chair are visible, and her features are not yet described.[10] Given the notorious slowness and deliberation with which Manet worked, this succession of preparatory works is not surprising. It is also worth noting that Manet adjusted the profile in the finished painting by letting the veil cover Suzanne's face; in all of the drawings the veil is lifted and her profile is more directly observed. The lowering of the veil deepens the sense of his sitter's impenetrability.

At the same time that Manet worked on the portrait of Suzanne, he painted that of his mother, Eugénie-Désirée Manet (1811–1885), sitting in the same garden, facing left and concentrating on the needlework she holds in her hand (fig. 15). Preparatory drawings for this appear juxtaposed with those of Suzanne in two of the sheets mentioned above, and the final portrait of his mother, which Duret called an "étude," while even freer than that of Suzanne, might well be considered a pendant to it.[11] The two paintings have almost the same dimensions, and the compositions respond to one another in a general way. The pairing nicely alludes to the cordial relations between the two women, who together comfortably maintained Manet's impeccably respectable household on the rue Saint-Pétersbourg.

Mme Manet at Bellevue would be Manet's last painting of his wife, who had already appeared in at least eleven of his oils.[12] Suzanne Leenhoff (1830–1906), born in Delft, was the daughter of an organist and chapelmaster and was herself an accomplished pianist. She and Manet married in October 1863, although their liaison had begun some thirteen years earlier. It is generally accepted that Léon Koella Leenhoff, born to Suzanne in January 1852, was Manet's son; in polite society he was known as her brother.[13] How Suzanne Leenhoff and Edouard Manet first met is still open to speculation; the dictum that she gave Manet piano lessons is questionable, since Manet at eighteen was old to be taking instruction of this sort.[14] Despite such ambiguities, Suzanne was warmly accepted by Manet's family (after the death of his father in September 1862) and by his literary and artistic friends. "It would appear that his wife is beautiful, very fine, and a great musician," wrote Baudelaire on the occasion of Manet's sudden wedding in October 1863.[15] Suzanne visited the dying Baudelaire and played Wagner to him; she corresponded with Zola (to whom she was devoted) and Mallarmé; and after Manet's death in 1883 she transformed their house at Gennevilliers into a shrine in his honor.[16]

Comparison of this painting with a photograph of Suzanne (fig. 16) illustrates the degree of simplification in Manet's last portrait of her. Her broad features, so lovingly rendered the year before in *Mme Manet in the Conservatory* (fig. 17), are now entirely suppressed. Her sensual mouth and frozen profile suggest an almost sphinxlike inscrutability, while her elegant hands are reduced to a few hasty strokes of vermilion. Just as the precise nature of his relationship with Suzanne was carefully masked during his lifetime, Manet seems intent upon maintaining a certain distance in this gentle yet enigmatic portrait of his wife.

CBB

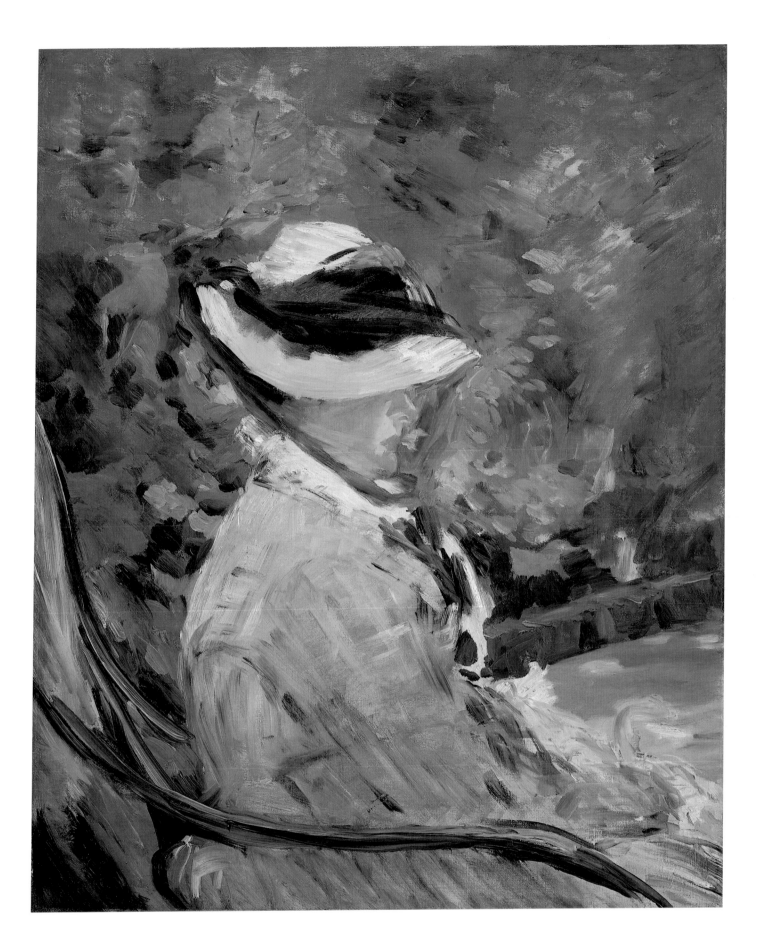

EDGAR DEGAS

FRENCH, 1834–1917
ITALIAN WOMAN, 1856–57
WATERCOLOR AND PENCIL ON PAPER,
8¼ X 4⅛ INCHES

Dᴜʀɪɴɢ ʜɪꜱ ꜰɪʀꜱᴛ year in Italy, between October 1856 and July 1857, Degas treated the almost obligatory subject of Italian women in local costume in several informal watercolors and drawings. Such colorful studies from life had almost become part of the art student's repertory; a generation of *pensionnaires* at the French Academy in the Villa Medici in Rome would complement their studies after Old Masters and the live model with sketches of the inhabitants of Rome and the surrounding countryside.[1] Less than two years after his arrival in Italy, the twenty-four-year-old Degas would repudiate such works for their banality: "I am not mad about this well-known Italian picturesque," he noted in July 1858; "whatever moves us no longer owes anything to this genre. It is a fashion that will always be with us."[2]

Initially, however, his responses to the "Italian picturesque" differed little from those of his more conventional contemporaries. Before reaching Rome, he had already recorded a woman in peasant costume in Sorrento, outside Naples (fig. 18), annotating his sketch with details of how she wore her hair, "braided into a crown around bandeaux."[3] Once in Rome, he joined the French students of the Villa Medici, where he attended life-drawing classes in the evening, in portraying peasant women from Trastevere and the surrounding countryside in their traditional dress.

In this delicate and rather tentative watercolor, Degas first drew the figure and her attributes in pencil; the underdrawing of her apron, the folds of her skirt, and the oval of her face can still be seen through the colored washes. In applying color he simplified even more: her right foot, the outlines of which are clearly visible, is now lost in the gray shadow cast by the stone block. Similarly, the darker patches that describe the shadows on her right arm, neck,

and chin are almost formulaic. As in the Sorrento study, Degas resolutely avoided pretty detail: the bearing of this peasant woman is taut and proud; her hands rest elegantly on the handle of her pitcher; and her spare features and simple dress enhance her dignity of comportment.

It was not in such sheets, however, that Degas affirmed his independence from academic convention; this emerged only in the paintings of old beggar women, dated to 1857, that break with both the picturesque and the sentimental.[4] Degas's watercolors remain remarkably close to those of his contemporaries, the sculptor Henri-Michel Chapu and the painters Jules-Elie Delaunay and Jacques-François Clère—*prix de Rome* winners in whose circles he moved at this time. In 1857 he recommended a striking male model to Chapu and traveled to Arrezo and Perugia in the company of Clère and Delaunay.[5] It was only after his momentous introduction to Gustave Moreau, eight years his senior, in early 1858, that Degas assumed the latter's disdain for such *pensionnaires*, "decent young fellows, who consider themselves artists, but are crassly ignorant."[6]

In addition to participating in the evening drawing classes at the Villa Medici, Degas may have joined students such as Chapu and Delaunay on sketching expeditions in the Campagna and Trastevere.[7] Before Degas's arrival in Rome, Chapu had drawn a very similar Italian woman in a letter to his parents dated June 19, 1856, with the annotation, "An Italian woman's costume as seen in the Campagna and in Rome at Trastevere." A larger watercolor by Chapu shows a model not unlike that of Degas carrying a jug on her head.[8] Finally, a watercolor by Delaunay in Nantes (fig. 19) bears direct comparison with Degas's *Italian Woman*, although the bulk of Delaunay's figure and the heaviness of her hands serve to emphasize the instinctive refinement and delicacy in Degas's approach to his sitter.

In his very popular travelogue *Rome Contemporaine*, published in 1861, Edmond About gave an account of the regular influx of peasants into Rome each Sunday, when they would congregate around the Farnese palace looking for work or buying and selling provisions. The peasant women, he wrote, "dressed in bodices, red aprons, and striped jackets, protect their tanned faces with headdresses of pure white linen. They are all worth painting, either for the beauty of their features or the simple elegance of their bearing."[9]

CBB

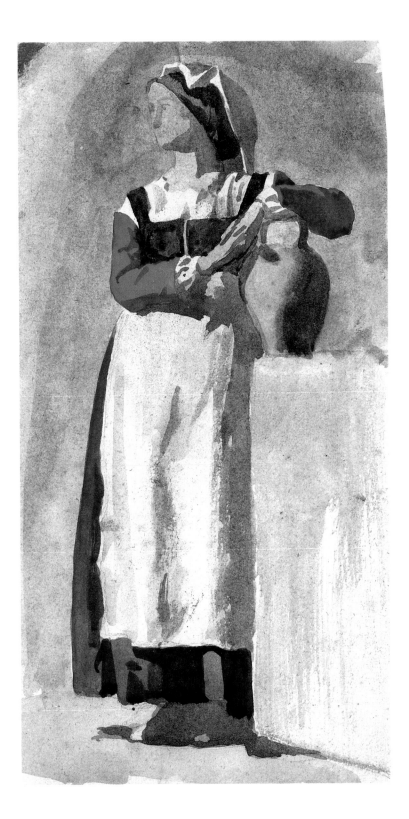

Edgar Degas

FRENCH, 1834–1917
The Dancer, c. 1880
PASTEL, CHARCOAL, AND CHALK ON PAPER, 12½ X
19¼ INCHES

In pastels or paint, the artist excels in silhouettes of little dancers with sharp elbows," commented Paul Mantz, not altogether approvingly, in April 1880.[1] And, indeed, the standing dancer who adjusts her sash—her back half turned to the viewer, her angular elbows jutting out—is a ubiquitous figure in Degas's repertory. She makes her first appearance in his ballet paintings of 1873 in the background of *The Dance Class* (Corcoran Gallery of Art, Washington, D.C.) and her last, in 1898, in the right foreground of the *Ballet Scene* (fig. 20), having provided the subject for a range of pastels and drawings in the intervening years.

The pastel *Dancer* relates very closely to *The Dance Lesson* of 1878–79 (fig. 21), the first in a series of paintings depicting dance rehearsals that employ a distinctive horizontal format.[2] The pastel is almost identical to the central figure in the painting, a standing dancer in *contre-jour*, tying her sash. The slight differences between the two dancers are significant, however. Whereas in the painting the girl's pointed nose and rather heavy jowls give her character, in the pastel her profile is much less sharply defined. Here it is at an even greater remove from the incisive chalk and pastel drawing of a head that is one of a number of preparatory studies for the pose and for which Nelly Franklin, an English dancer, modeled.[3] A similar attenuation is found in the act of adjusting her sash. In the painting the girl practically grapples with the bow, the ribbon firmly between her hands, while in the pastel her hands have moved behind the bow, adjusting something we cannot see.

It seems likely, therefore, that *The Dancer* was made after *The Dance Lesson*, and that both painting and pastel rely for the standing figure on a third, independent prototype. As early as 1873, Degas had made a spirited gouache drawing of a *Standing Dancer Fastening Her Sash* (fig. 22), which he seems not to have included in either of the great paintings of dance classes to which this drawing and others like it relate.[4] It has been suggested that a charcoal drawing of a *Standing Dancer Fastening Her Sash* (fig. 23), which is squared for transfer to another composition, and which was first published as a study for the standing figure in *The Dance Lesson* and its later variants, might well have been the starting point for both the painting and the pastel.[5] There are also arguments for its closer relationship with two later paintings: in the charcoal drawing the dancer wears a shawl over which her hair hangs loose—features connecting it with *Dancers in the Rehearsal Room with a Double Bass* (The Metropolitan Museum of Art, New York), painted at least three and possibly six years after *The Dance Lesson*;[6] the shawl also appears (with the chignon of the earlier works) in an even later variant, *Dancers at the Foyer (The Contrabass)* (The Detroit Institute of Arts).[7] However, the effects of light on the dancer's arms and elbows in the squared charcoal drawing relate more closely to *The Dance Lesson* and *The Dancer* than to either of the later variants, in which the upper half of the standing figure is shown in deep shadow.

What, then, is the status of the pastel *Dancer*, and how should it be dated? The delicate vertical grids that encase the dancer, at left by the toe of her slipper and at right by her elbow through the tarlatan of her tutu, are plumb lines that Degas often used to establish the position of the main figure, and do not indicate that the drawing was made for transfer.[8] Conceived as a single-figure study, the addition in the background of three diminutive dancers with broad features transformed the setting of the composition into a rehearsal room of considerable size. This perspectival device appears for the first time in Degas's work of the late 1870s and is most brilliantly employed in *The Dancing Lesson* of 1880 (fig. 24), to which this pastel should be compared.

A dating of around 1880 is also supported by an examination of Degas's handling in *The Dancer*. The neutral, gray paper is lightly covered by flesh-pink pastel, which establishes a somewhat muted tonality. Color is then applied in delicate hatching, concentrated hue appearing only on the trailing black neck ribbon; the knot of the blue sash, slightly off center; and the little blue bow on the figure's left shoulder, which gleams against the white strap. The spareness of this pastel—both in its handling and in its construction of space—recalls, from a considerably lower register, the magnificent *Dancer Resting* (private collection) and *Dancer with a Fan* (fig. 25), which date from about 1879 and 1880, respectively.[9]

Degas's preference for the rehearsal room allowed him to show his young dancers engaged in almost every activity except dancing. They exercise and rest; adjust their costumes and rub their tired limbs; scratch their backs and sit with their mothers. Underlying these informal and often witty depictions are a nobility and a sympathy that should not be underestimated. Not only are the particulars of the rehearsal room edited out in the pastel, but Degas's apparently straightforward observation of the young dancer adjusting her sash is itself partial and fabricated. For one major element in the dancer's dress is rigorously suppressed in this study, as in countless others like it; there is no indication of the dancer's knee-length calico bloomers, yet they were standard and considered '*de rigueur* in ballet circles until the turn of the century."[10] Only occasionally, in *Dancers Practicing at the Barre*, 1876–77 (The Metropolitan Museum of Art, New York) and *The Ballet Class*, 1881 (fig. 26), for example, does Degas choose to show this undergarment, and then with a fastidiousness and discretion that suggest bashfulness. Far more frequently he simply chooses not to see the ubiquitous bloomers.

"It is all well and good to copy what one sees," Degas confided to George Jeanniot, in a passage that has become famous, "but it is much better to draw only what remains in one's memory. This is a transformation in which imagination and memory collaborate."[11] This often-quoted passage has unexpected significance here. Degas was not the only painter of the ballet during the Third Republic: the suites of etchings and lithographs produced in the 1890s by Paul Renouard (1845–1924) unhesitatingly plagiarized and trivialized Degas's compositions.[12] Whenever Renouard depicted the dance class in session, his insinuating, coquettish dancers display their undergarments unashamedly (fig. 27). Prurient and vulgar, these lithographs nonetheless have a documentary fidelity that Degas disdained. He preferred, rather, in these studies, to reaffirm the ancestry of his dancers in the sisterhood of Nike.

CBB

14

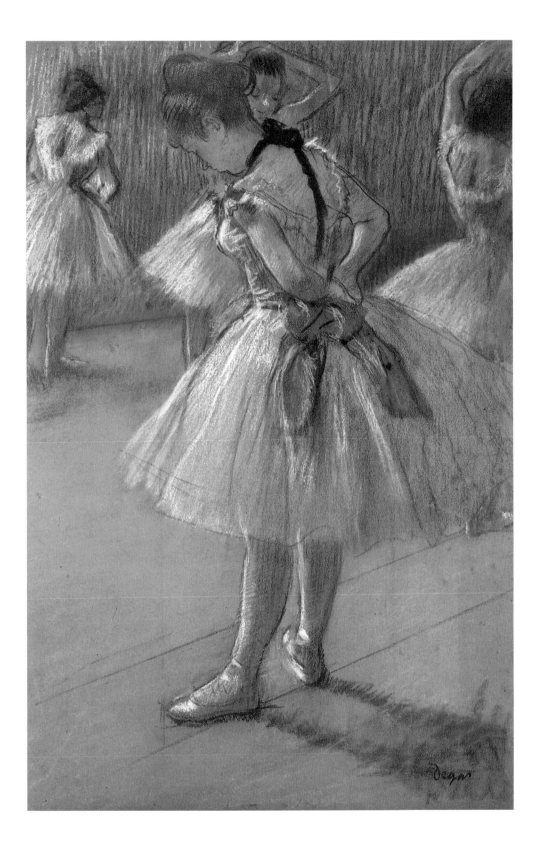

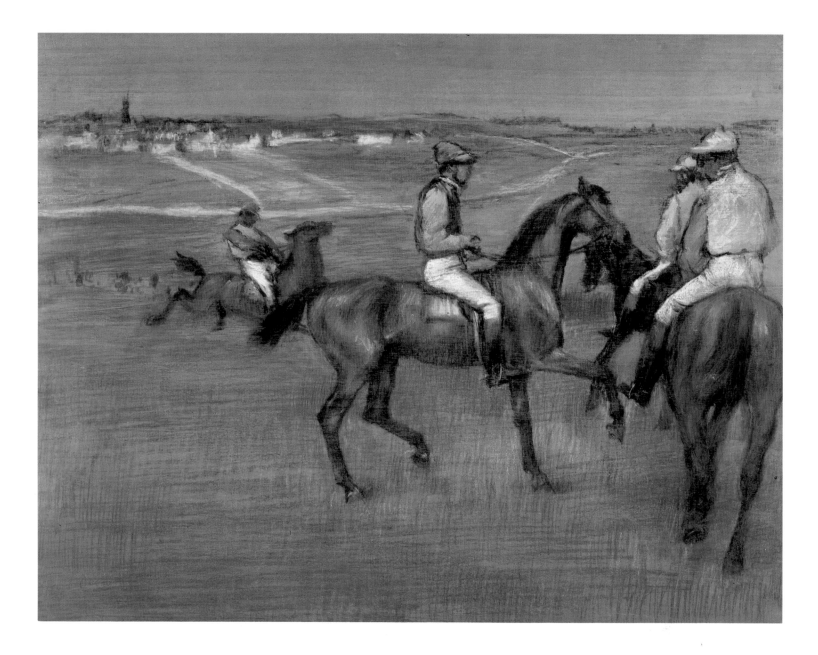

EDGAR DEGAS

FRENCH, 1834–1917
RACE HORSES, 1885–88
PASTEL ON PANEL, 11⅞ X 16 INCHES

RACE HORSES AND JOCKEYS, even more than dancers, occupied Degas throughout his long career as an artist.[1] Paul-André Lemoisne catalogued some ninety-one works in this category, spanning the period from 1860 to 1900—a number that did not include Degas's equestrian waxes and bronzes—and they embrace a range of sizes and mediums.[2] As with the Paris Opéra, the spectacle of the turf gave Degas the base material from which to forge images of modern life in an alloy that fused references to the art of the past with details observed from life and scrupulously documented. But more than any other of his subjects, this was a genre that fed upon itself and spawned countless variations and adjustments. From a repertory established very early, Degas proceeded to select individual jockeys and rearrange them, to repeat poses and refine them, until this hermetic world lost all connection with the reality of the race track. During the 1890s Degas's jockeys would emerge liberated from Baudelaire's "heroism of everyday life" to lead their horses calmly through undefined pastures, untroubled by this displacement and uneager either to reach their destination or to return home.

This diminutive composition of *Race Horses*, which falls toward the end of the first phase in this development, is immediately distinguished by its unusual support. It is pastel, and not oil, on panel: the wood here, possibly light mahogany, is the kind that might be used for cigar boxes.[3] Although pastel on panel is not a unique combination, it is extremely rare in Degas's oeuvre, and testifies to his continuing pleasure in experimenting with techniques and supports.[4]

Using the amber, grainy surface of the wood to suggest a mackerel sky, as well as the hills in the background, Degas applied the pastel lightly, at times tentatively. He varied the degree of pressure on his crayon: at its most insistent, it achieves the bright sheen of the jockeys' silks, but it is much more active in describing the closely hatched, wispy grass that occupies most of the foreground. Here, the point of the pastel moved rapidly, in vertical zigzags that occasionally scratched the wood. Some scratch marks are visible on the underbelly of the central horse; however, in painting the riders and horses, Degas's penmanship changed again. He allowed the surface of the wood to stand as the dominant color of the horses, building up their forms with strokes of orange red, gray, black and white, with traces of green spilling over from the surrounding grass.

There is also a lovely variety in the postures of the horses: the three jockeys in the foreground make up a closely linked unit, bound together not only in the interlocking of hooves, but also by the movement of the jockey in lime green, who turns around to catch the eye of his two companions. The serenity of this group contrasts with the rearing horse in the background, whose bridle is taut as his rider pulls him in—the single element of disorder in this otherwise quiet scene. The distant church tower with its attendant cluster of buildings and the pathways cutting across the hills, traced in white, create a sort of no-man's land, midway between the race track of Longchamp and the empty, barren hills of the late works.

Controlled and effortless, *Race Horses* brilliantly disguises its abundant antecedents. The composition and every figure within it can be traced back through a variety of studies and finished works—a characteristic of the inbred morphology unique to this subject.[5] Bennozo Gozzoli's fresco in the Palazzo Medici-Riccardi in Florence is the starting point for the pastel; Degas made several copies after the fresco on Gustave Moreau's encouragement between 1859 and 1860.[6] The central horse in profile assumes the pose of the steed in Degas's copy of Gozzoli's *Journey of the Magi* (fig. 28), a pose that Degas later studied from life in a sanguine drawing made in the mid-1860s (fig. 29) and one that would be much used in his race-horse compositions.[7] The horse and jockey with their backs to the spectator derive from another detail of the Gozzoli fresco, Degas's copy of *The Patriarch Joseph of Constantinople and His Attendants* (fig. 30), a pose that Degas would also study from life several times in the following decade. The prototype for the rear-view horse and jockey in *Race Horses* is probably the central rider, squared for transfer, in his *Three Studies of a Mounted Jockey* (fig. 31), where the configuration of the horses' limbs matches exactly.

Yet the figures in the pastel had already appeared in a variety of fully worked compositions made during the 1860s and 1870s. The godfather to the entire series, *The Gentleman's Race: Before the Start* (Musée d'Orsay, Paris), begun in 1862, reworked in c. 1882, included several figures that Degas would use again and again.[8] There was still another stage in the process that led to the pastel *Race Horses*. The rider in profile and the jockey seen from behind were brought together in the *Race Horses* (fig. 32), an oil on panel, nearly the same size as the pastel, that was begun in 1871–72 and reworked in 1876–78, and in which the rearing horse in the background appeared for the first time. This was not only the testing ground for a more ambitious composition—*The Racecourse, Amateur Jockeys* (Musée d'Orsay, Paris), begun in 1876 and completed in 1887—it was also the original design for the composition of the Annenberg pastel.[9]

Degas continued, almost obsessively, to rework and refine these individual elements. Although the bearded jockey in the center had been used in many race-horse paintings, Degas studied the position of his right thigh and upright bearing in several sheets of a notebook used between 1881 and 1884,[10] long after he painted *Race Horses* (fig. 32), in which this figure had again appeared. These notebook sketches, as well as the exquisite drawing of his friend Ludovic Lepic as a jockey (fig. 33), were used in the elaboration of the Annenberg *Race Horses*.[11]

Race Horses formed part of the prestigious collection of Théodore Duret (1838–1927), the first great advocate and historian of the Impressionist movement. Of the eight works by Degas that appeared in the Duret sale of March 19, 1894, four works may be identified from the detailed descriptions in the sale catalogue.[12] In addition to this pastel, Duret owned Degas's *Conversation at the Milliner's* (Nationalgalerie Berlin [East]), *Ballet Rehearsal* (Yale University Art Gallery, New Haven), and *Before the Start* (formerly with Paul Rosenberg, Paris).[13] It is not clear how or when Duret acquired these works, which date from the second half of the 1880s, although he purchased one of his dancers from Durand-Ruel for 2,000 francs.[14] His decision to sell this great collection at a time when Impressionist paintings were beginning to command respectable prices infuriated Degas. Duret's high reserves were not always met, and Degas rejoiced in such disappointed expectations.[15]

CBB

17

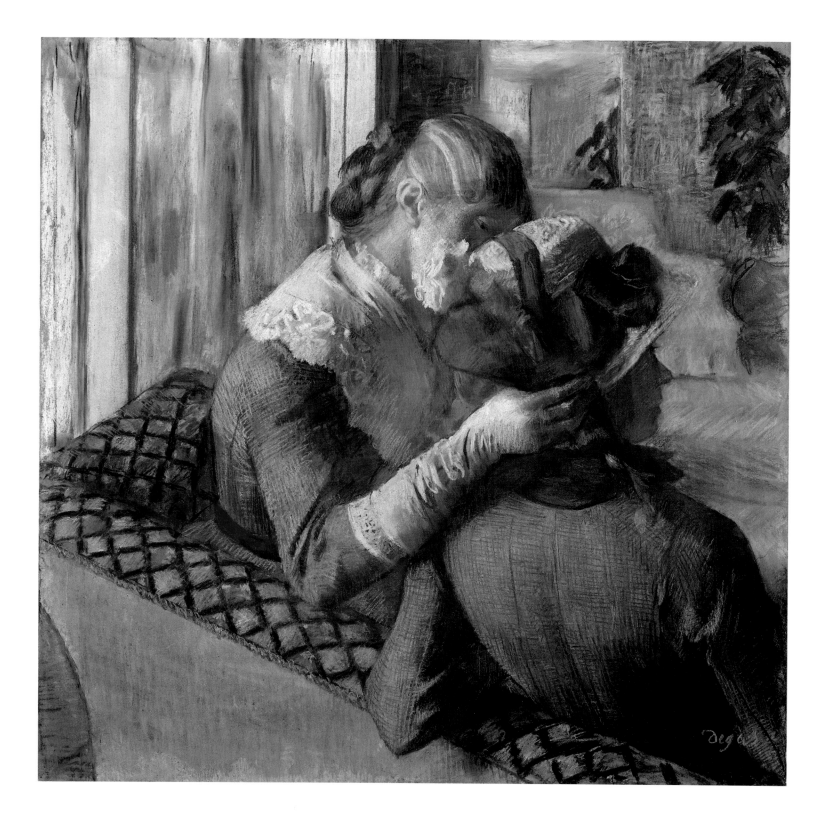

EDGAR DEGAS

FRENCH, 1834–1917

AT THE MILLINER'S, 1881

PASTEL ON FIVE PIECES OF WOVE PAPER BACKED
WITH PAPER AND MOUNTED ON LINEN,
$27\frac{1}{4}$ X $27\frac{1}{4}$ INCHES

THIS IS PERHAPS the most tender and enigmatic of the group of pastels in the milliner series (see fig. 34).[1] Although this pastel may at first appear to show a milliner helping a client with her hat, we are, in fact, presented with two women of similar status—a mother and daughter, perhaps, or two sisters—who are seated together on a diamond-patterned sofa. One holds a straw bonnet on the head of her companion, who looks to the right, presumably to judge the effect of the hat in a mirror we cannot see. The women wear almost identical costume: drab brown dresses, belted at the waist. The woman on the left, hatless, has an opulent lace fichu, through which the ruff of her blouse can be seen, and wears close-fitting long suede gloves. The second woman, whose auburn braids peek out from underneath her hat, has a blue velvet collar and is trying on a bonnet trimmed with swags of blue ribbon and a yellow flower. To the left of the two women, a net curtain covers a window in which shapes of blue and yellow appear, perhaps reflecting their accessories. In the background, across the parquet floor, a small sofa with slip covers gleams in front of a full-length mirror. Next to it is a round vase with a tall potted plant, its leaves repeated in the mirror behind the sofa. The vase is wedged in between another sofa, whose arm we glimpse at the edge of the composition.

At the Milliner's shares several characteristics of Degas's work of the early 1880s.[2] The figures dominate the picture plane and are caught in unusual positions: the women's bony elbows punctuate the diagonal of the sofa, upsetting the order of the scene, threatening almost to fall out of the frame. The spectator hovers somewhere behind the two women, looking down with a *"japonisant* bird's-eye view" into the far corner of the sofa.[3] And to the blandness of their costume Degas brings an unexpected chromatic intensity in the yellows of the glove, bonnet, and flower, and in the blues of the ribbon and collar, colors reflected in the white fichu and the window beyond.

Yet this startling and self-contained image was developed through a series of additions and extensions, as examination of the wove paper shows (fig. 35). Originally conceived on a vertical format $25\frac{5}{8}$ by $19\frac{5}{8}$ inches (identical in size to another *At the Milliner's* [fig. 36], where the cropping is equally audacious), this pastel may well have begun as a milliner arranging a hat on a hatstand.[4] It is difficult to imagine Degas contemplating a second figure within the confines of such a vertical composition, where the gesture of holding the hat

exists almost independently of the accompanying figure and is self-sufficient. The notion of a second figure must have presented itself very early on, suggesting the possibilities of a more expansive composition. Hence the addition of a large strip of paper ($6\frac{5}{16}$ inches) to the right and the squaring of the pastel with strips added along the left and upper edges. The pastel now assumed a format comparable to *At the Milliner's*, 1882 (fig. 37), for which Mary Cassatt posed.[5]

If Degas's ideas ran ahead of his instruments ("I felt so poorly made, so poorly equipped, so limp, yet it seemed that my artistic calculations were so right"), it is worth stressing that the additive process in works such as this was inseparable from the realization of the image.[6] Octave Mirbeau perceptively explained this creative mode in 1884: "You might say that it is not Degas who creates his compositions, it is the first line or the first figure he draws or paints that is responsible. Everything unfolds inexorably, mathematically, musically, if you will, from this first line and first figure, just as Bach's fugues depend on the initial phrase or initial tone for their development."[7]

Once this radical transformation of both subject and scale was conceived, it seems that Degas was able to discard his preliminary ideas effortlessly. With the exception of some hesitation in the area around the ear and hair of the hatless woman, the new composition emerged complete: the sureness of Degas's technique and the lucidity of his juxtapositions are a tour de force. There are no known preparatory drawings or studies for this work, and while the composition shares several formal qualities common to the milliner series of 1882–86—the sharp diagonal recession, the central fulcrum of the bent arm—the figures of the two women recur in no other work. *At the Milliner's* is the most finished of all the milliner compositions. The pastel is densely applied, with some smudging to suggest shadows on the side of the face of the woman on the right, yet the surface that Degas achieves is fine and seamless, more uniform and unified than in *At the Milliner's*, 1882 (fig. 36), where the pastel, while rich and thick, is applied more liberally and with less attention to evenness of touch.

The highly worked Annenberg *At the Milliner's* may indeed have been one of Degas's "articles"—his word for paintings conceived and executed for the market.[8] Yet if it is drawn in his "commercial style," Degas's treatment of the subject here is more ambiguous than in any of the other milliner compositions of the first half of the 1880s. While the pastel has clear affinities with other works in the milliner series—in the compositional devices previously mentioned; in the many similarities in dress and hairstyle with the figures in *At the Milliner's* in the Thyssen-Bornemisza Collection (fig. 34); in the muted tones of the women's dresses, which generally serve to heighten the color and sumptuousness of the hats and their trimmings—it also transgresses the conventions of this series at every turn.[9] No milliner is represented, nor are there hatstands, mirrors, or display of other headwear of any kind. The woman on the left, although hatless, must be a companion to the other, for only then does the fact that she is seated become explicable. Shop assistants were not per-

mitted to use the seats provided for clients; in Zola's *Au Bonheur des Dames* they are dismissed for nothing less, and it is inconceivable that a saleswoman, however senior, would have allowed herself such intimate access to a client.[10]

It is the tenderness of the gesture of the gloved woman, who holds the hat with infinite patience while looking down solicitously, that suggests sources for this work far removed from the *Grands Magasins* and the realist milieu. Huysmans described Degas's art as "savante et simple." Degas carried his erudition effortlessly: echoes of Renaissance painting reverberate in *At the Milliner's*.[11] The double profile and overlapping postures recall Leonardo's unfinished *Virgin and Child with Saint Anne* (fig. 38), which Degas had first copied in the Louvre in 1853. The two women's elegant and spare features, their angular forms and quiet concentration also suggest kinship with the serene and noble figures in Ghirlandaio's *Visitation* (fig. 39), another work that Degas had known since early manhood and copied during his apprenticeship in the Louvre.[12]

That he "bound the past to the most immediate pre_nt," in the words of the painter Jacques-Emile Blanche (1861–1942), was a creative process remarked upon by many sensitive observers of his art.[13] For Mirbeau, his contemporaneity was filtered through the simplifying and synthetic manner of the early Siennese masters.[14] But even earlier, in a review of the Fifth Impressionist Exhibition of 1880, Charles Ephrussi, a lesser critic, had perceptively praised Degas as "an estimable draftsman and pupil of the great Florentines, of Lorenzo di Credi and Ghirlandaio."[15] Ephrussi made these connections advisedly: in 1882 he acted as the intermediary in the Louvre's acquisition of the great Botticelli frescoes *Giovanna degli Albizzi Receiving a Gift of Flowers from Venus* and *Lorenzo Tornabuoni Presented by Grammar to Prudentia and the Other Liberal Arts*.[16] His comments are all the more interesting, however, since it is he who first owned the Annenberg *At the Milliner's*; discovering at what point the pastel entered his collection would help solve the vexed issue of when it should be dated.[17]

Charles Ephrussi (1849–1905)—"the Benedictine-dandy of the Rue de Monceau"—was born to a wealthy Jewish banking and corn-exporting family in Odessa. Along with his brother Jules, he penetrated the highest regions of Parisian society (he had arrived in Paris in 1871), and his successes with the aristocracy of the Faubourg Saint-Ge:main were remarked upon.[18] "These Russian Jews, this Ephrussi family, are terrible," fulminated Edmond de Goncourt, resentfully, in June 1881, "with their craven hunt for women with grand dowries and for positions with large salaries.... Charles attends six or seven *soirées* every evening in his bid for the Ministry of Fine Arts."[19] If Ephrussi never realized these ministerial ambitions, he became director and owner of the *Gazette des Beaux-Arts* in 1885, by which time he had already established himself as a serious art historian and collector. Between 1879 and 1882 he assembled an impressive collection of Impressionist paintings, which boasted Monet's *La Grenouillière* (National Gallery, London) and Manet's *Departure for Folkestone* (Philadelphia Museum of Art). Ephrussi was one of Renoir's most devoted supporters: he organized, in the artist's absence, his consignment to the Salon of 1881; he introduced him to the Cahen d'Anvers family; and he appeared, in top hat and redingote, in the background of Renoir's celebrated *Luncheon of the Boating Party* (Phillips Collection, Washington, D.C.). With Degas, Ephrussi's relations were equally cordial for a while. He may well have commissioned Degas to paint his portrait; in a letter to Henri Rouart, dated October 26, 1880, Degas wrote that he was eager to finish "Ephrussi's painting... for there is some good money to be made at the end of it and it is badly needed."[20] Ephrussi was one of the few intimates to be invited to Degas's housewarming in his new apartment on 21 rue Pigalle, in June 1882, as part of a select company that included the Rouarts, Daniel Halévy, and Durand-Ruel.[21] Finally, when Degas applied for a box at the Opéra in 1882, it was Ephrussi who may have smoothed his way with the director and secretary of that institution.[22] Writing to Berthe Morisot in April 1882, Eugène Manet remarked that "Degas has a seat at the Opéra, gets high prices, and does not think of settling his debts to Faure and Ephrussi."[23] This might refer to the unfinished portrait of Ephrussi, which would remain in Degas's studio and be sold as unidentified in his posthumous sale, but cannot be connected to any other known commission for which Ephrussi would have paid in advance.[24] We are quite well informed of Ephrussi's collection at this time through the correspondence of his former secretary, the symbolist poet Jules Laforgue (1860–1887), whose nostalgic letters from Berlin vividly evoke Ephrussi's bedroom lined with Impressionist paintings. Laforgue had left Paris at the end of November 1881, and in a precious letter written in Berlin to Ephrussi at the beginning of December, he recalled "Degas's nervous dancers and his portrait of Duranty," the former unidentifiable, the latter presumably the *Portrait of Duranty*, in pastel (private collection, Washington, D.C.).[25] Laforgue did not claim to make an inventory of the collection, and his memory was not infallible; he did not mention Degas's exquisite *General Mellinet and Chief Rabbi Astruc*, 1871 (City of Gérardmer), which Ephrussi may well have owned by this time.[26] But the absence of *At the Milliner's* in Laforgue's enthusiastic letter is worth noting. Furthermore, given that Ephrussi's interest in the Impressionists waned as dramatically as it had emerged (in 1887 he would publish the first monograph on the eminently respectable Paul Baudry) and that Laforgue's letters of 1882 allude to offers made for Ephrussi's Impressionist paintings rather than to works newly acquired, it would seem that Ephrussi's collecting came to a halt some time in 1882 or 1883.[27]

The speculation that *At the Milliner's* entered Ephrussi's collection after November 1881 (the date of Laforgue's departure from Paris), but no later than 1882–83, is confirmed with indisputable precision

from an investigation of Durand-Ruel's stock books.[28] Tracing the various references there to the pastel numbered 1923, initially entitled "A Corner of the Salon," and matching this with the same inventory number discovered on the back of *At the Milliner's*, one can now establish the following chronology. On October 12, 1881, Degas delivered the pastel entitled "A Corner of the Salon" to Durand-Ruel for 1,500 francs, his single largest deposit of that year.[29] The pastel was assigned the stock number 1923 and estimated for sale at 2,000 to 3,000 francs. Six months later, on April 21, 1882, Ephrussi purchased six Impressionist paintings from Durand-Ruel, including Degas's pastel, "A Corner of the Salon," for which he paid 2,000 francs.[30] Almost thirteen years later to the day, on April 24, 1895, Ephrussi returned to place the pastel—now called "The Conversation"—on deposit with Durand-Ruel, for an estimated selling price of 15,000 francs.[31] The pastel was not sold, however, and on April 7, 1896, Durand-Ruel purchased it for the company for 8,000 francs, listing it variously as "The Conversation," "At the Milliner's," and "Woman Trying on a Hat," and giving it a sale price of 40,000 francs.[32] The pastel remained in the family collection until the 1940s.

Thus, *At the Milliner's*, executed by October 1881, anticipates by nearly a year the first of a celebrated group that has been described as "an exceptionally cohesive unit of work."[33] Degas used the two alternate formats of the Annenberg pastel—the vertical and the square—in two of the subsequent milliner pastels of 1882 (figs. 36 and 37), for which *At the Milliner's* becomes a sort of prototype. Although it cannot claim precedence as Degas's first treatment of the theme, for he had exhibited a milliner, now lost, at the Second Impressionist Exhibition of 1876, *At the Milliner's* offered the starting point for many of the compositional devices that were developed in this remarkable series.[34] Yet in its immaculately finished surface, it also looked back to such pastels as *Women in Street Clothes*, c.1879 (Collection of Walter Feilchenfeldt, Zurich) and the *Dance Examination* (Denver Art Museum) of approximately the same date. And in its daring accretions and extensions, it relates to the *Portrait of a Dancer at Her Lesson*, 1879, where the same additive process was at work.[35]

And what of the subject of this pastel? The range of titles it was assigned in 1895-96 suggests that the image defied precision even then. Its first title, "A Corner of the Salon," was suitably noncommittal, although whether this was of Degas's choosing is not known. If Degas's imagination was stirred by the fire that ravaged the great Parisian department store Printemps, in March 1881, an incident widely reported in the press, and one that laid the seed for Zola's *Au Bonheur des Dames*, only coincidence of chronology affirms the link.[36]

Degas's interest in representing Mary Cassatt and her sister in fashionable settings may also have had some bearing on the genesis of this work. Certainly the plain costumes worn by the figures in *At the Milliner's* compare well with the subdued dresses worn by the Cassatt sisters in the series of them posed in the Louvre, and the fascination with the rear view is common to both. In his letter of October 26, 1880, to Henri Rouart, Degas mentioned that the Cassatts had just returned to Paris from Marly, and while Lydia was in ailing health until her death in November 1882, the possibility of her sitting for Degas here cannot be entirely ruled out, given the similarity of both the profile and the long suede gloves in Mary Cassatt's portrait of *Lydia in the Garden* (fig. 40), painted in 1880.[37]

It is almost easier to state what the pastel is not concerned with than to attach precise models or messages to it. More categorically than in any other milliner painting, Degas distanced himself from showing what George Moore described as "the dim, sweet, sad poetry of female work," although how fascinating he ever found this aspect of the milliner's life is open to debate.[38] Not only did Degas obliterate the shop assistant in *At the Milliner's*, relegating the ubiquitous mirror to a position off stage, he also hinted at the elegant furnishings of a *maison de haute couture* with the greatest discretion. For there is no doubt that the interior shown here belongs to the rue de la Paix and not the bustling, populous world of the burgeoning department store described in loving detail by Zola. The point is best made by comparison with photographs of such interiors, even a decade later, such as M. Félix's establishment on the rue Saint Honoré. The sofa and banquettes of the young ladies' room *chez* Félix (fig. 41) are as inviting and secluded as the diamond-patterned sofa in the pastel. The pier glasses that repeat the majestic palms in the fashion hall of the same establishment (fig. 42) are also to be found in the background of *At the Milliner's*.[39]

Noting that Degas was "brought up in a fashionable set," Gauguin commented ironically that he "dared to go into ecstacies before the milliners' shops in the Rue de la Paix" with their "pretty artificiality."[40] Yet such "pretty artificiality" is secondary in this pastel to something far more intriguing and more disturbing: women's intimacy, out-of-doors, as it were. Degas used a realist's vocabulary to explore moments of privacy that are perhaps impenetrable and did so with restraint and modesty. This is the great distance separating his art from that of Zola's. In fact, it was the British Impressionist Walter Sickert who seems to have best grasped Degas's enterprise in paintings such as *At the Milliner's*. Writing of one of his early visits to Degas's studio, in either 1883 or 1885, Sickert recalled Degas pronouncing that painters had made too much of formal portraiture of women, "whereas, their hundred and one gestures, their *chatteries*, &c., should inspire an infinite variety of design."[41] This is perhaps the most evocative assessment yet made of *At the Milliner's*.

CBB

BERTHE MORISOT

FRENCH, 1841–1895
THE PINK DRESS, c. 1870
OIL ON CANVAS, 21½ X 26½ INCHES

THE PINK DRESS is among the two dozen or so paintings made by Berthe Morisot before her thirtieth birthday to have survived: Mallarmé's "amicable Medusa" is thought to have destroyed the greater part of her early work in dissatisfaction and frustration.[1] The remnants of Morisot's signature, in red, at the lower right of the canvas, suggest that this was one of the rare paintings she considered acceptable for presentation to the sitter.

Fortunately, the circumstances in which *The Pink Dress* was painted are documented to a remarkable degree through the testimony of Jacques-Emile Blanche (1861–1942), society portraitist, friend of the Impressionists, and avid collector of the new painting.[2] Of Blanche's many recollections of his childhood in Passy, that elegant section to the west of Paris that is a continuation of the sixteenth *arrondissement*, his meetings with Berthe Morisot and her set are among the most vivid. He was particularly eloquent on the attractive circle of well-educated, upper middle-class young women who congregated at the home of Jean-Baptiste and Françoise Léonarde Carré at the Villa Fodor, a residence on rue Jean-Bologne built in 1856 by the celebrated French soprano Josephine Fodor-Mainveille, and, according to Blanche, the setting for *The Pink Dress*.[3] Passy society, as opposed to Parisian society, was dominated by families like the Morisots and the Carrés, and is the vital context for Morisot's early work.

Although written at the age of sixty, Blanche's recollections are full of pertinent details concerning *The Pink Dress*, and these give his somewhat Proustian efforts the quality of an eyewitness account. In an article dedicated to Julie Manet, Eugène Manet and Morisot's only child, he wrote: "I met Mlle Berthe at the Villa Fodor many times: I was meant to be playing games there, but it was really your mother that I went to see, for even then, paint brushes and colors interested me a great deal more than badminton and croquet. One day, she painted before my eyes a charming portrait of Mlle Marguerite in a light pink dress; indeed, the entire canvas was light. Here Berthe

Morisot was fully herself, already eliminating from nature both shadows and half-tones."[4]

Marguerite Carré he remembered as a rather beleaguered sitter, dressed "in the manner of Berthe Morisot," seated on the sofa "straight as a tent peg," reminding those who watched Morisot paint of a fashionable doll.[5] The portrait was completed over several sessions, since Morisot "constantly changed her mind and painted over what she had done once the session was at an end, and Mlle Marguerite was obliged to pose for months at a time, without the sketch seeming to advance any further."[6]

The Pink Dress has indeed retained traces of the struggle for form and idiom to which Blanche alluded, recording, almost in spite of itself, the artist's hesitations and changes of mind. In a bold, frontal pose, the young Marguerite Carré sits rather uncomfortably on a small sofa with white slip covers, her right hand nervously fingering the fabric of her pink dress. Although not immediately apparent, her light brown hair falls from behind her head—a domestic Olympia!—and she wears a discreet black net over one side of her chignon. On a small round table behind her are ornaments of a Japanese flavor: a painted fan and a decorated *cachepot* with a large rubber plant. Gazing directly at the spectator, Marguerite rests her left hand on a large bolster of gold and white, her left arm foreshortened in a pose that is daring, if not altogether successful. There is some further disjunction in the angle of the sofa, set at a slight oblique both to the background and the table even though Marguerite Carré's frontal posture seems to demand a more resolutely parallel placement.

In *The Pink Dress* Morisot's handling is at once aggressive and controlled, her "fury and nonchalance" held in check by her determination to give plasticity and vigor to the mundane objects she describes.[7] Much of the composition bears the marks of scraping and repainting, but nowhere is this as obsessive as in the background, where practically every element has been altered or reformulated. The clusters of bright red paint that bloom eerily from beneath the leaves of the rubber plant indicate that she changed her mind more than once about the sort of potted plant she wanted: rubber plant or geranium. Between the *cachepot* and the Japanese fan is the spectral outline of a perfume vial or decanter, an ornament she finally rejected. It is almost impossible to guess what Morisot may have painted in the background to the right of Mlle Carré, for this area has the feel of a battleground, so extensive is the scraping and repainting. It seems that even after she came to the felicitous decision to leave the

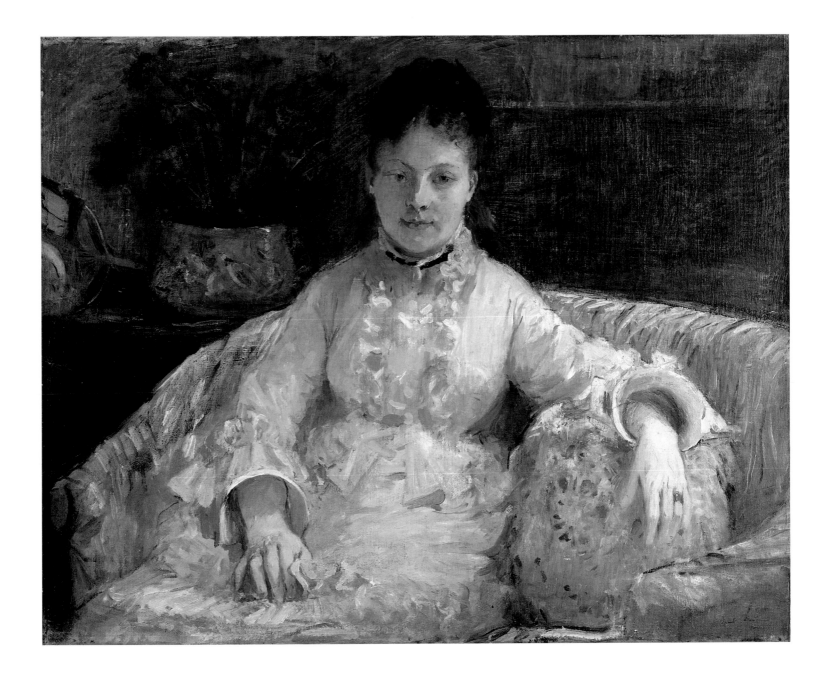

background empty—thereby detracting as little attention as possible from Marguerite—Morisot hesitated in her choice of tone. After first painting over in black, she effaced the color and repainted in brown; the textured penumbra that this process created serves well to emphasize the luminosity of the sitter and her dress.

The changes made in painting Marguerite Carré herself were less radical, but remain visible nonetheless. The sitter's hands and sleeves presented considerable difficulty and were moved more than once. Marguerite's right arm was initially placed closer to the edge of the sofa, and patches of pink paint, formerly the sleeve of her dress, are to be seen quite clearly through the grays and whites of the slip covers. That so much of the dark background tone is visible in this section suggests that the shape of the sofa itself was also adjusted.

Blanche's discussion of Morisot's painting at the Villa Fodor mentions the changes that are found in *The Pink Dress* almost point for point, and it is this concordance that lends such weight to his testimony. Blanche remembered Marguerite and her elder sister Valentine as among Morisot's earliest models, "with their full heads of light hair in lace netting" and in dresses "with the waistline just below the breast and with a fluted frill open in the shape of a heart." Over their collars they attached a "band of velvet that trailed down the back," and the effect was captivating: "Theirs was a look that said, 'Follow me, young man' and was one very much in keeping with the style of the Villa Fodor."[8]

Blanche could almost be describing Marguerite Carré as she is portrayed in *The Pink Dress*, and his discussion of the use Morisot made of accessories in her portraits is equally compelling. The artist favored "*cachepots* made of Gien earthenware, in which were placed rubber plants with large leaves"; she liked "comfortable squat armchairs and white slip covers, which she almost always used to hide the ugly rosewood furniture"—features that are much in evidence in this portrait.[9]

But it is his recollection of Morisot at work on *The Pink Dress* that has unexpected documentary value. The artist was surrounded by the indulgent and amused matrons of Passy, her own mother included, who teased her outrageously as the painting took on form: "Wherever did you get such ideas? To put a lilac piano in a portrait, to include muslin curtains, and to paint a rubber plant instead of a bouquet of flowers!"[10]

The exclamations of Morisot's audience are precious: We know that the artist hesitated before painting the rubber plant in its fashionable holder, and that she may have been persuaded to paint instead a more orthodox bouquet, which she then promptly eliminated. The passage also offers a clue as to what else may have once

appeared in the background, for it is not altogether impossible to imagine in the shapes behind the sofa on the right the contours of an upright piano, or even of muslin curtains, both elements wisely removed on one of the many reworkings that the composition underwent.

Blanche was in no doubt as to the identity of the sitter in *The Pink Dress*, and he had good reason to remember Marguerite Carré, since it was she who had first introduced him at age seven to Berthe Morisot in 1867.[11] Later writers have confused the issue in mistaking the sitter for Louise-Valentine Carré, Marguerite's elder sister, who briefly caught Manet's attention in 1870 and posed for the seated female figure in his first plein-air painting, *In the Garden* (fig. 43), until prevented from returning by her appalled mother.[12]

Albertie-Marguerite Carré was born in Paris on February 16, 1854, and was thus thirteen years Morisot's junior. On November 10, 1897, at the age of forty-five, she married Ferdinand-Henri Himmes (1852-1917), sous-chef in the Ministry of Finance, and previously the husband of her sister, Louise-Valentine, who had died in August 1896.[13] In October dispensation for the already related couple to marry had been requested from the French government.[14] They visited Julie Manet two weeks before their wedding, just after such permission had been granted: "How strange life is," recorded Julie in her diary, "For some time now everyone thought Mlle Carré would remain a spinster for the rest of her days. Her sister dies and life suddenly begins for her; for the first time in her life she considers herself to be somebody. It is almost as if the two sisters could not live at the same time."[15]

Part of the confusion concerning the identity of the sitter stems from the fact that both sisters shared the same husband, and thus the same surname. The accuracy of Blanche's memory is confirmed by the recollections of a living descendant of the Morisot household, Julie Manet's cousin, Mme Agathe Rouart-Valéry, who can remember Marguerite Himmes's visits when she was a young girl. By then, Marguerite's "round, well-powdered cheeks and fine features" were all that remained to evoke Morisot's portrait of her. On one such occasion, Mme Himmes unexpectedly encountered the master of the household, the great symbolist poet Paul Valéry, and was so intimidated that she hardly uttered a word.[16] Still living in Passy, Marguerite Carré died childless, at the age of seventy-nine, on January 31, 1935, her husband having predeceased her by some eighteen years on August 31, 1917. Valentine and Marguerite Carré are buried alongside Ferdinand Himmes in the cemetery of Passy.[17]

Tracing Marguerite Carré's date of birth and the meager details of her life is of great help in assigning a date to the painting itself. This

was something Blanche did not do, mentioning only that he had first been introduced to Morisot in 1867 and that his childhood reminiscences were confined to the Second Empire, which came to a close in September 1870.[18] Certainly, Morisot presents us with a rather shy, self-conscious sitter, full of face and rather uneasy under the artist's penetrating gaze. Although elaborately dressed, Marguerite Carré seems to be on the threshold of early womanhood, but she is clearly still quite young.

In trying to arrive at a date for *The Pink Dress*, which has been customarily dated to 1873, the influence of Morisot's mentor and teacher, Edouard Manet, is also of the greatest significance. Most recently the portrait has been ingeniously related to *Reading* (fig. 44), Manet's celebrated portrait of his wife Suzanne (see p. 10), which clearly provided Morisot with a prototype for her own composition.[19] The position of Marguerite Carré on the sofa derives from Suzanne reclining as she listens to her son read to her, although Morisot's sitter has little of Suzanne's composure. Curiously, Morisot lavished as much care on Marguerite's hands, finely modeled, with elegant, tapering fingers, as Manet had taken with those of his pianist wife. So much indebted to Manet's *Reading* is this portrait that it has been called, somewhat dismissively, "a simple exercise," and dated to late 1868: a time when Morisot would have had ample opportunity to study the painting at her leisure, while posing for the seated figure in Manet's *Balcony* (Musée d'Orsay, Paris).[20] Attractive as this hypothesis is, it is open to revision on many counts. First, *Reading* was not necessarily completed by the latter part of 1868. It is a painting on which Manet may have worked over a period of eight years, with parts of the painting executed in the early 1870s.[21] In a letter of March 1869, Berthe Morisot's mother noted with some asperity that Manet had finally painted his wife— "I think it was high time"—which could suggest that *Reading* was not completed, even in its initial form, until early that year.[22] And Morisot would have another chance to gaze at this painting, either at Manet's studio on the rue Guyot or at his family house, during her second protracted modeling session for him, in 1870, when he painted his celebrated portrait of her, *Repose* (Museum of Art, Rhode Island School of Design, Providence), in the early summer of that year.[23]

A date of c. 1870 for *The Pink Dress* is satisfying for other reasons. Whereas it is difficult to see Marguerite Carré as a fourteen year old (one thinks of Degas's bronze dancer of the same age), it is just possible to reconcile Morisot's image of burgeoning womanhood with a girl who had reached her sixteenth year. *The Pink Dress* is also very close in every aspect of its composition to the enigmatic *Two Seated Women (The Sisters)* (fig. 45), which is dated between 1869 and 1875.[24] This is another portrait that bears the imprint of the Villa Fodor: the polka dot dresses, the brightly patterned sofa, the black chokers are all elements evoked in Blanche's recollection.[25]

While the more aggressive handling in *The Pink Dress* owes something to the informal manner of another social intimate, Alfred Stevens, the solidity of modeling, the assured and insistent application of paint, and the rapt frontal gaze are features shared by Morisot's early work the *Portrait of Jeanne-Marie* (fig. 46), dated to 1871. *The Pink Dress*, with its lingering indebtedness to Manet, may well be the earliest of this related group and should be dated to around 1870.

Marguerite Carré would sit for Morisot twice more. She was the subject of a pastel portrait, now lost, that Eugène Manet had encouraged his wife to exhibit at the Dudley Gallery in London in October 1875.[26] She appears again as the svelte and elegant young woman in the *Young Woman in a Ballgown* (fig. 47), dated to 1873, which Julie Manet admired at the first Morisot retrospective at Durand-Ruel's gallery in March 1896.[27]

If previous discussion of *The Pink Dress* has suffered from a case of mistaken identity, there has been similar confusion over the provenance of this painting. Contrary to what has been repeated until very recently, Morisot's portrait of Mlle Carré did not appear in the Sixth Impressionist Exhibition of 1881.[28] Although the artist's submissions there included a *Young Woman in Pink*, the single detailed discussion of this painting, Nina de Villar's review in *Le Courrier du Soir*, disqualifies it as *The Pink Dress*. Apart from the improbability of Morisot exhibiting a work some ten years old at such a progressive salon, the review praised Morisot's portrait of a "woman whose eyes are as blue as the earrings that adorn her charming ears."[29] Not only are Marguerite's eyes blue gray, but she does not wear earrings. Similarly, it is impossible to confirm that *The Pink Dress* is the same work as the *Portrait of Mme H.* that appeared in two important early retrospectives of Morisot's work: Durand-Ruel's exhibition of 1902, and Bernheim-Jeune's of 1919. The charming *Portrait of Mme Hubbard*, 1874 (The Ordrupgaard Collection, Copenhagen) and the earlier, more severe *Portrait of Mme Heude*, c. 1870 (private collection) are equal contenders with Mme Himmes for these honors.[30] After leaving Mme Himmes's possession, *The Pink Dress* is firmly documented only in the prestigious collection of the Argentine Antonio Santamarina, in 1933. Santamarina had formed his impressive collection of Impressionist paintings between 1895 and 1930, and it thus seems that Marguerite Carré-Himmes would have parted with Morisot's portrait before she died in 1935.

CBB

Henri Fantin-Latour

FRENCH, 1836–1904
ROSES IN A BOWL, 1883
OIL ON CANVAS, 11¾ X 16⅜ INCHES

ONE SIDE of Fantin's art—his exquisite Flower Painting—we, in England, were the first to appreciate," wrote the critic and art historian Frederick Wedmore in 1906. This he attributed not merely to a favorable press, but to the energies of "the interesting etcher" Edwin Edwards (1823–1879) and his wife, Elizabeth Ruth (fig. 48), "alert, enthusiastic, as well as influential," who, for long years, were "of infinite service to [Fantin's] name."[1] First introduced to the Edwardses in February or March of 1861 by Whistler's friend the English painter Matthew White Ridley (1836–1888), Fantin-Latour tapped the English market during the 1860s both with Whistler's assistance and in informal arrangement with Edwards. Not until June 1872 did Edwards become Fantin's official agent in England. Thereafter, despite disagreements with him over prices and stratagem, the artist remained loyal to Edwards, and, after 1879, to his widow, until he finally severed all connection with the English market in January 1899.[2] Yet for almost thirty years, Fantin had provided the Edwardses with a steady supply of flower paintings, which they placed in collections and exhibitions throughout the country; his choice of flowers and accessories was, in large part, dictated by them.[3]

Hence the prodigious number of roses in Fantin's oeuvre, a flower beloved of the Victorian public and in the painting of which, as a contemporary, Jacques-Emile Blanche, wrote, the artist had "no equal."[4] *Roses in a Bowl*, most likely painted in the summer of 1883 at his wife's country home at Buré in Normandy, was precisely the sort of cabinet picture that appealed to this public. On a dark ledge that merges imperceptibly into the wall behind is placed a group of tea roses, set into a two-handled, footed vase—of a type that Fantin presumably favored because they "count for nothing, and don't distract the attention to be paid to the flowers."[5] The receptacle may have been provided by the Edwardses themselves in accordance with English taste, but was used again by Fantin in the much grander *Roses and Larkspur* of 1885 (Glasgow University), where similar roses appear, similarly arranged, as well as in the following painting, *Roses and Lilies*.

Although varnish obscures some of the delicate handling here, the artist has achieved a rich, almost dramatic resonance as the deeply colored flowers emerge from the penumbra to cast their glow into the surrounding shadows. With the artist's customary restraint, two leaves trail from the white rose on the right and touch the ledge; the vase and flowers leave long shadows, painted brown against brown, which give interest to the mottled background in this undifferentiated setting.

Simple and restrained, *Roses in a Bowl* nonetheless looks back to two weighty artistic traditions. Recalling his own early work of the 1860s, Degas noted, "In our beginnings, Fantin, Whistler and I were all on the same road, the road from Holland."[6] Unlike Whistler and Degas, Fantin never strayed too far from the Dutch seventeenth century in his respect for the minor genre of flower painting. Blanche wrote eloquently on Fantin's flower painting, calling him "a grandchild of Chardin's"—and, indeed, the effortless transformation of the foreground ledge into the background wall is a device that Fantin borrowed directly from the eighteenth-century master of still life.[7] Although the rediscovery of Chardin in the middle of the nineteenth century was of considerable importance for realist still-life painters such as François Bonvin (1817–1887) and Philippe Rousseau (1816–1887), Fantin was less directly influenced by him.[8] Yet if Chardin painted flowers rarely, one of his most accomplished followers, Anne Vallayer-Coster (1744–1818), made them her speciality, and in their simple elegance and easy charm (fig. 49) they are the true eighteenth-century ancestors of Fantin's peculiarly English genre.

CBB

26

HENRI FANTIN-LATOUR
FRENCH, 1836–1904
ROSES AND LILIES, 1888
OIL ON CANVAS, 23½ X 18 INCHES

I N JULY 1888 Fantin-Latour informed his old friend the Frankfurt painter Otto Scholderer (1834–1902) that he was already "very tired" painting flowers even though the summer was still young.[1] Writing from his wife's family home in Buré, Normandy, where he had spent every summer from 1880 and where he painted most of his flower pieces, he expressed something of the boredom that many commentators have found in his paintings of this decade.[2] The artist, after all, had been producing relatively small flower paintings almost exclusively for the English market since 1861. And the overwhelming and insistent manner of his dealer, Ruth Edwards, the widow and partner of Edwin Edwards (1823–1879), who had 'discovered' Fantin-Latour, may certainly have contributed to his disenchantment with the genre by this time.[3] Yet *Roses and Lilies*, dated 1888 and therefore probably painted at Buré in the summer of that year, bears no sign of such weariness, nor does it show the slightest falling off in artistic power. Thus it serves to question the charge of atrophy that is routinely applied to Fantin-Latour's work of this period.

Against a subtle lavender-gray and warm brown background, four stems of lilies, set in a plain glass vase filled almost to the brim with water, cast their gentle shadows. A bowl of roses, cut at full bloom, is placed to the left. Each lily is observed in great detail, from the vivid orange stamen to the creamy whites of the curving petals, dusted with mauve and yellow. What Ruskin had called "the finely drawn leafage of the discriminated flower"[4] could apply equally well to the roses—rich, full flowers, with the ridges of their petals carefully described—whose whites are set off by the most delicate strokes of blue. Unexpected highlights of blue also model the underside of the bowl that holds the roses, and create, in hatching lines, the outer edges of the vertical glass vase and the surface of the water inside.

Although we do not know the circumstances in which *Roses and Lilies* was painted, a detailed account of the artist at work the following summer serves to illuminate his technique and working method.[5] He used commercially prepared canvases known as *toile absorbante*, with a gessolike ground layer, whose luminosity was maintained through subsequent layers of paint. In *Roses and Lilies* he applied an *imprimatura* layer, here a thin, even glaze of brown, over the off-white ground, making the weave texture very apparent: this now formed the base color upon which his flowers would be painted. The *imprimatura* layer was itself enlivened by a thin stippled layer of lavender gray, handled in such a way as to produce a scumbled effect suggesting the randomness of the reflections cast by the blooms.[6]

In the account of the artist at work in 1889, Fantin-Latour waited until the day after he had prepared his canvas before picking the flowers he wanted to paint from his garden and choosing the appropriate vessels for them from among the vases supplied by Mrs. Edwards. He also placed the flowers against a piece of cardboard painted the same color as the background of his canvas, a procedure he may well have followed in executing *Roses and Lilies*.[7] Only after all this would he concentrate on painting the flowers themselves, which he did quickly and confidently, using relatively small strokes of impasto. A particularly attractive feature of *Roses and Lilies* is Fantin-Latour's use of the tip of the handle of his paintbrush, or a similar instrument, to incise and manipulate the wet paint. This device is employed effectively to suggest the edges of the petals of the central rose and the ribs of the lilies above. Delicate incisions, which allow the background tone to push through the whites, can be discerned on almost every lily: Fantin-Latour's line cuts cleanly through the thinly impasted surface and is sufficiently varied and discrete to avoid degenerating into a technical cliché. He followed a similar procedure in painting the tabletop and glass vase, where the original layer of blue paint has been almost completely removed by the scraping action of the brush handle, leaving the most delicate of scribbles to define the curved surfaces of the vase and the reflections within.

Such virtuosity, as well as the easy elegance of his compositions and their spare, unusual harmonies, distinguished Fantin-Latour's work from the genre painting of his English contemporaries, which the French critic Ernest Chesneau characterized as "one of microscopic analysis driven to the utmost extreme" and which provides the proper context for an appraisal of Fantin-Latour's flower painting.[8] It should always be remembered that Fantin-Latour's still lifes were made for a Victorian public—despite Durand-Ruel's numerous purchases in 1872 this aspect of his oeuvre found little favor in France[9]— and that from his earliest visit to London he had been intrigued by the Pre-Raphaelites.

By the late 1870s the lily had become vulgarized as Oscar Wilde's flower, and the pre-eminent symbol of the Aesthetic movement in England—a resonance strongly felt in the striking *White Lilies* (fig. 50), painted in 1877, and still perceptible in the more subdued *Roses and Lilies*. Furthermore, although his friendship with Whistler was long at an end by the 1880s, Fantin-Latour aspired in *Roses and Lilies* to the lofty realm that Whistler claimed for the artist in his celebrated "Ten O'Clock Lecture," delivered in London in February 1885. Whistler, another proponent of Art-for-Art's Sake, argued that the artist is privy to the mysteries of nature in recording her creations: "He looks at her flower, not with the enlarging lens, that he may gather facts for the botanist, but with the light of the one who sees in her choice selection of brilliant tones and delicate tints, suggestions of future harmonies."[10] For Fantin-Latour, as for Whistler, nature is always 'dainty and lovable': and it was through his determined rejection of a slavish and prosaic verism that he was able to aspire to the poetry of "hushed silence" that Paul Claudel discovered in his best flower paintings.[11]

CBB

PIERRE-AUGUSTE RENOIR

FRENCH, 1841–1919

NINI IN THE GARDEN, 1875–76

OIL ON CANVAS, 24³⁄₈ X 20 INCHES

ACCORDING TO Ambroise Vollard's memoirs, in the spring of 1875 Renoir rented a second Parisian studio and garden, at 12 rue Cortot, after he had sold his *Mother and Children* (The Frick Collection, New York) for the princely sum of 1,200 francs.[1] For the next eighteen months he divided his time between his home at 35 rue Saint-Georges and the upper story of this dilapidated seventeenth-century outbuilding on the Butte Montmartre, where he also had use of the stables to store his canvases and, even more important, free run of a large garden in which to paint in plein air. Having established residence in Montmartre, Renoir began work the following year on the masterpiece of his Impressionist period, the *Moulin de la Galette* (Musée d'Orsay, Paris), conceived between April and October 1876 in both the open-air dance hall and the garden of the rue Cortot.

As Renoir's son pointed out, his father rarely worked on one canvas at a time, and *Nini in the Garden*, signed but not dated, belongs to the period immediately before work on the *Moulin de la Galette* began in earnest.[2] Inspired by Monet's work at Argenteuil, Renoir had been experimenting since the early 1870s with the motif of young women in the garden: in size, format, and orientation, *Nini in the Garden* may be loosely grouped with *Woman with a Black Dog*, 1874 (formerly, Charles Clore Collection, London) and the radiant *Umbrella* of 1878 (sale, Christie's, May 11, 1988, lot 15). These paintings are identical in size (24 by 20 inches); each explores the problem of integrating the clothed female figure in ambient daylight and achieving a harmony between elegant *Parisienne* and exuberant nature.[3] Even more closely related is *Young Girl on the Beach* (fig. 51), which was probably painted at the same session: there, the model, Nini Lopez, sits on a similar garden chair wearing identical dress, but her presence is more assertive, now the chief element in the composition.[4] Both paintings convey the delight that Renoir experienced in the large garden at the rue Cortot. Georges Rivière, who had accompanied Renoir in his search for the ideal Montmartre studio, recalled that "as soon as Renoir entered the house, he was charmed by the view of this garden, which looked like a beautiful abandoned park. Once we had passed through the narrow hallway, we stood before a vast uncultivated lawn dotted with poppies, convolvulus, and daisies."[5] Beyond this, Rivière continued, lay a beautiful *allée* planted with trees stretching the full length of the garden—this was the view that Renoir used for his celebrated painting *The Swing* (Musée d'Orsay, Paris)—and at the end was a fruit and vegetable patch with dense bushes and poplar trees. It is difficult to know exactly which corner of the garden is represented in this painting, although Nini does appear to be sitting at the edge of an untidy lawn.

Renoir's model here, Nini Lopez, a young girl from Montmartre, appeared in at least fourteen of the artist's canvases between 1874 and 1878, and it has recently been suggested that she posed for the large *Mother and Children*.[6] Rivière described her as an "ideal model: punctual, serious and discreet" and admired her "marvelous head of shining, golden blond hair."[7] Renoir would also remember her as beautiful and docile, but somewhat duplicitous—he spoke of "a cer-

tain Belgian disingenuousness" in her.[8] Although Nini's mother entertained hopes that Renoir would eventually become her protector, these were finally disappointed when Nini married a third-rate actor from the Montmartre theatre.

In *Nini in the Garden*, which should be dated around 1875–76, Renoir's handling is energized, nervous, and experimental. He makes no attempt to unify the paint surface of his canvas: ridges of rich impasto sit alongside areas of barely covered ground. His color is nonetheless applied in dabs and strokes of varying touch, appropriate to the forms they describe. Thus, the leafy bushes in the background are a mosaic of greens, browns, and ochers; the sky in the upper left a series of blue strokes placed over the greens—the most obvious of Renoir's borrowings from Monet. Nini herself is painted more emphatically, the violet blue of her hat and underskirt the densest blocks of color in the composition. Nini's costume is very similar to, if not identical to, the one she wears in *Departure from the Conservatory* (fig. 52). Comparison helps establish the design of Nini's ensemble as it appears in *Nini in the Garden*: dark tunic over a light pinafore dress, with dark underskirt, this last element just visible through the grass and plants.

It is clear, however, that costume is of little concern to Renoir here. His chief interest is to record the sunlight as it filters through bushes and trees onto the diminutive and fashionably dressed *Parisienne*. He had already investigated these effects on the nude; *Nini in the Garden* marks an early stage in such treatment of the dressed figure. Somewhat tentatively, Renoir painted the reflections of foliage on Nini's face and the larger shadows on her dress. Her golden brown tresses are overwhelmed by the greens and browns of the background foliage; the forms of her dress dissolve in the dappled light and shadow.

Those elements of Renoir's luminist vocabulary that would cause such outrage in 1877—his colored shadows, the violet tonality of his outdoor scenes—are present in this early example: for example, the line of chartreuse that defines Nini's cheek and chin as well as the mauve patches of shadow on her dress. Although his plein-air painting still owed much to Monet—whose *Camille Reading*, 1872 (fig. 53), had explored the dappled effect of sunlight on the dressed figure—in the paintings he made in the garden of the rue Cortot, Renoir developed what Théodore Duret would consider his most striking contribution to Impressionism: depicting the human figure in the endlessly changing, mobile light of nature.[9] Renoir's exploration of light dancing over the human figure would achieve full expression in *The Swing* and *Moulin de la Galette*. In *Nini in the Garden* such effects are rendered a little hesitantly, but with the daring of experiment.

It is not only in matters of technique that *Nini in the Garden* is characteristic. Nini, in elegant tocque and fashionable dress, sits somewhat uncomfortably on the makeshift garden chair, her neat and relatively formal attire contrasting wittily with the overgrown and unkempt garden. She is transformed from professional model and working-class beauty into demure lady of the manor. And this transformation is made, typically, with both sympathy and tenderness and a complete lack of condescension. Julie Manet would recall Renoir saying how delicate he had found the people of Montmartre whom Zola had portrayed as bestial.[10] Yet his depiction of Nini is equally misleading, replacing the customs of Montmartre with a sweeter respectability. This was Renoir's great fiction—as willful as Zola's—and it was at the core of his figure paintings of the 1870s, sustaining a vision of modernity that was highly colored and eternally joyous.

CBB

30

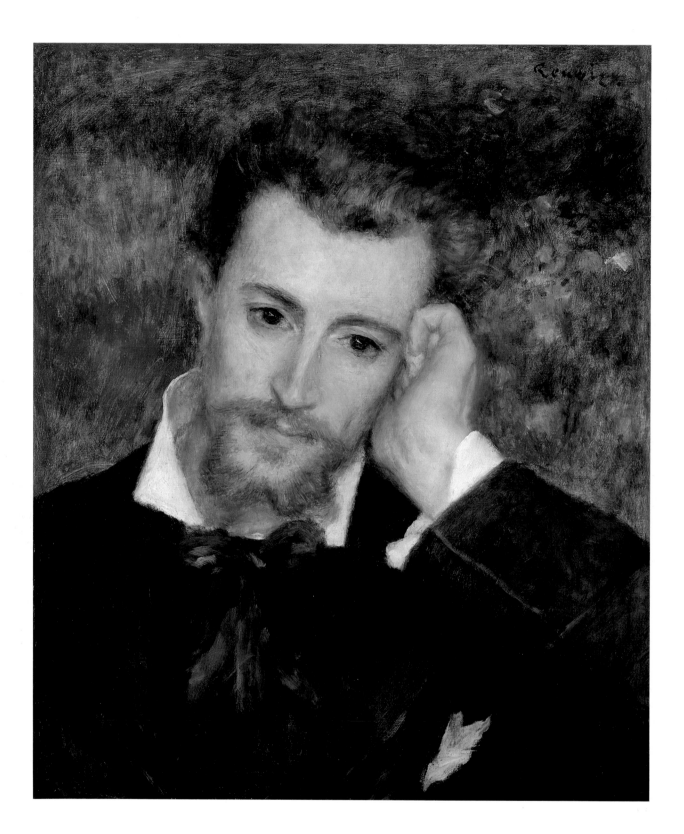

PIERRE-AUGUSTE RENOIR

FRENCH, 1841–1919
EUGÈNE MURER, 1877
OIL ON CANVAS, 18 9/16 X 15 1/2 INCHES

Toward the end of 1877 Renoir painted the portrait of Hyacinthe-Eugène Meunier, known as Eugène Murer (1846–1906)—celebrated pastry cook and restaurateur, published novelist and poet, and avid collector of the works of Pissarro, Guillaumin, Sisley, and Renoir.[1] This small canvas—a number 8—followed a format that Renoir had begun to use for the informal portraiture of his sponsors. It may be compared to his earlier paintings of Victor Chocquet and to his portrait of the Republican official Jacques-Eugène Spuller (fig. 54), which has been convincingly redated to 1877 and is very similar to the Murer portrait in handling and arrangement.[2] Renoir's ravishing portrait of Murer's son, Paul Meunier (fig. 55), painted between 1877 and 1879, is of similar dimensions.[3]

In the portrait of Eugène Murer, Renoir's loose and brushy handling adapts itself almost effortlessly to the constraints imposed both by genre—the public nature of commissioned portraiture, however informal—and by size. It is clear from the slight change in the placement of Murer's left hand and a certain indecision as to where the edge of his sleeve and the line of his shirt cuff should meet that Renoir experienced some difficulty in arriving at the appropriate pose for his model. Once solved, the formula was repeated in his portrait of Murer's half-sister, Marie (fig. 56).

Murer's elegant frock coat and *gilet* are painted freely, the white ground showing through the thin layers of blue-black paint. His blue-black foulard and pink pocket handkerchief—accessories of a dandy—are indicated by the most summary of strokes. Yet, at the same time, Renoir painted the two fine lines of blue silk to which Murer's spectacles are attached: these fall from the buttons of his waistcoat and disappear behind the wide lapel, an astonishing detail and one wholly unexpected in this bravura passage.

It is in the painting of Murer's face, however, that Renoir's handling is at its most exquisitely controlled. Murer's beard is a panoply of color, delicate touches of olive green, mauve gray, and orange that merge imperceptibly and whose richness is deliberately muted. The flesh tones of Murer's face are enlivened by a filigree of colored strokes—note especially the blues on the temples, under his eyes, around his nose—striations that give rhythm and mobility to Murer's intense gaze, but draw no attention to themselves.

In fact, the virtuosity and variety in Renoir's handling are secondary to his chief purpose: the creation of character and the exploration of intimacy. "Not only does he capture the features of his sitters," wrote Théodore Duret in *Les Peintres Impressionnistes*, published a year after the portrait of Eugène Murer was painted, "but it is through these traits that he grasps both their character and their private selves."[4] In this portrait, Murer appears as a sensitive, almost melancholy, sitter, frail and wistful, his slight frame overwhelmed by a costume that seems a little too large for him. Such vulnerability and introspection were by no means the characteristics most readily associated with Murer; the degree of idealization in Renoir's portrait of Murer becomes apparent in surveying the biography of this interesting figure.

Murer was born in Moulins, in central France, on May 20, 1846. Reared by his grandmother and much afflicted by the neglect of his parents, he came to Paris in the early 1860s. After a brief passage in an architect's office, he was apprenticed as a pastry cook with Eugène Gru, a socialist and little-known author who would remain in Murer's circle during the 1870s. Around 1866 Murer opened his own pastry shop and restaurant at 95 boulevard Voltaire in the eleventh *arrondissement*. He married; a child, Paul Meunier, was born in 1869. Nothing is known of his wife, who died shortly after childbirth. During the following decade, he was assisted at 95 boulevard Voltaire by his half-sister, the earlier-mentioned Marie, whose portrait would also be painted by Pissarro.[5]

Murer's business flourished sufficiently during the 1870s for him to devote more and more time to writing: in 1876 he published a novel, *Frémès*; in 1877, a collection of stories and poems called *Les Fils du siècle*.[6] Much taken with Auvers-sur-Oise, where he had gone as a guest of Dr. Paul Gachet to recover from illness, Murer built a house there—the appropriately named Castel du Four—into which he and his sister moved in 1881. Having sold his restaurant in Paris, Murer then acquired the Hôtel du Dauphin et d'Espagne in the center of Rouen, and together with his sister continued as a hotelier until her marriage in February 1897 to the playwright and theater director Jerome Doucet. Murer exhibited his collection of Impressionist paintings at the Hôtel du Dauphin et d'Espagne in May 1896; the paintings were, in fact, sold later that year to provide his sister Marie with her marriage portion. Murer would also be obliged to liquidate the hotel in Rouen. He spent the last decade of his life as a painter and pastelist—prolific but utterly mediocre, dividing his time between Auvers and his studio at 39 rue Victor-Massé in Montmartre.[7]

It was during the second half of the 1870s that Murer's interest in the Impressionists flourished. Reunited in 1872 with his school friend Armand Guillaumin, Murer began to hold regular Wednes-

day evening dinner parties at 95 boulevard Voltaire to which writers, musicians, and artists were invited. Zola, Cézanne, Pissarro, Sisley, Renoir, and Gachet attended, as did Alphonse Legrand, former employee of Durand-Ruel, who had recently begun dealing in works of the Impressionists independently and who would establish a gallery on the rue Lafitte in 1877.[8] Legrand may well have been responsible for encouraging Murer's interest in Impressionism and bringing him into contact with Renoir, who was soon requesting an advance from him against paintings on deposit with Legrand.[9]

The heyday of Murer's collecting spans a brief but intense three years. Between 1877 and 1879 his collection of Impressionist painting grew rapidly, and he noted to Monet in the spring of 1880 that "with the hundred paintings I own, I'm beginning to feel quite well off in Impressionists."[10] Renoir and Pissarro decorated his apartment and were commissioned to paint a series of family portraits (fig. 57).[11] Murer wrote articles reviewing the early Impressionist exhibitions;[12] he loaned five works from his collection to the Fourth Exhibition of 1879;[13] and submitted a proposal for a rejuvenated salon to the *Chronique des Tribunaux* of May 1880.[14] By this time his own collection had achieved a certain fame. As early as 1878 his name had appeared alongside those of Georges de Bellio and Chocquet as an important collector of Impressionism.[15] He was mentioned at length in an April 1880 article in *Le Coq Gaulois*, where the author was astonished that a pastry cook could have an apartment filled with Impressionist paintings.[16] In 1878 Pissarro asked Murer's permission to bring the Italian art critic Diego Martelli to visit the collection.[17] Although no catalogue of his collection was ever published, a relatively full listing by Paul Alexis, a friend of Cézanne's and Zola's, appeared in the radical newspaper *Le Cri du Peuple*, in October 1887. Murer's collection at this point numbered some 122 works, including 27 paintings by Sisley, 24 by Pissarro, 21 by Guillaumin, 14 by Renoir, 9 by Monet, and 8 by Cézanne.[18]

Murer's sponsorship of the emerging Impressionists consisted largely in advancing money to Pissarro, Renoir, Sisley, and Monet—all of whom were chronically impoverished in these years—in return for a specified number of canvases, either painted or to be painted. He seems to have felt at liberty to take paintings of whatever dimen-

sions pleased him, and was relentless in ensuring that these artists fulfilled their obligations, which he often tried to make contractual.[19] He paid little for these works: normally between 50 and 100 francs, and, on exception, 150 francs—prices not outrageously low for the time—although Pissarro was desperate enough to sell his paintings for as little as 20 francs.[20] Murer took it upon himself to offer artists' work to other clients, often without consulting them as to price, and was not always scrupulous in returning works he had taken on consignment. As late as January 1897, Pissarro wrote reminding Murer that he still owed him a painting he had shown fifteen years before to the collector Laurent Richard and then kept for himself "without any right and against all justice." Since Murer's collection had been sold just months before, it is unlikely that Pissarro ever received satisfaction on this point.[21]

The case against Murer, eloquently put by Georges Rivière in *Renoir et ses amis*, rests upon this sort of malpractice. Not only was he a voracious collector, the argument runs, but he was also an exploitative one, arriving at artists' studios when the rent was due, buying paintings by the armful for derisory sums in order to sell them years later at enormous profit.[22] This both credits Murer with a farsightedness that was beyond him and underestimates his commitment to the new painting at a time when such support was rare. Neither as generous as Gustave Caillebotte nor as discriminating as Chocquet, Murer was an impassioned if not altogether sympathetic partisan of Impressionism, who believed that "to buy his paintings is the greatest compliment that can be paid to an artist."[23]

If Monet found Murer's determination to extract canvases repugnant—Monet's letters of September and November 1878 are the most indignant he ever wrote to a collector[24]—Pissarro and Renoir maintained good relations with him long after he had stopped collecting. Although never entirely trusting him, both artists and their families visited Murer in Auvers and Rouen, Renoir buying artist's materials for him in Paris and even finding a couple to replace Murer and his sister at the Hôtel du Dauphin et d'Espagne during a particularly busy summer season.[25]

Through Pissarro, Murer came into contact with Gauguin—who lived in Rouen between November 1883 and November 1884—and

tried, unsuccessfully, to promote his work. Gauguin had shown at least one painting at Murer's hotel, but was skeptical of his promises to sell it.[26] Nonetheless, "Le Malin Murer," as Gauguin called him, is found writing to Gachet in June 1890, asking him to rent rooms to Mme Gauguin and her children for three months.[27]

Through Gachet, Murer met Van Gogh, whom he considered the greatest colorist of the century after Renoir.[28] Murer owned two of his paintings, notably *Fritillaries in a Copper Vase*, 1887 (Musée d'Orsay, Paris). Coming across him as he was painting, Van Gogh commented, "You are thin, and your painting is too thin. It needs fattening up." Murer was sufficiently struck by this to record the conversation in his diary.[29] He also recorded Van Gogh's suicide and last hours in a poignant journal entry that seems to have escaped the notice of most scholars.

But it was Renoir—in Murer's words, "the greatest artist of our century"—whom Murer esteemed above all others and whose paintings formed the core of his collection. Murer owned splendid examples of Renoir's paintings of the 1870s, including *The Harem*, 1872 (National Museum of Western Art, Tokyo), the portrait of *Alfred Sisley*, 1874 (The Art Institute of Chicago), *The Painter's Studio, rue Saint-Georges*, 1876 (Norton Simon Foundation, Los Angeles), and *The Arbor*, 1876 (Pushkin State Museum of Fine Arts, Moscow).[30] Neither Pissarro nor Sisley, whose work Murer collected in even greater number, was represented by such consistently choice paintings.

Murer undeniably bought his Renoirs cheaply—Pissarro was amazed that Renoir had agreed to paint the family portraits for 100 francs each—but in 1877 Murer's financial support was crucial to the painter.[31] In October of that year, Renoir, in desperation, had solicited Léon Gambetta for the curatorship of a provincial museum, a request that would have drastically altered the development of his art had it been granted.[32]

The portrait of Eugène Murer expresses Renoir's affection and gratitude in a way that his aloof letters to this rather demanding Amphitryon never could. As homage to a friend and patron, the painting may also have inspired Van Gogh, whose celebrated portrait of Dr. Gachet (fig. 58), painted in June 1890, reversed the pose that Renoir had chosen for Murer. Van Gogh had arrived in Auvers-sur-Oise in May 1890 and may well have seen Murer's collection. Renoir's portrait was certainly known to Gachet, who had been a close friend of Murer's since the early 1870s.

The portrait of Eugène Murer remained in Murer's possession after his other paintings by Renoir were acquired by the Parisian dentist George Viau in 1897. Following Murer's death on April 22, 1906, the portrait passed to his son, Paul, by then a garage owner in Beaulieu, in the south of France.[33] Paul Gachet noted with scorn that dealers were hesitant to pay the modest sum of 6,000 francs for the painting, and that it was eventually sold in 1907 for 2,500 francs.[34]

CBB

35

PIERRE-AUGUSTE RENOIR

FRENCH, 1841–1919

BOUQUET OF CHRYSANTHEMUMS, 1881

OIL ON CANVAS, 26 X 21⅞ INCHES

THE ABUNDANCE OF flower painting in Renoir's oeuvre is yet to be fully documented, but it is a genre that occupied him at every stage in his career and one that, until the late 1880s, allowed him to experiment with different color harmonies more easily than did figure painting. "When I paint flowers, I feel free to try out tones and values and worry less about destroying the canvas," Georges Rivière remembered him saying; "I would not do this with a figure painting, since there I would care about ruining the work."[1] The suggestion that Renoir's flower paintings were a vehicle for more daring tonal juxtapositions was developed by Julius Meier-Graefe, who perceived an almost abstract quality in them. Unlike Manet's flowers, he argued, which encourage us to smell, touch, and savor the flower with our eyes, Renoir's flowers are above all fictions of color, possessing an independent "immaterial completeness" that would be diminished by any comparison with the botanical species they represent.[2]

Flower paintings were also easier to sell. Although Rivière claimed that Renoir disposed of his flower paintings for little more than the flowers cost him, both Renoir and Monet turned to still life in the bleak period around 1880 as the most marketable of genres. It is no coincidence that Renoir used an established format for his still lifes: nearly all of his flower paintings of the 1870s and 1880s generally conform to the canvas size of 25 by 21 inches.[3] It is also telling that one of Renoir's first canvases to find an American buyer was the splendid *Geraniums and Cats* (private collection, New York), painted in 1881 and exhibited by Durand-Ruel at the National Academy of Design, New York, in April 1886.[4]

Bouquet of Chrysanthemums is of the standard format for Renoir's flower paintings. Painted on a coarse-textured canvas, it was executed rapidly, the thin washes of color first laid in to describe the diffuse mass of flowers without concern for their individual features. With the composition blocked out in this way, Renoir then brought each bloom into focus by applying delicately impasted strokes of color to define individual petals and stamens and thus give the bouquet its structure. He also took care to record the autumnal character of these flowers, which bloom for about six weeks, by showing the darkening edges of the red flowers with their drying, brittle stamens. Yet the chief effect is one of great luminosity and warmth. This he achieved by setting these highly colored flowers on an orange and blue background, against which they resonate, and by generously applying touches of white lead and chrome yellow, which vibrate on almost every flower.[5]

In his choice of composition, Renoir was clearly influenced by the spare and elegant flower paintings of Fantin-Latour, whose *Chrysanthemums*, 1862 (fig. 59), was one of the earliest French paintings of that flower. Like the *Chrysanthemums*, the flowers in Renoir's painting expand to fill the width of the canvas; both vase and ledge are painted simply, with no indication of the interior in which they are placed. Yet Fantin's crisp and controlled still life lacks the verve of Renoir's more explosive array, which follows from his own *Lilacs in a Bowl* (location unknown), painted in 1875 or 1878.[6] In both paintings the flowers enjoy an easy amplitude and expansiveness characteristic of Renoir's painting at this time.

Bouquet of Chrysanthemums should be dated to the autumn of 1881, and probably was painted either at the country house of his patron Paul Bérard, at Wargemont, outside Dieppe—where Renoir was a visitor in July and September 1881—or back in Paris before he left for Italy at the end of October.[7] In its overall harmony the painting recalls the portrait of *Jeanne Henryot* (private collection, Switzerland), and the still life's gentle, dappling light is also found in the portrait of *Alfred Bérard with His Dog*, 1881 (Philadelphia Museum of Art).[8] Renoir may also have been encouraged to paint chrysanthemums after Monet had taken up the subject in a series of still lifes painted at Vétheuil in 1880 and 1881—the two had shared flower motifs before—and, indeed, the flower appears in a second canvas by Renoir, the *Girl with a Fan* (fig. 60), painted the same year as *Bouquet of Chrysanthemums*.[9]

Did the chrysanthemum hold any special significance for Renoir and his peers? The flower had been cultivated in China and Japan for centuries and was venerated in Eastern art as one of the four noble plants painted by Chinese scholar-artists and as a preferred motif in Japanese screen painting of the Kano school.[10] Although the plant's introduction to France was relatively recent—imported to Marseille at the time of the Revolution, it seems to have been widely cultivated only after the Napoleonic Wars—by the 1880s it was described by botanical authorities as among the commonest ornamental garden plants, grown in French fields and meadows everywhere.[11] If the more austere traditions of the flower were hidden from Renoir—in seventeenth-century Chinese painting the chrysanthemum was a symbol of the scholar in retirement, and in Japan it was the emperor's insignia—its more general associations with the East were not. The *Girl with a Fan* (fig. 60) refers explicitly to the Oriental origins of the flower. Pointed in the direction of the red and white chrysanthemums is a painted round fan, with a Chinese motif, probably made in Japan. Both flowers and fan, then, are Eastern imports appropriated and made domestic by Parisian fashion. If it was the exoticism of the chrysanthemums that had distinguished them from other garden flowers, it was their autumnal message of renewal and growth that had a lasting significance for Renoir; chrysanthemums also provided the subject of one of his very last canvases.[12]

CBB

PIERRE-AUGUSTE RENOIR

FRENCH, 1841–1919
LANDSCAPE WITH TREES, C. 1886
WATERCOLOR ON PAPER, 10¼ X 13¼ INCHES

IN THIS DELICATE and sensitive watercolor, published here for the first time, Renoir described a secluded landscape in full sunlight. Using the white of the paper in various ways—as border, as distant background, as entry to the pathway—he applied washes of crimson, mauve, and pea green to lay out the shadows and general contours of his composition. Renoir's touch then became tighter and more concentrated and his color more vibrant in the depiction of the foliage, shrubbery, and rolling hills of the foreground and middle ground. The limbs of the tree on the left are created by the white paper itself: tiny hatching strokes of green, purple, and ocher define this negative space with grace and economy. Despite his freedom of handling and fluid application of color, Renoir never wavered in his sense of structure and topography: we are drawn into the clearing by a dusty pathway that disappears among the undulating hillocks and rocks of the middle ground. Equally assured are his observations of the effects of intense sunlight. The russet foliage suggests leaves that have dried out in the fierce heat, and the mauve washes in the foreground evoke a dusty, somewhat parched landscape in which the trees fail to give adequate comfort or shade.

In old age, when Renoir repetitively painted the landscape around his farmhouse in Cagnes, he confessed to the continuing difficulties he experienced with this subject: "I can't paint nature, I know, but the hand-to-hand struggle with her stimulates me. A painter can't be great if he doesn't understand landscape."[1] Renoir's efforts to gain mastery over his site and to organize it pictorially are apparent in the deliberate and analytical approach he adopted in *Landscape with Trees*.

Although it is not possible to identify the exact location of this watercolor, the refined and fluent handling and rather precise delineation of foliage suggest a date after 1885, when Renoir was returning to an Ingresque manner. In its application of color and its varied touch, the watercolor compares well with *Landscape* (Seattle Art Museum), redated by François Daulte to 1886.[2] The radiance and joyous luminosity of *Landscape with Trees* also evokes a more sun-filled setting: this sheet was probably executed during the summer of 1886, possibly while Renoir was staying with his wife and son at La Roche-Guyon in the countryside northwest of Paris.[3] Indeed, *Landscape with Trees* may have formed part of an album of such finished topographical views executed in 1886; several watercolors of similar dimensions and facture are known, and the possibility that Renoir constituted a sketchbook of views in the manner of Cézanne cannot be ruled out.[4]

CBB

39

PIERRE-AUGUSTE RENOIR

FRENCH, 1841–1919
RECLINING NUDE, 1883
OIL ON CANVAS, 25⅝ x 32 INCHES

RENOIR'S AMBITION to paint the female nude is the single consistent thread in his peripatetic existence of the early 1880s. Approaching this elevated subject with the "gaucherie of an autodidact" (according to Julius Meier-Graefe), he attacked the classical canon on a variety of fronts: the journey from the *Blond Bather*, 1881 (The Sterling and Francine Clark Art Institute, Williamstown, Mass.) to the great *Bathers* of 1885–87 (Philadelphia Museum of Art) was neither inevitable nor directly routed, but loaded with experimentation. *Reclining Nude*, painted midway between these icons, is a good example of Renoir's search for the appropriate idiom in which to treat high art.[1]

Reclining on a mossy bank with the sea in the distant background, her ruddy mane of hair braided in a heavy plait, Renoir's nude dominates the autumnal landscape while remaining very much a part of it. Although the overall effect is still sketchy, the nude's figure is painted with great concentration, and her flesh and hair are densely worked: strokes of pink, white, and mauve are applied insistently to produce a fleshy form of real solidity. In contrast to this, the landscape and sky are rendered hastily, the cream ground still visible beneath the blues, reds, and greens surrounding the naked girl.

Renoir had difficulty with the pose—his foreshortening of the left arm is not entirely successful—and he was indecisive about the degree of nudity to portray: pentimenti show that the drapery initially extended to cover more of his model's ample thigh. By placing the figure resolutely *within* the landscape, he was obliged to attend to the illusion of depth and mass, something no longer of overriding interest to him. Thus, the model tends to float against the grassy bank; we see, but do not feel, the weight she places on her left elbow; and spatial recession into the slope beyond is blocked by the firm surfaces and insistent contours of her supine form.

For Meier-Graefe, such awkwardness constituted Renoir's supreme skill, since it bore witness to the sincerity of his quest for a classical language.[2] Renoir himself noted that in treating the female nude when he was forty, he was starting all over again.[3] This remark has particular poignancy here, since the *Reclining Nude* follows the format of the female *académie* that had been a set student piece from the eighteenth century (see fig. 61) and was still an exercise commonly undertaken by aspiring nineteenth-century artists (fig. 62). But here Renoir was also paying homage to the master of the genre; his figure conforms closely to Ingres's *Grande Odalisque*, 1814 (fig. 63), but is pared of any reference to the seraglio. At this point, Renoir could have seen the *Grande Odalisque* on only two occasions; it was exhibited in 1867 and 1874, but did not enter the Louvre until 1899.[4] Renoir recounted to Meier-Graefe that his appreciation of Ingres's art had come only when he was copying Delacroix's *Jewish Wedding* in the Louvre for his patron Jean Dollfus in 1875. Hanging next to Delacroix's painting was Ingres's portrait of Mme Rivière, to which his eye returned again and again.[5] Yet Ingres was far from an obvious model for the Impressionists, and if the sensuous arabesques of the *Reclining Nude* make comparison with the *Grande Odalisque* unavoidable, the painting itself, with its textured handling and warm, ruddy hues, is paradoxically the least Ingresque of all his nudes of this period.[6]

But Renoir did more than simply graft his style onto a venerable academic tradition. His *Reclining Nude* is rooted in direct experience and observation, and it is from the fusion of the two that Renoir's nudes derive their stature. After a summer in Normandy as guests of several wealthy clients, Renoir and his wife Aline Charigot spent September of 1883 in Guernsey, one of the Channel Islands between England and France.[7] Renoir was charmed by the island's beaches and rocky coves, and even more so by the uninhibited behavior of the young English holidaymakers, whose freedom and naturalness he found particularly appealing. "Here one bathes by the rocks, which also serve as changing rooms, because there is nowhere else to go," he wrote to Paul Durand-Ruel on September 27, 1883. "And you cannot imagine how pretty it all looks, with men and women lying together on the rocks. It's more like a Watteau landscape than the real world." The unexpected informality of the bathers there—as opposed to the elegance of the Normandy resorts—provided him with "a source of real motifs" that he could use "later on." He would leave Guernsey at the beginning of October, he continued, "with a few canvases and some documents from which to make paintings in Paris." He concluded this letter by recounting the pleasure he had taken in "surprising a group of young girls changing into their bathing costumes, who, although English, did not seem at all alarmed."[8]

This vivid letter immediately brings to mind the easy sensuality of the *Reclining Nude*, and the painting should be related to Renoir's experience of Guernsey and dated to late 1883. Although it has been placed at various dates in the 1880s, François Daulte was the first to suggest the convincing date of 1883, based, presumably, on comparison with Renoir's signed and dated *Nude in a Landscape* (fig. 64).[9] The Annenberg painting, however, has a distinctive russet tonality, and the handling of the nude is more even and carefully worked than in the Parisian painting. It is closer to *By the Seashore* (fig. 65), securely dated to the Guernsey visit of autumn 1883, in which the summary handling of the expansive coastal setting, where orange reds and greens predominate, is very like the treatment of the background in this painting.[10]

Renoir would use the pose of the *Reclining Nude* in several paintings of the 1890s, notably the *Reclining Nude*, 1890 (Norton Simon Foundation, Los Angeles) and *Bathers in the Forest*, 1897 (The Barnes Foundation, Merion, Pa.).[11] The Annenberg *Reclining Nude* does not seem to have been intended for exhibition—by reason, no doubt, of its exploratory nature—and may well have been given by the artist himself to Arsène Alexandre, the prominent art critic and supporter of Renoir's work, whose small collection boasted three other nude compositions from the early 1880s, including the full-scale chalk drawing for the Philadelphia Museum of Art's *Bathers*, which is now in the Louvre.[12]

CBB

41

PIERRE-AUGUSTE RENOIR

FRENCH, 1841–1919
THE DAUGHTERS OF CATULLE MENDÈS, 1888
OIL ON CANVAS, 63¾ X 51⅛ INCHES

THE PORTRAIT OF *The Daughters of Catulle Mendès* was the most ambitious and most recently painted of the twenty-four works Renoir submitted to the Impressionist exhibition that opened at Durand-Ruel's gallery, 11 rue Lepelletier, on May 25, 1888.[1] Renoir seems to have started work on it the last week of April, with the forthcoming exhibition very much in mind. "There's something good about figure paintings," he wrote to the father of the sitters. "They're interesting, but nobody wants them."[2] However, as Théodore Duret first pointed out, the portrait may not have been a commission in the strictest sense: "Mendès had long been an admirer of Renoir's, who, in return, wanted to do a portrait of his daughters, whom he found to be charming, as indeed they were."[3] This was also an opportunity for Renoir to reassert himself as master of a lucrative genre in which he had been preeminent a decade earlier. Such a hypothesis is confirmed, in fact, by the letter Renoir wrote to Mendès in late April, shortly after returning to Paris from visiting his ailing mother in Louveciennes. This letter, which has somehow escaped the attention of Renoir scholars, is revelatory; it throws new light on the genesis of the portrait of Mendès's daughters and also provides information on Renoir's working method. It deserves to be quoted in full: "My dear friend, I have just returned to Paris and beg you to tell me immediately if you want portraits done of your beautiful children. I shall exhibit them at Petit's Gallery [a mistake for Durand-Ruel] in May, so you can see why I am in such a hurry. Here are my terms, which I am sure you will find acceptable. Five hundred francs for the three, life size and all together. The eldest girl, seated at the piano, turns to give the note to her sister, who finds it on her violin. The youngest, leaning against the piano, listens on as one must do at that tender age. I shall do the drawings at your house, and the portrait at mine. P.S. The 500 francs are payable 100 francs a month."[4]

Renoir jotted down a quick sketch of the portrait on the letter (fig. 66), which shows that he first conceived of it in a horizontal format similar to *Children's Afternoon at Wargemont* (fig. 67), the portrait of the Bérard children he had painted in 1884.[5] None of the intervening drawings he made *chez* Mendès are known, but in the course of working out the composition Renoir altered the format and reduced the act of tuning up to the minimum. Whether he worked exclusively from drawings, or used photographs of the three girls as well, remains to be established, given the speed with which he painted and the scant opportunity he had to work with the sitters in front of him.

The letter also lays to rest the myth that Mendès paid the trifling sum of 100 francs for this grand portrait, often cited as an example of the low esteem in which Renoir's transitional paintings were held.[6] Compared to the prices fetched by established Salon painters—and even, by the late 1880s, by Renoir's fellow Impressionists Monet and Degas—500 francs was low, although it represented the annual salary of a schoolteacher at that time.[7] But it was more a *prix d'ami* than an official transaction, for Mendès, who had known Renoir since 1869, was not a collector of Impressionist paintings and owned no other work by him—and the circumstances of the commission were unusual, to say the least. Renoir's jaunty request to Mendès in November 1888 for 100 francs, which carried with it little sense of outrage, was, therefore, a reminder that the final installment for the painting was due, and not, as has previously been suggested, a plea for overdue payment.[8]

If Renoir had hoped to reaffirm his reputation as a portraitist after his showing at Durand-Ruel's, he was at first disappointed. Berthe Morisot, whom Renoir had persuaded to exhibit alongside him, informed Monet that the exhibition had been a "complete fiasco," although Renoir and Whistler were the least to blame.[9] Three months after the exhibition closed, Renoir was still smarting from adverse criticism and lamented to Pissarro that he had received no further portrait commissions.[10] He even submitted *The Daughters of Catulle Mendès* to the Salon of 1890—his last appearance there had been in 1883—but the painting was hung too high to be seen:

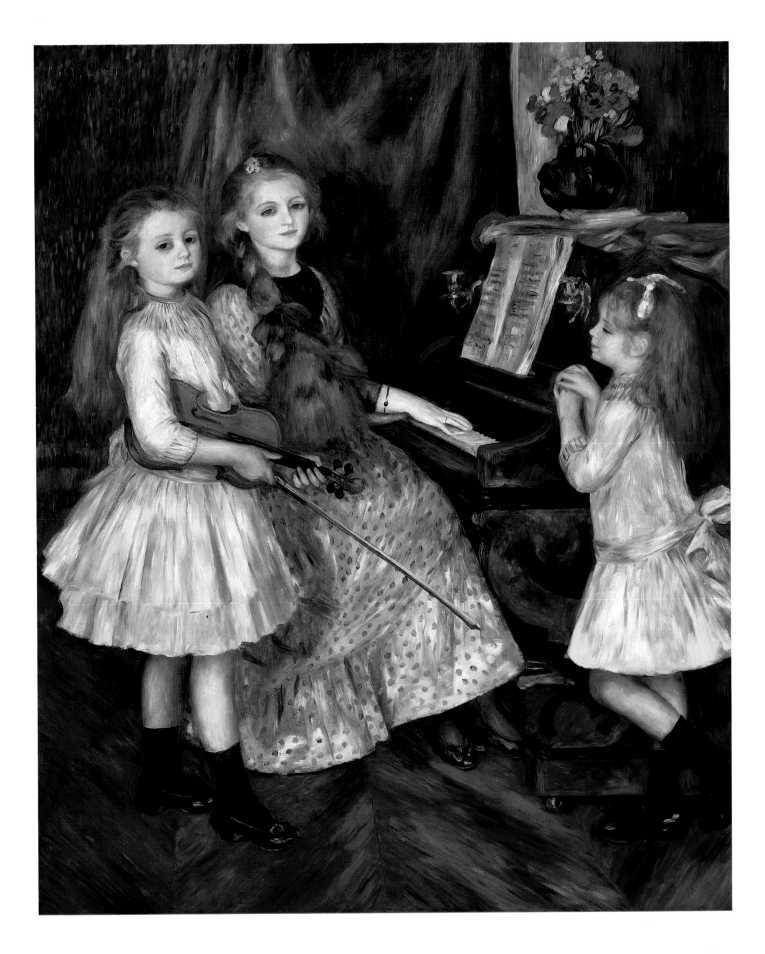

Arsène Alexandre commented that the organizers had "assassinated" the portrait, and Renoir still bitterly recalled the episode in a newspaper interview he gave at the height of his fame in 1904.[11]

Renoir's "Salon painting"—the term is Julius Meier-Graefe's—represented Renoir's most ambitious attempt yet to reconcile his linear style of the mid-1880s with the more natural painterly and colorist instincts he could never entirely suppress.[12] It is richer in handling than the portrait of Julie Manet (fig. 68), painted in 1887, and more animated, despite its monumentality, than the portrait of Marie Durand-Ruel (fig. 69), painted in 1888 and which Renoir himself found "monotonous."[13]

Remarkably direct and assured, both in conception and execution, the portrait of *The Daughters of Catulle Mendès* may have been worked out over several sittings, but with a minimum of reworking. Renoir had some trouble placing the eldest daughter's left hand—pentimenti of flesh tones can be seen through the piano board—and he may also have shifted the line of her hem. But such changes are very slight. He applied the paint in lush, opaque layers of unmediated hue: with the exception of the richly impasted vase of flowers on the piano, probably painted last of all, there is an effortless consistency in Renoir's handling here. No single element is given prominence, and the brushwork is disguised to produce a paint surface that, while oily, has the sheen of porcelain.

And yet Renoir's finish is highly idiosyncratic and his colorism almost abstract. The luminosity and vibrancy of the portrait is achieved by a precarious balance between sitters and setting, in which both are given equal emphasis. Strokes of mauve and orange on the white dresses and highlights of red in the girls' magnificent tawny tresses maintain the pitch established by the orange reds of the curtain in the background and the piano and floorboards in the foreground. These elements, which Renoir treated synthetically, are described no differently than the young girls themselves. Thus, the patch of hair at the end of the eldest daughter's pigtail, with its highlights of red and brown, is painted in the same way as the parquet floor below. The cloth that covers the upright piano and the sheet music underneath the vase and on the music stand are identical in handling and tone to the youngest girl's hair and dress. It is this new preoccupation with value that so impressed Félix Fénéon in his sympathetic review of Durand-Ruel's 1888 exhibition;[14] and Renoir's quest for pictorial unity was fully endorsed by Pissarro, whose experiments with pointillism at this time reflect a similar reassessment of Impressionist technique.[15]

The portrait of *The Daughters of Catulle Mendès* has been reasonably compared with portraits of the children of wealthy clients such as Cahen d'Anvers and Paul Bérard from earlier in the 1880s, as well as a group of slightly later paintings that depict young women around a piano (fig. 70)—the most celebrated of which, *Young Women at the Piano*, 1892 (Musée d'Orsay, Paris), commissioned for the Musée du Luxembourg in the winter of 1891, exists in five versions.[16] However, none of these examples correspond in facture

to the robust yet highly controlled manner of painting that characterizes the portrait of the Mendès girls, which is closest in handling to the sumptuous *Bather* (private collection, Tokyo), painted at almost the same time.[17] Of interest here is Renoir's capacity to maintain the energy and vibrancy of the smaller *Bather* on the grander and more public scale of his group portrait, which Meier-Graefe described as painted with the vehemence of a Frans Hals.[18] By 1890 Renoir would return to an altogether more subdued style, in which his figures are highly colored and increasingly idealized and where surface animation is completely suppressed.

Claude Roger-Marx rightly identified the period from 1888 to 1890 as marking a transition between styles, but saw the seductive, if dissonant, paintings of these years as "works of convalescence."[19] Another interpretation is possible. The new vitality in Renoir's *Daughters of Catulle Mendès* might be explained as an instinctive response to the French painters of his beloved eighteenth century, whose work held particular appeal in the late 1880s. "Those people who appeared never to paint nature knew more than we do," he wrote to Durand-Ruel in the autumn of 1888, and it is helpful to consider the Mendès portrait in the light of this comment.[20] Renoir's debt to the eighteenth century, and to Fragonard in particular, went beyond sharing motifs and appropriating a certain rococo charm: it derived from an appreciation of the artificiality of eighteenth-century genre painting, its distance from a straightforward description of reality, its urgent stylization. Fragonard's celebrated *Music Lesson* (fig. 71) may well have been in Renoir's mind when painting the Mendès children, but his understanding of rococo fantasy informs the painting in a more general way.[21]

Renoir's portrait of *The Daughters of Catulle Mendès* is one of his most compelling images of awakening adolescence and has been widely documented as such. It has imposed its charm on commentators otherwise troubled by the metallic lighting and stylized features of the young girls. Gustave Geffroy, in his review of the 1890 Salon, called the portrait "an intimate poem celebrating the instincts of childhood and the stirrings of the intellect."[22] Yet it demonstrates once again Renoir's unerring capacity for idealization and romance: the serene and self-assured poses assumed by Claudine, Huguette, and Helyonne (reading from left to right) betray nothing of the turbulent and highly unconventional ménage to which they belonged.

For Renoir's sitters were the offspring of a longstanding liaison between the Parnassian poet, publicist, and impressario Catulle Mendès (1841–1909) (fig. 72)—born in Bordeaux, of Portuguese-Jewish extraction—and the soprano and composer, Augusta Holmès (1847–1903)—born in Paris of Irish parentage, whose reputation for "song and seduction" was legendary in Belle Epoque Paris.[23] Mendès, one of the most influential and prolific French authors of the second half of the nineteenth century, had founded the *Revue Fantaisiste* in 1861—one of the first journals to publish Baudelaire, Théophile Gautier, and Théodore de Banville—and soon became a

central figure in the group of neoclassical poets known as the Parnassians. An ardent Wagnerian and a playwright and librettist of some distinction, Mendès was editor-in-chief of several prominent literary journals and in this capacity was able to sponsor a generation of symbolist writers. In 1897 he established readings of early French poetry at the Odéon theater in Paris and in 1900 was commissioned to write the official report on French poetry of the second half of the nineteenth century.[24]

Mendès's literary energies were equaled only by his libidinous adventures, and he was notorious even in an age generally tolerant of irregular behavior. The Goncourts described the nocturnal activities of this "cast-off Bohemian" in salacious detail, writing admiringly of "this anemic-looking figure, whose nights are a ceaseless round of coition and copulation," constantly amazed that one in whom "the flame of love" burned so ardently could maintain such an enormous literary production.[25] Married in 1866 to Gautier's eccentric daughter, Judith, Mendès abandoned her in 1874 for Augusta Holmès, whom he had seduced at Bayreuth. Five children were born of their union: a child died in infancy, and Raphael, the eldest, and only boy, died at the age of sixteen in 1896—but Holmès and Mendès were never married and led a turbulent life together. In November 1885, Mallarmé mentioned their impending separation to an English correspondent: "Things are no longer charming between them."[26] By this time, Mendès's liaison with the stage actress Margaret Moreno, a leading lady and a friend of Sarah Bernhardt, was public knowledge. The breach between Mendès and Holmès was briefly repaired—the couple were together again when Renoir's portrait was painted—but the "long concubinage" came to an end in the early 1890s. In 1894 Mendès had his family recognize his children by Holmès, and three years later he married Jane Mette, a writer twenty-six years his junior, with whom he lived peacefully until his death in a train accident in February 1909.[27]

In Augusta Holmès, Mendès had found a woman worthy of him. Daughter of an Irish cavalry officer who had settled in France, she was brought up at Versailles and quickly showed an aptitude for poetry, languages, and music. She was reputed to be a great beauty and posed as the model for Henri Regnault's *Thetis Delivering Arms to Achilles*, his Prix de Rome of 1866, and was renowned above all for "her golden tresses that fell in waves and beautiful... eyes that were like the seas of Ireland"—attributes her daughters inherited from her in generous proportions.[28] An enthusiastic Wagnerian and virtuoso pianist, she was proposed marriage by Camille Saint-Saëns and studied under César Franck. She began composing in the 1870s and from this time dramatic symphonies and symphonic poems flowed from her pen. A measure of her success was the commission to write the *Ode Triomphale* for the Revolution, after Charles Gounod de-

clined the honor. The work was performed at the Palais de l'Industrie in September 1889 by some nine hundred singers and three hundred musicians.[29] Like Mendès's writing, her music is largely forgotten today, although the songs have survived better than the large-scale work. When the American opera singer and composer Ethel Smyth met her in 1899, Holmès's fame had already waned, although Smyth praised her *Chanson de Gars d'Irlande* as a "fierce song" that would have gone around the world had there been any demand for a song in French dedicated to Irish home rule.[30]

The three daughters of this extraordinary couple owed their golden hair and lily-white complexions to their mother's Irish good looks, and their medieval names to their father's passion for the era of Ronsard and the poets of the Pleiad. Despite the hostile comments Mendès's behavior generally solicited, his deep affection for his children and his sense of responsibility toward them emerge clearly. "There is something in Mendès of the Jew who loves his children more than his wife; survival of the race" was the barbed insight of the novelist Jules Rénard.[31] The Goncourts, who found Holmès's singing and pontificating intolerable, reported in May 1895 that she detested children, took little interest in them, and that they were now legally in their father's charge.[32] Mendès's grief at the unexpected death of his eldest child, Raphael, in July 1896, is attested to in a moving letter from Mallarmé.[33]

Brought up in the Mendès's family home at Châtou by Catulle's sister, the young girls were protected from the unconventional world in which both parents lived. Henri Barbusse, the poet and polemicist who married Helyonne, the youngest daughter, in 1898, recorded the impressions of his first visit to Châtou in a passage that brings Renoir's portrait immediately to mind: "They are all very blond and very pretty, Huguette, Claudine, Helyonne. They live far from the world of artists, actors, and writers...They are very playful, very cheerful, a little shy, and very well behaved. Claudine [the middle daughter] is perhaps more outgoing, more straightforward, more friendly. Huguette [the eldest], rather more exquisite, with something delicate and quivering about her. Helyonne [the youngest] is a reserved child, but she is extraordinarily beautiful."[34]

We are not informed as to how well Renoir knew the young girls—he often visited Mendès at 4 cité de Trévise, his second-floor Parisian apartment, with its distinctive Japanese curtains, and he must have met the children there many times.[35] In this portrait, however, he achieved both intimacy and monumentality, capturing the beauty and purity of Mendès's three daughters with instinctive economy and conviction, and alluding to the energetic literary milieu in which their notorious father moved by the most discreet of symbols: the lemon-colored modern paperback novel on top of the piano.[36]

CBB

CLAUDE MONET

FRENCH, 1840–1926
CAMILLE MONET ON A GARDEN BENCH
(THE BENCH), 1873
OIL ON CANVAS, 23⅞ X 31⅝ INCHES

Toward the end of December 1871, Monet, his wife Camille Doncieux (1847–1879), and their four-and-a-half-year-old son Jean left Paris for the neighboring suburb of Argenteuil, where they would live for the next seven years. For the substantial sum of one thousand francs per annum, they rented a large villa for three years on the boulevard Saint-Denis (fig. 73) from Emilie-Jeanne Aubry, to whom Manet had recommended them.[1] Monet remembered immediately removing the screens from the windows of the large atelier at the Maison Aubry—the previous tenant, the realist painter Théodule Ribot (1823–1891), had converted this room into an "obscure dungeon"—and he recalled with delight the view from the windows that looked onto the Seine.[2] Yet, of all the vistas, it was the view of the extensive garden, some two thousand square meters in size, that appealed particularly to him, and he would paint it from a variety of aspects during the three years he and his family remained in this house.[3]

In *The Bench*, the garden is at its most formal and orderly. Walled in on two sides, with geraniums planted in a neatly trimmed border, the garden becomes the setting for one of Monet's rare plein-air figure paintings. Camille Monet, elegantly attired and seated on a garden bench, leans forward with her elbow resting on her lap. She appears to turn toward an unexpected observer, and holds a letter in her gloved hand. Discarded to her left is a bouquet of flowers, presumably offered by the man who leans languidly against the bench and gazes down at her, his eyes crinkled by a smile hidden beneath his beard. The identity of this gentleman caller has caused endless speculation; Monet, in old age, remembered him simply as a neighbor from Argenteuil.[4]

Monet recorded the afternoon light in spectacular intensity. The geraniums and the featureless woman to the left are portrayed in direct sunlight, and the vibrancy of the background is maintained through the optical mixture of reds and greens. The colors darken somewhat on the right, where the shrubbery is shaded by the overhanging tree. By contrast, the figures in the foreground are in shade, but so bright is the afternoon sky that they are practically modeled in blue. The slats of the green bench reflect the full force of the afternoon sky and are painted sky blue; the gray trousers of the smiling visitor are edged with a stripe of the same hue, as is the upper part of his hand. The bridge of the man's nose is described in blue gray, as is Camille's. Her hair, peeking out from under her little hat, is painted blue black.

Never before had Monet translated his observations of the way sunlight models form with such precision. In this highly analytical painting, he explored how the effects of both filtered and direct light modify and, in some instances, eliminate local color. In achieving this, he experimented with a register of hues so heightened that it allowed him no extension.

Monet's handling of paint is similarly audacious and assured. Rich, unmediated color is applied in swift dabs and strokes, and his technique is succinct: only in the mound of geraniums did he create surface by using successive layers of paint. The cream ground, visible in patches under Camille's dress and in the lower section of the bench to her left, has no pictorial function here; it is not yet employed to suggest space or structure. The artist tackled a variety of forms with impressive confidence: his vocabulary changed from the tight, concentrated dabs of color on the flora in the background to the quickly brushed sweeps of blue gray and black on the costumes of the figures in front. The bouquet of flowers was painted wet on wet with no revision; the ribs of the bench still bear the marks of the brush swiftly trailing across the canvas. Yet, if the flounce of Camille's crinolines and the kaleidoscope of geraniums are bravura effects, Monet's touch became suddenly tender and feathery in the painting of her face and hat: Camille's features are enlivened by the most delicate hatching strokes of pink, blue, and red.

However, the boldness and economy of Monet's language cannot disguise an inarticulateness that is at the very core of this composition. For all its solidity of form—the unhesitating touch, the joyous color, the monumentality of the central figure—*The Bench* remains one of the most enigmatic and disconcerting works in Monet's oeuvre. The use of language is masterful; but what is Monet trying to say?

46

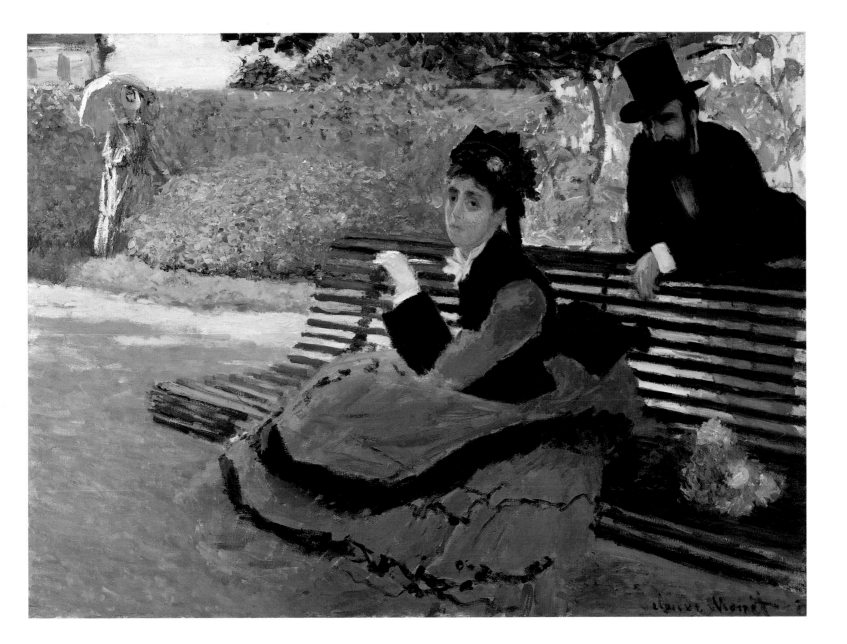

Certainly the genre itself was not new to him. Monet's ambitious decoration inspired by Manet's painting of the same title, *Le Déjeuner sur l'herbe* (Musée d'Orsay, Paris), in which Courbet had appeared, had been painted eight years earlier. The lush depiction of a family garden had provided the subject for such great works as *Terrace at Sainte-Adresse*, 1867 (The Metropolitan Museum of Art, New York) and *Jeanne-Marguerite in the Garden*, 1868 (The Hermitage, Leningrad).[5] With these paintings in mind, Zola had praised this strain in Monet's work as the richest and most promising: "Like a true Parisian, he brings Paris to the country and is incapable of painting a landscape without including well-dressed men and women. He loses interest in nature once it no longer bears the mark of everyday life."[6] Although Zola's insight dates from 1868, and would become less relevant for Monet's work as it developed after the mid-1870s, it serves nonetheless as a starting point for discussion of *The Bench*. For what distinguishes this painting from Monet's earlier figure paintings of the 1860s is a transformation in milieu. Monet is no longer the artist who brings Paris to the countryside: he brings Paris to the suburbs.[7] By the 1870s, Argenteuil—with its regattas, bicycle races, and fifteen-minute train journey from the Gare de l'Ouest—was not merely the capital of Parisian recreation. It was being colonized by members of the Parisian middle classes, who established both primary and secondary residences there, much to the annoyance of older inhabitants, who complained of large amounts of land being sold off to build "bourgeois houses with stylish gardens surrounded by walls and closed off on their facades by iron gates."[8] The Maison Aubry, enclosed in its spacious grounds, was such a property. It is the house on the far left in Monet's painting of the boulevard Saint-Denis (fig. 74). Although Monet was only a tenant, and frequently late with his rent, his allegiances were to this Parisian world, and his aspirations were impeccably bourgeois. So respectable and manicured is the garden in *The Bench*, so far removed from the windswept, untidy corner of the same garden Monet painted again the same year (fig. 75), that it seems legitimate to question Monet's naturalism here. The discomfort and malaise of his two figures only reinforce the tension that pervades this highly colored scene.

This sense of deep unease has frequently been explained in simple biographical terms. Argenteuil, the argument runs, provided Monet with an escape, a retreat, from the rigors of city life, allowing him a "personal dialogue with nature." Yet this newly found harmony of existence was undermined by the emptiness and boredom of his marriage and by the isolation and alienation he experienced as an effect of burgeoning industrialization and urban development.[9] Thus interpreted, *The Bench* communicates the marital tensions Monet and Camille experienced; but it has also been read as an essay on courtship.[10] Alternatively, it represents amorous flirtation,[11] and yet another interpretation sees the smiling, rather sinister man as Monet's "smug proprietor."[12]

One of the more suggestive biographical readings has attempted to relate *The Bench* to a firmly documented event: the death of Camille's father, Charles-Claude Doncieux.[13] Writing to Pissarro on September 23, 1873, Monet informed him: "A piece of bad news awaited my wife on her return from Pontoise: her father died yesterday. Of course, we are obliged to go into mourning."[14] Thus, Camille is portrayed in *The Bench* wearing mourning dress; her somber expression is explained by her grief; and the mysterious visitor either offers condolences (in the form of a bouquet) or may be seen as a symbol of death itself.

Joel Isaacson also sought a clue to *The Bench*'s ambiguous narrative by examining its pendant, the striking *Camille in the Garden with Jean*

and His Nurse (fig. 76), in which Camille confronts the spectator with a gaze that is almost insolent. There, he argued, Camille was dressed in half mourning, in a costume appropriate for the second half of the year of mourning prescribed for a daughter, and on the strength of this he proposed a date of around June 1874 for both paintings.[15] Not only does this argument overlook the evidence of the signature on *Camille in the Garden with Jean and His Nurse*—which is signed and dated 1873—but it fails to acknowledge the byzantine customs of mourning dress in France. Nineteenth-century mourning dress was not a specific costume, for which one could locate designated prototypes. Rather, it was a reordering of the wardrobe to stress certain elements and to display as much black as possible. In a suburban town such as Argenteuil, the wearing of elaborate mourning dress would communicate not only bereavement but status, and servants would be expected to wear attire of a similar nature.[16] If Monet did indeed paint Camille in mourning dress in *The Bench*, this would be consistent with the other elements of bourgeois existence that are emphasized here: the well-tended walled garden, the black frock coat and top hat, the fashionable crinolines.

It is, however, impossible to prove that *The Bench* is a testament to Camille's mourning, although it is intriguing that Camille is also shown in a black dress in Monet's celebrated *Poppies at Argenteuil* (Musée d'Orsay, Paris), purchased by Durand-Ruel in December 1873 and possibly painted while she was in mourning.[17] It is also clear that a strictly biographical reading diminishes the painting and fails to explain the uncertainty and agitation that create its singular mood. Even so, Isaacson's discussion focuses attention on the major issues—costume and narrative—and it is here that some key to the painting's meaning might be discovered.

Elegant Parisians enjoying the pleasures of the country: even if the realities of Argenteuil intervened to complicate this bucolic image, the theme itself was not new in nineteenth-century art. Yet it had rarely been confronted with any seriousness. Daumier's lithographs of the 1850s had ridiculed overdressed Parisians sweltering in unshaded fields, portraying them as intrepid explorers venturing forth into uncharted terrain (fig. 77).[18] By the 1860s, the journalist Eugène Chapus observed: "Everyone in the middle class wants to have his little house with trees, roses, dahlias, his big or little garden, his rural *argentea mediocritas*."[19] Daumier's amusing squibs attacked this pretension with like scorn (fig. 78), and thus the subject of *The Bench* was introduced, a generation earlier, on the pages of the illustrated journal. But where Daumier satirized, Monet equivocated. Camille's wide-eyed and troubled expression—but one that is ultimately meaningless, given the problems of narrative—recalls the staring mannequins of the fashion plate (fig. 79), a source of popular imagery with a more elegant resonance than the mocking lithographs in *Le Charivari*.[20] Indeed, she and her companion might have been modeling their costumes for the latest edition of *La Mode Illustrée*, in which the garden setting with bench was a favorite motif. For Monet, the fashion plate takes the place of the old master print: in the development of this figure painting, *La Mode Illustrée* has a function similar to Marcantonio Raimondi's *Judgment of Paris* in the creation of Manet's *Déjeuner sur l'herbe*.

Monet does not acknowledge the gulf between the ephemeral publications of Paris fashion and the exalted genre of narrative painting. He takes fashion very seriously, not as Baudelaire's *flâneur* —detached and objective—but as consumer. In *The Bench*, the costume Camille wears is very much à la mode. Her toque is trimmed with lace and flowers, a ribbon hanging from behind. Her hands are gloved; she wears an overskirt, trimmed with velvet, above a more

fully tiered and layered underskirt, and a jacket with oversized cuffs of velvet. This up-to-date ensemble (the dress can be dated c. March 1873) is very close to the spring costume advertised in *La Mode Illustrée* (fig. 80) and described as "a dress of velvet and damask, in olive green, with a pleated, flounced skirt, the tunic made of damask and similar in color to the velvet."[21] Yet, the transition from fashion plate to figure painting is unmediated, and thus falters. Monet's commitment to the heroism of everyday life is literal: he has no time for Daumier's derision and breaks equally with the insinuating clarity of painters of fashion such as Tissot (fig. 81). But despite his deep concern for costume and property, and his willingness to ennoble them, *The Bench* conveys no lucid message; it merely hints at drama.

Monet's attempt to revitalize narrative figure painting through a truly modern idiom is a poignant and grandiose undertaking that finally fails. Rarely had he struggled to fuse so many disparate elements to convey what Zola had termed "the exact analysis and interesting study of the present."[22] In doing this, he had also looked back to a tradition well established in the history of art, but characteristic above all of eighteenth-century French painting: the pairing of images in pendants, works linked by size, subject, and composition.[23] Both *The Bench* and its companion of almost identical dimensions, *Camille in the Garden with Jean and His Nurse*, portray the same spot in the garden of the Maison Aubry (in the latter, Monet has moved back a little to include more of the garden wall).[24] The paintings must have been painted within days of each other and were probably meant to hang together. Many years later Monet hinted as much, in a reply to an inquiry about the identity of the figures in *The Bench*. Writing in June 1921 to Georges Durand-Ruel, he noted, "There must be two paintings of the same genre."[25] The two paintings satisfy the requirements of pendants at almost every level: they each have three figures; the color harmonies are the same (black against red and green); and the compositions balance one another—*Camille in the Garden with Jean* is weighted to the left, *The Bench* to the right. Even the signatures are symmetrical. Yet the pendants provide no mutual reinforcement of narrative; they do not relate in terms of "before" and "after," an anecdotal trait much employed in conventional genre painting of the period. They share simply an aspiration toward legibility, each portraying a moment pregnant with meaning, yet rendered inexplicable by Monet's confident brush.

A lucid and sensitive appraisal of *The Bench* has recently described this painting as one in which Monet came closest "to the kind of modern conversation piece that was so important to both Manet and Degas, although it has none of their wit or nervousness."[26] An investigation of the painting's disparate sources, as well as the context in which it was painted, further helps to identify its powerful irresolution. For *The Bench* marks a watershed: Monet's great *Luncheon (Argenteuil)* (fig. 82), painted shortly after the pendants, rearranges the same elements on a far larger scale, and he finally resolves the challenge of narrative by virtually suppressing the figures altogether. Here the women are reduced to staffage, barely visible behind the branches of the overhanging trees; Jean plays contentedly by the same garden bench, but his presence there is an afterthought. Setting has finally triumphed over sitter, and the shift toward landscape would thenceforth be irresistible in Monet's work.[27]

Yet, in the final analysis, the self-referential qualities of *The Bench* are overwhelming. Something of the painting's enigma may be explained by the ambiguities inherent in Monet's own position as an artist during the latter part of 1873, and here the crucial text is Duranty's program for an iconography of modernity, published as a review of the Second Impressionist Exhibition in 1876. In his encouragement of "modern conversation pieces" very much in the manner of *The Bench*, Duranty wrote: "As we are solidly embracing nature, we will no longer separate the figure from the background of an apartment or the street. In actuality, a person never appears against neutral or vague backgrounds. Instead, surrounding him and behind him are the furniture, fireplaces, curtains, and walls that indicate his financial position, class, and profession."[28] Transposed to the gardens of his rented villa at Argenteuil, *The Bench* makes a statement on Monet's "financial position, class and profession." The artist's income for the years 1872 and 1873 had been unprecedented: largely through Durand-Ruel's patronage, he received 12,100 francs for thirty-eight paintings sold in 1872 and more than double that amount—24,800 francs—the following year.[29] Such recent affluence is mirrored in the elegant setting of *The Bench*—the impeccable frock coat and walking dress, the reluctant assertiveness of Camille, at age twenty-six the well-to-do *maîtresse de maison*. Furthermore, as a member of the provincial bourgeoisie, whose parents were more tolerant of their son's aspirations as an artist than of his liaison with his obscure "mistress" from Lyon, Monet may have felt more comfortable in the Parisian colony at Argenteuil than he cared to admit.[30] However, all of this was compounded by another activity that fully engaged Monet during much of 1873: his organizing a painter's cooperative with Pissarro, the "Société anonyme coopérative d'artistes-peintres, sculpteurs, etc.," whose charter, based on a baker's union, was finally drawn up in December 1873. The syndicalist structure of the Impressionists' founding organization linked the enterprise to a radical constituency that proved increasingly uncomfortable for all the charter members except Pissarro.[31] It was certainly at odds with the image of domestic tension and bourgeois complacency that is so forcefully conveyed in *The Bench*.

Thus the provincial newlyweds and their illegitimate son have become Parisians established in the better section of Argenteuil, the factories and chemical stench out of sight. The mistress from Lyon is transformed into the lady of the manor. The painter of everyday life, armed with Zola's and Manet's blessings, has courted and organized opposition as an *artiste indépendant*. This accretion of personal contradictions strained the amalgam of conflicting sources to the breaking point: *The Bench* contains these elements precariously—mystifying in its narrative intentions, disconcerting in its promiscuous appropriation of old and new. *The Bench* is Monet's genre painting as *Interior* (Philadelphia Museum of Art) is Degas's: it represents the brief moment when he took on a subject category that was created by Manet and Degas.[32] Despite his command of their syntax and his forceful expression of it, this painting lacks the psychological acuity of their best work. *The Bench* remains, nonetheless, an extraordinary painting, but one that was without progeny and without solution.

Although it is unclear for whom *The Bench* and its companion were painted, the two paintings were divided early on, *The Bench* entering the prestigious collection of Eduard Arnhold (1849–1925) by 1903, when it appeared in public exhibition in Berlin for the first time.[33] This accounts for its reproduction in several unlikely German publications, and the absence of commentary on the painting in early French studies on Monet. A recently discovered photograph of Arnhold's picture gallery (fig. 83) shows that *The Bench* hung in exalted company, between Manet's *The Artist: Portrait of Marcellin Desboutin*, 1875 (Museu de Arte Moderna, São Paulo,) and *Young Woman in Spanish Costume*, 1862 (Yale University Art Gallery, New Haven), and as a pair to one of his versions of *La Grenouillère*.[34]

CBB

49

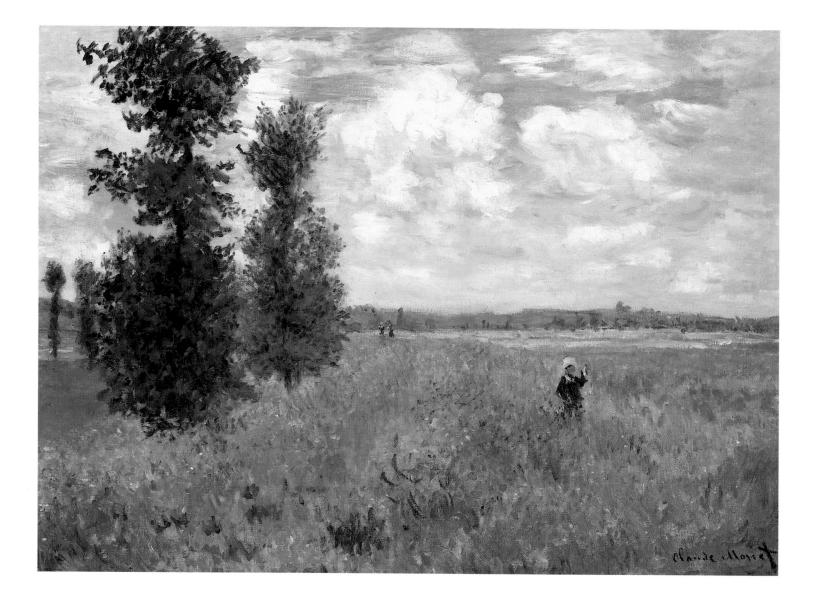

CLAUDE MONET

FRENCH, 1840–1926
POPPY FIELD, ARGENTEUIL, 1875
OIL ON CANVAS, 21⁵/₁₆ X 29 INCHES

IN THE SUMMER of 1875, Monet painted four very similar views of the neighboring fields of the plain of Gennevilliers, just southeast of Argenteuil (figs. 84–86).[1] These were not the first entirely rustic landscapes he had painted at Argenteuil—the celebrated *Poppies at Argenteuil* (Musée d'Orsay, Paris) dates from 1873—but they rigorously suppress any reference to those aspects of suburban life that had furnished Monet with the subject of his landscapes for the previous two and a half years.

The Annenberg *Poppy Field* records a summer's afternoon with rolling clouds set against a deep blue sky. The two poplars seen in the distance on the far left of the canvas mark the bank of the Seine as it flows north toward Epinay: the silvery river is just visible through them.[2] Standing in the poppy field, Monet's eight-year-old son Jean clasps an unidentifiable object in his left hand. In the foreground, two imposing poplars connect almost at a right angle with the flowering field. This L-shaped armature corresponds in a general way to the proportions of the golden section; the composition as a whole recalls both Ruysdael and Constable. Yet, it is saved from being formulaic by the thrusting diagonals of the flowering field that recedes in a wide curve to the left, trailing away into the distance behind the second large poplar. To balance his composition, Monet reverted to a favored device: lines of yellow and white paint, dragged across the middle ground above Jean's straw hat, admirably evoke the sun bursting through the clouds onto the green fields below.

Monet's handling here is much freer and far more broken up than in the earlier *The Bench* (p. 46), the paint now applied in flickering dabs and strokes of color, with the buff ground particularly active in the lower half of the canvas as part of the field. Dots of red in the dense green foliage of the first large poplar, and, to a lesser degree, along the bark and treetop of the second, maintain the vibrancy Monet achieved in the painting of the poppy field itself. Calligraphic strokes of red, blue, green, and white—an explosion of color—are balanced by the denser passages of blue and white in the sky, where the exposed priming gives depth and texture to the clouds.

Although Monet did not exhibit this painting in the Second Impressionist Exhibition of 1876, it is just the sort of "transcript from nature" that Mallarmé described so well in September 1876. Arguing that the landscapes of Monet, Sisley, and Pissarro were complete works and that their sketchy appearance was a contrived effect, Mallarmé concluded: "In these instantaneous and voluntary pictures all is harmonious, and [would be] spoiled by a touch more or less...."[3] Monet's four views of the fields of Gennevilliers do indeed have a determined, carefully constructed feel to them: their intensity has led the historian of Monet's Argenteuil period to conclude that they represent "not only summer personified, but also summer preserved."[4]

There is a hidden poignancy to the peaceful and bucolic image that Monet has achieved in this group of paintings. The meadows and fields of Gennevilliers were seriously threatened at this time: they stood to become the dumping ground for untreated sewage waste piped out from the city of Paris. Baron Haussmann's administration had first experimented with small sections of Gennevilliers as a residue for such waste in the 1860s; by 1872 fifty acres were irrigated with sewage, and the number more than doubled by 1874.[5] It was at this time that both a governmental and a prefectural commission proposed to irrigate practically all of Gennevilliers to accommodate the increasing amount of waste from the capital. Outraged residents of Argenteuil fought vigorously against such plans. Describing present conditions, one opponent noted: "During the real heat of the summer, from sun up to sun down, a fetid stench rises from these fields. Should our countryside, whose general appearance is so radiant, be a victim of this transformation, so little to its advantage?"[6]

In fact, plans to transform Gennevilliers into the "cesspool" of Paris advanced haltingly. Further, there is no evidence to suggest that Monet, who was generally uninterested in municipal affairs, was involved in the fierce lobbying that occurred at this time. Yet, the disjunction between the calm, colorful vistas he painted that summer and the depredations—both actual and potential—to the fields he represented is overwhelming. His landscape is both idyll and fiction, his vision both selective and simplifying. Scrupulously attentive to certain details, Monet placed himself squarely inside the densely colored field in this painting, at a point far closer to the trees than in the other three versions. Further, although he was at pains to show the freshly made haystacks in both the Boston and New York paintings (figs. 84, 85), in this work the fields in the background are treated so summarily that the stacks are discernible, if at all, only as the merest dabs of flesh tone.[7] In fact, their absence removes any trace of the agrarian process from this painting; not only did Monet resist the consequences of burgeoning modernization that would eventually transform the fields of Gennevilliers altogether, but he pared his image to reduce topography to the minimum. The artist's concentration on means and not matter is the ultimate achievement of this precocious summer landscape.

CBB

CLAUDE MONET

FRENCH, 1840–1926

CAMILLE MONET IN THE GARDEN AT THE HOUSE IN ARGENTEUIL, 1876

OIL ON CANVAS, 32⅛ X 23⅝ INCHES

IN JUNE 1874 Monet signed a six-and-a-half-year lease on a newly built villa in Argenteuil almost next door to the property he had been renting from Mme Aubry on the boulevard Saint-Denis.[1] This house, into which he and his family moved the following October, was the property of a carpenter, Alexandre-Adonis Flament (1838–1893)—"my landlord from Argenteuil to whom I still owe more than I realize," as Monet wrote almost ten years later—who was to become the first owner of Monet's monumental *Déjeuner sur l'herbe*.[2] The Pavillon Flament appears in the final stages of construction in the background of *Camille in the Garden with Jean and His Nurse* (fig. 76), its roof still unfinished, and it is just visible in the upper left-hand corner of *The Bench* (p. 47). This house and its gardens, in which Monet felt so much at home, provided the subject for seven of his paintings in 1875 and ten the following year, making it the single most important motif of Monet's final years in Argenteuil.[3]

Camille Monet in the Garden at the House in Argenteuil belongs to the group of paintings done in the summer of 1876, and may have been among those from June, when Monet was working on "a series of rather interesting new things."[4] Camille is shown standing in a long summer's dress and hat next to two saplings and an imposing cluster of hollyhocks. The "maison rose à volets verts," which Cézanne and Victor Chocquet had visited in February of that year,[5] dissolves in the background under the intense sunlight of the summer's afternoon, its spacious lawn just visible to the right, a patch of lime green washed out by the sun. Monet's handling is at its most energized here. The paint is applied in flickering stabs of color that establish a constantly vibrating surface in which nothing is at rest. Characteristic of his technique in the mid-seventies, no single element is particularized or given preference: Monet's abbreviated and fleeting touch pulsates evenly over the entire canvas.[6] The simultaneous contrast of green and red in the flower beds creates a rhythm that is continued into the peripheries: note the deft touches of red on Camille's face and hat; the crimson lake that describes the upper branches of the tree; the touches of vermilion that pick out the top of the roof from under the leaves and emphasize the rose bricks of the house below the upper green shutter. Such proto-pointillist handling is again apparent in the treatment of the sky behind the mass of foliage in the upper left of the canvas: the sky literally penetrates through, with dabs of blue and white paint placed on top of the greens throughout the branches and leaves.

It is possible to reconstruct Monet's garden from the group of paintings done in 1875 and 1876, in order to locate each view specifically and to suggest, in turn, both the degree of control and selection in his vision. Monet's garden was a circular affair, with a pathway bordered on both sides by flowers and a large lawn in the middle (fig. 87). At the far end of the garden were planted clusters of striking ornamental flowers—hollyhocks to the southwest, gladioli to the southeast (fig. 88)—and beyond them a patch of land thick with trees. In the various views he painted, Monet's garden appears by turns manicured and lush, domestic and savage.[7] Indeed, the same

site can assume strikingly different aspects. In a *Garden with Hollyhocks* (private collection, London), Monet posed Camille next to the same hollyhocks as in this painting, but now she faces in the opposite direction, looking up toward the house, lost in an overpowering, almost threatening, vegetation, with no reassuring signs of the suburban home at hand.[8]

In *Camille Monet in the Garden at the House in Argenteuil*, it is Monet who is looking up from the far end of the garden, his back to the trees, the widening curve of the pathway disappearing off to the right of the canvas. As comparison with a twentieth-century photograph (fig. 89) confirms, he took great care with the two-story house in the background, indicating the bright green shutters, the corbels on the roof and the shadows they cast, and the veranda in front of the house. Yet the expanse of garden is telescoped, Camille appears waiflike and diminutive beside the young trees, and the most insistent element by far in the entire composition is the group of hollyhocks surrounded by other flowers. It is this motif that offers a clue to the significance of the painting.

Monet's garden paintings at Argenteuil have most recently been interpreted as a retreat from the harsher realities of the town itself, a return to nature, part of the artist's growing disaffection for modern life in the suburbs.[9] More generally, what more appropriate subject for an Impressionist?—the effects of light, the array of color, the motif observed and recorded in plein air. Yet, the bourgeois flower garden was neither natural nor eternal: it was a relatively recent phenomenon in the history of the French garden, and one whose popularity among the well-to-do middle class can be documented to the third quarter of the nineteenth century.[10] Until this time, the extensive private flower garden simply did not exist as a respectable and self-sufficient entity, but by the 1860s the situation had changed.[11] Ernouf and Alphand's *L'Art des jardins*, first published in 1868, proclaimed that in recent years a revolution in gardens had taken place that was as momentous as André Lenôtre's introduction of the formal garden to seventeenth-century France, namely the appearance of the private garden with an abundance of flowers.[12]

Thus, the flower garden of the Pavillon Flament—laid out, it may be presumed, by Monet himself—offers another aspect of the artist's impeccably bourgeois aspirations, his search for comfort and respectability. In its own way, it, too, is a symbol of modernity and progress, and therefore shares something with the Gare Saint-Lazare that Monet would paint repetitively the following year. Furthermore, Monet's garden at Argenteuil followed the latest fashion: his choice of curving pathways and a circular lawn was in keeping with the then-current preference for "les lignes et les surfaces courbes," a reaction against symmetry that would be found excessive by the 1880s.[13] Similarly, Monet's planting of large circular clusters (*corbeilles*) of high-standing flowers surrounded by flower beds of distinctive color was another convention that became firmly established in the 1870s and would become orthodox by the following decade. The cluster of hollyhocks that towers over Camille represents the latest trend in garden design.[14]

In light of this, it is clear that Monet's garden paintings make reference both to fashion and modernity, and are less "natural" than they first appear. The contrast with the subjects Monet would paint in Paris the following year becomes less marked, the break between Argenteuil and Paris less dramatic. As Théodore Duret would observe in 1878, "Above all [Monet] is drawn towards nature when it is embellished and towards urban scenes; from preference he paints flowery gardens, parks and groves."[15]

CBB

52

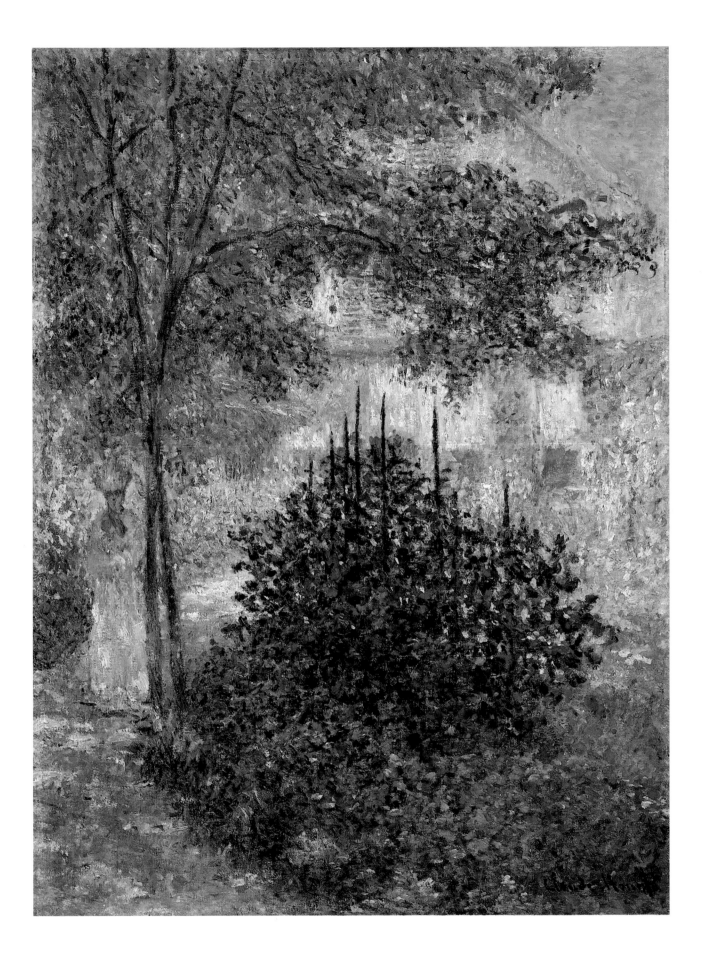

CLAUDE MONET

FRENCH, 1840–1926

THE STROLLER (SUZANNE HOSCHEDÉ), 1887

OIL ON CANVAS, 39⁹/₁₆ X 27³/₄ INCHES

THE STROLLER SHOWS Suzanne Hoschedé (1866–1899) in the meadows just south of Le Pressoir, Monet's home at Giverny. Suzanne was the third daughter of Alice and Ernest Hoschedé, and, after his first wife, Camille, who died in 1879, the artist's preferred model. Suzanne married the American Impressionist Theodore Butler (1876–1937)—they had met skating at Giverny—on July 20, 1892, four days after Monet and Alice Hoschedé were officially married. She died in February 1899 after five years of illness.

The painting belongs to the same campaign as two others, *Suzanne Reading and Blanche Painting* (private collection, France) and *Suzanne Reading and Blanche Painting in the Meadows of Giverny* (fig. 90), all three executed at the same site. Indeed, Suzanne's costume here is identical to the one in the latter painting.[1]

Although not dated, *The Stroller* was probably painted in the summer of 1887, and Monet's intentions are laid bare in an unusually revealing letter to Théodore Duret of August 13, 1887: "I am working like never before on a new endeavor, figures in plein air as I understand them, painted like landscapes. This is an old dream of mine, one that has always obsessed me and that I would like to master once and for all. But it is so difficult! I am working very hard at it, almost to the point of making myself ill."[2]

Monet's return to figure painting, which had started the year before with Suzanne as *The Woman with a Parasol* (Musée d'Orsay, Paris), would continue intermittently during the next four years with paintings of the Hoschedé daughters in boats and the Monet and Hoschedé children in the Giverny countryside.[3] The mode was abandoned altogether in 1890, when Monet turned to series painting as a way to resolve his dissatisfaction with the limitations of Impressionist subject matter. But it is clear, both from his correspondence and his itinerary of the following years, that it was in 1887 that Monet's efforts in this new direction were at their most concentrated.[4]

In *The Stroller*, Suzanne is posed, almost like a photograph, in one of the "vast and deep" meadows in front of Monet's garden, "where," wrote Octave Mirbeau, "rows of poplars, in the dusty mist of the Normandy climate, form charming, dreamlike backdrops...."[5] Over a gray-beige ground—visible only in the upper sections of her skirt—the paint is applied in successive layers of varied, yet consistently emphatic, brushwork. If the energetic, flickering dabs of blues, greens, mauves, and pinks in the background anticipate Monet's feathery handling in *Bend in the Epte River near Giverny* (Philadelphia Museum of Art) of 1888, the tree trunks, grass, and figure of Suzanne herself are rendered in more deliberate strokes, whose heavier rhythms anchor the pulsating chromatism of leaf and sky.

Despite the mosaic of brushstrokes and colors in the upper sections, Monet was less concerned here with recording the effects of light and shadow on Suzanne than with fixing a presence that is at once more permanent and more abstracted. Details of Suzanne's expression and costume are suppressed—not, as in the paintings of the seventies, to better evoke the fleeting instant, but, rather, to simplify and render monumental. Yet, it is the balance of elements here, both sitter and setting worked to the same degree of finish and completion, that is central to the "new endeavor" he described to Duret. Writing to the society portraitist Paul Helleu on August 19, 1887, Monet noted, "I have undertaken figures in the open air that I would like to finish in my own way, like I finish a landscape."[6] In keeping with this, Monet refused to reduce landscape to mere background—something for which he would reproach Renoir in the early nineties—while ensuring that his figures never overpowered or entirely dominated the composition. Suzanne is painted with the same touch and accent as the trees and grass, yet she remains a discrete presence, never simply part of the landscape. It is this decorative equilibrium, deceptively easy at first glance, that was achieved only after much struggle on Monet's part.[7]

Although Monet would have been appalled at the suggestion, he was significantly influenced at this time by the Broadway paintings of a much younger American painter, John Singer Sargent (1856–1925).[8] Sargent came to paint with Monet at Giverny in the summer of 1887—a visit in June is securely documented, another in August is possible—and his *Claude Monet Painting at the Edge of a Wood* (fig. 91) may well show the very site on which *The Stroller* was painted.[9] As John House has observed, Monet was intensely interested in Sargent's experimentation with figure painting out of doors and would have seen Sargent's most ambitious plein-air painting, *Carnation, Lily, Lily, Rose* (The Tate Gallery, London), on display at the Royal Academy, London, in May 1887, when Monet was visiting Whistler there.[10] Although it is generally assumed that Sargent followed Monet in these years—Monet noted to Alice Hoschedé in April 1889 that "Sargent ... proceeds by imitating me"—Sargent's Impressionist paintings consistently treat certain themes that appear only sporadically in Monet's canon between 1886 and 1890, where they are new departures for Monet.[11] The conclusion that there was mutual influence is unavoidable: more self-consciously posed, less interested in atmospheric nuance, Sargent's Broadway paintings have the consistency of touch and easy balance of sitter and setting that Monet achieved in *The Stroller*.

The Stroller is furthermore suggestive of Monet's capacity to refine his art in accordance with the latest developments in the painting of the avant-garde. By the mid-1880s, reaction against Impressionism had led Gauguin and Van Gogh, in particular, to experiment with broadly drawn monumental figures of nonnaturalistic color, resonant with symbolic meaning. *The Stroller*, with its unusually bold contours and highly patterned surface, shares in the enterprise of a younger generation in seeking to transform the fugitive effects of nature into something immobile, abstracted, and decorative.[12] In an unexpected way, *The Stroller* is godmother to Van Gogh's *Girl in White* (fig. 92), painted three years later.

CBB

54

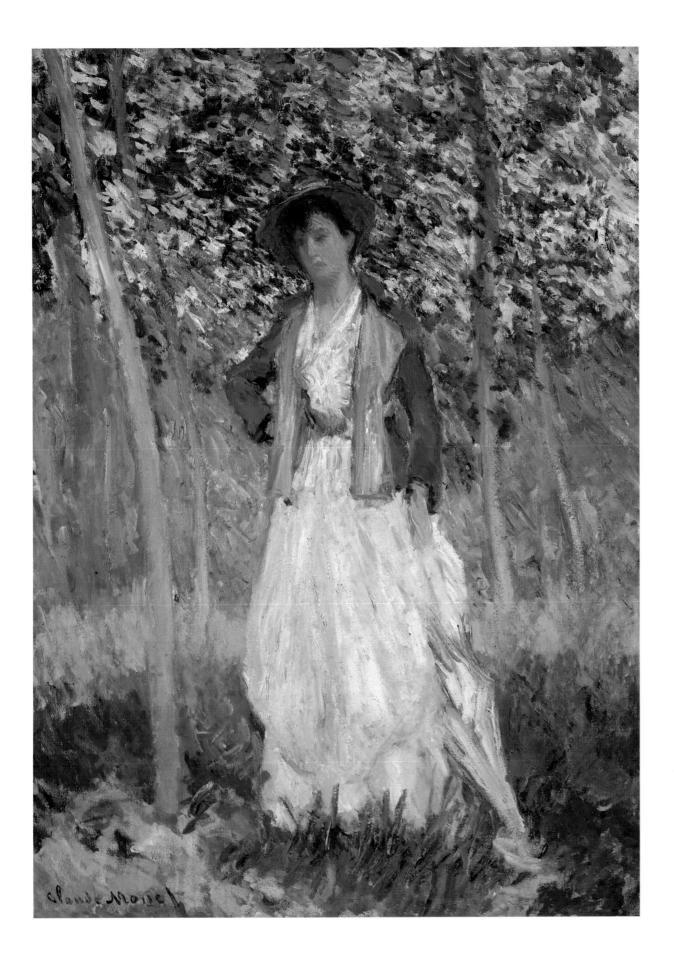

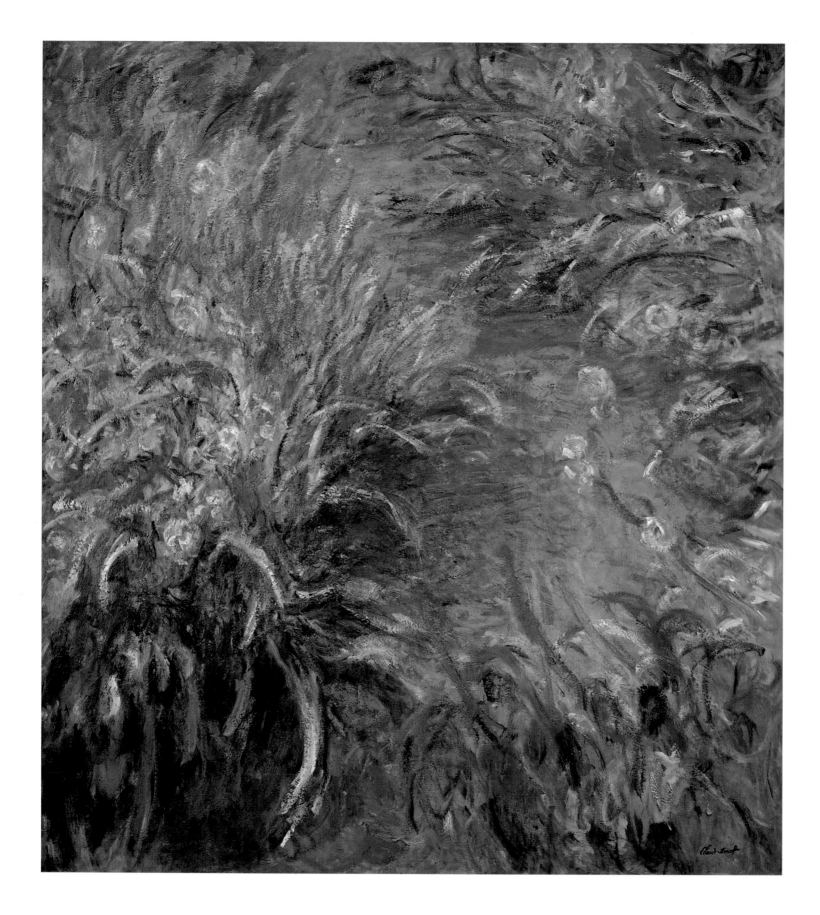

CLAUDE MONET

FRENCH, 1840–1926

THE PATH THROUGH THE IRISES, 1914–17

OIL ON CANVAS, 78⅞ X 70⅞ INCHES

IN AN INTERVIEW given in 1918 and published posthumously, Monet discussed the working method he had evolved, in the face of impending blindness, to create the monumental series of decorations on which he was occupied exclusively during the last decade of his life. By now "insensitive" to the "finer shades of tonalities and colors seen close up," he found, however, that his eyes did not "betray" him when he stepped back and "took in the motif in large masses...." He continued: "I waited until the idea took shape, until the arrangement and composition of the motifs had little by little inscribed themselves on my brain."[1]

Indeed, *The Path through the Irises*—one of the many large-scale canvases painted in plein air, and referred to by Monet as his "sketches"—captures and fixes both the explosive color and joyous virility of a flower that abounded on Monet's property at Giverny. Despite the wildness of his handling—the flailing strokes of red, blue, green, and violet pink dragged dry on dry—Monet's control of the form and structure of his composition is unwavering. The pathway curves in an arabesque and disappears to the upper left, with irises in plentiful bloom on each side. Monet's bird's-eye perspective and daring magnification of the flowers tend to diminish the pathway; from contemporary photographs (fig. 93) it is clear that the garden's paths were wider and the flowers less encroaching. Yet Monet's commitment to the reality of his site is uncompromising. The power of *The Path through the Irises* resides precisely in this concentration on the physical, in Monet's rigorous attachment to what Cézanne had called "that magnificent richness that animates nature."[2]

However, the nature that Monet painted was by this time both fabricated and subject to his organization and control. By the 1920s the water garden at Giverny had become a celebrated and colorful confection; since the turn of the century, it had been noted that the aging Monet was never as happy as in the company of his small army of "blue-bloused and sabotted gardeners," discussing with them the mysteries of propagation, grafts, and color schemes.[3]

The iris was one of Monet's favorite flowers[4]—in "Le Clos Normand" they lined the pathways leading to his house—and the pathway by the Japanese bridge was one of his favorite motifs. A group of paintings done in 1900 shows clearly the path with irises as it approaches the bridge (fig. 94) and disappears behind it.[5] It was a segment of this view that Monet isolated in *The Path through the Irises*, painted between 1914 and 1917, at a time when he must have had great difficulty focusing visually on the flowers themselves, although the monumental sketch betrays none of this insufficiency. Characteristic of his working method in these years, Monet painted a cluster of similarly scaled compositions that share the same motif: for example, *Irises* (fig. 95) and *Irises on the Pathway* (private collection, France), in which the flowers themselves are not in bloom.[6] He then

shifted his canvas a little more toward the lily pond itself, in the exuberant and freely painted *Iris* (fig. 96), in which individual forms are less clearly articulated. In this painting the pathway is cut off and the blue of the pond intrudes to form a triangle of water reflecting in the center of the composition. *Iris* was, in turn, the starting point for two other large sketches of *Irises by the Pond* (fig. 97), where the flowers have fully yielded to the ever-encroaching water.[7]

For Monet's friend, the critic Octave Mirbeau, irises evoked a dusky sensuality.[8] Although Monet himself often represented water lilies (see *Water Lilies*, p. 58) as passive, supine elements, floating calmly above the animated surfaces of the all-seeing pond, irises took on an altogether more forceful, straining energy in his late work, their wild leaves and pulsating blooms assuming a thrusting, almost threatening, masculinity.

Monet's published correspondence for the period from 1914 to 1918 is also mute on the genesis of *The Path through the Irises*, although we know that his obsession in the years after 1914 with the panels he would bequeath to the French government led him to work with great economy: practically every canvas he painted in the last decade of his life related in some sense to the decorations in process.[9] What, then, is the status of *The Path through the Irises*? Initially, this painting and its cognates seem to bear little connection with any of the great decorations. On the contrary, the ample and expansive presentation of both the flowers and pathway in this group of paintings effectively blocks out both sky and water—the two essential elements of all the grand panels, whether retained or not. After a visit to Giverny in 1920, the Duc de Trévise characterized the subject of Monet's decorations as "the subtle play of air and water, under the varied fire of the sun. The earth, being too material, is excluded...."[10] None of the composite panels that have been recorded includes the pathway and irises with such singularity of focus.

Yet, a relationship between *The Path through the Irises* and the grand decorations, although attenuated, does exist. As previously noted, once Monet had painted the irises and the curving pathway, his vision moved inexorably toward the banks of the lily pond, until the water came to occupy equal space in his compositions (see figs. 96, 97).[11] By anchoring the irises and the pathway to the edge of the pond itself, Monet returned to a motif that had a well-defined place within the schema of the water-lily decorations. The edge of the riverbank with irises shrouded in the haze of dawn provides the subject of the fourth and final panel for *Morning* (Musée de l'Orangerie, Paris), installed in the first room of the Orangerie and painted between 1921 and 1926, several years after *The Path through the Irises* was painted. This section, painted on a squared canvas, is the ultimate reprise of a motif that had once enjoyed independent status, but that, in the visionary last works, could exist only in submission to the water itself.[12]

Monet's determination to engage himself with motifs he could hardly see succeeded through the intervention of memory and imagination, as he himself divulged.[13] In the end he was forced, almost in spite of himself, to adopt a method of painting in which these forces collaborated—the equation recalls Degas—and, indeed, *The Path through the Irises* is a fine example of this reflexive manner of painting, recently described as Monet's "conceptualization on a grand scale of the repertoire of gestures he had had at his command for so long...."[14]

CBB

CLAUDE MONET

FRENCH, 1840–1926
WATER LILIES, 1919
OIL ON CANVAS, 39¾ X 78¾ INCHES

WITH RARE exceptions, Monet confined himself to painting views of the water garden at Giverny during the last thirty years of his life. As early as 1897, the year of his first *Nymphéas*, he spoke of his ambition to execute a monumental decorative cycle for a circular room with motifs from the water garden as its subject.[1] In 1902, he increased the size of this garden by nearly four thousand square meters, diverting the river Ru and constructing sluices to create an enormous lily pond beyond the railroad tracks on his property.[2] Thereafter, Monet produced an annual crop of canvases that focused more and more narrowly on discrete sections of the pond: on the lilies themselves, but also on the reflections of sky, clouds, and trees in the water. Obsessed by these studies, Monet undertook his grand decorations at the outset of World War I. By October 1915, he had built a third atelier on the northwest corner of his property, large enough to accommodate twelve huge panels in sequence, and during the next six years he worked relentlessly to bring this decorative cycle into being.[3] Twenty-two panels were officially dedicated in two rooms at the Orangerie in May 1927, after lengthy and tortuous negotiations with the French government. Monet, who had died the previous December, never saw his project realized, although he left strict instructions for its installation and display.[4]

With some embarrassment, Monet confessed to being totally absorbed in the decorations throughout the course of World War I.[5] Despite cataracts and failing eyesight, he established a regular working method: during the spring and summer months, he would paint what he called his "sketches" directly in front of the motif on canvases of considerable size. After October, he would return to the panels themselves (too large to be moved from his third studio), with which he was rarely satisfied. Contemporary accounts suggest that he may have been working on as many as fifty full-scale panels at any one time.[6]

From 1915 onward, all of Monet's energy was directed toward the not yet commissioned decorative series, although *Water Lilies* and its cognates fall into an independent group and stand somewhat apart. On August 25, 1919, Monet informed Gaston and Joseph Bernheim-Jeune, dealers with whom he had done business since 1900, that he was working "in full force," aided by the "splendid weather"; "I have started on an entire series of landscapes, which quite thrills me and which, I believe, may be of some interest to you. I dare not say that I am pleased with the paintings, but I'm working on them passionately: they provide some repose from my *Décorations*, which I've put to one side until the winter."[7]

On October 11, Monet told the Bernheim-Jeune brothers that the change in weather had forced him to stop painting in plein air, and that he looked forward to their visit.[8] The next month, the dealers purchased four large-scale *Water Lilies*, all signed and dated 1919, which are among the rare paintings that Monet released in the last decade of his life.[9] Given the artist's reluctance to part with his most recent work, and his determination to keep his decorations intact, the group of canvases to which *Water Lilies* belongs is something of an anomaly in Monet's oeuvre: they are works painted specifically for the market, and do not relate to a decorative panel then in process.

Although only four *Water Lilies* were sold in the fall of 1919, eleven canvases are recorded in this series. All take the same segment of the lily pond as their motif; all are painted on canvases measuring approximately three by six and a half feet;[10] and all record shifting moments of a summer's day, with the flowers more or less open, and the reflections of the sky and clouds above more or less serene. Of the four that Monet signed, three survive intact and one has been divided in two; these paintings share a similar facture and are more finished than the seven that Monet did not sign.[11]

Yet within the controlled and limited range Monet imposed, there is an astonishing variety of tone, mood, and detail. In this *Water Lilies*, the richly painted flowers are fully opened, but the sky is overcast and cloudy. By contrast, in *Water Lilies* (fig. 98), one of the paintings not sold to Bernheim-Jeune, Monet exalted in the splendor of a summer's afternoon: the paint is applied more aggressively, the reflections of the sky are painted deep blue, and the rolling clouds are masses of pink.[12]

The group of *Water Lilies* would be Monet's last independent series: thereafter, he would not permit himself the indulgence of painting canvases on this scale unrelated to a specific decoration. In February 1920, he confided to the dealer René Gimpel: "Last year I tried to paint on small canvases, not very small ones, mind you; impossible, I can't do it any more because I've got used to painting broadly and with big brushes."[13]

Yet Monet's instinctive economy reasserted itself before long: contrary to his normal working method, he returned to this motif and, presumably, to this group of sketches for the subject of one of the large panels, nearly twenty feet long, that he painted early in 1921 (fig. 99). Conceived originally for the second room of the Orangerie, this was eventually eliminated from the four panels of similar dimension that were finally installed in this gallery.[14]

In a review of Durand-Ruel's very successful exhibition of Monet's first *Nymphéas* series in May–June 1909, the critic Roger Marx wrote that Monet "had reached the ultimate degree of abstraction and imagination joined to the real" in these works.[15] For Monet and his contemporaries, the possibilities of this aesthetic equation were accepted with more sympathy and insight than a strict modernist interpretation of the artist's late work would allow.[16] Degas was "intoxicated" by Monet's *Nymphéas*; Gimpel compared his initial viewing of the monumental decorative panels to being "present at one of the first hours of the birth of the world"; Clemenceau was "bowled over" by them and pushed Monet into creating his last great series for the state.[17] Furthermore, Monet's late decorative canvases were eagerly sought both by dealers and collectors, who found themselves facing the elderly artist's stubborn refusal to part with any of his last works. With great reluctance, Monet sold one of the large decorations to the Japanese collector Prince Matsukata for the astonishing sum of 200,000 francs in October 1921.[18]

Perhaps even more surprising is the ease with which contemporaries "read" these expansive compositions. The effortless and poetic legibility of Monet's late work is a further aspect that has been somewhat obscured in recent literature.[19] Arsène Alexandre, describing *Water Lilies* and its companion of the same title,[20] then in the collection of Henri de Canonne, wrote convincingly of the sequential relationship between the two works, illustrative of "two moments in the life of a water lily": "In the second work [the Annenberg *Water Lilies*], we see three groups in full flower assert themselves, in their golden discs encased in purple, against the cloudy waters that reflect a turbulent sky. This painting overwhelms us with its life force, and could well be called 'Maturity.'"[21]

CBB

58

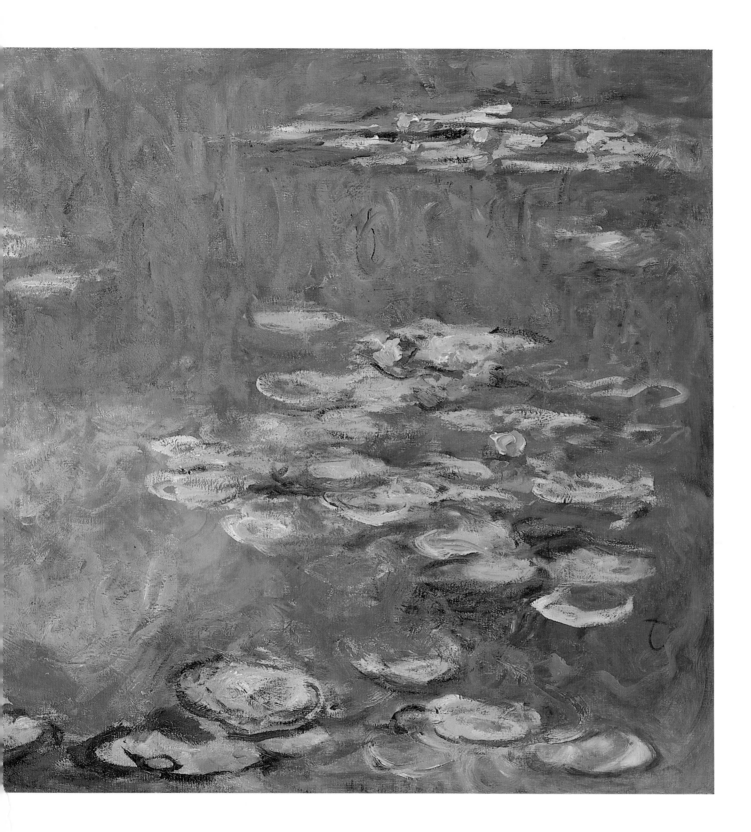

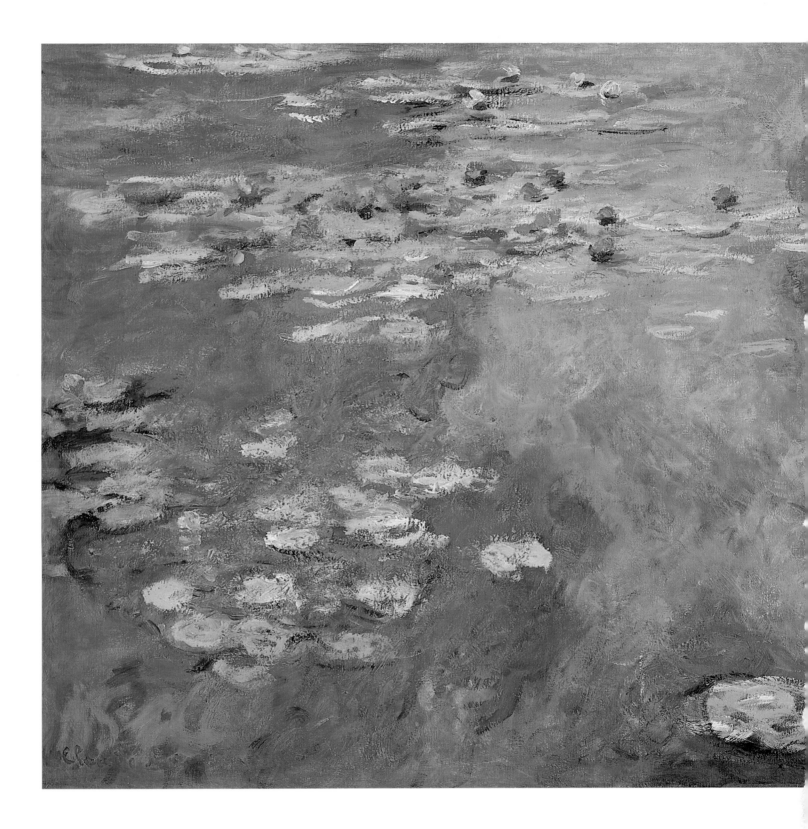

Henri de Toulouse-Lautrec

FRENCH, 1864–1901

The Streetwalker (Casque d'Or), c. 1890–91

OIL ON CARDBOARD, 25½ X 21 INCHES

PORTRAITURE IS fundamental to the art of Toulouse-Lautrec. From his most whimsical sketches to his elaborately prepared lithographs, all his images are based on closely observed, carefully noted figures with whom he had direct contact. Even in his most ambitious canvases, such as *Ball at the Moulin Rouge* (fig. 100), virtually all the participants can be identified. And if this vast accrual of personages has, for us in this century, merged into an anthology of all that was typical of Paris at the turn of the century, it is only at the sad cost of the merging of these assorted characters into typicalness, which was never Lautrec's intent. For him the descriptive recording of the individual was paramount, even given his great, innovative powers to unite his surfaces through seemingly effortless patterns of plastic lines. Some hundred years after their creation, Lautrec's posters advertising the nightclubs of the Moulin Rouge immediately bring to life La Goulue and Valentin le Désossé, Jean Avril in the *Divan Japonais,* or Aristide Bruant in the *Ambassadeurs.* Many of these people, along with others, appear and reappear in his works as they did in Lautrec's late-night prowling in cafés and dance halls in Montmartre, a newly emerging quarter on the outskirts of Paris, after his move there in 1882 (he would have a series of apartments and studios there for the remainder of his life). Other people, such as the subject of this picture, appear only once, although from the reports of his friends—and from the pictures themselves—there is no doubt that the distinction between a model and an intimate (however fleeting the acquaintance) was never drawn. "He only made revealing portraits of people he professed to like."[1]

In several cases, such as here, the facts surrounding the person portrayed—for all the startling candor of the image—have been lost. This disarmingly pert yet somehow vulnerable woman is known only by the nickname she bore in honor of her pile of golden hair, swept up on the top of her head to resemble a helmet, "La Casque d'Or." It was a style probably made fashionable among the demimonde of Montmartre by the dancer La Goulue (Louise Weber) (fig. 101); we know that wigs in vivid colors were produced in imitation of it and worn by dancers in clubs.[2] Her profession is known from the title the picture has borne since it was first shown at Joyant's in 1914: "La Pierreuse" (The Streetwalker). The belief that she was called Amelie-Elie seems to be without substantial documentation.[3]

She was tremendously successful at her profession, first as a semi-independent when her lover and protector (and probably pimp) was the infamous police assassin and anarchist Liaboeuf, who was eventually guillotined.[4] Her allure was such that she caused fights on the streets among her pursuers, sometimes to the point of drawn knives and pistols; one incident resulted in two deaths and a wounded bystander. She became the submistress of a brothel on the rue des Rosiers; thereafter, presumably in the late 1890s, her fame (and, one sadly suspects, her fortunes) faded.

As engaging as these few biographical notes are in expanding our romantic sense of Lautrec and his life in the underworld of Paris,

there is little in the picture itself to confirm a novelistic reading of it. The Casque d'Or sits in a garden before a patch of saplings, a dirt path extending up a hill on the right. Her legendary sensuality is denied by the high-collared, buttoned-up brown coat she wears; only the crest of her hair, beautifully worked in orange shadows and lavender highlights, suggests her flamboyant reputation. It is pulled down nearly over her strongly penciled eyebrows; is it indeed a wig? Her limpid eyes are unblinking; her slightly crooked mouth is firmly set. She has the strong presence of nearly all of Lautrec's portraits; many have attempted to characterize the compelling sense of presence that she conveys. Fritz Novotny comes closest, drawing an analogy between Lautrec and Chekhov.[5] In his view, whatever their roles in the drama, the characters remain somehow outside, larger than the painting or play itself, through the power of their intrinsic reality. If the Casque d'Or moves us with her Piaf-like poignancy, tempered by a determined tenacity, we must also draw back from her, because of the consistent balance of sympathy and distance with which Lautrec portrayed all his characters. His great genius is that he never merely characterized; he made his seemingly limitless fascination with his characters our own.

The hair and features are carefully modeled in fine, delineated strokes. The working of the surfaces releases outward into broader and looser application, the lower section of the coat and sleeve depending for definition almost entirely on the color of the board support. The trees behind are treated with a broadness that suggests Lautrec's knowledge of and admiration for the late works of Manet. The wall at the top of the hill is described by a few white and lavender strokes. The picture is structured with concentric degrees of focus, all other elements taking a supporting role to the definition of the face and head.

Although the work has been dated as late as c. 1898,[6] Lautrec's close friend and eventually his dealer, Maurice Joyant, certainly is correct in placing it at the beginning of the decade.[7] A date of c. 1890–91 was confirmed by Gale Barbara Murray in her thorough work on revised dating.[8] We know that as early as 1887,[9] Lautrec would often seat his subjects in the little and, by all evidence, rather squalid and undernourished garden of his neighbor Père Forest in Montmartre. Several similar portraits of women show them seated against the foliage in an assortment of portable chairs; the Casque d'Or sits on a metal folding park seat. The most striking comparison to this picture within the group is the portrait of Berthe La Sourde, who, like the Casque d'Or, was a creature most likely encountered at night.[10] It is as though Lautrec wished to bring these women whom he had first met in the gaslight of the cafés or brothels into the clear light of day to better subject them to his penetrating observation.

He placed them in shadowless light and exposed their pallid complexions against the verdant green of Père Forest's feeble saplings. The introduction of landscape was a passing thing for Lautrec, and he used the garden only as a foil to remove his subjects from their more natural setting of moving crowds. As he himself vigorously noted: "Only the figure exists; landscape is and only should be an accessory. The pure landscape painter is only a brute. Landscape can only serve to allow us to better comprehend the figures. The same is true of Millet, Renoir, Manet, and Whistler, and when the painters of figures do landscapes, they treat them like a face. The landscapes of Degas are remarkable; they are landscapes of a dream; those of Carrière are like human masks! Monet has abandoned the figure because he cannot do it!"[11]

JJR

60

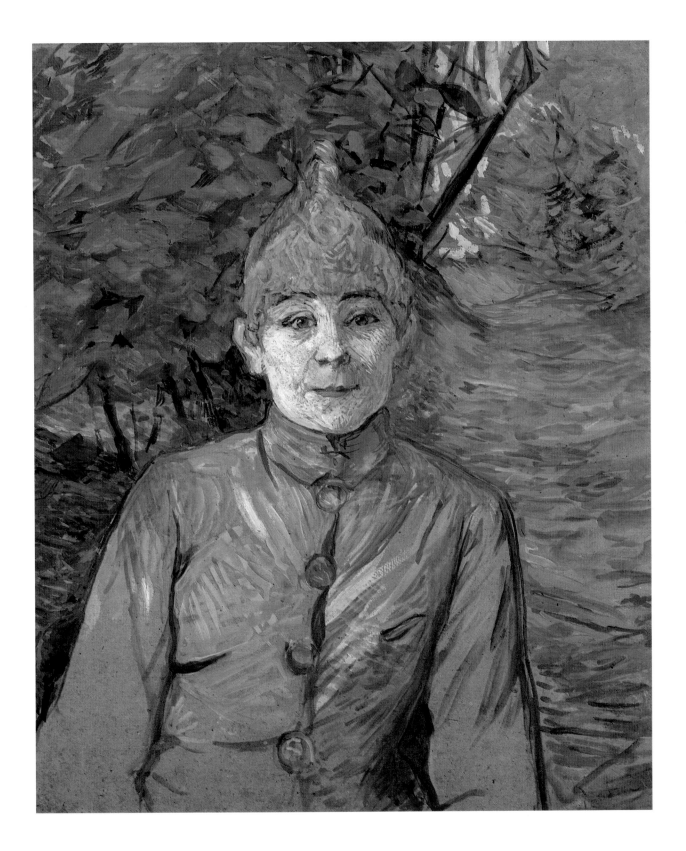

pour
HG IBELS
TLautrec

Henri de Toulouse-Lautrec

FRENCH, 1864–1901

Henri-Gabriel Ibels, 1893

GOUACHE ON PAPER, 20½ X 15½ INCHES

The jaunty and self-assured Henri Ibels is placed with direct aplomb in the top third of a nearly empty space, his lively features defined by a finely worked network of pale yellow highlights. The natural color of the support creates the shadows. His hat, with its upturned brim, and his lavish cravat are quickly worked in broad washes of blue and purple. The same colors are applied in sweeping strokes to define the oversized lapels and exaggerated shoulders of his abundant overcoat. The head is set off by an aura of white paint, which abruptly shifts to a sharp sea green around the face, giving the flesh tones a particularly lurid pallor. It is a swift and amusing portrait of Lautrec's close friend that is completely in keeping with what we know of this fellow-artist, whose ingenuity in their mutual artistic affairs—and sometimes audacious manipulation of shared clients—bonded their relationship, encouraged by their appetite for the circus, musical cabarets, and dance halls of Montmartre. This image is not without its darker side. The elevated pose used by Lautrec and the quality of mischievous self-possession that plays across the face of Ibels make this portrait Lautrec's Pierrot, the wily and infectiously gay character in Watteau's painting at the Musée du Louvre (fig. 102), who carries with him a cloud of vulnerability and melancholy: Théophile Gautier's "tragique de blancheur."[1]

Henri Ibels (1867–1936) was one of the founding members of the Nabis brotherhood, the small group of French artists that included among its original members Bonnard and Vuillard.[2] Their aesthetic formation developed out of Gauguin's circle at Pont-Aven in the late 1880s, and they saw themselves as returning painting and printmaking to a more flattened and stylized imagery that would reintroduce both the social responsibility and the spiritual elements they felt had been abandoned by the Impressionists. Ibels himself was also associated with the anarchist movement and often made satirical prints on the follies of the bourgeoisie and depicted subjects drawn from the street life of the working classes and the popular theater. He was known as "le Nabi journaliste," for his illustrative lithographs. It was this interest that probably first brought him into contact with Lautrec in the late 1880s.[3] By the early 1890s they were constant companions. With his considerable skills at promoting himself and his friends, Ibels got himself and Lautrec the commission to illustrate a series of covers of sheet music of songs then popular in the cabarets of Montmartre. They showed together at Le Barc de Boutteville gallery in 1891, and it was through Ibels that they shared the ambitious project to illustrate Georges Montorgueil's *Le Café-Concert* in 1893 (fig. 103). Siegfried Bing was persuaded by Ibels in 1895 to commission them to provide designs for stained-glass windows (Lautrec's was executed by Tiffany in New York) for his new gallery, L'Art Nouveau. Although they had no further collaborations, their friendship continued until Lautrec's death.

Despite their shared projects and mutual interests, they were artistically quite different. Ibels worked within the range of illustrative commentary and social criticism, often in the form of very telling and humorous caricatures. Lautrec, while greatly interested in this side of art, expanded far beyond the restraints of specific commentary, just as his forms would never take the emphatic outlines and abrupt silhouettes of his colleague.[4] Yet, even with distinctions of temperament and artistic rank, their friendship held true, Lautrec reveling in Ibels's bravura manner and aggressive chicanery.

This sketch is nearly identical to a pen and ink drawing now at Smith College (fig. 104), also done in preparation for a lithographic portrait of Ibels that appeared in the journal *La Plume* on January 15, 1893.[5] The illustration accompanied an article on Ibels by the critic Charles Saunier, who had the previous year noted the affinity between the two artists and praised both Lautrec and Ibels for their acute realism. To judge by the configuration of the inscription on the pen and ink drawing, which is identical to the journal illustration, it, rather than this more ambitiously worked gouache, must have served as a direct source for the published portrait.

JJR

Henri de Toulouse-Lautrec

FRENCH, 1864–1901
Woman before a Mirror, 1897
OIL ON BOARD, 24½ X 18½ INCHES

By THE EARLY 1890s, Lautrec became a steady visitor to the celebrated brothels of Paris on the rue des Moulins, the rue des Rosiers, and the rue Richelieu, often taking a room in those luxurious palaces of pleasure for several days, receiving his friends much as he would in his apartment or studio. In 1892 he even designed, at the behest of the proprietress, a room à la Pompadour for an establishment on the rue d'Amboise. The indolent, cloistered lives of prostitutes became the subject of some of his most powerful works, about fifty paintings in all, as well as numerous drawings and prints, including a complex set of lithographs done in series, *Elles*, of 1896.

To what degree the intention of these sustained visits was, in part, amorous is far from clear; Lautrec's sexuality continues to be as much analyzed as it is undefined. But there can be no doubt that he struck up an easy and confidential relationship with these women who allowed him complete access to their twilight world of idle anticipation, naive gaity, and physical intimacy, one to another. Prostitution as a subject for art was, of course, not novel in late nineteenth-century France. Much has been written about the precedents for Lautrec's pictures in the literature of Baudelaire and Zola or, more specifically, in the work of those artists he admired: Manet, Constantin Guys and, above all, Degas. But if Manet's *Olympia* (Musée du Louvre, Paris) and *Nana* (fig. 105) were done, in part, to confront the falseness of bourgeois standards, just as numerous artists in the 1890s would treat the theme with social and moralizing intent, Lautrec, who drew upon this underworld more than perhaps any other artist in the nineteenth century, consistently withheld judgment, not even straying into the indulgent humor with which Degas showed the madams and mademoiselles in his monotypes.

Here, a woman, nude except for her black knee stockings, stands firmly planted in her room, gazing at herself in a full-length pier glass. Her abundant red hair is knotted high on her head; the pallid whiteness of her skin assures us that her hair is its natural color. She holds a nightgown in her right hand; her peignoir with embroidered cuffs is flung over the seat of an overstuffed neo-rococo love seat with a carved wooden dolphin ornament. The walls are covered with a rich scarlet cloth, the same material that seems to form a partial baldachin over the head of the unmade bed. The room is carpeted in a dense red and green woven fabric; its reflection in the mirror catches the light across the room (out of our sight) to suggest a window to the left.

It is a disarmingly still and neutral image. The woman's ample hips and loosely muscled back may suggest a certain poignancy of age, yet the image she contemplates in the mirror is firm and youthful. Her upright stance is that of a model holding a pose—and we know Lautrec would hire women in the brothels for the day to pose for him—with neither coyness nor posturing. Only the heap of bedclothes at the top of the bed introduces an erotically suggestive image,[1] and it is strange that many have seen bitterness or sharp irony in this picture.[2] The profession of the woman is clear; what thoughts she may have about it are unaddressed. The only emotion other than the artist's clear pleasure in witnessing this pale woman with radiant hair, posed in a lushly appointed airless bedchamber, is that distant and deeply affecting sense of sadness that pervades this hermetic scene.

In his early brothel pictures and prints, Lautrec delighted in the community of the women, and the majority of his works on this theme are given over to multifigured images of them together, waiting, sleeping, waking, or lovemaking. It is only in his later pictures, which are many fewer in number and very different in character, that the narrative elements fall away, and he depicts these women quite apart from any specific professional context. In this sense, *Woman before a Mirror* bears a close comparison to two other major pictures from late in his career: *Woman before a Bed*, of 1899 (fig. 106) and *Woman Adjusting Her Nightgown*, done in the year he died (fig. 107). In both cases, the figure is posed centrally in the space against the effects of her room. These two later works may be compared to the single nudes of Renoir (fig. 108), an artist with whom Lautrec remained on good terms throughout the 1890s.[3] However, the more telling parallel, particularly for *Woman before a Mirror*, must be drawn to Lautrec's most profound hero, Degas, whom Lautrec knew through the composer and musician Désiré Dihau and his family, who lived near Lautrec in Montmartre. Lautrec fervently admired the work of the older artist, and related to his friend and dealer Maurice Joyant his immense pleasure when Degas visited his exhibition in 1893: Degas arrived late in the day, silently gazed carefully at all the works while humming to himself, and only when halfway out the door, turned to the young Lautrec and said, "I see you are one of us."[4] Lautrec's perceptive understanding of Degas's technique and methods are no more apparent than here.

In this work of 1897, the vigorous graphic fluidity, the constantly moving plastic lines, and the animated outlines of his earlier work have now distilled into a coloristic unity and evenness of handling that parallel his abandonment of the narrative, genre aspect of his earlier treatment of brothel subjects. While he has given great attention to the beautifully modeled strokes that define the nude herself, these now loosen more gently than before to define the room and furnishings. The preeminence of the figure over her surroundings that occurred in earlier pictures is now diminished; the physical context is given greater weight, just as in Degas's painted and pastel bathers of the late 1880s and 1890s (fig. 109). The broad strokes that depict the mirrored image—the dark hatching across her reflected stomach and the blurring of the outline of her arm by a series of noncontinuous lines, the absence of any edge to her mirrored face, effacing the distinction between the artificial and real—directly recall the works by the older artists in which the medium takes on an independence from conventional modeling. The denseness of handling and new manipulation of deep tones are unimaginable without the precedence of Degas's pastels. The very darkness of this picture—the sealed containment of the room in which stands this radiant figure who is, so strangely, neither beautiful nor ugly—is brought about by Lautrec's understanding of the works of the older artists. The nude before the mirror stands as one of Lautrec's most hauntingly mute pictures, remarkable even among his abundant outpouring of paintings on this theme. It is not surprising that some critics, in their attempts to explain its effectiveness, have naturally turned for comparison to the nudes of Goya and Rembrandt (fig. 110).

JJR

64

GEORGES SEURAT

FRENCH, 1859–1891
GRAY WEATHER, GRANDE JATTE, C. 1888
OIL ON CANVAS, 27¾ X 34 INCHES

IN 1890 GEORGES SEURAT showed ten pictures with the Société des Artistes Indépendants at the Cours la Reine of the Palais d'Industrie in Paris;[1] among them were two landscapes showing the banks of the Seine painted during the previous two or three years, which the critic Jules Christophe selected for particular note: "The effect is calm and gentle, with a harmonious placement of grays; the peaceful tonalities of the two studies of the Grande Jatte are delightful."[2] In his review Georges Lecomte stated that "*The Grande Jatte, Gray Weather*, proves that even in the torpor of an opaque sky, the sun still acts with a muffled and latent diffusion of light."[3] This praise would not have been particularly pleasing to an artist who had earlier responded indignantly to a similar subjective appraisal of his work: "Certain critics see poetry in what I have done. No, I apply my method and that is all there is to it."[4] By his own description, Seurat set out to discipline the creation of paintings through the systematic application of carefully calculated formulas concerning color, composition, and line, which superseded those works of the older generation of Impressionists—Zola's "Nature seen through temperament."[5] During the second half of the 1880s he laid a foundation for a new, objective mission for the many artists of his own generation who were drawn to his methods. Yet, for all the rigor of intention and application of his theories, the outcome always seemed to comprise a balance of systematic application and poetic expression. This duality is no more apparent than in the vigorously analytical yet subtly evocative painting *Gray Weather, Grande Jatte*.

The site is one of the best known in nineteenth-century French painting: the island of the Grande Jatte. Stretching for over one mile in the river Seine, just northwest of Paris, this narrow strip of land (six hundred feet at its widest), opposite factories and the dense working-class neighborhoods of Clichy and Valois-Perret on the right bank, with the more arboreal and prosperous middle-class suburbs of Courbevoie and Asnières to the north, was a favorite outing place for Parisians by the 1880s. Thanks to the easily available train service from the Gare Saint-Lazare, they came in mobs on summer Sundays to swim, fish, boat, or to take the air with their pets. The Grande Jatte was one of the favorite haunts of Seurat and his friends; boys swimming along the banks at Asnières became the subject of his first ambitious painting, *The Bathing Place (Asnières)* of 1884 (fig. 111). Two years later at the eighth, and last, Impressionist exhibition, he showed *Sunday Afternoon: Island of the Grande Jatte*, 1886 (fig. 112), the celebrated picture resulting from a long gestation that included numerous drawings and oil sketches and that established his reputation among the avant-garde, permanently dividing the artists of the older generation of Impressionists, who had shown together since 1874.[6] Both of these grand pictures are monumental experiments in the long French tradition of depicting figures in a landscape, and their complexity is immense. However, particularly in the latter part of the decade, Seurat painted landscapes on a more modest scale, on summer outings to the French towns on the Channel and, on at least three occasions, when revisiting the site of his great achievement of 1886. He returned to nature, as he noted, to "wash" the light of his Parisian studio from his eyes, and "to transcribe most exactly the vivid outdoor clarity in all its nuances."[7] It was Seurat's practice to work in plein air only for drawings and small oil sketches; his final paintings were done in his studio, which was often lit by gaslight.

This picture shows a dull, overcast summer's day on the Grande Jatte, devoid of the rowers, boaters, and fun seekers who populate the 1886 picture, which contains some forty figures. The idle boats are tied up to the mooring posts driven into the shallows along the bank: a little sailboat on the far left; two punts with pennants (perhaps from their rowing clubs) fluttering from the mooring poles; and a steam-powered craft firmly secured between two other poles, its dinghy tied up separately. As large as the latter boat seems in this context, it is probably just a small pleasure craft of the kind that moves gaily downriver in the 1886 painting, its guide sail, which goes up over the metal arch on the stern, furled away.

The view across the gently flowing river to the suburb of Courbevoie behind a concrete embankment is framed by the trees of the island. A path worn on the grass moves strongly across the foreground, the boldness of its diagonal somewhat dissipated as it weaves in and through the little grove of trees on the left. The surface of the painting is densely, but not evenly, covered by a series of small brushstrokes applied with great deliberation. Directly placed pure colors alternate within each area of definition: orange/green, blue/yellow, and white/gray. A border of alternating strokes of red and blue surrounds the entire canvas. The effect is at once freshly panoramic

and spatially flattened. As Robert Goldwater noted, the diagonal placement of the tree trunks is balanced by the visual union of the foliage to the surface of the picture plane, just as the strong angle of the path is spatially thwarted by the even horizon of the bank beyond.[8]

The painter Charles Angrand (1854–1926) described his working visits to the Grande Jatte with Seurat in 1885 or 1886: "The luxurious summer grasses along the bank had reached such a height that it obscured a boat, just along the bank, which he wished to depict. To avoid any trouble, I did him the service of cutting away the grass; afterwards he eliminated the boat from his picture. He was no slave to nature, oh, no! But he was respectful of it, not imaginative. His greatest attention was given to the tonalities, the colors and their interaction."[9] The picture Seurat was painting is not the one shown here, but Angrand's description of Seurat's attitudes applies. As abstract as his theories about the making of a picture may have been, the subject and the place were central issues, and questions of poetic mood and response to specific locations were, particularly in the independent landscapes, critical aspects of his work. It is unusual for Seurat, who was very prudent about his titles, to have given a descriptive title to this painting: "Gray Weather." At least three of his harbor pictures bear the notation "Evening," along with the name of the town in which they were painted, but never was he as specific in noting the climatic nature of the moment as he was here.[10] In this he was drawing close to the intention—at least in title—of the Impressionists, particularly Monet, whose declared purpose was to capture specific climatic effects. Given Seurat's relationship to the older generation of Impressionists and his supposed dependency on their attitudes and style—a link that has been seriously questioned in recent criticism[11]—this is an idea worth testing. Is this, indeed, a closely witnessed record of a temporal and climatic condition in nature?

Félix Fénéon, the critic and friend of Seurat, was among the first to note that one of the grave dangers of Divisionist painting was that, through its increasing refinement of the applied, separate strokes that characterize its practice, the interaction of colors tended to cancel one another out, creating a somewhat dulled coloristic effect that may have been just the opposite from the vibrancy intended. That is certainly not the case here, where despite the intensity and degree of density of color strokes, the relationship is so refined and delicately balanced that the overall muted effect is as intended.[12] This phenomenon proved a danger only for those followers of Seurat who practiced his Divisionist techniques with less rigor and strong-

mindedness. The subtlety and degree of forethought exercised here argue for a completely calculated effect, an effect that is described by the title. The strokes, for example, are not applied with an even denseness. They vary markedly in their thickness and degree of color contrast from one zone of the picture to another, just as the priming layer is not applied evenly but, rather, with considerable forethought to align with the bands of pattern within the picture: the lighter path, the water, and the sky are painted directly on unprimed canvas, whereas a white underpainting shows in spaces between the strokes in darker areas, to further enhance the contrasted color strokes and create illusionist space. The final effect is one of great formal lucidity and absoluteness, yet it has a definite sense of the place and the atmosphere in which it was witnessed. The subjective element is in enchanting accord with the objective calculations of its realization; the "scientific" and the "poetic" duality is resolved on the highest possible aesthetic and experimental plane.[13]

The border is painted, allowing the picture to distance itself from its original wooden frame, taking the shadow of the frame away from the image with an aura of gentle vitality. The painted border has been frequently discussed and its originality questioned on the assumption that Seurat returned to this picture at some later date to adjust its surround, as he was known to have done in other cases.[14] However, careful observation of the edge of the picture suggests that this is not the case. The image of the landscape is carefully brought up to a fine edge of exposed, ungrounded canvas well within the perimeter of the outer edge of the canvas. This dark razor line is particularly evident in the highlight of the tree trunk to the right, which plays so effectively in and out of the third dimension, in contrast to the dark border just beyond—with the blue and red alterations applied on the same exposed canvas with great method.

The exact date of this painting remains unclear. It was first shown in the sixth exhibition of Les Vingt in Brussels in February 1889 and has often been ascribed to the previous year, although other works probably dating from 1886–87, including the *Bridge at Courbevoie* (fig. 113), which bears certain comparisons to it, were also shown there for the first time. Camille Pissarro (1831–1903), on a visit to Seurat's studio in 1887, noted that Seurat was just beginning to experiment with both contained painted borders and frames painted with Divisionist strokes, explaining that "the picture is not at all the same with white or anything else around it. One has positively no idea of the sun or of grey weather except through this indispensable complement. I am going to try it out myself."[15] The inclusion of the painted border here suggests, therefore, a date of 1887 or later,

rather than 1886 (*Gray Weather, Grande Jatte* was not shown in Paris by Seurat in the exhibition of 1887.) If one follows the argument that Seurat's overall stylistic development proceeded toward a more abstracted, patterned series of compositions in the latter 1880s, culminating in the complex, frontal geometry of *Parade* (Musée du Louvre, Paris) in 1890, then *Gray Weather, Grande Jatte* should certainly fall slightly later than either the *Bridge at Courbevoie* (fig. 113) or another depiction of the same site, *The Banks of the Seine: Grande Jatte* (fig. 114), neither of which has a painted border. Further, the poetic aspect of *Gray Weather, Grande Jatte*, both in the evocation of atmospheric effects and the slightly melancholy mood it expresses in its grayed, depopulated scene, suggests an emotional evolution beyond the two other pictures.

The early history of the picture is worthy of note. It first belonged to Seurat's friend Alexandre Séon (1855–1917), whom he met as a fellow-student at the Ecole des Beaux-Arts in Paris in 1878 or 1879, where they studied with Henri Lehmann (1814–1882). Séon followed a less progressive course than Seurat; he became a successful painter and illustrator, somewhat affected by Seurat and his friends, but remaining more within the limited conventions of the Salon. Their friendship seems to have renewed in the late 1880s, just as Seurat was in a state of disillusionment at the hostile reaction to *Sunday Afternoon: Island of the Grande Jatte* from some of the Impressionists (particularly Monet and Renoir) and progressively more wary of the adaptation of his methods by his circle of followers. Given the relative prosperity of his family, Seurat had no financial need to sell his works, and it is known that he sometimes gave even important canvases to his friends. Séon may have come to this picture in this fashion. For example, in the distribution of Seurat's estate, he was the recipient of a small oil sketch of the *Grande Jatte*, which Seurat's mother (although probably not his wife, whom he kept secret from all his family and friends until literally the day of his fatal illness) had been encouraged to give to him by the theorist Félix Fénéon and the painters Paul Signac and Maximilien Luce.[16] By the 1920s, the picture had come into the collection of the New York lawyer John Quinn, one of the most active and enlightened collectors of progressive painting.[17] It joined one of the single most important gatherings of the artist's works ever accrued, ten in all, including Seurat's final masterpiece, *The Circus*, which Quinn bequeathed to the Musée du Louvre in Paris.

JJR

69

Paul Cézanne

FRENCH, 1839–1906

PORTRAIT OF UNCLE DOMINIQUE AS A MONK, c. 1866

OIL ON CANVAS, 23¹³/₁₆ X 21⁷/₁₆ INCHES

COURBET IS becoming classical. He has painted splendid things, but next to Manet he is traditional, and Manet next to Cézanne will become so in turn.…Let's only trust ourselves, build, paint with loaded brushes, and dance on the belly of the terrified bourgeois. Our turn will come, too.…Work, my dear fellow, be brave, heavy pigment, the right tonalities, and we'll bring about the triumph of our way of seeing!"[1] So wrote Cézanne's friend the painter Antoine Guillemet (1843–1918) in a letter of September 1866 to a colleague from the Acádemie Suisse, Francisco Oller, who had briefly returned to his native Puerto Rico. The letter was truly prophetic of the pictures Guillemet would witness being done when he joined Cézanne in Aix the following month. At the age of twenty-seven, Cézanne had brought his art to a point that, as Lawrence Gowing has recently noted, "we may if we wish call the beginning of modern art."[2] The *Portrait of Uncle Dominique as a Monk*, painted in the company of Guillemet that autumn, is one of the pivotal masterpieces marking Cézanne's first realization of his tremendously vigorous powers of innovation.

Cézanne's early development was fraught with passionate exploration for a means of realizing the ambitions he had discussed so earnestly with his childhood intimate in Aix, Emile Zola. Like Guillemet, Cézanne and Zola were determined to make their marks; Cézanne's means of doing this in the late 1850s and early 1860s was the execution of a group of intensely worked landscapes and figure subjects, often charged with a macabre obsession with violence and intense sexuality. During the summer of 1866—perhaps first in a landscape of the Seine at Bennecourt—he began experimenting with paintings in which he abandoned the brush altogether, working, as Courbet had in his landscapes and flower pictures (although never with figures), exclusively with a palette knife. This method, due to the necessity of swift execution and density of paint, helped him achieve a directness of execution and boldness of image that he would characterize some thirty years later in reviewing his canvases

of that time as *une couillarde:* literally, "ballsy." This vividly coarse word aptly summarizes the "ostentatious virility [that] suited the crudity of the attack with which the palette-knife expressed the indispensable force of temperament for a few months in 1866."[3]

The paint is literally troweled over a partial underpainting of olive gray, which itself has been swiftly pulled over the coarse, unprimed canvas. The density of the paint is such that there is a sculptural relief to the surface: "the painting of a mason."[4] Individual strokes do not blend into one another but, rather, were made in an immediate and direct manner, the colors having been mixed on the blade itself, then flowed onto the surface. For the simplicity of the palette—even the laid background is made up of black, white, and just a little blue—the range of tonality is remarkable. The intense contrast of white and red in the face stands apart from the deep black of the sitter's hair and beard, which are enveloped by the pure white cowl. Beneath the blue ribbon that holds the more thinly painted, black wooden cross, the whites of the costume are blended with yellow and threads of blue. The massive hands are done in less contrasted tones than is the face, the strokes more elongated and sustained than the staccato attack of the knife that defines the features. The immediacy of the overall image is realized in a centrifugal wave of coloristic and gestural rhythms progressively easing in intensity and contrast from the face outward to the edge of the canvas, where the blade glides off the surface, leaving the olive underpainting exposed in places. At no time previously was Cézanne so completely in command of his execution, nor was he, until this point, able to achieve a work of such force and vigor.

The sitter is the artist's maternal uncle, Dominique Aubert. During the autumn of 1866, and perhaps into the following January, Cézanne did nine portraits of him in various guises.[5] They all seem to have been done at Cézanne's father's house outside Aix, Jas de Bouffan, as reported by Antony Valabrègue, who himself had earlier sat for Cézanne: "Fortunately I only posed for it one day. The uncle is more often the model. Every afternoon there appears a portrait of him, while Guillemet belabors it with terrible jokes."[6] It is altogether a remarkable group of works, for which the uncle must have sat with considerable patience.

Seven of the portraits show him only from the chest up. In another, *The Advocate* (fig. 115), approximately the same size as this painting, he gestures rhetorically, suggesting, as does his costume, his profession as a lawyer. Regardless of their sizes, all of his portraits are done with equal vigor of handling, although it could be argued that

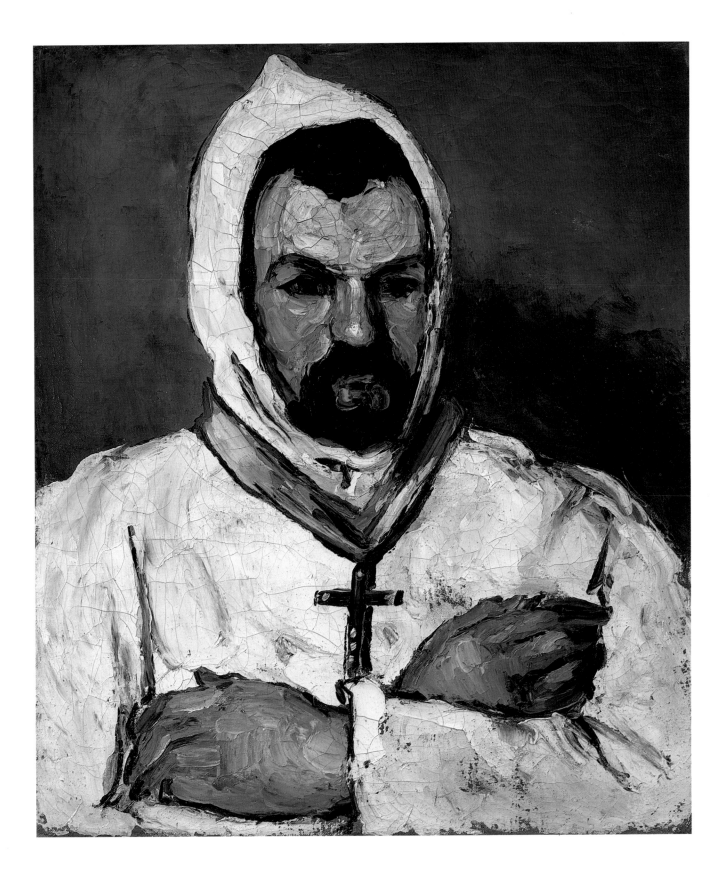

none reaches the density of application of this picture or—particularly through the gesture of the crossed arms—its massive intensity. Part of this may be due to the state of preservation of the present picture, in which the height of the impasto has survived to a remarkable degree.

To what extent this painting is, in any conventional way, a portrait has long been a matter of discussion. Certainly, given the critical role of the picture in the stylistic evolution of Cézanne's work, much more discussion has been devoted to it as a painting than to its subject. Yet the ferocious presence of the figure brings one back to some attempt to characterize him as a man, a speculation thwarted by the absence of any real information about him. It has often been said that his patience, particularly to the point of posing in various guises, must have been great and his nature pliant. However, it is only here that he is cast in an assumed role, that of a Dominican monk. Whether the white habit was put on simply to accommodate his nephew's desire to paint large areas of white or had some further meaning is also unclear.

It has been noted that during the generation of Cézanne's father, a staunch republican who, like his son, scorned the politics of the Second Empire, the masterful orator and essayist Jean-Baptiste-Henri Lacordaire (1802–1861) was one of the dominant forces in French liberal politics.[7] Through his sermons at Notre Dame, Paris, and his editorship of the newspaper *L'Avenir*, Lacordaire advocated programs of radical social reform through a revival of moral principles. In 1838, while in Rome, he reestablished the Dominican order —the "watchdogs of Christ"—and brought the order back with him in 1840 to France, where he met with only limited success, although he ever afterward called himself a monk.[8] By the mid-1860s an association with Lacordaire carried with it an almost nostalgic identification with lost causes; certainly, the expressive determination and staunchness of Uncle Dominique as portrayed here are in keeping with the character of the historical Dominican. However, we know too little about Dominique Aubert's religious convictions—or those of the young Cézanne, who was to take on the piety of his mother and sister Rose later in life but who, at this point, was probably more affected by his father's agnosticism—to draw a firm conclu-

sion. It must also be realized that the white habit may simply be a verbal pun—Dominique/Dominican—an association Cézanne used on other occasions.[9] Yet, even in comparison with all the other portraits of Dominique Aubert, there is in this picture—in the characterization as well as in the costume—a particular force of physical presence that tempts one to extend some type of interpretation beyond the immediate identity of the man, especially in view of the degree to which narrative and literary associations figured in Cézanne's work during the remainder of the decade.

Whatever its meaning—should there be any—the *Portrait of Uncle Dominique as a Monk* would continue to provide Cézanne with a kind of figurative resource well after he had abandoned direct palette-knife painting. By the following year, the palette knife would play less and less of a part in his technique, as would an interest in coarse, heavy, worked impasto and a palpable weight of paint. However, the density of surface achieved so swiftly in the autumn of 1866 would continue, albeit with progressively slower and more blended application, through the 1870s. The unity he achieved here between the physical surface and the control of spatial realization would sustain him throughout his life. And the pose itself, a stolid male figure with his arms resolutely folded over his chest, would recur repeatedly, particularly in the 1890s (see fig. 116).

As Guillemet had noted to Oller, their gods were Courbet and Manet, the figures they had set out to challenge. At this critical point in his art, it would almost seem that Cézanne was addressing his debt to both in equal measure, while at the same time introducing a kind of innovation from which he, and much of the course of later art, would never turn back. The Courbet influence is most apparent: swift use of the palette knife to apply brilliantly contrasted black and white, interlaced with flashes of intense color. However, Courbet's surfaces, even in his most broadly applied palette-knife pictures, never build to this degree of density, nor did he ever abandon chiaroscuro to the extent Cézanne had here. For Courbet, the contrast of sharply juxtaposed lights and darks was always to a spatial end, hence the dramatic virility and force of his paintings in this manner. Cézanne's blacks—even those that edge Dominique's hands and cuffs— are in plane with the whites and blues and are not passively sub-

merged into shadows, as had been the practice to this point in the history of art. The figure is, in the intensity of its creation, literally wrought into space by the density of the paint application; "Cézanne was intensifying Courbet's least acceptable peculiarity, making it obtrusive, systematic and obsessional."[10]

The debt to Manet is less obvious, yet the very notion of posing a friend in costume may have derived from Manet, as in such pictures as the *Bon Bock* (fig. 117), in which the figure is cast in a nearly theatrical role. And, perhaps more profoundly in comparison with the same picture, Cézanne's interest in a completely controlled tonal harmony through an animation of applied brushstrokes may owe much to Manet, as radically different in temperament as the two artists were and as contrasting as their two achievements may be.

The early works such as the *Portrait of Uncle Dominique as a Monk* were, ironically, among the last to be seriously appreciated. In their seemingly obsessive vigor of creation and implicit violence, they have often been placed into a vague category of Cézanne-before-he-becomes-Cézanne—that is, before the calming influence of Camille Pissarro (1831–1903) at Pontoise in the early 1870s and Cézanne's evolution into a more studied, analytical painter. (Yet it was Pissarro who first recognized the innovative genius of the young painter and saw the accomplishment in the pictures of the later 1860s.) At best, it was only recently that works such as this have been understood both for their intrinsic worth, as products of a fully mature and launched artist, and for their place in his later development. This rather abrupt development in his career has, in turn, done much to misguide our understanding of the often implicitly narrative aspects, as

well as the more impassioned, less cerebral elements, of his later art, which more formal interpretations have often set aside. The confusion about early Cézanne, which continued into this century, is illustrated by the history of the *Portrait of Uncle Dominique as a Monk*. It was bought by the Frick Collection in 1940 and perceptively discussed in a news release prepared by the collection.[11] Noted in a 1947 handbook of the collection, it was contrasted with the later *Chestnut Trees at Jas de Bouffan* (The Minneapolis Institute of Arts), as a work that "might be by a different hand" and that "recalls the romantic period of Cézanne's youth"[12] (Cézanne was twenty-seven years old at the time he painted it)—only to be sold in 1949.[13]

For all the swiftness of execution and barely disguised passion of this painting, it also has a formal resolution and control, the surface vitality completely in balance with the spatial effect, and stands completely on a par with the achievements of the following four decades. Furthermore, the picture seems to have pleased the sitter (one hopes out of more than pure sentiment), who kept this one throughout his lifetime, Hugo Perls buying it from his estate outside Aix. As late as 1903, with the death sale of Emile Zola, at which several pictures of this period were sold, the admittedly highly reactionary critic Henri Rochefort, in an article on the "love of Ugliness," could declare such pictures mere 'daubs,' an affront to the traditions of Rembrandt, Velázquez, Rubens, and Goya.[14] Ironically, such sarcasm can be credited with some insight if turned into the positive: the *Portrait of Uncle Dominique as a Monk* now rests comfortably within the grand artistic lineage as outlined by Rochefort.

JJR

73

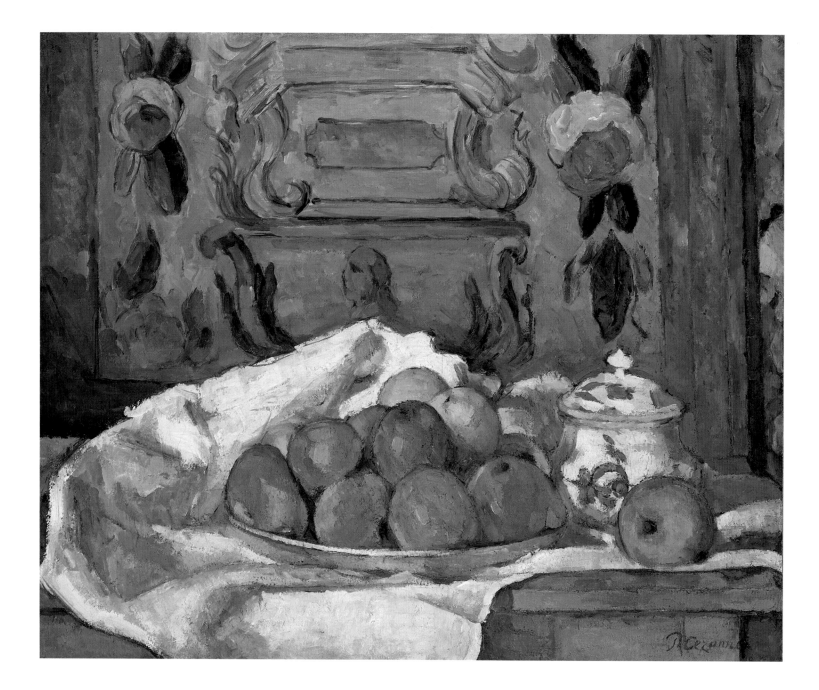

PAUL CÉZANNE

FRENCH, 1839–1906
DISH OF APPLES, 1875–80
OIL ON CANVAS, 18⅛ X 21¾ INCHES

By THE EARLY 1870s, Cézanne had assimilated many of the spatial concerns and techniques of the Impressionists, with whom he would show in their first exhibition in 1874. Under the influence of Camille Pissarro (1831–1903), whom he joined in Pontoise in 1872, the impassioned and swiftly worked surfaces of his earlier pictures subsided (see *Portrait of Uncle Dominique as a Monk,* p. 71) for the calmer, more analytical methods that he would apply throughout the rest of his life. At no point, however, did he completely adopt the concerns of Pissarro, Monet, Renoir, or Armand Guillaumin (1841–1927). Transient natural effects and the textures of objects in light were for him too insubstantial to be proper subjects of art. His goal was the "making out of impressionism something solid and durable like the art of museums."[1] This desire to establish something permanent is nowhere more apparent than in the series of still lifes he painted during the second half of the 1870s. *Dish of Apples* is one of his most complex and monumental resolutions to this end.

A plate filled with apples sits just at the edge of a heavy wooden bureau with an overhanging top. To the right is a brightly decorated porcelain sugar bowl and a lone green apple. These objects are placed on a white linen cloth, its density evidenced by the stiffness with which it mounds up behind the apples. A gaily ornamented object hangs on the wall behind the bureau. To the right appears the banded edge of what appears to be a tapestry. The only perspectival elements are the overhanging top of the bureau and a small wedge of wooden surface behind the cloth at the right. The monumental effect of objects rendered in space depends almost entirely on the massive weight of the modeled apples, the forceful curve of the plate, the turned sugar bowl, and the modeling of the napkin, in which conventional chiaroscuro plays a very limited role, the absence of black being marked. All who have written about this still life have commented on its profound gravity and weightiness, that "solemn quality of truth" mentioned by Georges Rivière.[2]

The objects in the foreground are rendered with a dense application of lean paint to create a surface like richly embossed leather. The napkin, which in profile so disconcertingly recalls that of Mont Sainte-Victoire, is more fluidly handled, although still with a build-up of numerous layers. In contrast to the deliberate and angular constructivist strokes of the foreground elements, the background is more lightly rendered, with a thinness of paint that allows for quick ornamental touches. These same, looser and more broadly scaled strokes continue on both sides in the blue field, the whole background taking on an animated flatness that pushes the grandly modeled foreground elements even more forcedly into space.

The complexity of color applied is at one with the spatial manipulation. The light falling on the foreground elements brings the colors to their full brilliance. Each element of the palette recurs in the background, albeit in more subdued tones: moss green, light blue, and ocher only lightly interlocked with the sharper yellows, reds, and oranges that are given fuller play in the foreground. The picture is a tonal harmonization of much greater range and complexity than the initial impression of solidity suggests. This very complexity—in terms of composition, textural variety of paint handling, and diversity of palette—makes the picture difficult to place in the artist's notoriously elusive chronology.

The blue decorative object, with curving architectural ornaments and a portrait medallion flanked by leaves and flowers, was often described in the literature as some type of tapestry or cloth hanging. However, in 1960, Robert Ratcliffe identified the object as the lower part of one section of a large, six-panel, double-sided decorative screen (fig. 118)[3] that is perhaps Cézanne's earliest recorded painting. The artist, late in his life, noted he had painted the screen in 1859–60 for his father's workroom, reportedly assisted by Emile Zola, carrying out the project in a moment of very high spirits.[4] On the large screen he and Zola painted a somewhat comic Arcadian scene in the manner of Lancret. It remained intact long after Cézanne's death; however, only the Arcadian scene, now mounted flat, seems to have survived.[5] He often quoted the screen in the background of his still lifes; sometimes as here in the form of a flat, isolated detail, and sometimes folded. Given its scale and the presence here of the lowest band of ornament, he must have dismantled it and hung it on the wall so that its bottom would just clear the Louis XVI commode before it. The sugar bowl, another recurring prop in the small repertory of objects Cézanne would use in Aix over a long time period, appears to be used for the first time here.

All of these facts securely place the picture in Aix, where Cézanne spent much of 1876 and all of 1878. But exactly when was it painted? The loose and varied handling of the background is in contrast to the almost tensely labored quality of his still lifes of the mid-1870s, when his working of surfaces was most analytical, with clearly directional strokes and an almost mathematical network of cross-hatched field color. The absolute closing of the foreground with little escape into space fits well within this time period. Yet the considerable range of handling here makes a date in the mid-1870s seem inappropriate; perhaps it should be placed later in the decade.[6]

Often overlooked in discussions of Cézanne's work is the range of his expressive temperament. In *Dish of Apples,* a quality of formal resolution—the grandeur of the foreground elements foretelling the still lifes of much greater scale that would follow in the 1880s—is balanced by the gaily painted sugar pot and the rococo screen. In an eighteenth-century reference the screen is treated with a curvaceous levity, introducing a counterclassical baroque dimension. It was a moment, with the introduction of one of the most relaxed productions of his early youth, in which he could, with tremendous mastery and considerable expressive range, combine gaiety with solemnity, analytical definition with decorative painting, and monumental resolution with beautifully maintained, flat, stage-set description.

JJR

PAUL CÉZANNE

FRENCH, 1839–1906
THE BATHERS, c. 1888
WATERCOLOR AND PENCIL ON PAPER,
4⅞ X 7⅞ INCHES

SIX NUDE FIGURES lounge along the bank of a river. Three—the two actually in the water and the man about to dive from the opposite shore—seem to be observed with great candor. The others are more formally posed, their postures and gestures recalling the drawings after studio models, old master drawings, and sculpture in the Musée du Louvre that filled Cézanne's sketchbooks. The relief-like space aligns the figures into a shallow frieze, which is subtly modulated, first by a series of soft pencil lines that defines all the elements and then is reinforced by intense blue watercolor lines laid on with the same sensuous vitality as the pencil sketch. Broad slashes of blue, extended to thinned washes in the water and the sky, are interspersed with quick strokes of yellow and green in the foliage. It is an image of wonderful spontaneity and freshness, an evocation of a pastoral Arcadia, which recalls the summer outings that Cézanne took with his boyhood friends Emile Zola and Baptistin Baille into the countryside around Aix. And yet for all its immediacy, it is a composition that bears a complex relationship to other small works that repeat, always with variations, elements appearing here, and stands—with some two hundred other works by Cézanne on the subject of bathing nudes—as one of the most enigmatic themes of his career.

This watercolor almost certainly was detached from one of the sketchbooks that Cézanne carried with him to record observations about the objective world, in which he also developed his thoughts on the bather subjects, a theme that he well understood was one of the most elevated in the history of French painting and that throughout his career he would transform and bring honorably into the twentieth century. A sheet in pencil and watercolor of similar dimensions (fig. 119) has the same figurative elements, albeit rearranged somewhat within the composition, and at least three oil paintings contain similar figures (see figs. 120, 121).[1] Neither watercolor seems, however, to be a study, in the conventional sense, for any of the paintings. When viewed within the larger context of other variations on the theme, clearly each work—as interdependent as each may be in adapting elements from one to the other—retains complete independence, and it is impossible either to trace precisely a development in them as a group or to establish a priority of borrowing within them.

The meaning of these figures and the bather subjects in general has prompted much speculation within Cézanne scholarship. Unlike his landscapes, still lifes, and studies of posed (and clothed) models after the late 1870s, which depend absolutely on the artist's analytical interpretation of the motif before him, they retain a quality of purely imaginative invention that marked many of the sensuously romantic works of the beginning of his career. The evolution within this theme—the easing of narrative implication and its dependency on his own self-knowledge of the creation of the "art of museums" that he desired[2]—is far from clear. But as one begins to understand better the absence of any clear break (or rather the subliminal continuation of much of the expressive energy from the early work throughout his entire career), the expressive pleasure to be found—along with the enchanting skill with which he treated his subject in watercolors such as this—becomes more accessible.

Perhaps it was this sensuality, as well as the formal rigor of his creation, that attracted Renoir, who owned this watercolor. The work was inherited by his son Jean, who lent it to an exhibition in Berlin in 1927. Cézanne and Renoir were on cordial terms from their first meeting in 1863, and they worked together in the South of France in 1882. Near the end of his life, Renoir, in conversation with the dealer Ambroise Vollard, related how he acquired this watercolor: he was working near l'Estaque (where he visited in 1882 and again in 1888) when, by chance, he found the watercolor stuck behind a rock, noting that Cézanne had labored over it in at least twenty sessions.[3] The myth of Cézanne as the furious titan emerged from tales such as this and from other anecdotes about the rages the artist would fall into over his own works, destroying or abandoning them in the countryside—and a useful myth it was well into this century, when Cézanne's style continued to perplex so many. The watercolor itself, however, is in pristine condition and shows no ill effects of abandonment in the countryside; nor in the spontaneity of execution does it appear to be the product of long labor. It seems more likely that Renoir acquired the watercolor through conventional channels. We do know that at the first showing of Cézanne at Vollard's in 1895, Renoir and Degas vied over another watercolor (Degas won).[4] The tale Renoir told to Vollard has often confused the dating of this piece, which has sometimes been associated with Renoir's 1882 visit to the South.[5] However, it compares in handling to works from the later part of the 1880s or early 1890s, and Renoir's tale was, indeed, an innocent jest.

JJR

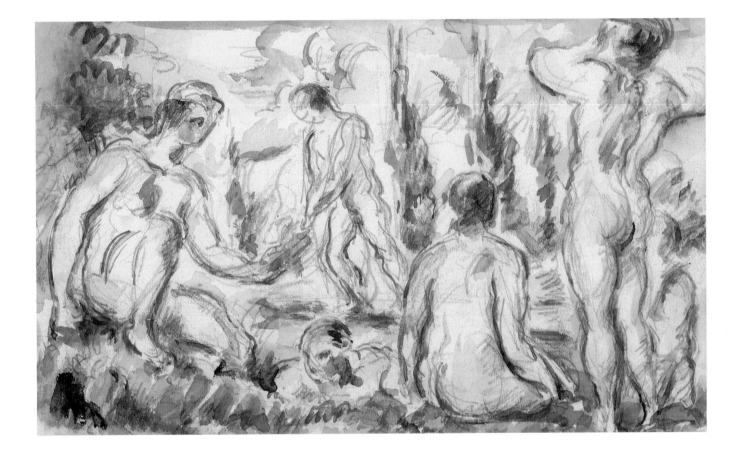

Paul Cézanne

FRENCH, 1839–1906

The House with the Cracked Walls,
1892–94

OIL ON CANVAS, 31½ x 23¾ INCHES

Few other landscape images in Cézanne's career solicit such emotional response as *The House with the Cracked Walls*.[1] An ocher-walled farmhouse sits at the top of a steep, rocky hill; a huge shelf of rock emerges on the right, while at the left, the earth seems terraced and is covered with only sporadic vegetation. The house itself has a sharply extended eave on one side, a profile similar to others in Cézanne's landscapes, such as the Maison Maria on the forested road to the Château Noir (fig. 122), with the same slightly askew, off-center single window. The site seems abandoned and the building disintegrating, with tiles falling from the roof (two have fallen against the rocks and one on the roof of the small structure on the right), while the shutters and window mullions have long since been salvaged or simply rotted away, leaving a dark, skull-like aperture. The large fissure that rends the upper part of the house and continues below into the attached, projecting outbuilding declares a slow but persistent collapse of the entire structure. It is indeed a haunting image, made even more so by the exposure of the locale, the bleaching light on the facade and the rock, and above all, the completely airless quality created by the unrelieved density of the confining ink-blue sky. It is, as Meyer Schapiro suggests, "a hermit's vision of heat, solitude and ruin in nature—a space for the Saint Anthony of Cézanne's youthful imagination,"[2] a place without life, abandoned and deeply forlorn. Theodore Reff has even suggested that Cézanne may have intended this as a narrative; he may well have known Edgar Allan Poe's short story "The Fall of the House of Usher" and illustrated "that once barely-discernible fissure...extending from the roof of the building, in a zigzag direction, to the base...rapidly widened...and the mighty walls came rushing asunder."[3]

Precedents for such romantic morbidity can be found in Cézanne's early, tormented subject pictures of violence and death, and, most specifically, in the *House of the Hanged Man, Auvers-sur-Oise* (fig. 123), which Cézanne showed in the First Impressionist Exhibition of 1874, and again, having made the selection himself, in the Exposition Universelle of 1899–1900.[4] That picture shows the house of a suicide in the village of Auvers-sur-Oise, which had about it a local legend of despair and the macabre, and the house itself has long sustained the implicative association given by the title, although the visual escape into the spring-green fields beyond lightens the drama. It seems somewhat unlikely that, just when Cézanne was joining with the Impressionists and abandoning the darker aspects of his earlier work, both in technique and subject, the Auvers structure would be meant to sustain the weighted theater that seems so much more completely realized here.[5]

Cézanne was often drawn to isolated and uninhabited sites, perhaps as much by his desire to work in complete privacy as by the attraction of such places in themselves. During the 1890s, he sought out such sites to the east of Aix, toward the foothills of Mont Sainte-Victoire, rather than the more populated regions where he had gone more regularly before. The road to Le Tholonet, passing through a sparsely wooded, rocky landscape, had particular appeal and just off it was the abandoned quarry of Bibémus, where he kept a small hut for his equipment within the high red walls of the artificial canyon. He was attracted to the seldom-used house, Château Noir, just above this road, belonging to an absentee chemical engineer. Despite its local name, its walls were actually stained a deep red, not unlike the color of the boulders in the quarry at Bibémus. It was a sinister place with half-finished structures and pointed gothic windows that held great appeal for Cézanne, who attempted to buy it, unsuccessfully, although he continued to paint there throughout the 1890s.[6] It is tempting to draw parallels between the Château Noir (fig. 124), with its enclosed and mysteriously distanced quality and local notoriety (it was sometimes called the Maison du Diable) and the present picture; however, a better comparison in the sense of evocative landscape motifs to which he may have been drawn would be the abandoned mill just below the Château Noir, whose blocks were slowly being reconsumed into the natural setting through the unhusbanded undergrowth (fig. 125).

Unlike these sites, which may well have been quite near the cracked house and which recur in paintings and watercolors throughout Cézanne's later years, the cracked house is a unique image. It is a work of remarkable absence of atmosphere and perspectival calculation. Except for the wedge of shadow under the eaves and the view through the top of the window into the pitch-black interior, no perspectival devices were used. The trapezoidal silhouettes of the house and its two appendages are in a subtle repetition with the flattened outline of the right-angled projection of the rocks. The trees stand in complete profile, and the white shelf of rock on the right, despite the tremendously controlled suggestion of recession through the coloristic modulation of its surface, is only one step away from a complete identification with the picture plane, nearly exactly like the large repoussoir that fills the similarly claustrophobic and dense view of the Bibémus quarry, *The Red Rock* (fig. 126). All surfaces are handled with equal deliberation, both in terms of density of paint and degree of painterly animation within any given passage: the directional strokes of the terraced bank are paralleled in equal alignment to the side of the house, the leaves, or the sky itself. The drawing of the tree trunks aligns in a nonspatial manner, the left limb of the double-branched tree, third from the left, overlaying exactly the trunk of the tree behind it, while the etched line that describes the edge of the large white rocks does as much to hold its projection to the picture's surface as to create the crevice into which the house sinks. The most dramatic passage of the painting—the frayed outline of the cracks themselves—is the one element that departs from the measured application of all other areas.

JJR

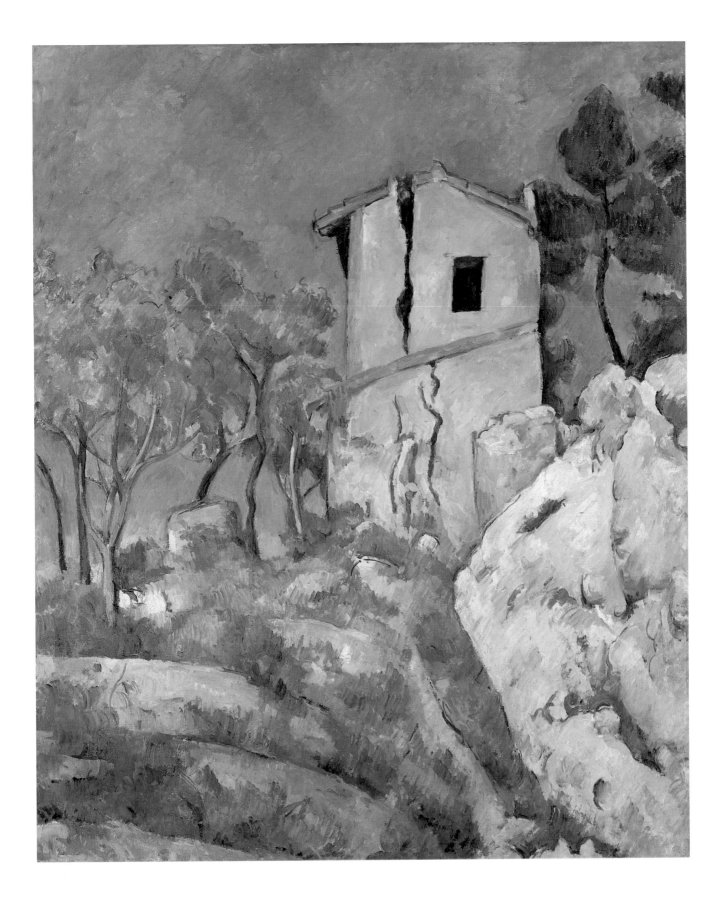

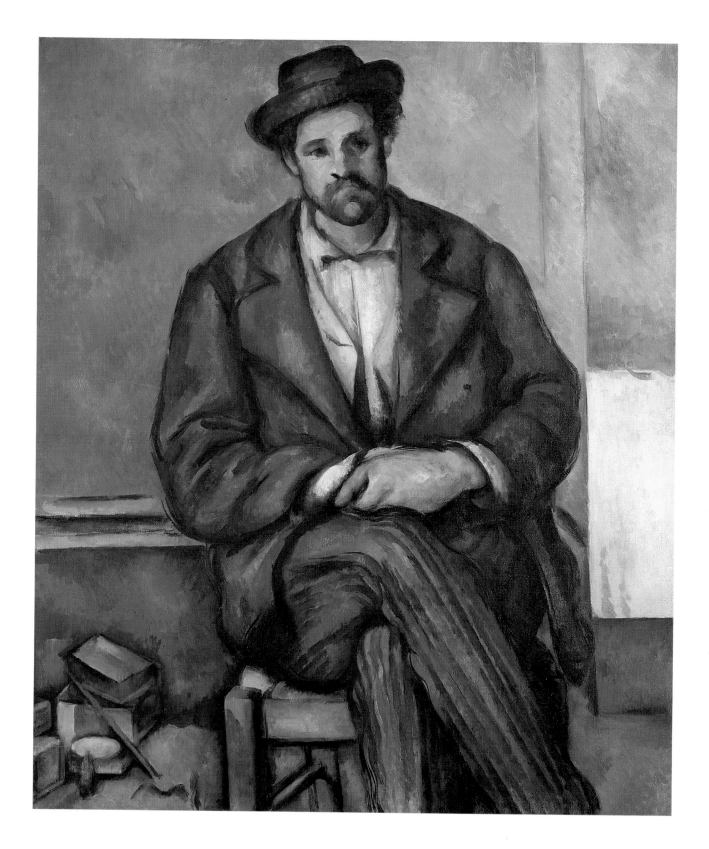

Paul Cézanne

FRENCH, 1839–1906
Seated Peasant, 1895–1900
OIL ON CANVAS, 21½ X 17¾ INCHES

As EARLY AS 1923, Georges Rivière related the sitter for *Seated Peasant* to those men who posed for the series of cardplayers painted by Cézanne beginning about 1890 (see fig. 127). Although this rather melancholy young man who sits stolidly on a simple cane chair cannot be identified as one of the models in any of the five versions of cardplayers,[1] he almost certainly was, like them, one of the farm hands who worked at Cézanne's mother's house, the Jas de Bouffan, near Aix, and to whom Cézanne turned through the 1890s for his figure studies. Some of these figures recur in several paintings and watercolors;[2] others, like this man, appear only once. Most of them are posed in a simple, plastered room, probably in the château itself, the only ornament being an applied wooden chair rail.

This is a remarkably hermetic picture, smaller than any other of his male studies of this decade and, perhaps because of this, more concentrated and refined in handling. A highly restricted palette of grays, blues, browns, gray greens, and pale yellows is only occasionally relieved with touches of red and purple. The build-up of a lean application is remarkably harmonious and studied. Wetter, attenuated strokes, such as the purple strip on the right knee or the two drips of terre-verte on the whitewashed wall at lower right, seem almost gaily spontaneous in the otherwise stern development of the picture.

For so seemingly simple a composition, the spatial illusion is very complex. The room appears to be L-shaped, the wall, with its continuation of the chair rail, projecting into the space to the right of the figure and then turning parallel to the plane of the back wall, banded with a panel of whitewash that is not aligned with the chair rail. The perspective of the chair is directly frontal, receding symmetrically to one vanishing point for both sides of the caned seat and the one rail visible between the man's legs. However, the small perspectival wedge on the right is so surrounded by the ample thigh, the fall of the coattail (which almost but not quite comes into contact with the chair), and the triangle of wall seen beyond the chair that its spatial implications are quite different from those of the more simply constructed section to the left—although this area, too, is made more complicated by the inexplicable white form that appears under the sitter's projecting hip, where the wooden rail must be attached to the caning.

The spatial animation of the picture is heightened by the introduction on the lower left of an intricate still life. A group of geometrical objects—two green-bound books, two small boxes, a white square object with a round top, possibly a small bottle, and a stick—seem to be carefully placed on a heavy cloth, raised (by a crate?) above floor level. Cézanne often introduced still-life elements into his male figure studies—the book-strewn library in which he painted the critic Gustave Geffroy in 1895 (fig. 128) being perhaps his most complex perspectival exercise—although never do they play such an independent role as here, as if their introduction were meant almost as some type of spatial subplot. This is truly a case of a figure taking on the aspect of one more still-life element in the composition, very much the "apple" that Cézanne requested Ambroise Vollard to become when he sat for his portrait in 1899.[3] Not only is the painting daunting in a formal sense, but there also remains, as in many of Cézanne's figure studies and portraits of the 1890s, a vaguely disturbing irresoluteness in its final psychological expression.

Many of the farm hands who posed for Cézanne at the Jas de Bouffan were older men with whom he felt great sympathy and perhaps a degree of identity, admiring their "simplicity and natural dignity."[4] They, like him, had stayed in their native region, rejecting the modern ways of the North.[5] After 1902 these sentiments would culminate in a series of studies of his aged gardener, Vallier, at the studio at Les Lauves, two of which are posed quite similarly to the figure here. However, the *Seated Peasant*, for all his forbearance, seems lacking, to a degree, in this kind of vivid presence. He is dressed in a jacket and yellow vest (very much like the clothes Cézanne must have worn, as documented by a photograph of the artist taken by K.-X. Roussel in 1906),[6] and with a tightly knotted string tie (also like that described as having been worn by Cézanne).[7] Sullenly he poses for the artist in his slightly oversized coat, his striped trousers loosely fitting his rather stout form. His mouth is drawn down into a habitually natural line, one assumes; his exaggeratedly huge, literally ham-fisted hand comes, because of its disproportionate scale, well out from his chest. His complete frontality—shoulders in an even balance with the folded hands and crossed legs—places him even more monumentally in the space. Here is some type of blunt life force, firmly and irrefutably planted in bovine melancholy.

With the exception of identifiable portraits, none of Cézanne's male figure studies of the 1890s, including the cardplayers, can be clearly dated, although this picture has always been placed within the second half of the decade.[8] A "Portrait of a seated man with crossed legs, folded hands, gray background" appears in Vollard's stock books by 1900,[9] although there is no certainty that this is the same picture. By comparison with other works on this scale, *Seated Peasant* stands well apart from the *Standing Peasant* (fig. 129), which can be stylistically related quite closely to the cardplayers, and the studies for them from the early years of the decade. In turn, in his painting of a figure of a peasant now in Ottawa (fig. 130)—although somewhat larger—with the legs similarly terminated at the ankles, Cézanne pulled the whole figure more tightly to the picture plane. Somewhat less confined and hermetic in its handling and spatial definition, the Ottawa picture of the peasant, justly placed after the turn of the century, contrasts strikingly in his cunning and alert animation to the figure here. A closer comparison can be drawn to the *Man with Folded Arms*, which appears in two variants (see fig. 116),[10] although there is an elegance to the lean model who posed for them that is quite distinct from the Annenberg painting. As always in comparing images within any given category of Cézanne's work, one returns to the idea that it is his direct response to the subject—in this case the stolid and beefy young peasant—that dictated the form his picture would take.

JJR

81

Paul Cézanne

FRENCH, 1839–1906

STILL LIFE WITH WATERMELON AND POMEGRANATES,
1900–1906

WATERCOLOR AND PENCIL ON PAPER, 12 X 18½
INCHES

Even in comparison with the other large watercolors done by Cézanne near the end of his life, this work stands as a particularly audacious achievement. Five rounded objects—a melon, two pomegranates, a glass water carafe, and the same white sugar bowl that appears in *Dish of Apples* (p. 74)—completely fill a tabletop. The forms are first established by a light network of drawn pencil lines over which Cézanne flooded abundant panels of transparent color, which, playing off the exposed white of the paper, gives these modest objects a monumentality that is equal in spatial effect to that of his oil still lifes and exceeds them in coloristic brilliance. Rarely does the artist respond so directly to the reflective interrelationships of objects, the yellow pomegranate mirrored in the sheen of the melon, the green and lavender light flashing from the cut flutes on the carafe, the objects laid into a luminous shadow reflected from the polished table surface.

Emile Bernard recorded a set of observations made to him by Cézanne, whom he visited in Aix in 1904. One statement seems particularly apt in terms of this watercolor: "Drawing and color are not separate at all; insofar as you paint, you draw. The more the color harmonizes, the more exact the drawing becomes. When the color achieves richness, the form attains its fullness. The contrast and connections of tone—there you have the secret of drawing and modeling."[1]

Geometry plays little role in Cézanne's spatial creation. Even the table edge, begun on the left as an exposed sliver of white paper, is transformed by a streak of purple wash, disappearing altogether to the right. The wall beyond—perhaps with an opening to the left into another room—falls as a curtain of color dynamically progressing from cool to warm, right to left. The inexplicable white form just at the left edge—a partially seen porcelain object[2] or the outline of a chair back—sets the plane by its open silhouette.

Some of the abundant richness of this watercolor comes directly from the artist's response to the objects themselves. He used them, with the introduction of a wine bottle, in another watercolor of equal liberality, although more linearly analytical (fig. 131). The presence of the cut melon in another work (fig. 132) dispels the previous confusion of this simple, rounded form with an eggplant.[3] As John Rewald has noted,[4] the almost formidable monumentality of Cézanne's work put off at least one early critic and, indeed, in works such as this—as with the late Mont Sainte-Victoire and bather subjects—Cézanne exceeded his own earlier powers to bring creation into balance with observation and the handling of his materials into accord with spatial definition. The colors and their relationship to the objects in space are brought here to a peak of harmonic intensity. Humble observations, such as the four thumbtack marks still clearly visible from when Cézanne pinned the sheet of heavy, woven paper to his board, bring one soberly back to the simplicity of his materials and the grandeur of his creation.

JJR

PAUL CÉZANNE

FRENCH, 1839–1906
MONT SAINTE-VICTOIRE, 1904
WATERCOLOR ON PAPER, 12⅝ X 9¾ INCHES

THIS WATERCOLOR showing Mont Sainte-Victoire through a proscenium of arching trees first appeared in Cézanne literature in 1953;[1] its attribution was confirmed by François Daulte the following year.[2]

The sheet bears an inscription on the reverse in a bold hand, later reinforced by darker ink: "Année 1904/de Paul Cézanne/Emile Bernard." Beneath this in finer script appears: "Mars 1936/Cette acquarelle de Paul Cézanne a appartenu à la collection de mon père le peintre Emile Bernard/Michel-Ange Bernard" (March 1936/This watercolor by Paul Cézanne belonged to the collection of my father the painter Emile Bernard/Michel-Ange Bernard).

Emile Bernard had, on his return from Egypt, visited Cézanne in Aix in 1904, striking up a friendship that provided, through Bernard's later recording of their conversations,[3] rare insights into the attitudes and working methods of the reclusive Cézanne late in his life. Bernard documented the visit by painting a portrait of Cézanne; he also copied a still life by the older artist.[4] Cézanne allowed him to stay on the lower floor of his studio just outside Aix at Les Lauves, the very building—the one in the middle ground here—that commanded such a magisterial view of the mountain, which became the dominant motif for Cézanne in his late landscapes. Despite the wary and sometimes suspicious temperament of the isolated artist, Bernard's visit seems to have been mutually pleasurable for both men; their correspondence continued over the next two years.

The encounter for Bernard was profound. As he noted in a letter to his wife: "After looking at the situation in retrospect, I think that I can be considered as his spiritual son and, as such, truly respectful of my old master, because, as you know, I always wrote, fought, and spoke in order to justify and defend the old and forgotten Impressionist and to praise his glory even though I had nothing to gain from these actions (since I possess only a watercolor of his, of the Mont Sainte-Victoire, seen from his studio, which he offered me as thanks for having done his portrait during our visit of 1904)."[5]

85

Paul Cézanne

FRENCH, 1839–1906
MONT SAINTE-VICTOIRE, 1902–6
OIL ON CANVAS, 22¼ X 38⅛ INCHES

Upon the death of his mother in 1899, Cézanne was forced to sell the Jas de Bouffan, the large property outside Aix, in order to settle her estate and divide the proceeds with his two sisters. The loss of this house, where he had lived and worked since childhood, must have been a grave blow for a man so completely settled in his ways and patterns of working.[1] He moved to an apartment in the center of the city, but it was not long before he bought a site just north of Aix and there built a studio that he started to use in the fall of 1902. It was placed on the slope of the hill called Les Lauves, which commanded a grand and encompassing view of Aix to the south and, to the east, the vast, sweeping plain with quilted fields, farmhouses, and clumps of trees that terminate in the majestic profile of Mont Sainte-Victoire.

This great marble pile, rising dramatically from the valley in the intense southern light, had long been a symbol of Provence.[2] Cézanne recorded it with loving attention from the 1870s on; there are some fifty-five images of it among his paintings and watercolors, making it one of his most repeated and varied themes.[3] In many of the earlier views, such as those taken from Bellevue, the mountain forms a blunted cone; later he drew closer to its base, working at the Château Noir or Bibémus quarry. When seen from the village of Gardanne, the profile stretches to become a craggy plateau. From the heights of Les Lauves the mountain presents its most dramatic profile: the slowly rising contours from the north (the left in the pictures) crest in a stupendous peak of rock, then fall steeply away,

the land lifting toward the south into the broad slopes of Mont du Cengle.[4]

Cézanne painted this view at least fourteen times after his move to Les Lauves in 1902, as well as addressing it in numerous watercolors. None of these objects is a repetition of another; each comes at the motif from a different point of view, focusing on individual elements in the near, middle, and far grounds. Many seem to be in direct response to the changing light and atmosphere that sweep over the broad plain. Cézanne's response to transient climatic effects in these paintings is utterly different from the Impressionist response to temporal effects, yet the ranges of mood and temperament within these pictures clearly suggest specific awareness of changes of light and atmosphere. Cumulatively his pictures of Mont Sainte-Victoire embody, perhaps more than any other set of images, his last titanic struggle to weld nature into art through his profoundly complex workings of color. They have often been discussed in the grandest terms, Lionello Venturi finding the late paintings of Mont Sainte-Victoire a transformation by the artist into a nearly "cosmic" realm of creation: "The structure is more and more implied, and less and less apparent."[5] We can grasp dimly, albeit through the heated literary style of Joachim Gasquet, who pretends to recall his conversations with Cézanne much after his death, what the mountain meant for Cézanne: "Look at Ste.-Victoire. What *élan*, what an imperious thirst for the sun, and what melancholy, in the evening, when all this weightiness falls back to earth….These masses were made of fire. Fire is in them still. Both darkness and daylight seem to recoil from them in fear, trembling. There above us is Plato's cave: see how, as large clouds pass by, the shadow that they cast shudders on the rocks, as if burned, suddenly swallowed by a mouth of fire."[6]

As grandiose and naively pretentious as Gasquet may have been, the urgent sense of drama he brought to the theme in response to the painting has affected nearly all those who have written about these pictures since.

86

The present view is from a point near the studio. As John Rewald has noted, "To reach it, he turned left from the main road into a lane called Chemin des Marguerites, to the right of which lies a field that yields this view of the immense valley dominated by Sainte-Victoire."[7] Rewald photographed this site about 1935 (fig. 133), before the urban spread from the city engulfed it forever. The small, wedgelike farmhouse to the far right was still standing; the more extended set of buildings, still in place, dominated the forward layer of the middle ground. Cézanne did three pictures of this general vista: two watercolors and the present painting. One watercolor (fig. 134),[8] nearly square, is taken from essentially the same elevation as the painting in its left half, the cluster of farm buildings again in line with the crest of the mountain, although the north slope humps up more gently and the transition across the plain to its base is more fluidly crossed by diagonals in and through the clumps of trees. One pistachio tree flames up in the foreground, its spreading limbs establishing the lyrical movement that continues throughout the picture. In another sheet (fig. 135),[9] he drew closer to the buildings, lower and more to the right, with the mountains placed farther to the left. In executing this version, Cézanne progressed through two distinct experimental phases; at some point in its evolution he decided to expand the sheet to the right by adding a second piece of paper, which allowed him to show more of the valley, making the broad, horizontal plain of Mont du Cengle, in intense blue and purple, the dominant element. In so doing, he also set the house more absolutely in the middle ground, and further expressed the vaporous, distant presence of Mont Sainte-Victoire itself.

Considered together, these two watercolors are revealing in comparison with the Annenberg picture, which itself underwent a dramatic creative evolution. As evidenced by the photograph of the painting first published by Venturi in 1936 (fig. 136),[10] in which the divisions were more apparent, it is clear that the painting was executed on five different pieces of canvas that, judging by their varying textures and the artist's technique within a given area, were added over a period of time (fig. 137).[11] The dominant image of the mountain is tightly contained within the section to the upper left (measuring 17½ by 25½ inches). To this section two narrow, vertical strips were added at the right (about 2⅛ by 17½ inches each); they extend the view over to the isolated, small farmhouse. Another broad section across the bottom (about 4⅛ by 30⅜ inches) extends to the first of the two vertical strips and allows the artist to expand downward through the yellow, sloping hill. A fifth, vertical section (22¼ by 8 inches) was added to the right, allowing the incorporation

of still more of the broad plain of Mont du Cengle and the valley before it. In a general way Cézanne was paralleling what he had accomplished in the extended watercolor, although in much more deliberate additive phases. Through the creation of a sweeping, horizontal format, he was able to address the grand vista down the valley so aptly recorded in the 1935 photograph. The question is, of course, how he carried out this process, in what sequence, and, finally—in comparison with other views of the mountain—to what formal and expressive ends.

There is little intrinsic physical evidence in the additions to the painting to aid in plotting the state of the image at the time of each addition. Brush strokes continue over all the divisions onto adjoining sections, the artist clearly working overall on the evolving format, in the method recorded by those who witnessed him at work late in his life.[12] However, the largest single section, that of the essential image, is on a standard-size, commercially available canvas.[13] Despite their diversity of scale, all of the late Mont Sainte-Victoires are, with two exceptions, on these prestretched canvases, which were readily available from suppliers of artists' materials.[14] It therefore seems likely that Cézanne, in his early consideration of this painting, conceived of it as a quite restricted view of the mountain, focusing in very tightly in a way not unlike the format of the watercolor now in the National Gallery of Ireland in Dublin (fig. 138). How far he got in the execution before his decision to expand the composition (both downward and to the right) is not clear. Since the lower addition extends to the limits of the original canvas, it seems likely that his first objective was to gain more space in the foreground; this format has parallels in the Zurich watercolor (fig. 134) and, more pointedly, the painting in Moscow (fig. 139). This is, however, speculation: there are great limitations in comparing works from one medium to another within Cézanne's oeuvre, since it is clear that for him drawings, watercolors, and paintings retained considerable independence from one another, with very few direct parallels between them. Perhaps having experimented by extending the two-sheet watercolor, he made the bold decision to shift his composition radically and began the three-stage expansion to the right, each step allowing him to adjust his response to his motif, which has parallels in other works.

Based on what we know of Cézanne's working methods, such a procedure is rare, if not unique. Among the Impressionists, such manipulation of format is evident in the works of Degas before the 1890s, of which there are numerous examples of sections added during the evolution of a work.[15] However, given Cézanne's considerable distance from Degas, both temperamentally and in their quite

opposite artistic intentions, it seems highly unlikely that any parallel can be drawn. Other than the extended watercolor, there seems to be only one other occurrence among the surviving works of physical manipulation of a canvas: a panoramic *View of L'Estaque from the Sea* (fig. 140), nearly a third of which has clearly been added to the right.[16] Equally perplexing is the actual format of the completed picture. On at least three occasions Cézanne took advantage of the long horizontal of his open sketchbook to draw extended vistas (fig. 141);[17] the early painting *The Cutting*, now in Munich, follows a similar format, as does the freely painted view of *Auvers: Le Quartier du Val Harmé* of a decade later.[18] There are also the two very elongated decorative paintings of *Nymphs by the Sea*, although these were done as overdoors for Victor Chocquet and follow a well-established decorative shape from the eighteenth century.[19]

Such comparisons do little to clarify in any essential way the present picture. It, however, if taken in isolation, does provide its own explanation of its development. The mountain is presented with a nearly pristine clarity, its contours elegantly established by strokes of brilliant blue; the western slope, constructed of fine, translucent brushwork over white priming, flashes back the radiant light that falls over the entire landscape. This same light puts the north slope into luminous shadow. The sky behind the peak is evenly painted with modulated strokes of green, blue, and lavender, with patches of white interspersed within it as serenely floating clouds. The valley beneath the mountain proceeds downward in stately layers of green and ocher to the large farmhouse, which, in its clear, geometric articulation, sits firmly within the surrounding fields and trees. However, as the composition extends downward, the paint is laid on with a broader and wetter brush, the color modulations constricting into more tightly knit sets of spatial adjustments. The same is true of the handling to the right of the mountain, the now more upright strokes within the plain increasing in breadth and energy of application. The greens and blues of the sky in the right third of the picture

verge into near abstraction of color harmony as they sweep off the edge of the canvas, much of which is left bare in the vigor of execution. Yet, the small farmhouse, in three-quarter perspective, spatially defines itself within the ocher field to the left and establishes the rhythm of recession in space that extends beyond it, into the southern part of the valley.

The expressive impact is one of immense acceleration from left to right, almost to the point of optically bending the space into a great arch, as the scale of brushwork increases and the color drops in value in response to the dark purple outlines of Mont du Cengle across the panorama. The artistic battle at stake here—perhaps it is not too much of an exaggeration to use such a theatrical term for this picture—is to express the exaltation of the grandly encompassing view and at the same time to maintain a sense of topographical space throughout the long extent of the canvas in its final form. In this, Cézanne, working stroke by stroke on the whole painting as his ambitions for it shifted throughout its physical evolution, wrestled with a formidable artistic problem: the danger of creating a picture in which "color had remained color without becoming the expression of distance."[20] This problem he masterfully solved. Given our knowledge of the canvas additions, we are allowed a unique insight into his visual and mental processes and are awed at the success of his resolution.

Each of the late Mont Sainte-Victoires has a profoundly unique expressive quality. Here, what began as one of his most serene and refined, nearly crystalline, recordings of the motif builds symphonically, with no loss of the initial intent, into a mightier, more majestic image. As he would do in numerous other pictures near the end of his life, although with fewer sequential stages than here, he attained in this landscape the goal he stressed to Emile Bernard in April 1904: his desire to record "the spectacle that the Pater Omnipotens Aeterne Deus spreads out before our eyes."[21]

JJR

PAUL GAUGUIN

FRENCH, 1848–1903
THE SIESTA, 1892–94
OIL ON CANVAS, 34¼ X 45¹¹⁄₁₆ INCHES

THREE WOMEN in missionary dress (even the white-printed blue pareu worn by the foremost figure is made of fabric manufactured in England for the South Seas market) lounge on a porch that extends into a sun-drenched lawn. A fourth, more industrious, figure presses a pile of white and red fabrics with a flatiron at the far end of the porch. Beyond them, in a shadow cast by the porch roof or the house to which it is attached, one woman squats on her haunches, engaged in some endeavor out of our sight, while near her a sixth form, extremely difficult to decipher, could be a woman sprawled comfortably on her side, initiating, perhaps, the picture's title, which does not appear in the early literature.[1] It is a genre scene of domestic ease and desultory activity,[2] with little or no suggestion of the brooding sensuality that so often pervades Gauguin's depictions of Tahitian women; and it is almost completely lacking in the implied narrative so often employed in his multifigure compositions. Everything here is untroubled. As evidenced by a contemporary photograph taken by Gauguin's friend Charles Spitz (fig. 142),[3] Gauguin was depicting a daily occurrence, perhaps indeed at siesta time, given the long shadows and raking light, when Tahitian women gathered in communal ease, disposing themselves with an unaffected grace, which was one of the first things that attracted Gauguin upon his arrival in Papeete in 1891.[4]

Despite its immediacy—John Rewald likens the picture to a snapshot[5]—it is one of Gauguin's most carefully considered and formally developed works and one that draws on numerous visual sources for its spontaneous effect. The grand foreground figure, resting on her hand, recalls in her simply rounded form and contained outline the frescoes of Giotto and the Italian primitives, postcards of which Gauguin carried with him to Tahiti.[6] Even her huge foot, with its earth-green highlights, rests firmly on the pink and lavender planks in an exact outline. The woman just beyond is shown in equally precise profile; it is only with the two other women on the porch that Gauguin's firm compositional control eased somewhat, although the occurrence in another picture of the figure in a pink blouse seated on the edge of the porch[7] suggests the care with which he has noted and adjusted her pose here. The landscape parallels the careful blocking out of the total pictorial space: panels of highlight and shadow in peach, sharp yellow green, orange yellow, and deep green lift away from the spatial perspective of the porch, continuing the interplay of two and three dimensions. The emphatic perspective of the boards of the porch—a rare device in the Tahitian pictures, in which spatial illusion most often depends on color relationships and overlapping forms—prompted Michel Hoog to speculate that for this picture Gauguin turned to specific Japanese prints, particularly a colored engraving of a temple with a sharp prospective (fig. 143).[8] Degas, who often used diagonal linear perspective with great subtlety (fig. 26), seems a more likely source.[9]

The cerebral calculation used in creating this picture may argue for a date of 1894, the year after Gauguin, feeling the hopelessness of his financial situation in Tahiti, and perhaps sensing that he

had overdone his retreat from Western culture, returned to France. His reimmersion into European art, past and present, as well as a certain emotional distance from his Tahitian subject matter, could partially explain the unique position this picture holds within his oeuvre. However, in other documented works from this Parisian interval, when he did continue, both in painting and in prints, to deal with Tahitian subjects, there is a calculated exploitation of his themes—a formal manipulation of them into more decorative and abstract images—that is absent here. In *The Siesta*, for all the control exercised, the final effect is in complete harmony with an immediate sense of place. Therefore, a date just prior to his departure seems more likely. The notion that the picture may have been executed early on his return to the South Seas in 1895 is essentially dispelled by Richard Brettell's observation that this size canvas—a standard size 50 sent from Paris—was frequently used by him in Tahiti during the first stay, but does not recur thereafter.[10]

There is also the possibility that the work, particularly given its great importance within his oeuvre, was carried with him on his return. This speculation is partially supported by the physical evolution of the picture as we know it, since there are numerous evidences of a rethinking of the composition and of the specific elements within it, as well as radical color changes, which are established by close examination of the surface.[11] Still vaguely visible just to the right of the first porch post, under the small bush and the pink-and-yellow patch of lawn, is the outline of a seated figure, possibly another version of the figure of the woman seated at the edge of the porch. Even in its present location the figure has been adjusted. Gauguin also rethought the lower right section of the painting, where the loosely woven basket now appears. At one point this object was the image of a small dog, whose outline is still suggested by the blue lines that deflect away from the perspective lines of the porch; its nose can be discerned at the side of the basket and its body extends to the right (fig. 144).

Changes in color during the physical history of the picture are equally complex. The deep blue of the sarong of the central figure was originally a rich red, not unlike that in the sarong, also with white flowers, of the girl in *On the Beach* (1891, Musée d'Orsay, Paris)[12] or the nearly identical red cloth worn by the woman in the provocative *Otahi* (private collection).[13] The first color is clearly evident through the drying crackle of the blue. The white cloth on which the woman in red now lies may have been enlarged when the dog was painted out. The pink of the porch can be seen through areas of the cloth, especially near its edges. Finally, it has been pointed out that the flat top of the straw hat worn by the central figure bears repaints.[14] These repaints, assuredly by Gauguin, judging from the technique, cover flake losses in a layer that had completely dried before the second application of paint.

As striking as these changes may be, they are hardly unique for Gauguin, who in nearly all of his more ambitious canvases went through a period of compositional readjustment with shifts in color balance to achieve his final effect. There is almost certainly no evidence of "unfinish" at any point in the surface where it has been suggested—perhaps because of the strongly silhouetted forms and the flattened fields of color—that some final degree of modification is absent.[15] It is a painting on which the artist seems to have worked for a considerable time, yet its actual date remains unclear, without any further documentation concerning its early history. It clearly is a work that absorbed Gauguin completely, and his efforts were fully justified by the grandness of his final achievement.

J J R

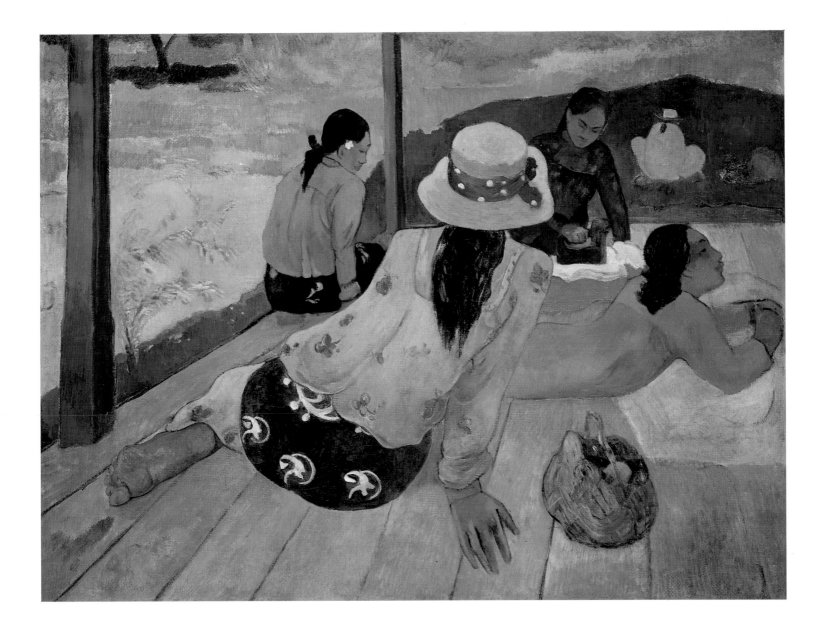

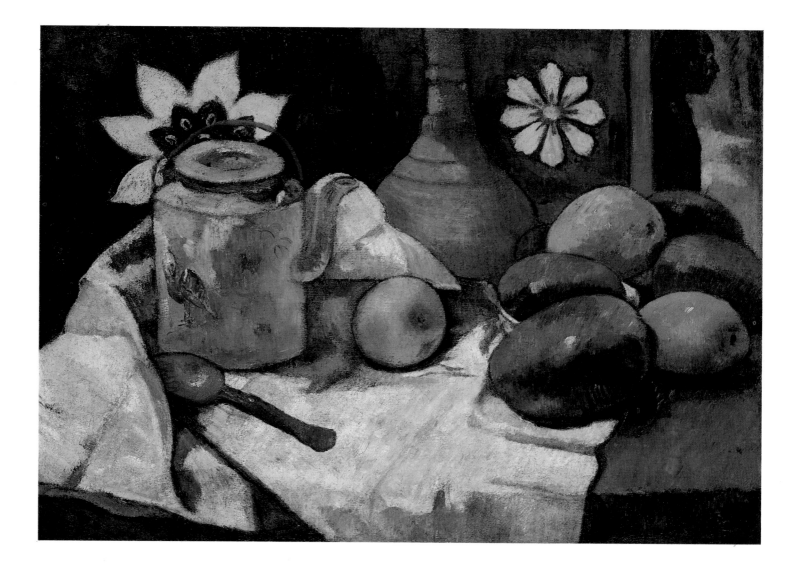

PAUL GAUGUIN

FRENCH, 1848–1903

STILL LIFE WITH TEAPOT AND FRUIT, 1896

OIL ON CANVAS, 18¾ X 26 INCHES

On A SIMPLE plank table, common objects from Gauguin's daily life in Tahiti are carefully laid out on a white napkin: a Japanese teapot (decorated with reeds and a crane in blue underglaze), a wooden spoon, a turned earthenware jug, seven mangoes in varying degrees of ripeness, and an eighth, smaller fruit, perhaps another mango. The backdrop is deep blue; on it are two brilliant, yellow, stenciled flowers. The right side of this wall is pierced by an opening through which is seen a half-length nude figure, some distance back, in profile silhouetted against a sun-dappled landscape. While all the elements are completely of the place, nothing could be more different from the three other Tahitian pictures in this exhibition, or from the great majority of pictures done during the last decade of Gauguin's life. As brilliant as the colors are here—in the sensuous pulpiness of the fruit and the exotic patterns of the background—it is a still life realized completely within the manner of his French contemporaries. It is arguably the closest he ever drew, in his mature works, to Cézanne. Camille Pissarro's skepticism at Gauguin's notion that "the young would find salvation by replenishing themselves at remote and savage sources"[1] seems perfectly justified. It is as if the great distance from Paris intensified Gauguin's memory of his French sources.

Cézanne, among all the older figures of the Impressionist movement, most impressed Gauguin. They seem to have first met, through the intercession of Pissarro, at Pontoise in the late 1870s. Although their relationship was far from intimate—Cézanne referred to Gauguin's paintings as "Chinese images"[2] and later in his life warned younger painters away from the decorative influence of Gauguin and his circle—Gauguin's devotion to Cézanne's paintings was immense. While still a well-to-do stockbroker, following his marriage in 1873 and just after becoming aware of this group of progressive painters, Gauguin started to form a collection of their work, to which he would carefully add until the disastrous stock-market collapse in 1882, which hastened his abandonment of his own bourgeois life and provided his final liberation as an independent painter. In his collection were five or six works by Cézanne.[3] He took the collection with him in 1884 to Copenhagen, where he briefly joined his wife and family. While he was slowly forced to sell off the paintings over the next several years of severe hardship, there was one work by Cézanne with which he was most reluctant to part: *Still Life with Apples in a Compote* (fig. 145).[4] This picture, used by Maurice Denis in his *Hommage to Cézanne* in 1900, nurtured Gauguin through his remaining years in France: its elements recur in at least three paintings from the Bretagne period,[5] and Gauguin copied it exactly in the background of his *Portrait of a Woman, with Still Life by Cézanne* of 1890 (fig. 146). At the time of his return trip to Paris in 1893, it

seems to have been the one important possession he still retained from his earlier life—his dealer Ambroise Vollard noted that the Cézanne was the featured object in Gauguin's meager studio on the rue Vercingétorix.[6] And even in this still life, painted three years later and far away from the Cézanne picture itself, the densely worked surface of hot, contrasting colors (Cézanne accused Gauguin of stealing "my little sensations");[7] the spatial manipulation of the gathered, white cloth and the angled eating implements (Gauguin substituted a spoon for Cézanne's ivory-handled knife);[8] and, above all else, the monumental realization of these forms within a box of space show that for Gauguin, "his" Cézanne was still vivid in his mind. Even the floral ornaments in the background, often taken to be Gauguin's imaginative departure from the type of flat designs he saw in Tahiti, are now proved to be drawn from the pattern on the printed or stenciled cloth he used to bind his own copy of his satirical newspaper, *Le Sourire*,[9] and are Gauguin's "Tahitian" response to the blue-gray wallpaper with emerging floral patterns in Cézanne's still life. As Richard Brettell has noted, "Gauguin 'translates' Cézanne into Tahitian."[10]

The haunting figure seen through the opening is Gauguin's one complete departure from the model of the Cézanne still life: while Cézanne would often break the continuous background of his pictures with shifting architectural elements that recede into deeper, terminating planes, he never allowed such a dramatic release from his contained, illusionistic space. However, such a device—particularly with a figure in profile—was often used by Degas, and early on Gauguin took it up as one of his favored means of enlivening his own still lifes while introducing a turn of narrative suggestion. As early as 1886, in his portrait of Charles Laval, the two elements of still life and portrait complement one another playfully, if enigmatically. The same relationship occurs frequently in the Tahitian still lifes—note particularly the girl, seen almost as a framed portrait, in the 1901 *Sunflowers on a Chair*[11]—while the introduction of a detached, enframed figure brings to a theatrical climax such pictures as *The Spirit of the Dead Watching*.[12] Here, however, the seemingly benign figure has less dramatic import—as if the powerful reality of the still-life elements dispel any mystical intrusion—and one suspects that its inclusion is Gauguin's attempt to distance himself from Cézanne and the Western tradition.

It is ironic that in 1897, the year following the execution of this picture, Gauguin wrote to the Paris dealer Chaudet requesting that he sell the Cézanne for the low price of six hundred francs, so hopeless were the artist's finances. Chaudet did so, although only half the money reached Gauguin before his death. *Still Life with Teapot and Fruit* marks the peak of Gauguin's absorption with the artist who governed so much of his development; thereafter Cézanne's influence on Gauguin ebbed and that of Degas and Puvis de Chavannes reemerged to partially soften his spatial imagery. However, even near the end of his life, in his journal *Avant et après*, he wrote about works by Cézanne: "It is better to go and see them. The bowl and ripe grapes exceed the border, on the napkin the apples, green and those which are prunish red blend. The whites are blue and the blues are white. What a painter Cézanne was!"[13]

JJR

93

PAUL GAUGUIN

FRENCH, 1848–1903
THREE TAHITIAN WOMEN, 1896
OIL ON PANEL, 9¹¹⁄₁₆ X 17 INCHES

To THE UNKNOWN collector, I salute you. That he may excuse the barbary of this little picture: the state of my soul is, no doubt, the cause. I recommend a modest frame and if possible one with a glass, so that while it ages it can retain its freshness and be preserved from the alterations that are always produced by the fetid air of an apartment" (Paul Gauguin). This modest bit of instruction for the future care of his painting, so humble and practical for an artist known for his rages and harsh demands on himself and the world, once accompanied this panel.[1] The letter is on a drawing (fig. 147) that relates to another painting, one he did in Paris after his return from his first trip to Tahiti in 1893.[2] The note has the poignancy of a letter in a bottle set loose at sea, optimistically assuming that this thing on which he had lavished so much care would, in the hands of some future owner, receive the attention it deserved.

It is an object almost unique in the tremendously vigorous output of Gauguin during the last phase of his life in Tahiti, where, cutting himself off by progressive degrees from contact with his European connections, he pursued his "savage" vision with remarkable energy and tenacity despite nearly constant physical and financial hardship. During this time he succeeded with heroic magnitude, in canvases of monumental scale and grandeur. Yet, in *Three Tahitian Women*, his interest was more that of the subtle craftsman, the Gauguin of the woodcuts and wooden sculpture, whose intention was not to jar and seduce his Parisian audience, as with the works he sent in batches to his dealer Ambroise Vollard, but rather to take pleasure in the complex working of this small panel.

The piece of teak on which he painted was a door from a cabinet or compartmented chest. One hinge, over which the painted composition carefully continues (and which still moves on its pin!), is still present on the upper right side; the lower hinge was pulled off, leaving a cutout profile. Paintings on panel are rare for Gauguin at any point in his career, although he was constantly in search of good, hard woods for his sculpture, especially in Tahiti. It would be tempting, if sentimental, to assume that he had reached a point of desperation (as was evident in his pleas for proper paper and canvas to Vollard and his loyal friend Georges-Daniel de Monfreid, in which his frequent complaint and threat was that he simply did not have the materials to continue his work).[3] But his use of this little door, abruptly wrenched from a cabinet, was probably out of choice rather than necessity. The wood was originally painted a pale celadon green, to judge from the dribbles on the left edge. The household paint was roughly scraped away, leaving an irregular surface, still clearly evident, over which he laid a white ground and then a thinner, and perhaps incomplete, layer of deep alizarin red. Over this he densely brushed the most intense colors in a manner reminiscent of the enameled quality of his "cloisonné" pictures from the earlier 1890s,[4] although here the sharp separations of contained areas of color have blurred and all the elements—the rose, lavender, and brilliant emer-

ald distant landscape; the iridescent stream eddying over the rocks; and the sparsely leafed tree on the same plane as the figures—have coalesced into a continuous, decorative unity of great delicacy. The three self-possessed women (only one of whom returns our gaze) seem to be quoted from memory rather than the products of direct observation, so complete is their absorption into the landscape, their angular gestures in harmony with the tree at right. The almost lacquerlike buildup of the surface is underscored by the application of the white garlands on the heads of the two women in red sarongs. These are precisely cut, with a fine, sharp instrument, into the surface of the paint down to the white ground, creating dazzles of light in their blue-black hair. It is a picture of magical sumptuousness and refinement, more a finely worked object than a robust painting.

The earliest mention of this picture appears to be in a letter to Gauguin from his friend Monfreid, who faithfully continued to watch over his affairs in Paris. It is dated November 11, 1898, and enclosed with it was a check for four paintings sold by Vollard: "the second of women bathing in a dappled [*papillottant*] landscape recalls the small panel that you sold (or gave) to Dr. Gouzer."[5] Wildenstein noted that "Gouzer" is Monfreid's confusion of Nolet (there being only one surviving panel that fits this description), the doctor who had gained Gauguin's confidence sufficiently to be trusted with the safekeeping of this picture upon his return to France, in the hope that he could sell it and send Gauguin the money.[6]

Monfreid's use of the word "papillottant" (butterflylike) in describing this picture and *The Bathers* of 1898 (fig. 148) is apt. While painted on canvas and considerably larger (23¾ by 36¾ inches), the later picture shares with this panel the envelopment of the figures by the landscape, all areas of the surface equally intense in contrasted, brilliant highlights and saturated shadows, creating a slightly blurred, dazzling surface not unlike the wings of an exotic butterfly. In their unity of decorative harmony, the two pictures resemble works such as *The Bathers* of 1897 (Barber Institute, Manchester) or the most complexly refined of Gauguin's pictures in this mode, the *Tahitian Pastoral* of 1898 (The Tate Gallery, London).[7] In his small group of works from the 1890s in which the figures and the landscape are given equal balance, Gauguin is perhaps paying tribute to one of his pantheon of the truly great, Puvis de Chavannes (1824–1898),[8] whose works have the detachment and innocent purity (and slight rhetoric) of true allegory. But unlike them, Gauguin's paintings of this type are permeated with a haunting sensuality, a quality of erotic dreaminess, quite different from the monumentally realized figures that dominate his work of the late 1890s and that stand as his more public declarations.

Perhaps it was to this small and quite special group of "papillottant" paintings, of which this picture is the first and, in many ways—given its small scale and splendid state of preservation—the most magical, that Gauguin was referring when he wrote late in his life from the isolation of the Marquesas Islands: "I have lingered among the nymphs of Corot, dancing in the sacred wood of Ville-d'Avray."[9] "These nymphs, I want to perpetuate them, with their golden skins, their searching animal odour, their tropical savours. They are here what they are everywhere, have always been, will always be. That adorable Mallarmé immortalized them, gay, with their vigilant love of life and the flesh, beside the ivy of Ville-d'Avray that entwines the oaks of Corot."[10]

JJR

94

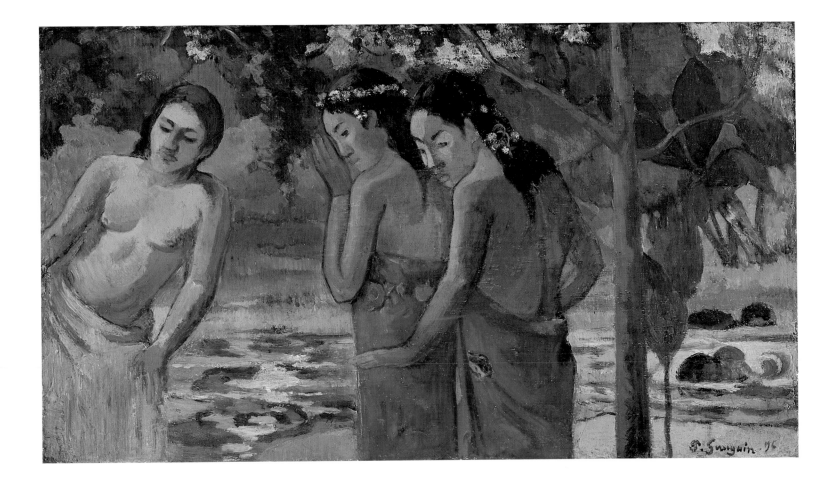

PAUL GAUGUIN

FRENCH, 1848–1903

PORTRAIT OF WOMEN (MOTHER AND DAUGHTER),
1901 or 1902

OIL ON CANVAS, 29 X 36¼ INCHES

TWO WOMEN, nearly one and a half times life size, sit before an open field bordered by a thatched hut, three isolated trees, and a distant line of dense foliage. Their half-length placement in the foreground gives them the permanence and spiritual absoluteness of Byzantine icons. The younger woman in red steadily gazes out, protectively holding the arm of the much older woman in a purple, floral-print missionary dress, her stare made all the more penetrating by the absence of the whites of her eyes. The auburn hair of the figure on the right falls over her red dress and frames her finely drawn mouth and nostrils, while the shadows of her jaw modulate into a green, patinated-bronze tone. The features of the older woman are more roughly modeled, the slightly darker flesh tones laid over deep terra verde shadows; the demarcation between the regions of highlight and shadow has an abrupt absence of transition, the contrast most apparent in the sharp line of shadow that cuts into her left cheekbone and down under the jawline, over which the skin is tautly drawn. Through this mask her dark eyes, set far back, penetrate intensely. The two figures hold us in their different gazes with equal steadiness. There is a measured equilibrium between them that disallows either the ascendancy of youth or the repression of age. *Portrait of Women* is a picture of tremendous dignity and presence.

The painting is enigmatically neither signed nor dated, a rare occurrence for Gauguin's later work, and one that has led to considerable disagreement about the date of this arresting image. Arguably it is the painting called "Portraits of Women" shown at the memorial exhibition at Vollard's in 1903,[1] and its presence there prompted its early fame; it appeared in exhibitions in Berlin, Leningrad, and Prague within the next decade. Arsène Alexandre placed it as early as Gauguin's brief trip to Martinique in 1887, mistaking the women for Creoles,[2] but it must have been done just before or after his departure from Tahiti for the Marquesas Islands in 1901.[3] Within the varied works from this time there is a certain ease of handling (sometimes mistakenly taken as lassitude), here most apparent in the somewhat summary treatment of the dresses and landscape, in which the earlier tightness of execution and elaborate building up of planes and color fields have been replaced by a more direct way of painting. The change is confirmed by the absence of the self-consciously exotic or decorative elements present in the earlier, more "Tahitian" paintings. Color has returned to its observed, nondecorative state. The brilliant, exotic color that permeates the landscapes of the 1890s has departed, the cloud-dotted blue sky here recalling Pissarro as well as Gauguin's own initial experimentation with landscape early in his career.[4] The women themselves, as immediate as they are, appear freer of narrative context than before; the human evocation is now in a broader, more absolute plane of existence.

It has long been known that the image of the two women depends upon a photograph, perhaps taken in Tahiti about 1894 by either Jules Agostini or Henri Lamasson (fig. 149).[5] The photograph was in the collection of Mme Joly-Segalen and was, in all likelihood,

found among Gauguin's effects in the House of Pleasure in Hiva Oa (Marquesas Islands), which Victor Segalen visited just after Gauguin's death in 1903. There are at least two other documented cases of Gauguin's use of photography for his works, quite aside from his frequent pillaging of postcards and illustrations of old masters, his French contemporaries, and objects and sculptures from Southeast Asia and the South Pacific, which—despite or perhaps because of his increasing isolation—led him to individual poses, compositions, and expressive ideas.[6] These photographs served—just as they had Cézanne in his figural compositions—to distance Gauguin from the changeable moment and perhaps the emotional distraction of his models, and, ironically, to allow him to study the sitters with a more literal directness.

In the Joly-Segalen photograph, two women sit on the stoop of a house, the younger one's mouth drawn down at the edges, her hand firmly grasping the sinewy arm of her older companion. The younger woman's stare into the camera has all the disquieting candor typical of late-nineteenth-century slow-exposure photography, in which transient expression is repressed into the sterner visage of a held pose. The older woman is even more aloof, her head still and unflinching in accord with the limitations of photographic recording. In the painting, Gauguin cropped the image in half and adjusted it into something quite different. The young woman's protectively grasping hand is now laid gently over the forearm of the older figure; her mouth is pulled up, giving her a contained and classically elevated beauty. The older woman's left arm now leans with less dependent weight on the lap of the other; her drawn-up knees, on which her hands now cross serenely, are in the same plane as her forearm and that of the young woman. Gauguin foreshortened her thighs so emphatically that one hardly realizes that, as can be seen with the aid of the photograph, the two women are actually seated. Their physical and emotional relationship has been balanced in relation to that of the photograph, their union now affirmed by the evenly spaced trees behind them, the whole scene stabilized and united by the continuous horizon. The appeal of the photograph for Gauguin is readily apparent; what he made of it is something transformingly grand and heroic.[7]

One also senses new, or renewed, awareness on the part of Gauguin of the traditions in European painting, which he, in part, addressed by taking up multifigured portraits. From his by then self-confirmed, isolated perspective, he was engaged in ruminative rethinking of that which went before in the history of painting. Pinned to the wall of his studio before which he posed the model for the photograph he used in creating *Girl with the Fan* of 1902 (Museum Folkwang, Essen) there was an illustration of Hans Holbein the Younger's well-known *Woman with Two Children* from the Kunstmuseum Basel (then thought to be a portrait of the artist's family). It is almost certainly this image to which Gauguin turned when painting *Mother and Two Children* of 1901 (The Art Institute of Chicago), reversing the positions of the children and in many ways neutralizing the melancholy of the Holbein—essentially making it his own. With this as a premise—compelled by the notion that just because of this portrait's out-of-time quality—there may also be an earlier visual source for it. One thinks of the equally famous Holbein double portrait, then as now in Dresden, of *Thomas Godsalve and His Son John,* 1528 (fig. 150).[8] There is, of course, much that is different between the two—men versus women, three-quarter profile versus full face—yet the half-length format, the two figures drawn tightly to the foreground, and above all the dignified examination of youth and age, suggest a relationship.

JJR

96

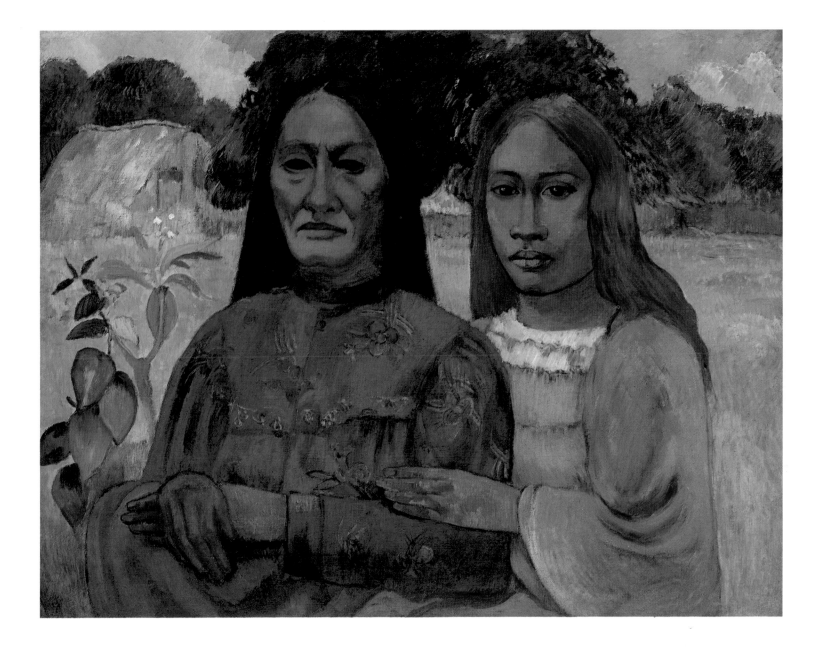

VINCENT VAN GOGH

DUTCH, 1853–1890
THE BOUQUET, C. 1886
OIL ON CANVAS, 25½ X 21⅛ INCHES

IN JULY 1886, Vincent's brother Theo van Gogh wrote to their mother in Holland, reporting on the activities of Vincent, who had joined him in Paris earlier that spring: "He is mainly painting flowers—with the object to put a more lively colour into his next pictures. He is also much more cheerful than in the past and people like him here. To give you proof: hardly a day passes or he is asked to come to the studios of wellknown painters, or they come to see him. He also has acquaintances who give him a collection of flowers every week which may serve him as models. If they are able to keep it up I think his difficult times are over and he will be able to make it by himself."[1] There survives a large group of pictures by Vincent of flowers in vases, which can be dated to that summer and fall and which introduce both a new vigor of handling into his art and an abundance of color that previously had not existed in his dark and brooding realist subjects painted in the North.[2]

This return to Paris[3] by the thirty-three-year-old artist marks his entry into the mainstream of French progressive painting, and it is during this time, through his alert absorption of the divisionist techniques of many of the artists whom he would see that year for the first time, that he developed the foundations for the tremendously vigorous and innovative work he would do over the next four years. It was a time of rapid transition in his work,[4] but also one that allowed a reabsorption into painting of the recent past, underscoring Van Gogh's true independence from his immediate artistic context and calling to mind all the more strongly the revolution that he was able to bring about in the short time remaining to him.

The Bouquet has long perplexed scholars as to its place within Van Gogh's production. For some critics, it bears strong resemblances to the flower pieces done in Paris,[5] just as he was breaking away from his dark, early manner and learning the pleasures of a heightened palette and, ironically, turning to subjects that were less socially charged than his earlier concerns. For others, it must date to the first phase of his work in Arles,[6] where he went in February 1888 to escape the harsh Paris winter and perhaps to gain an independence from the intensity of Parisian artistic activity, like his friend Gauguin through his work in Pont-Aven and Martinique. It has even been speculated that the picture may have been done after his forced retreat to the asylum of Saint-Rémy, near Arles, in 1889.[7] All this conjecture can be supported to some degree by comparisons with other flower pieces and still lifes; no one conjecture is completely satisfying with the evidence as given.

A randomly gathered group of flowers is placed in a handled pitcher, with fronds falling down around the base of the container on the table. They have most often been identified as chrysanthemums, which certainly would provide the great range of color in the smaller blooms, although the strident reds and pinks of those blossoms in the center just at the neck of the pitcher suggest the introduction of another, softer, less autumnal variety. The petals are painted with a staccato directness and vigor—applied like icing by a pastry chef—in an overall rhythm of even brightness, their intensity of color further heightened by the dark blue that is pulled in and around them and provides the ground color for the picture. The constant animation of the surface is continued in the rapidly hatched lines in green and earth red, which sets off the bouquet in an aura of moving paint strokes. Only the longer branches strewn around the foreground are done with a more languorous and sustained drag of the brush, as opposed to the very rapid execution of the flowers, smaller leaves, and surrounding elements. It is an electric tour de force of rapid execution; it is, perhaps, not surprising that for some the picture must date to the end of Van Gogh's career at Saint-Rémy —the period of *The Starry Night* (fig. 161), when all elements within the image partake in a surging animation.

Van Gogh must have been fully aware of the flower pieces by his French contemporaries (for example, Theo owned Degas's famous *Woman with Chrysanthemums* [fig. 151] in 1887),[8] but there is little here to suggest the influence of Degas or Monet or Renoir, who also excelled in this genre. The painting's source, to the degree that we can point to one, is rather to an older style of painting, in all likelihood the flower pictures of the painter from Marseille, Adolphe Monticelli (1824–1886). Vincent first saw the work of Monticelli in Paris at the dealer Delarebeyrette's in 1886.[9] Monticelli's nonanalytical use of color, with highlights emerging without transition from a dark background, appealed to him tremendously, even to the point that he encouraged Theo to buy works by this still obscure painter. They eventually, probably in joint ownership, acquired five oil paintings, and Vincent frequently referred to Monticelli throughout his correspondence over the next four years, even noting that one of his reasons for abandoning Paris and establishing himself in Provence was to draw closer to the southern world of Monticelli. The brothers owned one flower picture by him (fig. 152), and its influence on those of Van Gogh's flower series that are clearly documented to the Paris period has long been noted; a comparison to this picture is equally telling. The Monticelli has the same airless density as the Van Gogh, the jabbed-on color contrasting, dark to light (without any working out of complementary colors), all within a surface that is covered with strokes of an equal degree of high impasto. The Monticelli image, with its suggestion of a cast shadow, is less intensely realized than the Van Gogh, which is spatially more drawn to the surface. Van Gogh's tabletop and the picture itself are dissolved in the same, hatched brushstrokes, giving the picture a more visionary, less-witnessed quality in comparison to the Monticelli, yet in pictures such as this by the older artist, Van Gogh found (as he would later in the works of Delacroix) the release from both his earlier dark manner and the more coloristically analytical paintings by his immediate contemporaries, which laid the base for his further explorations.

Therefore, this suggests that *The Bouquet* be placed chronologically back with Van Gogh's Paris production, perhaps to about the same time in 1886 as the *Bowl with Zinnias* (fig. 153),[10] which contains the same vigorous cross-hatching in high impasto, with a similar disinterest in modeled forms, features that would be reasserted in the flower pieces done later in the Paris period. However, this observation is made with the recognition that while there is nothing within the earliest group of flower pictures to match the emotional intensity displayed in the execution here, such complete absorption in the painting of flowers would not reappear in Van Gogh's work until he encountered the sunflowers of Provence in Arles.

JJR

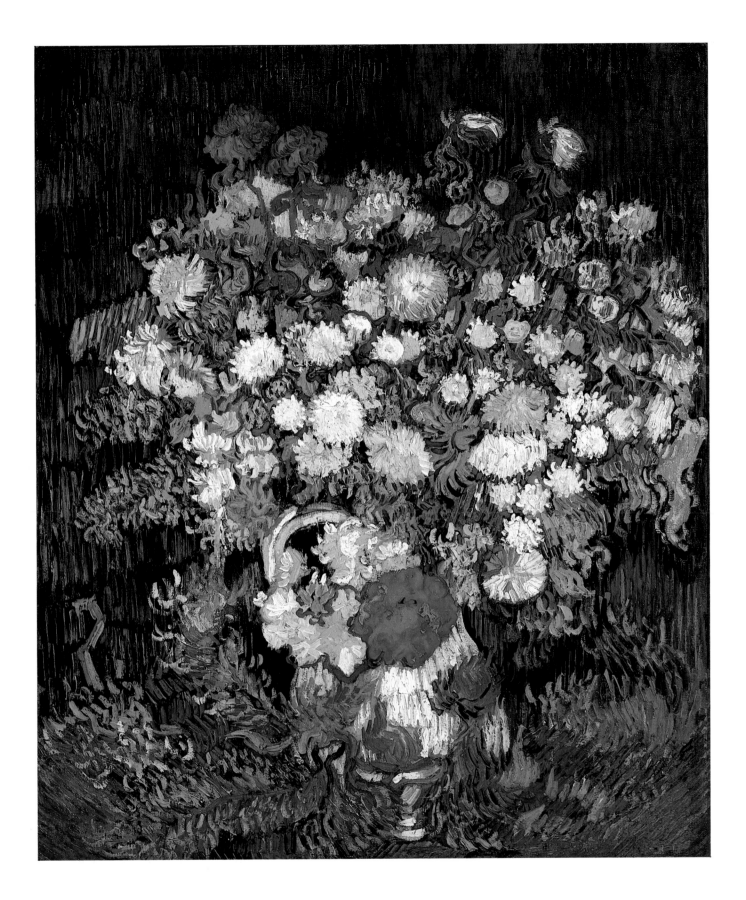

VINCENT VAN GOGH
DUTCH, 1853–1890
LA BERCEUSE (WOMAN ROCKING A CRADLE), 1889
OIL ON CANVAS, 36½ X 29 INCHES

VINCENT VAN GOGH painted five images of Mme Roulin as "La Berceuse," the woman seated before a brilliant, floral wallpaper, holding the rope by which she rocks the cradle of her newborn daughter.[1] They bridge in time the terrible breakdown of December 23, 1888, when Vincent, seemingly enraged by Gauguin to the point of complete madness, mutilated his left ear and retreated to his room in the "yellow house" in Arles to die. They stand, together with the series of vertical sunflowers with which this image is so intimately connected, among his grandest and most powerful achievements. His intention was to go well beyond the conventions of contemporary portraiture and the symbolically associative figural images painted by his friends Emile Bernard and Gauguin. "La Berceuse: that gigantic and inspired image like a popular print"[2] was what Albert Aurier, the first critic to take serious note of Van Gogh (and his only substantial commentator during his brief lifetime), called it.

Augustine-Alix-Pellicot Roulin (1851–1930) was thirty-seven years old when she met Van Gogh through her husband Joseph, the postmaster at the railroad station in Arles near Vincent's house. As so poignantly evidenced in the frequent letters that Vincent wrote to his brother Theo in Paris, Joseph Roulin, a hard-drinking, outspoken republican, was the one person with whom Vincent struck up a substantial friendship during his fifteen-month stay in the provincial city. Starting in the fall of 1888, Vincent painted numerous portraits of the postman and all the members of his family (see figs. 154 and 155). He also incorporated the couple into two of his imaginary, multifigured compositions.[3] Roulin's tall, spare figure, in appearance more Russian than French, as Vincent noted,[4] held great appeal; the seeming peace of his marriage, exemplary in the manner of his own parents,[5] provided a kind of solace for Vincent that was hard sought in his isolation, both physical and psychological. The family also provided ready models for him and Gauguin in a city where sitters were difficult to find and rarely sympathetic once they began

to pose for him; he lamented, "I despair of ever finding models."[6]

Much has been written about the relationship between Van Gogh and this woman. By her own confession[7] she was frightened to pose for him, particularly after her husband was transferred to Marseille on January 22, 1889. His departure came as a great blow to Vincent, who by then depended heavily upon his companionship. However, there is no weariness apparent in any of the portraits he made of her and her children, and it has often been overlooked that it was Augustine Roulin who was the first to visit Vincent in the hospital on Christmas day of 1888, after his savage breakdown. She continued to pose for him during the period of his convalescence when his head was wrapped in bandages, although the neighbors around the place Lamartine petitioned to have Vincent confined following his breakdown. For him she became a kind of Great Mother, her heavy figure and still features embodying for him the solace of calm hope.

His thoughts on Mme Roulin, or rather the allegorical portrait he would do of her as "La Berceuse"—a phrase to be translated as either *the lullaby* or *the rocker,* in reference to the unseen cradle that she rocks—can be followed through his correspondence with Theo. The work's first overriding evocation is that of a spiritual image that would bring a lulling calm to those in distress, and in a letter probably written on January 28, 1888, he related the idea he had "to paint a picture in such a way that sailors, who are at once children and martyrs, seeing it in the cabin of their Icelandic fishing boat, would feel the old sense of being rocked come over them and remember their own lullabys."[8] Despite the somewhat incoherent passage in which this idea is introduced (a rare incidence, in fact, since Vincent's letters are remarkably clear-headed and self-analytical, even when he was at his most endangered), it makes direct reference to the novel *Pêcheur d'Islande* by Pierre Loti, which he had recently read and discussed with Gauguin. The text deals with the dreadfully lonely and despairing life of Breton sailors in the waters off Iceland, and Vincent was deeply impressed that Gauguin had himself been a sailor,[9] although his claim to having been to Iceland seems to fall within one of Gauguin's many self-aggrandizing exaggerations. The idea of making "La Berceuse" into a votive image like a popular chromolithograph, to which Van Gogh so often referred in connection with it, remained with him. In a letter to Theo attributed to May 25, 1889, he proposed that if one arranged "La Berceuse" in the middle and the two canvases of sunflowers to the right and left, "it makes a sort of triptych...a sort of decoration, for instance for the

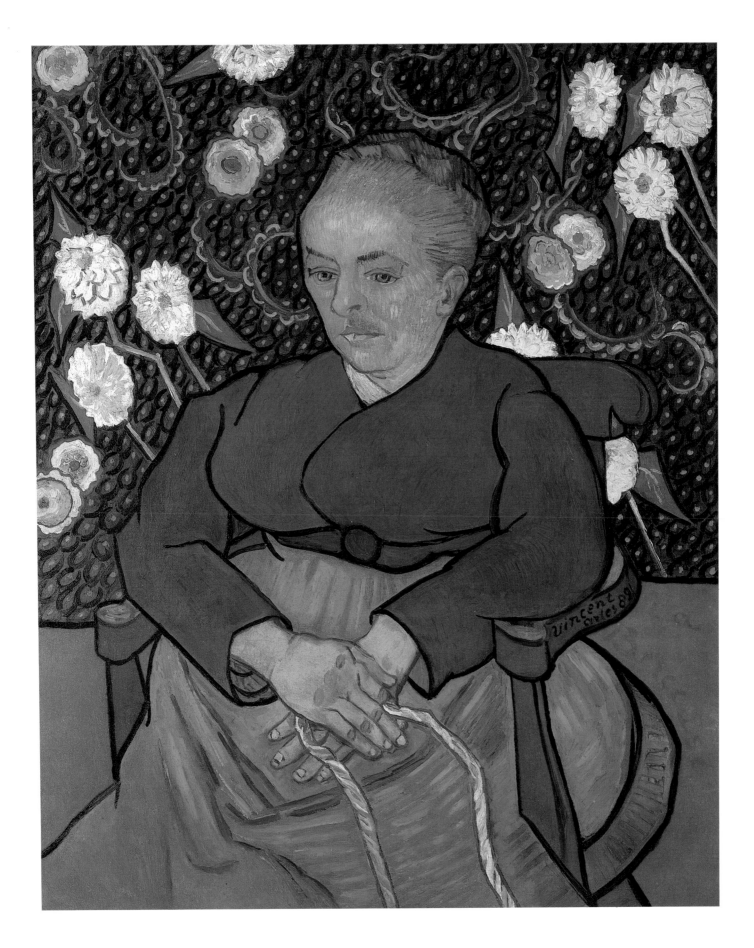

end of a ship's cabin" (see fig. 156).[10] Immediately, however, he added a stylistic note—"Then, as the size increases, the concise composition is justified"—which reveals that his concern with the arrangement was as much formal as it was expressive. At another point he gave an expanded idea of the possible relationship between "La Berceuse" and the series of sunflowers: "I picture to myself these same canvases [replicas of "La Berceuse"] between those of the sunflowers, which would thus form torches or candelabra beside them, the same size, and so the whole would be composed of seven or nine canvases."[11] The idea of series had already emerged before in the repetitions of the sunflowers (see fig. 157) he made to decorate the room of the yellow house in anticipation of Gauguin's visit. His introduction of a painting of Mme Roulin into a serial conception is certainly based on his carefully considered interplay of a palette of ocher and sharp green, although the association of her image, flanked by two vases of flowers, like a Madonna on an altar between floral offerings, is justly inevitable, particularly given what is known of the potency of both images for Van Gogh.

The first mentions of "La Berceuse," in two letters to Theo and one to the Dutch painter Arnold Hendrik Koning, date from January 1889. To Theo he wrote: "I am working on the portrait of Roulin's wife, which I was working on before I was ill,"[12] and "I think I have already told you that besides these [replicas of sunflowers] I have a canvas of 'La Berceuse' the very one I was working on when my illness interrupted me. I now have two copies of this one too."[13] In the letter to Koning acknowledging his New Year's greetings, he informed his friend: "At present I have in mind, or rather on my easel, the portrait of a woman. I call it 'La Berceuse,' or as we say in Dutch (after Van Eeden, you know, who wrote that particular book I gave you to read), or in Van Eeden's Dutch, quite simply 'our lullaby or the woman rocking the cradle.' It is a woman in a green dress (the bust olive green and the skirt pale malachite green). The hair is quite orange and in plaits. The complexion is chrome yellow, worked up with some naturally broken tones for the purpose of modeling. The hands holding the rope of the cradle, the same. At the bottom the background is vermilion (simply representing a tiled floor or else a stone floor). The wall is covered with wallpaper, which of course I have calculated in conformity with the rest of the colors. This wallpaper is bluish-green with pink dahlias spotted with orange and ultramarine....Whether I really sang a lullaby in colors is something I leave to the critics."[14]

The emotional letters to Theo about the image contrast sharply with the careful, stylistic description given to Koning, and show the dichotomy between mind and feelings that this image held for Van Gogh. The bias to see in the paintings products of an inspired madness is here more strongly refuted than in any other of his most "loaded" images; the equilibrium of a formal composition, a stylistic intention, and a narrative expression are brought into perfect accord.

The five versions of "La Berceuse" mentioned in the letters survive,[15] and this one was the canvas chosen by Mme Roulin for her own out of those that had been done up to that time—an intelligent choice, according to Vincent's appraisal: "She had a good eye and took the best."[16] (The painting did not remain with the family long, for it was sold in 1895, along with four other Van Gogh portraits of members of the family, to the Parisian dealer Ambroise Vollard.)[17]

Because of its documented early history, this painting has always been considered as possibly the first, or primary, version of "La Berceuse" (as an alternative to that in Otterlo; fig. 158), which was begun before Vincent's collapse in December, probably in the company of Gauguin, who also painted a portrait of Mme Roulin seated in a similar chair at that time.[18] However, the primacy of neither version can be established with certainty. Both have the date 1889 on the arm of the chair, but the placement of the hands is unique in this version, while the wallpaper in the Otterlo painting is more robust and animated than in any of the others. As early as January 28, Vincent reported to Theo in a letter that he was making copies of the painting destined for the Roulin family, a document that strongly supports its preeminence in the series. This picture must have served as the model for the other three paintings, which, with one exception, follow it in fairly precise detail, including the wallpaper design. Mark Roskill has pointed out that the secondary motif of the wallpaper, not the flowers themselves but the paisleylike orange curves within red dots on a green field, recurs in the background of the portrait of Dr. Félix Rey (Pushkin State Museum of Fine Arts, Moscow), the physician who so sympathetically saw Van Gogh through the December–January crisis and whose portrait he referred to in the letters written in late January.[19] However, this same motif occurs as well in the Otterlo version and seems simply to have been much on Van Gogh's mind before and after Christmas. The strongest argument in favor of the Annenberg painting as the first is its one major difference from the other four, namely, the position of the woman's hands, which here cross right over left, just the reverse of the others. What has been overlooked is that by doing so, Mme Roulin covers her wedding band in the early version, while the ring is prominently shown in the others. The significance of this detail—as profound as the distinction may be—is obscure. Her dual role as mother and wife is interlocked throughout Van Gogh's discussions of the subject. It

might be proposed that he painted her first in the pose that came most naturally (right hand over left) and then realized that by shifting her hands in the four subsequent versions of the picture, he could reveal her ring and pay tribute to her role as wife, in a marriage that he so much admired, while the cradle rope emphasizes her role as mother.[20]

On quite another level—and certainly a subjective one—there are in this picture a power and a deliberateness of both characterization and monumental realization absent from the other four. The absolute set of the head, the deliberateness of the gaze, and the completely assured execution of the deep blue outline of bodice and chair place it somewhat apart from the others, although it must be emphasized that repetition of images within a series did not necessarily entail a diminishment of energy and strength of execution.

Should this in fact be the first version, whose execution would then have been interrupted by his illness, one might expect to find physical evidence, and there is some indication of a distinct time lapse within certain sections. The area of the green skirt that extends beyond the arm of the chair, for example, is worked in quite a different manner from the rest of the skirt. The rope that passes through her hand lacks the directional tautness that occurs in the other versions and may be reworked in the left part, modeled over a salmon base with strokes of yellow, lavender, and a little green, the whole braided together by the red outline, whereas the right section is painted directly on the green of the skirt with no base color.

In the end, whatever relationship this picture has to the others, they, individually and as a series, all have a nobility consistent with Van Gogh's ambitions: "Perhaps there's an attempt to get all the *music* of the color here into 'La Berceuse'."[21] As he confided to Theo, he wished that this image—bluntly executed in harsh and defiant outlines in radiant color—would have an immediacy and popular appeal that would recall his earlier populist and socially conscious works. Few pictures concerned him as much in his letters as this, and perhaps more is known from the correspondence about his expressive intention here than in any other work. He was apprehensive at times about it: "But as I have told you already, this canvas may be unintelligible."[22] Yet he also seemed to have realized the magnitude of his success: "I know very well that it is neither drawn nor painted as correctly as a Bouguereau, and I rather regret this, because I have an earnest desire to be correct. But though it is doomed, alas, to be neither a Cabanel nor a Bouguereau, yet I hope that it will be French."[23]

<div align="right">JJR</div>

VINCENT VAN GOGH

DUTCH, 1853–1890
OLIVE TREES: PALE BLUE SKY, 1889
OIL ON CANVAS, 28⅝ X 36¼ INCHES

Upon Van Gogh's arrival at the asylum at Saint-Rémy in the spring of 1889, the olive trees that grew in cultivated groves near the walls of the sanitarium took on a special meaning for him. They, even more than the dense, wavering cypresses, which would also provide him with the subjects of some of his greatest works during that period, became identified for him with the South and all those things that endure and thrive in intense sunlight. A group of three canvases showing these orchards, all from a point of view angled slightly down into the groves, date from that May and June and were sent to his brother Theo.[1] In late November he reported to Theo that he had been "knocking about in the orchards, and the result is five size 30 canvases, which along with the three studies of olives that you have, at least constitute an attack on the problem."[2]

In the interval Van Gogh had suffered one of his worst bouts, seemingly prompted by a visit back to Arles on July 14. He was confined to his rooms in the sanitarium for over two months. This second group of five pictures was the first theme to which he returned in the late autumn when he felt secure enough to venture outside again. The sequence of execution within the five canvases remains unclear. None, as opposed to earlier groupings such as the sunflowers or those of a woman rocking a cradle (p. 101), is a replica or variant copy of another; each seems both compositionally and coloristically to have provided him with a different way to address his ideas on the subject with a new urgency, which, by the fall, had become even more important for him.

Part of his intention in the early winter group of olive-grove paintings was to directly address the abstractions that he felt were deflecting the talents of his friends Gauguin and Emile Bernard, the latter having sent to him a photograph that fall of a picture of Christ in the Garden of Olives (fig. 159),[3] a subject that Gauguin had done the same summer and written about to Van Gogh (fig. 160).[4] Vincent, who so often had followed with poignant sympathy and tolerance the work of his fellow-painters, was outraged: "The thing is that this month I have been working in the olive groves, because their Christs in the Garden, with nothing really observed, have gotten on my nerves. Of course with me there is no question of doing anything from the Bible—and I have written to Bernard and Gauguin too that I considered that our duty is thinking, not dreaming, so that when looking at their work I was astonished at their letting themselves go like that.... It is not that it leaves me cold, but it gives me a painful feeling of collapse instead of progress....What I have done is a rather hard and coarse reality beside their abstractions, but it will have a rustic quality, and will smell of the earth."[5] In his pictures of olive groves he was true to his intention: he addressed his subject with a renewed energy of execution and analytical observation of color variations that are remarkable, particularly in contrast to the views of cypresses such as *The Starry Night* (fig. 161), which allowed him a visionary intensity that, arguably, far exceeds the power of "dreaming" in those religious narratives of Bernard or Gauguin.

"The olive trees are very characteristic, and I am struggling to catch them. They are old silver, sometimes with more blue in them, sometimes greenish, bronzed, fading white above a soil which is yellow, pink, violet-tinted or orange, to dull red ocher. Very difficult though, very difficult. But that suits me and induces me to work wholly in gold or silver. And perhaps one day I shall do a personal impression of them like what the sunflowers were for the yellows."[6] He never proceeded with this train of thought: to do a series as with the sunflowers. Each of the five pictures of olive groves varies considerably from one another to the point that they may be, in fact, different orchards or seen from very different points of view. In turn, the sky and quality of light range greatly within them; one is dominated by a great sun disk (fig. 162), while in all the others the sun is behind the artist's easel. However, they are consistent in their quick staccato application of paint, which is laid on with a controlled analytical placement of contrasted colors that suggests Van Gogh's interest in the formal theories of Seurat, whom Vincent met at least once in Paris in 1888 and whose pictures greatly impressed him.[7]

In *Olive Trees*, the pointilistically executed sky—strokes of blue, pink, yellow, and a sharp aqua laid with masterful integration over the white ground—gently holds its own with the mass of trees beneath, whose trunks are defined by alternating strokes of tightly keyed alizarin and brick red, which, like the more contrasted dark green, light pink, and pale green of the leaves, continues the animation of the sky, without a loss of definition of the masses. The more broadly worked strokes of the earth are done in alizarin, purple, and a peach tone over a ground that has been unified by a light coat of pink brown to indicate what appears to be the furrows newly plowed for winter planting, creating islands of soil banked around the roots of the trees. The effect of unity and spatial integration of sky, trees, and earth is so great that the slow realization of the two repoussoir shadows in purple on each side, cast by trees behind us, seems almost disruptive in a slightly sinister way.

For some viewers, the olive trees, and particularly these pictures from the early winter, are imbued with the emotionally frail state of the artist. However, at least here, the quality of nature charged by the artist's emotion seems distinctly absent, and one is more aware of the pensive and highly lucid revelation of the coloristic variations possible within this theme. The landscape of the South was as much a resource for Van Gogh's analytical thought as it was a potential embodiment of his subjective and often pantheistic vision. "It is really my opinion more and more,...if you work diligently from nature without saying to yourself beforehand—'I want to do this or that,' if you work as if you were making a pair of shoes, without artistic preoccupations, you will not always do well, but the days you least expect it, you find a subject which holds its own with the work of those who have gone before. You learn to know a country which is basically quite different from what it appears at first sight."[8]

Following the worst bout of mental collapse that Van Gogh is known to have suffered during his short life, he seems to have re-entered his work with a control and a formal sense of invention that extended his work to still another plane. In this, as is evidenced by his letters, the olive trees, along with the coloristic variations they allowed him in the clear winter light, must have taken on not the expressionistic associations that the gnarled branches have suggested to many, but a relationship with something very tenacious, ancient, and of the place, these groves that were so carefully husbanded and cultivated by people who, for Vincent, represented a kind of continuity and persistence that, at least for a moment in time, he, too, was able to achieve.

JJR

VINCENT VAN GOGH

DUTCH, 1853–1890
WOMEN PICKING OLIVES, 1889–90
OIL ON CANVAS, 28½ x 35¹³/₁₆ INCHES

DURING THE LATTER PART of 1889 Van Gogh's thoughts were full of the pastoral paintings of Puvis de Chavannes (1824–1898) and Millet (1814–1875), who humbled him by their achievement—that Frenchness to which he so often referred as threatening him, with his "Northern brains," with artistic impotence[1]—and also spurred him on: "I did not want to leave things alone *entirely*, without making an effort, but it is restricted to the expression of two things—the cypresses—the olive trees—let others who are better and more powerful than I reveal their symbolic language."[2] Such ruminations prompted him to ask, in the same letter: "Who are the human beings that actually live among the olive, the orange, the lemon orchards? The peasant there is different from the inhabitant of Millet's wide wheat fields. But Millet has reawakened our thoughts so that we can see the dweller in nature. But until now no one has painted the real Southern Frenchman for us. But when Chavannes or someone else shows us that human being, we shall be reminded of those words, ancient but with a blissfully new significance, Blessed are the poor in spirit, blessed are the pure of heart, words that have such a wide purport that we, educated in the old, confused and battered cities of the North, are compelled to stop at a great distance from the threshold of those dwellings. And however deeply convinced we may be of Rembrandt's vision, yet we must ask ourselves: And did Raphael have this in mind, and Michelangelo, and da Vinci? This I do not know, but I believe that Giotto, who was less of a heathen, felt it more deeply—that great sufferer, who remains as familiar to us as a contemporary."[3]

These thoughts, just as it was becoming difficult to work outside, seem to have prompted in December and early January 1889–90, a third group of olive-grove pictures—three in number (this picture, one in Washington, D.C. [fig. 163], and one now in Lausanne)—all involving three figures helping one another pick the olives.[4] "I am working on a picture this moment, women gathering olives....These are the colors: the ground is violet, and farther off, yellow ocher; the olives with bronze trunks have gray-green foliage, the sky is entirely pink, and three small figures pink too...."[5] Just before Christmas (December 23, the anniversary of his collapse in Arles), he wrote to his mother in Holland: "I hope Theo has sent you my studies, but I started still another rather big picture for you of women gathering olives. The trees, gray-green, with a pink sky and a purplish soil....I had hoped to send it one of these days, but it is drying slowly."[6] That same day he wrote to his sister, who lived with his mother: "I hope you will like the canvas for you and Mother which I am working on at present a little. It is a repetition of a picture for Theo, women gathering olives."[7] It seems likely that this picture is the same as the one mentioned December 15; by January 3 he was already sending

to Theo in Paris "'The Women Gathering Olives'—I had intended this picture for Mother and sister, ... I also have a copy of it for you, and the study (more colored, with deeper tones) from nature."[8]

The following day, January 4, he wrote to his sister as well, noting that he had sent a number of pictures to Paris the day before: "I designated the one with the olive trees for you and Mother. You will see, I think, that in a white frame it will take on a mild color, meaning the contrast between pink and green."[9]

Because the early provenance of the other two pictures of olive groves begins with Theo's widow, by process of elimination it seems most likely that the present painting is, indeed, the one sent to his mother and sister. Which of the other two is, in fact, the study done "from nature," continues to be unclear.[10] The pictures of women picking olives form a series in a stricter sense than the five olive groves that immediately preceded them (see p. 104). The three compositions are nearly identical and their palettes very similar, to the point that the "deeper tones" Vincent mentioned are difficult to identify with either of the two that stayed with Theo. In turn, all three have a modulated quality and a certain paleness that sets them quite aside from the five earlier olive groves. In this Vincent was making a very conscious stylistic distinction, perhaps remembering just as he would for the figurative subjects themselves, the cool harmonious pictures of Puvis, which, for Vincent, had restraint and equilibrium, a quality of "a strange and providential meeting of *very* far-off antiquities and *crude* modernity."[11] It is in this spirit that he referred perhaps to the present picture, "done from memory after the study of the same size made on the spot, because I want something very far away, like a vague memory softened by time."[12] He was attempting a specific effect: "All the colors are softer than usual."[13] And he was fully aware that the effect was certainly much less immediate and more subtle than many works that preceded it. To his sister he wrote: "I hope that the picture of the women in the orchard of olive trees will be a little to your liking—I sent a drawing of it to Gauguin a few days ago, and he told me that he thinks it good, and he knows my work well and would not hesitate to say so if he thought there was nothing in it. Of course you are quite free to choose another one to replace it if you like, but I dare believe that you will come back to this one in the long run."[14]

For all our associations of energy, high emotional expression, and serene magnitude felt before the works of Van Gogh, there is a quality here that is rare in his work—a lyricism and true charm in tonalities, with a nearly sentimental pleasure taken (as by many artists within the pastoral tradition) from the women's shared gathering of the fruits. Quite like his hero Puvis, it was a sense of far distant permanence, that quality of "something a little studied" that he mentioned in his letters.[15]

The state of the paint surface is exceptionally well preserved here. The gently lifted impasto survives wonderfully, and his rubbing down of certain sections of the prepared ground to vary his surface, subtly modulating the overall spatial effect, is immediately apparent. Van Gogh wrote, "I think that probably I shall hardly do any more things in impasto; it is the result of the quiet, secluded life that I am leading, and I am all the better for it. Fundamentally I am not so violent as all that, and at last I *myself* feel calmer."[16]

JJR

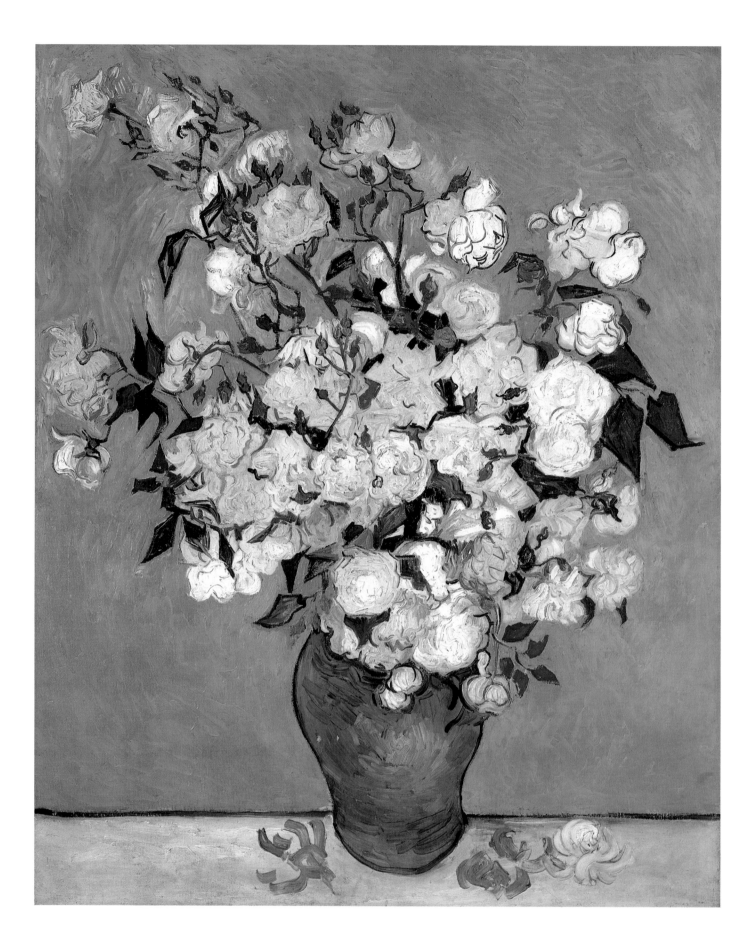

VINCENT VAN GOGH

DUTCH, 1853–1890
VASE OF ROSES, 1890
OIL ON CANVAS, 36⅝ X 29⅛ INCHES

ON MAY 13, 1890, VAN GOGH wrote to his brother Theo from the asylum of Saint-Paul-de-Mausole in Saint-Rémy, reporting that he had finished another canvas of "pink roses against a yellow-green background in a green vase."[1] It was his last letter from the South, where he had gone in 1889, full of the hope that his isolation from Paris would give him the calm to practice his art and the new perspective he so badly needed. The letter continues: "I tell you, I feel my head is absolutely calm for my work, and the brush strokes come to me and follow each other logically." Dr. Théophile-Zacharie-Auguste Peyron, who had supervised his care so attentively in the cloister-made-hospital, reviewed the state of his patient three days later, the day Vincent departed for Paris: "The patient, though calm most of the time, has had several attacks during his stay in the establishment which have lasted from two weeks to one month. During these attacks the patient was subject to frightful terrors and tried several times to poison himself, either by swallowing the paints which he used for his work or by drinking kerosene which he managed to steal from the attendant while the latter refilled his lamps. His last fit broke out after a trip which he undertook to Arles, and lasted about two months. Between his attacks the patient was perfectly quiet and devoted himself with ardor to his painting. Today he is asking for his release to live in the North of France, hoping that its climate will be favorable." In the column headed "Observations," Peyron noted "cured."[2]

In few of Van Gogh's works are his own self-analysis and that of his doctor so profoundly confirmed as in *Vase of Roses*. It is, for all its grandeur, a work of consummate calm and easily achieved splendor. Nothing of the distraught nature of the artist's mind or of his intense vision is evident here. An abundant bouquet of roses in a green faïence jar is placed firmly in the center of a pink table against a green background. The elegantly drawn stems seem to be thornless; the weighty blooms are laid on with a rich fluidity, many of them edged with a color that ranges, in the central section, to quick, wet strokes of deep alizarin, while others, particularly on the upper right, are outlined with penlike fineness in blue. The fluency of the execution is no better revealed than in the fallen leaves and bloom on the table, the left cluster made up of eight swift strokes, the right, nineteen.

The picture immediately recalls the series of seven upright sunflower paintings done about a year before,[3] with their great, ranging stalks filling the entire picture (see fig. 157). They are the gold of the South that Vincent wished to celebrate when he forced himself to attain the "high yellow note"[4] in what he often referred to as his most visionary and strained moments of execution. Yet nothing could be more in contrast than the dry, angular sunflowers and the moist sensuality of early summer portrayed in *Vase of Roses*. The heroic stridence of the sunflower pictures has resolved itself into a more gentle realization and even acceptance of beauty in confronting the subject. As with the *Women Picking Olives* (p. 106), Van Gogh has come to a peaceful resolution with a more subdued palette, diminished impasto, and, one thinks, increased pleasure of applying paint in a way completely harmonious with the loveliness of his subject. It is remarkable that a painter of such a short career could bring himself through a cycle of almost unrelenting intensity into a calm maturity, particularly during his three brief years in the South. Even so, some three months after executing this picture, he would fall victim once more to his psychic disease—this time, in Auvers-sur-Oise—and succeed in his attempt to destroy himself.

Just after leaving Saint-Rémy he spoke several times to his brother and mother of the wonderful surge of activity that marked his final days at the asylum: "And those last days at St. Rémy I still worked as in a frenzy. Great bunches of flowers, violet irises, big bouquets of roses...."[5] There are eleven pictures that can be dated between the end of April and his departure on May 16; this was an almost superhuman achievement.[6] The paintings were still too wet to pack at the time of his departure, and he left them behind in the safekeeping of Dr. Peyron, who dutifully shipped them off to Auvers, where they arrived at the end of June;[7] he received them in a much less settled state of mind than when he had executed them only a month before.

Among this group are four flower still lifes: two of irises, one horizontal and one vertical, and two of roses, which differ in format in the same way.[8] The horizontal picture of roses, now in a private collection,[9] was described by Van Gogh to Theo as "a canvas of roses with a light green background."[10] The vertical picture is *Vase of Roses*, which he mentioned as being in process the day after.[11] The bunches of flowers themselves are different, the ones in the vertical *Vase of Roses* simply being taller and more full of buds. The vase in the horizontal picture of roses is an unglazed earthenware jar with a handle, the one here is more upright, a green faïence vase, seemingly the green vase mentioned in his May 13 letter.

Van Gogh varyingly described the roses he was painting as pink *and* white or simply (in the May 13 letter) pink. One can see by the edges of the pink tabletop of the Annenberg picture, which have been protected from light by the frame, that the pigment in the roses has faded to a distinctly paler tone. Also judging from the protected edges, the same shift can be found in what is undoubtedly the same pigment used for the background of the *Irises* (The Metropolitan Museum of Art, New York), although there perhaps to a more radical degree. This is a frequent occurrence in Van Gogh's paintings. However, close examination of the roses in the Annenberg picture reveals that, particularly in the lower areas of brushstrokes, which have been literally shaded by passages of impasto, the original, more heightened, pink does survive. Alerted by this in attempting to visualize the original harmony, one sees clearly that the flowers here must always have been, as they still very much are, a subtle blending of pink and white, outlined with the same brush in green. The description of this picture as "white roses" in 1908 suggests that this shift in pigment occurred quite early.[12]

There would be moments during the next three months in Auvers when Van Gogh would regain, particularly in figure subjects, the sense of scale he had achieved those last days in Saint-Rémy. However, *Vase of Roses* truly marks for the last time the completely resolved and untroubled manner declared by the letters: the logic, the calm, the "steady enthusiasm."[13]

<div align="right">JJR</div>

EDOUARD VUILLARD

FRENCH, 1868–1940
THE ALBUM, 1895
OIL ON CANVAS, 26¹¹⁄₁₆ X 80½ INCHES

IN THE CENTER, a group of three women on a canapé examine an open album. Another woman, on the right, arranges flowers; two others group themselves on the left; the seventh is situated at the edge near the frame. It is appropriate for this painting, and the others with which it forms an ensemble (five in total), to make an observation that applies, no less than before, to all the works of this artist and the best of his contemporaries—namely, that the design, or rather the definition of the objects, possesses in the paintings only the plastic value of an arabesque. The pleasure of naming these objects undoubtedly intervenes in that which is given by the images, but this is hardly the point. Its real essence is abstract. The general effect is of red and green enlivened with yellow. These are basically woven together in the background in narrow, juxtaposed strokes, yet they emanate throughout the picture with the subtlest of variations, the reds descending sometimes almost to browns and blacks, at other moments lifting to vermilion and tones of rose. The yellow is sometimes muted nearly to beige. The color at times is divided into small, isolated touches, in other passages it is gathered into delicately modulated masses. The contrast between those two processes is brought to its height at the center."[1]

This evocative and loving description of *The Album* was given by its owner, Thadée Natanson, in 1908, when he was forced to sell it, along with much of his collection. (The sale contained twenty other works by the painter, as well as splendid examples of Delacroix, Cézanne, Seurat, K.-X. Roussel, and Bonnard). Few people were better suited to address the subtly intimate yet grandly realized achievement of Vuillard. Since 1891 Natanson had been the editor and publisher, with his two brothers, of the progressive and lively Parisian journal *La Revue Blanche*. Along with music criticism by Claude Debussy and sports by Léon Blum, it had frequent contributions from Stéphane Mallarmé and the young André Gide. For eleven years *La Revue Blanche* was, as John Russell has noted, simply "the best periodical of its kind that has ever been published."[2] Many of the artists who designed its frontispieces—Vuillard and Bonnard among them—formed an alliance. When they first showed together in the shop of Le Barc de Boutteville in 1891, they called themselves the Nabis, from the Hebrew word for *prophet*, at the suggestion of one of their members, Paul Sérusier. In contrast to the Impressionists some two decades earlier, much of their formulation was theoretical, based on the premise that visual reality is only a beginning for art, which then, through poetic, symbolic, and formal processes, would lead to more general and profound revelations. Gauguin, with whom Sérusier studied at Pont-Aven, was their central hero. The evocative and finely wrought poetry of Mallarmé and the seamless music of Debussy are often recognized as their nonvisual equivalents. Some, such as Maurice Denis, who eventually gave himself over completely to criticism, or Henri Ibels (see p. 62), who never quite left the world of illustrated journalism, soon wandered from the initial premise of the group. Others—most importantly Bonnard and Vuillard—were nurtured by the liberating theories of the Nabis and pursued a new goal: to create art that was suggestive rather than declarative, sensuous rather than descriptive, and, perhaps most importantly, decorative in the sense of harmonious unification and continuous rather than objectively illusionistic. It is in the true spirit of these intentions that Natanson described Vuillard's pictures.

One of the central tenets of the Nabis—albeit a principle not followed consistently by any of their members—was the abandonment of the conventional paintings so firmly linked with the Parisian bourgeois collectors who had provided the first audience for the Impressionists. The young critic Albert Aurier, chief spokesman for the Nabis, stated in 1891: "Painting can only have been created to decorate with thoughts, dreams and ideas the blank walls of human

buildings. The easel picture is nothing but an illogical refinement invented to satisfy the fancy of the commercial spirit of decadent civilizations."[3] The Dutch Nabi painter Jan Verkade (1868–1946) recalled that a war cry went up in the early 1890s: "No more easel pictures! Away with useless bits of furniture! Painting must not usurp a freedom which cuts it off from the other arts! The painter's work begins where the architect decides that his work is finished!...There are no such things as pictures, there is only decoration."[4] And if the Nabis regretted that Gauguin was rarely allowed the opportunity to work on a large decorative scale, the grand public murals of Puvis de Chavannes (1824–1898) were there to lead them.

Of course, the abandonment of easel painting was not an absolute principle for Vuillard, who, unlike many of his Nabi colleagues, avoided generalized theories and formulations; many of his most beautiful works in the 1890s were remarkably fine, small panels (fig. 164). Yet, starting in the early nineties with the stage flats he executed for his schoolfellow friend Aurélien Lugné-Poe,[5] he began working on a large decorative scale that would bring Aurier's theoretical postulations to an enchantingly seductive reality in a series of closely interconnected private commissions.[6] The first commission came from a cousin of the Natansons, Desmarais, in 1892, for six long horizontals and a folding screen to decorate his study. The themes, as they nearly always would be for Vuilllard, were drawn from the gentlest and most untroubled of domestic genres—women gardening, children playing with a dog, a dressmaker's shop like the one run by Vuillard's mother.[7] Following the success of these, Thadée Natanson's older brother Alexandre requested a more ambitious series of nine large, upright panels depicting children and nursemaids in the public gardens of Paris (fig. 165). Although they were in their original positions for a short time, these two series, like those done later in the 1890s for Claude Anet and Dr. Vasquez, seem to have been carefully calculated to make a complete decorative scheme. It is this quality that Paul Signac noted in 1898: "What is especially noteworthy about these two panels is the clever way in which they fit into the decoration of the room. The painter took his key from the dominant colors of the furniture and the draperies, repeating them in his canvases and harmonizing them with their complementaries....Truly, these panels do not look like paintings: it is as if all the colors of the material and carpets had been concentrated here, in the corner of this wall, and been resolved into handsome shapes and perfect rhythms. From that viewpoint the work is absolutely successful, and it is the first time that I have received this impression from a modern interior."[8]

The works commissioned by Thadée seem to have been more loosely considered in this sense, as unified as they are in color and composition. Three, including *The Album*, are extended horizontals,[9] one a large vertical (fig. 166), and the fifth, a rectangle of an easel scale (fig. 167). Although it is difficult to speculate on their original arrangement, all have one dimension in common. Vuillard himself confirmed the unity of the five apart from all the other works done by him for the Natansons: in a personal chronology he drew up after the turn of the century, he simply noted in the listings for 1895, "The panels done for Thadée; December."[10]

The Natansons' apartment on the rue Florentin, just off the place de la Concorde, was one of Vuillard's favorite haunts throughout the

nineties. Thadée's wife, the high-spirited Misia Godebska,[11] was, after his mother, the central figure in his life, their relationship summarized as allowing "the security and assurance of a perfect understanding."[12] Many of his most enchanting small paintings of this period document the richly patterned interiors of their apartment (fig. 168)—nearly always shown at night with the large rooms pooled with light from heavily shaded lamps. One of the 1895 series, *Conversation (Pot de grès)*, appears in the background of his *Misia, Vallotton, and Thadée Natanson* (fig. 169). Another, *Embroidering by the Window* (fig. 166), appears in an undated photograph of Misia, and, like *Conversation*, it is seemingly unframed (or surrounded with simple molding) and placed on a strongly patterned wallpaper.[13] *The Album* appears behind Misia in the Karlsruhe interior of c. 1897 (fig. 170); she is shown playing the piano while her brother, the comic Cipa Godebska, listens intently. But clearly the placement of this work was hardly sacred, since it reappears in a photograph of a billiard room with Thadée and his sister-in-law Ida Godebska (fig. 171).[14] It is therefore difficult to speak of these five works precisely as a decorative series in comparison with others; yet it is because of Thadée's own description of them as an "ensemble" that we must acknowledge Vuillard's careful consideration of them as a harmonious pictorial unit. They also share a sustained evenness of psychological unity: young women in striped blouses setting about their leisurely, civilized tasks within richly textured interiors, with the continuous presence of flowers—all of them autumnal chrysanthemums—in a tonality underscoring the essential palette of all five works.

Everything is subdued and peaceful. The elegant full-bosomed women—all perhaps variants of his friend and patron, Misia—are literally fused in the most serene way with their surroundings. Their charming, patterned day dresses, observed in chic understatement with the attention one would expect from a dressmaker's son, play counterpoint to the room and its objects: the plane of the printed mutton-chop blouse of the central figure in profile is juxtaposed with the marbleized cover of the album; the suspenders of the figure arranging flowers on the right wittily play off the striped red fabric of the overstuffed chair beyond. The women exist, as do all the other women in the series, in a slightly hermetic world of domestic ease and leisure that echoes seventeenth-century Dutch genre pictures, the light seeming at first to come from some unknown source near the center and then to be suffused throughout the whole composition. But if the light is that quality of still radiance so loved in Vermeer's pictures and extolled by Vuillard's friend Marcel Proust, it falls within a space that has been translated through the interiors of Degas. The space is completely lucid, yet all calculation is subtly held in check. Just when gatherings of color would seem to nearly turn geometric clarification into pure pattern, Vuillard introduced in perspective the precisely defined little mahogany (or red Chinese lacquer) table and the long cardboard box, its ribbons suggesting a florist's delivery, providing some small narrative outside our reading. However, in contrast to earlier multifigure interiors such as *The Suitor* of 1893 (Smith College Museum of Art, Northampton, Mass.), which is given a cerebral quality by its mathematical calculation of a complex arrangement of foreshortened planes, upright panels, and a subtle interweaving of oblique angles, in *The Album* there is just

enough spatial elucidation to rest serenely in balance with the sensuous interplay of two-dimensional pattern. When Vuillard takes up the theme later in the decade, in the 1897 *Large Interior with Six Figures* (Kunsthaus, Zurich), his pleasure in the tapestrylike surface has receded into a more literal and descriptive mode, not only explaining the space of the room more specifically but also reintroducing the quality of nearly theatrical interplay between his characters, which seems absent in *The Album*.

And yet, is *The Album*—or the series of five pictures—completely without narrative implication? Much of Vuillard's great power to seduce is in his ability to mysteriously suggest a glimpse, a moment, that we only half understand. The seven women partake in shared pleasures in a completely sisterly manner. The sense of their gentle apartness in a rich bourgeois interior, very like the Natansons' rooms where these pictures would hang, suggests a modern reference to the seven vestal virgins, those wise Roman women representing domestic virtues and the value of isolated perspective, who appear throughout seventeenth-century French paintings.

Vuillard would, of course, be too elusive and too independent of mind to force any historical (or for that matter, contemporary) reference. Yet his life in the 1890s was a balanced routine of picture looking, visits to the theater, and attendance at soirées (particularly at the Thadée Natansons, where he was famous for his nearly mute good manners but always stayed to the end), which constituted, at least in part, the creative ingredients for a picture as subtle and implicative as this. Things he witnessed—either saw or sensed—were filtered through his memory and imagination. For his close and intimate friends Thadée and Misia, he produced a series of pictures that are at once completely of their time in the fashion of the clothes and the decor, yet quite out of time in a mood of domestic calm.

The complete ease with which he approached his subject is no better evidenced than by the means with which he painted it, and, as Thadée himself noted, the real subject is just this. *The Album* is executed in a complex weave of light brushstrokes with very little buildup of paint (except in the faces), no color overlapping another. A buff ground seems to have been scraped away in silhouetted patterns, most obviously in the large bouquet to the left, over which

the pigments are laid without underpainting or modulated tones, almost as if applied with a stencil to accommodate each color variant. At times these surfaces, which follow the described object only in a general way, have the quality of inspired accident—the easing of a figure into an overall network of patterns—that is so admired in Japanese glazed ceramics. Sensuously rich lines appear—the long wet stroke defining the top of the arch-backed sofa, for example—like comets in a starry firmament, clear but almost immediately subsumed by the pattern of the whole. No one element—line or pattern, dark or light, recessive or aggressive color—outweighs any other.

This ability to suggest mode and to imply narrative without breaking the discrete intimacy of his scene, along with his very understated control over his material, was beautifully expressed by the young André Gide when he saw two decorative panels (not the Thadée set) at the Salon d'Automne in 1905: "To return to M. Vuillard's decorations, I don't know quite what is the most admirable thing about them. Perhaps it is M. Vuillard himself. He is the most personal, the most intimate of story-tellers. I know few pictures which bring the observer so directly into conversation with the artist. I think it must be because his brush never breaks free of the motion which guides it; the outer world, for Vuillard, is always a pretext, an adjustable means of expression. And above all it's because M. Vuillard speaks almost in a whisper—as is only right when confidences are being exchanged—and we have to bend over towards him to hear what he says.

"There is nothing sentimental or high-falutin' about the discreet melancholy which pervades his work. Its dress is that of everyday. It is tender, and caressing; and if it were not for the mastery that already marks it, I should call it timid. For all his success, I can sense in Vuillard the charm of anxiety and doubt. He never brings forward a color without making it possible for it to fall back, subtly and delightfully, into the background. Too fastidious for plain statement, he proceeds by insinuation.... He never strives for brilliant effect; harmony of tone is his continual preoccupation; science and intuition play a double role in the disposition of his colors, and each one of them casts new light on its neighbor, and as it were exacts a confession from it."[15]

JJR

EDOUARD VUILLARD

FRENCH, 1868–1940

ROMAIN COOLUS AND MME HESSEL, 1900–1905

OIL ON CARDBOARD AFFIXED TO CANVAS, 14½ X 22⅜
INCHES

DURING THE 1890s Vuillard's greatest attachment, other than to his mother, to whom he was profoundly devoted, was to the young and capricious Misia Natanson, wife of one of Vuillard's most important patrons, Thadée Natanson, for whom he did a series of decorative panels including *The Album* (p. 110) in 1895. By the turn of the century, the brilliant world that surrounded the Natansons and their journal, *La Revue Blanche*, had shifted its artistic and intellectual focus; the journal itself ceased publication in 1903, its demise hastened by Thadée's worsening finances. Perhaps an even harder blow for Vuillard was Misia's divorce from Thadée to remarry into quite a different world in 1905, this preceded by a troubled liaison with Alfred Edwards, an immensely rich and onerous man who hastened Thadée's financial collapse. As silent and withdrawn as Vuillard was by all descriptions, these events must have meant a great sea change in his life.

Salvation—and for a man so completely dependent on a regular pattern of domestic intimacy it was just that—came through another woman with whom he formed an attachment, perhaps even stronger than that with Misia. She was Lucie Hessel, wife of the art dealer Jos Hessel, who directed Bernheim-Jeune, one of the most successful galleries in Paris. After the turn of the century Edouard and Lucie met nearly every day. Portraits of her (fig. 172) and her friends, both formal and as elements in his interior genre scenes, proliferated. Her apartment on the rue de Rivoli and her houses at Versailles and in Normandy became his second homes and the source of much of his art. (Vuillard died at the beginning of the war, attempting to reach her Norman house by train.)

Lucie Hessel could not have been more different from Misia Natanson. She was tall, strong-jawed, and nearly Wagnerian in her ardent manner, in contrast to the sensuous and subtle Misia. Her world was grander and more conservative than that of the *Revue Blanche* group: less daring, more aristocratic. The evolution of Vuillard's style—particularly through the portrait commissions he received from the higher levels of the bourgeoisie and the aristocracy—reflected, at least in part, this shift in his social milieu.

"Interested in life, greedy of confidences, devoted to her friends, and enterprising as Vuillard was not, she receives the painter every evening about six, does him the honours and keeps him to dinner. Vuillard has a refining influence on Jos Hessel and indirectly, on the customers who consult him.... Lucie by a thousand quasi-maternal attentions, knew how to protect him, amuse him, deaden the shocks, and initiate him into the underside of a society which, but for her, he would not have had the time or the inclination to study. Into his almost monastic life, she introduced the noise and dust of the world."[1]

Here, Mme Hessel sits at a long table in her apartment on the rue de Rivoli, reading or perhaps opening her morning mail. She is still dressed in her peignoir. A large silver tray, holding a warming bell (for her coffee?) and a porcelain cup, shares the tabletop with a blooming Christmas cactus. A heavily shaded lamp projects from the left. Beyond her on a red plush banquette, intent upon his writing on

a drop-leaf desk, is Lucie's (and Vuillard's) close friend, Romain Coolus. Born René Weil in Rennes in 1868, he attended, like Vuillard, the Lycée Condoret in Paris and launched himself early into a career as a philosopher. His audacious and progressive attitudes (he had his students read Stéphane Mallarmé) forced his resignation from his teaching post in Chartres in 1891. He immediately became one of the most loyal contributors to *La Revue Blanche*, where he served as theater critic; the *Revue* published his first two books.[2] During the 1890s he became one of the most lauded playwrights of the boulevards; the success of his comedies carried into the 1920s.[3] He was a bosom friend of Toulouse-Lautrec (fig. 173) and was sometimes bullied into staying with Lautrec during his extended residencies in the florid brothels on the rue d'Ambroise or the rue des Moulins. He had a great gift for friendship. Annette Vaillant (the daughter of Alfred Natanson, Thadée's brother) remembered him fondly: "short and sturdy, with a crooked face, a scholar with a hoarse voice and a cracked laugh."[4]

These two figures—Coolus a continuation of Vuillard's earlier life, Lucie Hessel his new Egeria (the name given her by Vuillard's friends for the muselike powers she had over him)—share the picture-filled room with the intimacy of long friendship, each intent on his or her own task. Yet, despite its snug contentment, the interior is presented without the complex working of patterns and subtle spatial invocations of those small, most intimate pictures of the 1890s (fig. 174).

The medium is laid on with fluidity and ease, a directness and a seeming absence of calculation, that signal a new stage in the evolution of Vuillard's style. The colors have become more brilliant—the fuchsia of the blooming plant setting the tonality that reappears in the gradations of the lampshade, swift strokes gaily suggesting the images of the pictures on the wall, the shadows between the cushions on the banquette balancing the light blue of Mme Hessel's robe. And whereas Vuillard nearly always, even in the most completely developed pictures of the 1890s, painted with directness and with little or no buildup, there is a new breadth here that suggests an easing away from the intellectual formulations of the Nabis into a less analytical spontaneity.

Much is made of the exposed surface of the board that provides the middle tones throughout. As opposed to the quick-drying distemper paintings on this scale, which precede this picture, the oil here is rich and deliciously viscous, allowing him to go back to the paint—as he did, for example, in defining the lace panels on the shoulders of Lucie's robe—with the end of his brush. Further, the vague sense of mystery and the inexplicable, implied narratives of the earlier interiors with pools of light have ceased here. We are no longer entering the theater in the middle of an act. Whereas the lamp is quickly suggested, it is not the light source even for Mme Hessel's work; the room is flooded with an undramatic, bright morning evenness.

There is a new maturity here, in the world that Lucie Hessel made possible for Vuillard. The subtler and intellectually swifter world of Misia is behind him. A new spontaneity has emerged; intimacy seemingly is now achieved without the burdens of probing into things that run too deeply. This is not to say that any of his powers have subsided. The open armchair in the right foreground, for example, presents as formidable a difficulty in formal spatial delineation as any problem he presented himself with earlier, but now he established it more loosely, allowing the form to dissolve onto the exposed board. Vuillard seems more able to relax, and perhaps even to celebrate the virtues of friendship and domestic calm, in a more accepting, less urgent manner.

JJR

GEORGES BRAQUE

FRENCH, 1882–1963

BOATS ON THE BEACH AT L'ESTAQUE, 1906

OIL ON CANVAS, 15 X 18⅛ INCHES

Fauvism, pioneered in the early years of the new century by, among others, Matisse, André Derain (1880–1954), and Maurice Vlaminck (1876–1958), built on Impressionist and neo-Impressionist pictorial innovations. While retaining a love of light, color, and domesticated landscape, the Fauves employed the pictorial elements in an increasingly arbitrary fashion, more for abstract purposes than for descriptive or representational functions. As a result, color and brushwork became dazzlingly independent, while a specific sense of locale was sacrificed in favor of generalized depictions. Braque was entranced by the Fauve style when he visited the 1905 Salon d'Automne in Paris,[1] later proclaiming that "Matisse and Derain opened the road for me."[2] He became the youngest member of the group, and first came to prominence in 1906 as a Fauve painter. Braque exhibited at the March 1906 Salon des Indépendants, the only event at which the entire Fauve group was seen together in that period; however, he was unhappy with his first canvases in the new style and subsequently destroyed them. A change of scene was needed.

With Othon Friesz (1879–1949), another Fauve painter and an old friend from Le Havre, Braque went to Antwerp, where he stayed from August 14 to September 11, 1906, and began to lighten his palette. After returning to Paris for the rest of September and part of October, he traveled, once more with Friesz, to the southern port of L'Estaque, where he remained until February 1907. The small village with a rounded harbor and low rents,[3] west of Marseille and up against the foothills of the Alps, had been a font of inspiration for Derain and, preceding him, Cézanne.[4] There Braque's color brightened dramatically and became almost completely arbitrary in its application, and he produced his first truly Fauve works, including *Boats on the Beach at L'Estaque*. It was an intoxicating breakthrough, as he later described: "For me Fauvism was a momentary adventure in which I became involved because I was young.... I was freed from the studios, only twenty-four, and full of enthusiasm. I moved toward what for me represented novelty and joy, toward Fauvism. It was in the south of France that I first felt truly elated. Just think, I had only recently left the dark, dismal Paris studios where they still painted with pitch!"[5]

Boats on the Beach at L'Estaque ought to be considered a companion to *L'Estaque* (fig. 175) and *L'Estaque, Wharf* (fig. 176), the latter dated by Braque to November 1906.[6] In these harbor scenes of similar color harmonies, Braque utilized a conventional composition of horizontal registers such as is seen in *The Port of Antwerp* of 1906 (fig. 177); anchoring the foreground space in each is a solidly described form, either a rock, a wharf, or boats.[7] Also evident are the violets and crimsons that appear in the Antwerp canvas. Braque does expand on his earlier formulas with Fauve-style brushstrokes to define the water, with the use of white, and with the generally more exuberant and arbitrary color harmony. Whereas the other Fauves tended toward primary colors, Braque departed from these, favoring pink, ocher, orange, and purple tonalities; he added, too, to the Fauve vocabulary with his characteristically long, serpentine lines that define the boats. It was as though Braque's first task in the southern sun were to further liberate his color, and so he maintained his usual approach to subject matter and composition. *Boats on the Beach at L'Estaque* can be counted among his first fully realized Fauve canvases. Only upon forsaking his observations of the sea in favor of the landscape (see fig. 178) did he advance within the Fauve agenda, gradually eliminating the foreground while compressing space, and formulating more agitated compositions. The serpentine line became an increasingly dominant motif in these synthetic and more generalized treatments of nature; whether defining a road, a hillside, or a tree, it helps flatten the space by its abstract quality.

At the March 1907 Salon des Indépendants, Braque finally met Matisse, Vlaminck, and Derain. The occasion was auspicious not only because of this meeting but also because Braque showed and sold six L'Estaque paintings, and that year signed a contract with Daniel-Henry Kahnweiler, Picasso's dealer. The following summer, 1908, coincidentally at L'Estaque once again, Braque produced his first Cubist canvases, in which the lessons of Fauvism contributed toward compositions with trees on the most forward-leaning planes and with the familiar path through a landscape.

MR

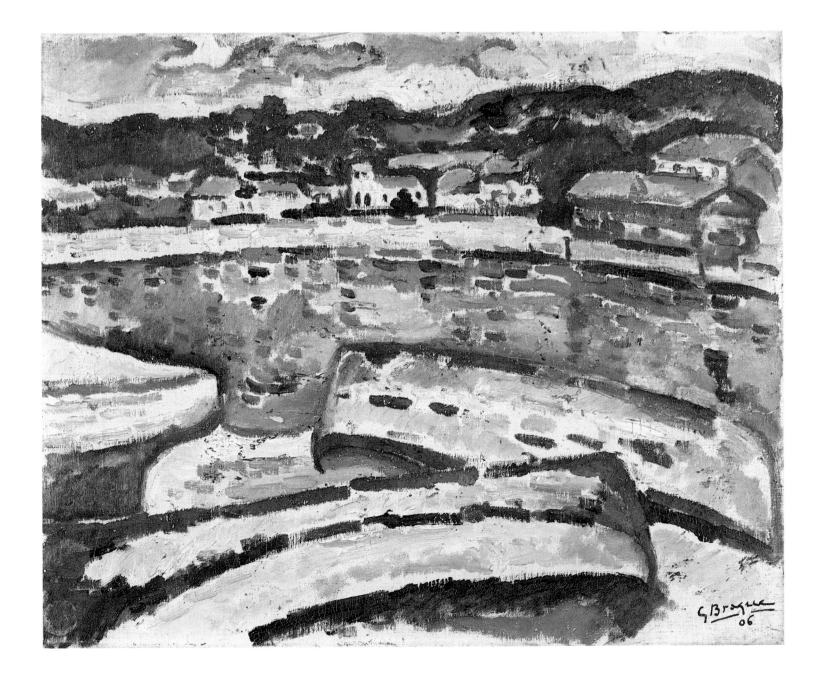

PIERRE BONNARD

FRENCH, 1867–1947
MEADOW IN BLOOM, C. 1935
OIL ON CANVAS, 35½ X 35⅝ INCHES

MEADOW IN BLOOM offers a luxuriant landscape,[1] probably of Bonnard's garden at his home Le Bosquet in Le Cannet. Here, in contrast to the exhilarating jumble of *The Garden*, c. 1936,[2] Bonnard created a more carefully tended, not nearly so agitated, image of nature, including pruned plantings and what appears to be a plowed field. The vegetation is cultivated and is enjoyed by someone. "There is hardly any Bonnard landscape as deserted as it first seems," wrote Jean Clair, "only showing itself to be inhabited after a lengthy look. A landscape existed for him, not in itself, but in the function of a human presence, no matter where he might tuck it."[3] In this case the human presence is the woman in white in the upper left center of the composition.

Although Bonnard usually distorted his subject matter for pictorial purposes, *Meadow in Bloom* is, nevertheless, distinctive in his landscape oeuvre. Instead of creating a semblance of spatial recession, Bonnard tipped the field upward in a fashion that can be described as at once stylistically primitive and advanced. Bonnard analyzed the methods of naive artists in 1936: "Sunday painters: their naive love of objects leads them to discoveries. Techniques correspond to necessary artifice, the requirements of nature causing a limitation."[4] As if momentarily copying the practice of the dabbler, in order to carefully inventory and record all of the plant types observed in the garden as well as the activities of both the hobbyist and the farmer, Bonnard eliminated shadows, employed a miniaturistic approach, and artificially flattened the space into a register of horizontal planes. The flattening of space is, of course, a technique also employed by sophisticated painters. Bonnard wrote in 1935: "Planes through color. Rough out with color contrasts."[5] Hence, we move from brown to lavender in the lower section, then to the large field of green, a row of purple flowers and dark-green, spiky plants in the middle ground, then to a pattern of alternating orange and dark purple bands above. Bonnard knowingly distinguished himself from his contemporaries, who finally sought to dispense with subject matter. He wrote in 1934, "When one distorts nature, it still remains underneath, unlike purely imaginative works."[6] For Bonnard, subject and structure meld with neither being compromised; he is not interested in making "purely imaginary works," that is, complete abstractions.

If *Meadow in Bloom* appears exceptional in comparison with Bonnard's late landscapes, it is altogether reminiscent of his contemporaneous still lifes and interiors. In its exaggerated perspective, with the green plain a kind of terrace poised precipitously above the plowed field, the composition resembles many in which a tilted tabletop or floor is seen—for example, *The Table* of 1925 (fig. 179); also repeated are the horizontal bands at the lower edge. Too, the juxtaposition of the curious brickwork in the upper left with the field recalls the patterns of tilework side by side with shutters in so many backgrounds of his figurative paintings.[7] It would appear, then, that *Meadow in Bloom* is a unique attempt by Bonnard to apply the compositional arrangement of his domestic environments to a landscape.

MR

118

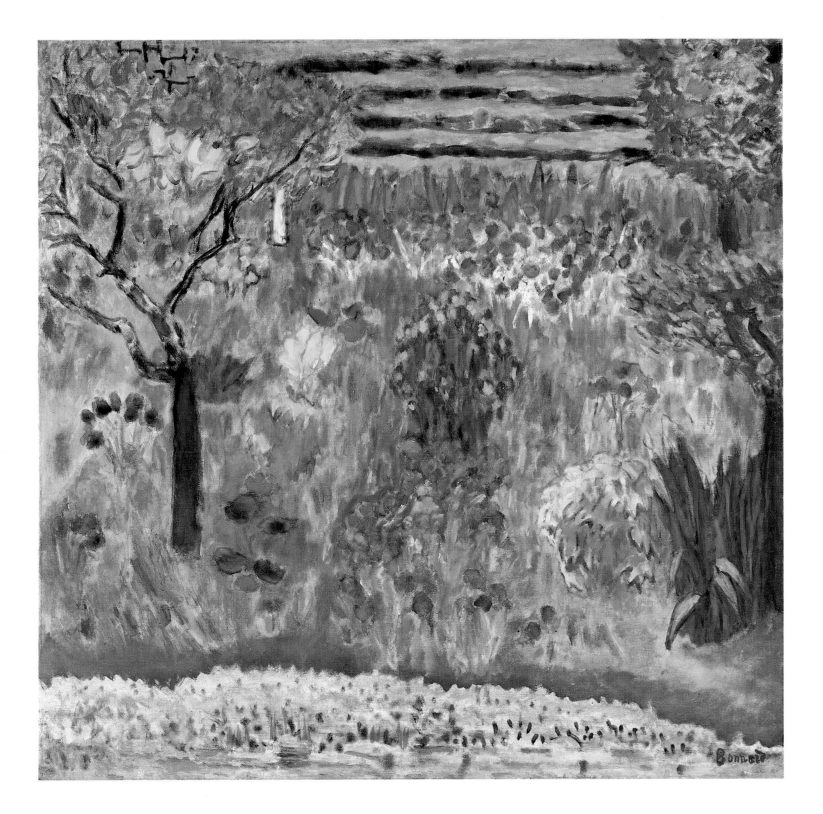

Henri Matisse

FRENCH, 1869–1954
ODALISQUE WITH GRAY TROUSERS, 1927
OIL ON CANVAS, 25⅝ X 32 INCHES

In the late teens and early 1920s, Matisse painted many works in which a female figure is shown seated in front of an open window. Then, gradually, he began to close in the environment of his apartment at 1 place Charles-Félix in Nice, doing away with the windows and placing Moorish-style screens,[1] oriental fabrics, and flowered papers in the background to create a stage set for the figure. As he came to emphasize these decorative patterns, he gave the figure the guise of an odalisque. Although he had portrayed odalisques before, following winter trips to Morocco in 1911–12 and 1912–13, the lush Mediterranean environment of Nice, where he had taken up residence, inspired renewed fascination with the theme. Matisse's odalisques are at once exotic and erotic, in the tradition of the hothouses created by Delacroix and Ingres. When asked about his interest, however, Matisse sidestepped these associations: "I paint odalisques in order to paint the nude. But how is the nude to be painted without being artificial? And also because I know it exists. I was in Morocco. I saw it."[2] Certainly the odalisque in *Odalisque with Gray Trousers*, with her athletic body and disproportionately small head, is less sensual than others Matisse painted during the 1920s. The image of a voluptuous harem girl has been diminished, in part due to the influence of Michelangelo's sculpture, for about this time in his career Matisse was adapting a number of poses from figures in the Medici Chapel.[3]

Matisse's compositions of the 1920s, culminating in such works as the one here, render all elements equal in weight. That is, even while the sculptural figure is in dramatic contrast to the flat planarity of the various fabrics, Matisse's ambition is to make a vibrant unity of diverse, equally emphasized parts. This dynamic organization is reinforced by the sharp, sometimes discordant, color contrasts. Rhythm is the crucial vehicle by which the painting is constructed, staccato when jumping from pattern to pattern or color to color, languorous when following the full curves of the samovar, echoed by the figure's exaggerated body.

Odalisque with Gray Trousers varies from other works of 1927 by the absence of the oft-repeated table and by the distinctly more contrived depiction of the figure,[4] but the inclusion of the samovar marks it as a work of that year. From 1920 to early 1927, Matisse's principal model was Henriette Darricarrère. Although the artist generalizes his figures to such an extent that positive identification is made difficult, comparison with a contemporaneous photograph (fig. 180) suggests that the pursed-lipped figure with hair gathered at the sides of her head is, indeed, Henriette. Therefore, the painting can with a fair degree of certainty be dated to early 1927.[5]

It has been proposed that *Odalisque with Gray Trousers* is related to a drawing entitled *Seated Odalisque, Ornamental Ground, Flowers, and Fruit* (fig. 181).[6] While there are numerous variations between the two images, if an amusing lithograph of 1929 entitled *Odalisque, Brazier, and Cup of Fruit* (fig. 182) is compared with both, the relationship becomes more assured. The lithograph combines features of the painting and the drawing, suggesting that the first two works were part of the same thought process.

MR

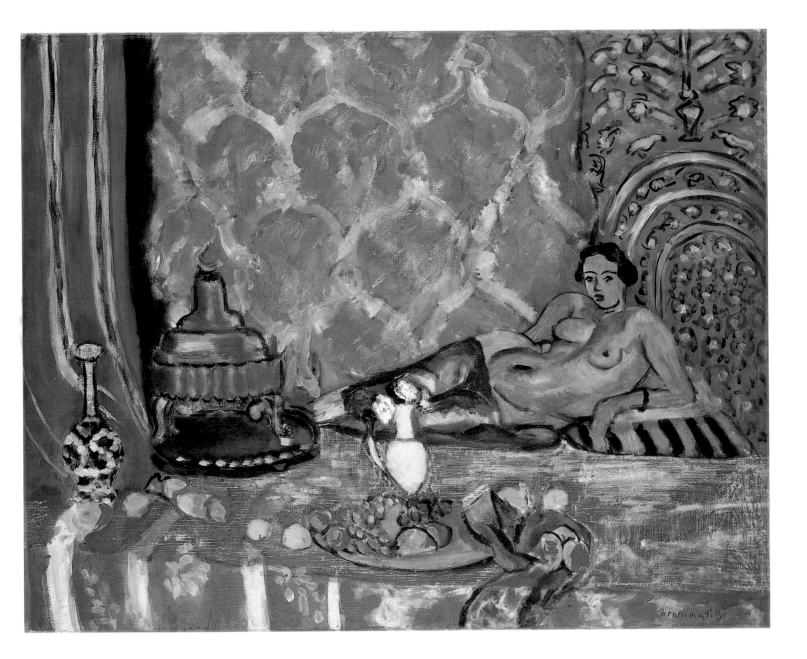

DOCUMENTATION

CAMILLE COROT
French, 1796–1875
The Little Curious Girl, 1850–60
Signed lower right: Corot
Oil on board, 16¼ x 11¼″ (41.4 x 28.5 cm)

PROVENANCE: Gift of the artist to George Camus, Arras, February 24, 1864; Boussod and Valadon, Paris; Sir William Van Horne, Montreal, by 1893; Mrs. William Van Horne, as of 1962.

EXHIBITIONS: Art Association of Montreal, 1893, no. 13, 1908, no. 9, 1912, no. 25; Art Association of Montreal, "A Selection from the Collection of Paintings of the Late Sir William Van Horne, K.C.M.G., 1843–1915," October 16–November 5, 1933, no. 127; The Tate Gallery, London, "The Annenberg Collection," September 2–October 8, 1969, no. 10.

LITERATURE: Alfred Robaut and Etienne Moreau-Nélaton, *L'Oeuvre de Corot* (Paris, 1905), vol. 2, no. 1042 (repro.); John La Farge, *The Higher Life in Art* (New York, 1908), n.p. (repro.); E. Waldmann, "Art in America—Modern French Pictures: Some American Collections," *The Burlington Magazine*, vol. 17 (April–September 1910), p. 65; August F. Jaccaci, "Figure Pieces of Corot in America: I," *Art in America*, vol. 1 (1913), pp. 82, 86 (repro.), 87; "Pictures in Sir William Van Horne's Collection," *The New York Times Magazine*, September 19, 1915, p. 21; C. Bernheim de Villers, *Corot: Peintre de figures* (Paris, 1930), no. 139 (repro.), p. 56; Seymour de Ricci, "L'Incendie dans la collection de Sir William Horne," *Beaux-Arts*, May 14, 1933, p. 4; Charles Wasserman, "Canada's Finest Art Collection," *Mayfair*, vol. 26 (October 1952), repro. p. 53; R. H. Hubbard, *European Paintings in Canadian Collections: II. Modern Schools* (Toronto, 1962), p. 151.

NOTES
1. This remark was made to Camille Pissarro and overheard by Corot's biographer Alfred Robaut; quoted by Jean Dieterle in Wildenstein, New York, "Corot," October 30–December 6, 1969.

2. Alfred Robaut and Etienne Moreau-Nélaton, *L'Oeuvre de Corot* (Paris, 1905), vol. 2, nos. 309 and 550.

3. *Tableaux à la Plume* (Paris), 1880, p. 312; quoted in Charles Sterling and Margaretta M. Salinger, *French Paintings: A Catalogue of the Collection of The Metropolitan Museum of Art*, vol. 2, *XIX Century* (Greenwich, Conn., 1966), p. 65.

4. As listed in Robaut and Moreau-Nélaton, 1905, index, p. 52.

5. Quoted in Denys Sutton, *Edgar Degas: Life and Work* (New York, 1986), p. 96.

6. L. Roger-Milès, *Corot* (Paris, 1891), pp. 84–85.

7. John La Farge, *The Higher Life in Art* (New York, 1908), p. 162.

8. For the critical response to the 1909 exhibition, see, especially, Raymond Bouyer, "Corot: Peintre de figures," *Revue de l'art ancien et moderne*, vol. 26 (July–December 1909), pp. 295–306.

9. This label on the reverse of the painting was recorded by Robaut and Moreau-Nélaton, 1905, vol. 2, no. 1042: "Donné à mon ami M. Camus, fils. C. Corot, ce 24 février 1864." The mahogany backing to which the board is now mounted prevents confirmation that the label is still attached.

10. Ibid.

11. Ibid., vol. 3, nos. 975 and 1341. Camus purchased *The Dreamer at the Fountain* with the intercession of Dutilleux for 600 francs. On June 29, 1861, Corot wrote from Ville d'Ivray to Dutilleux in Arras to assure Mme Camus that he had "not forgotten the little landscape and that it will be sent any minute." Ibid., vol. 4, p. 339, letter no. 123.

12. Charles Baudelaire, *Art in Paris, 1845–1862: Salons and Other Exhibitions Reviewed by Charles Baudelaire*, translated and edited by Jonathan Mayne (Greenwich, Conn., 1965), p. 24.

13. It is tempting to identify *The Little Curious Girl* on the basis of physical resemblance with the eldest daughter of Mme Edouard Delalain (later Mme de Graet), who was the owner of a textile shop on the rue Saint Honoré for whom Corot worked briefly before his career as a painter, and who received him as a friend for more than twenty years. In 1825 Corot had already drawn a portrait of Mme Delalain. Between 1845 and 1850 he made individual portraits of the entire family, including that of the eldest daughter at about age eight (sale, Hôtel Drouet, November 20, 1987, lot 9). A letter written to Dutilleux on September 23, 1853, from the village of Bourberouge in Normandy, mentions Corot's stay with the Delalain family during which time Mlle Delalain may well have served as his model (Robaut and Moreau-Nélaton, 1905, vol. 1, p. 152). This would narrow the suggested period of execution of the painting to a more precise date. Such identification remains, however, speculative until more firmly documented.

14. For the theme of melancholy in Corot's painting, see Antje Zimmermann, "Studien zum Figurenbild bei Corot," Ph.D. diss., University of Cologne, 1986.

15. Baudelaire, 1965, p. 197.

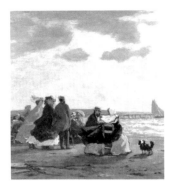

EUGÈNE BOUDIN

French, 1824–1898
On the Beach, Dieppe, 1864
Signed and dated lower right: E. Boudin
 1864
Oil on panel, 12½ x 11½″ (31.7 x 29.2 cm)

PROVENANCE: James McCormick; sale, American Art Association, New York, March 28–30, 1904, lot 158; Daniel G. Reid, New York; W. O. Cole, Chicago; Knoedler and Co., New York.

EXHIBITIONS: Philadelphia Museum of Art, "Exhibition of Philadelphia Private Collectors," summer 1963 (no catalogue); The Tate Gallery, London, "The Annenberg Collection," September 2–October 8, 1969, no. 3.

LITERATURE: Robert Schmit, *Eugène Boudin, 1824–1898* (Paris, 1973; suppl., Paris, 1984), vol. 1, no. 301 (repro.); Jean Selz, *E. Boudin* (Paris, 1982), p. 61 (repro. cover).

FIG. 1 Camille Corot (French, 1796–1875), *A Woman Reading,* 1869, oil on canvas, 21³⁄₈ x 14³⁄₈″ (54.3 x 37.5 cm), The Metropolitan Museum of Art, New York, Gift of Louise Senff Cameron in memory of Charles H. Senff

FIG. 2 Bernard Lépicié (French, 1698–1755) after Jean Siméon Chardin (French, 1699–1779), *Little Girl Playing Badminton,* engraving, 12³⁄₈ x 9¼″ (31.5 x 23.5 cm), Philadephia Museum of Art

FIG. 3 Camille Corot, *Woman with a Pearl,* c. 1868–70, oil on canvas, 27½ x 21½″ (70 x 55 cm), Musée du Louvre, Paris

FIG. 4 Octave Tassaert (French, 1800–1874), *Poor Child,* 1855, oil on canvas, 13 x 9¾″ (33 x 24.8 cm), John G. Johnson Collection at the Philadelphia Museum of Art

FIG. 5 James Abbott McNeill Whistler (American, 1834–1903), *Blue and Silver, Trouville,* 1865, oil on canvas, 23³⁄₈ x 28⁵⁄₈″ (59.3 x 72.8 cm), Freer Gallery of Art, Smithsonian Institution, Washington, D.C.

NOTES

1. Boudin to Martin, June 14, 1869; quoted in G. Jean-Aubry and Robert Schmit, *Eugène Boudin*, translated by Caroline Tisdall (Greenwich, Conn., 1968), p. 74.

2. Charles Baudelaire, "The Salon of 1859," in *Art in Paris, 1845–1862: Salons and Other Exhibitions*, translated and edited by Jonathan Mayne (Greenwich, Conn., 1965), pp. 199–200.

3. Quoted in John Rewald, *The History of Impressionism*, rev. and enl. ed. (New York, 1961), pp. 37–38.

4. Ibid., p. 38.

EUGÈNE BOUDIN
French, 1824–1898
On the Beach, Sunset, 1865
Signed and dated lower right:
 E. Boudin—65
Oil on panel, 14¹⁵⁄₁₆ x 23¹⁄₁₆″ (38 x 58.5 cm)

PROVENANCE: Cadart and Luquet, Paris; Wildenstein and Co., New York.

EXHIBITIONS: Galerie Schmit, Paris, "Eugène Boudin, 1824–1898," May 5–26, 1965, no. 13; The Tate Gallery, London, "The Annenberg Collection," September 2–October 8, 1969, no. 4.

LITERATURE: G. Jean-Aubry and Robert Schmit, *Eugène Boudin* (Paris, 1968), no. 59 (repro.); G. Jean-Aubry and Robert Schmit, *Eugène Boudin,* translated by Caroline Tisdall (Greenwich, Conn., 1968), no. 59 (repro.); Robert Schmit, *Eugène Boudin, 1824–1898* (Paris, 1973; suppl., Paris, 1984), vol. 1, no. 342 (repro.); Jean Selz, *E. Boudin* (Paris, 1982), p. 38 (repro.), p. 61.

NOTES

1. As noted somewhat later by Baedeker, Trouville-sur-Mer (adjoined by the slightly less fashionable Deauville, just across the Touques River) "is one of the most frequented watering-places on the coast of Normandy. The season lasts from July to October and is at its height in August, when living here is extremely expensive." Karl Baedeker, *Northern France,* 5th ed. (Leipzig, 1909), p. 153.

2. Robert Schmit, *Eugène Boudin, 1824–1898* (Paris, 1973; suppl., Paris, 1984), vol. 1, p. XL. See also Joanna Richardson, *La Vie Parisienne, 1852–1870* (New York, 1971), p. 189. Isabey, who is more securely connected with the art and society of the preceding reign of King Louis-Philippe (1830–48), painted anecdotal views of figures on the beaches at these sites.

3. Boudin to Martin, February 12, 1863; quoted in G. Jean-Aubry and Robert Schmit, *Eugène Boudin,* translated by Caroline Tisdall (Greenwich, Conn., 1968), p. 50.

4. Boudin to Martin, August 28, 1867; quoted in ibid., p. 65.

5. Boudin to Martin, September 3, 1868; quoted in ibid., p. 72.

FIG. 6 Eugène Boudin (French, 1824–1898), *Beach Scene at Deauville,* 1865, oil on canvas, 16½ x 25¼″ (42 x 65 cm), Collection of Mr. and Mrs. Paul Mellon, Upperville, Va.

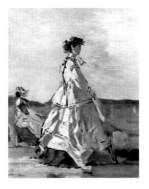

EUGÈNE BOUDIN
French, 1824–1898
Princess Metternich on the Beach,
 c. 1865–67
Oil on paperboard, mounted on
 panel, 11⁹⁄₁₆ x 9¼″ (29.4 x 23.5 cm)

PROVENANCE: Purchased from the artist by
M. Duval, Paris, 1867; Kuenegel, Le Havre;
Wildenstein and Co., New York; Mrs. Ira
Haupt, New York.

LITERATURE: G. Jean-Aubry and Robert
Schmit, *Eugène Boudin* (Paris, 1968), no. 83
(repro.); G. Jean-Aubry and Robert Schmit,
Eugène Boudin, translated by Caroline Tisdall
(Greenwich, Conn., 1968), no. 83 (repro.);
Robert Schmit, *Eugène Boudin, 1824–1898*
(Paris, 1973; suppl., Paris, 1984), vol. 1,
no. 356 (repro.).

NOTES
1. Robert Schmit has recently discovered that
it was bought from Boudin by M. Duval, a
gilder, in 1867. See *Eugène Boudin, 1824–1898*
(Paris, 1973; suppl., Paris, 1984), suppl.,
p. 136.
2. "Elle, toujours elle! Dans la rue, au Casino,
à Trouville, à Deauville, à pied, en voiture,
sur la plage, au bal des enfants, au bal des
grandes personnes, toujours et partout, ce
monstre qui n'est rien et qui n'a rien, ni grâce
ni esprit ni bienfaisance, qui n'a que l'élé-
gance que lui vend, cent mille francs par an,
son costumier...." Edmond and Jules de
Goncourt, *Journal: Mémoires de la vie littér-
aire,* edited by Robert Ricatte (Paris, 1956),
vol. 2 (*1864–1878*), p. 72 (author's trans.).
3. "Avec un nez en trompette, des lèvres en
rebord de pot de chambre, très pâle, l'air
d'un vrai masque de Venise...." Ibid., vol. 1
(*1851–1863*), p. 1268.
4. Quoted in John Rewald, "Un Portrait de la
Princesse Metternich par Edgar Degas,"
L'Amour de l'Art, vol. 3 (March 1937), p. 89.

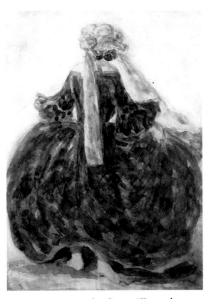

FIG. 7 Constantin Guys (French,
1802–1892), *A Fashionable Woman,*
watercolor on paper, 13½ x 9¼″
(34.2 x 23.4 cm), Phillips Collec-
tion, Washington, D.C.

FIG. 8 Photograph of Princess
Metternich

FIG. 9 Edgar Degas (French,
1834–1917), *Princess Pauline
Metternich,* c. 1861, oil on canvas,
16⅛ x 11³⁄₈″ (41 x 29 cm), National
Gallery, London

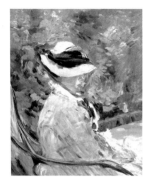

EDOUARD MANET
French, 1832–1883
Mme Manet at Bellevue, 1880
Oil on canvas, 31¾ x 23¾″ (80.8 x 60.5 cm)

PROVENANCE: Suzanne Manet; Max Liebermann, Berlin, by 1902; deposited in Kunsthaus, Zurich, 1933, no. 8; Mr. and Mrs. Kurt Riezler, New York; Mr. and Mrs. Vladimir Horowitz, New York, by 1947.

EXHIBITIONS: Stedelijk Museum, Amsterdam, "Honderd Jaar Fransche Kunst," July 2–September 25, 1938, no. 158; Paul Rosenberg and Co., New York, "Masterpieces by Manet," December 26, 1946–January 11, 1947, no. 9.

LITERATURE: Théodore Duret, *Histoire d'Edouard Manet et de son oeuvre* (Paris, 1902), no. 275; Paul Jamot, Georges Wildenstein, and Marie-Louise Bataille, *Manet* (Paris, 1921), vol. 1, no. 397, fig. 57; Etienne Moreau-Nélaton, Manet catalogue MS., Bibliothèque Nationale, Department des Estampes, Paris, 1926, no. 288; Adolphe Tabarant, *Manet* (Paris, 1931), no. 322; Gotthard Jedlicka, *Edouard Manet* (Erlenbach and Zurich, 1941), repro. opp. p. 301; Adolphe Tabarant, *Manet et ses oeuvres*, 8th ed. (Paris, 1947), p. 385; Fogg Art Museum, Cambridge, Mass., *Drawings from the Collection of Curtis O. Baer*, January 11–February 25, 1958, p. 60; Sandra Orienti, *Tout l'oeuvre peint d'Edouard Manet* (Paris, 1970), no. 313, (repro.); Germain Bazin, *Edouard Manet* (Milan, 1972), repro. p. 81; Karl-Heinz Janda and Annegret Janda, "Max Liebermann als Kunstsammler," in Staatliche Museen zu Berlin, *Forschungen und Berichte*, vol. 15 (1973), pp. 106, 135, no. 64; Denis Rouart and Daniel Wildenstein, *Edouard Manet: Catalogue raisonné* (Lausanne and Paris, 1975), vol. 1, no. 345; Charles F. Stuckey and Naomi E. Maurer, *Toulouse-Lautrec: Paintings* (Chicago, 1979), p. 150, fig. 2; Leal Senádo de Macau and Museu Luís de Camões, Macau, *Femme Assise (Paysage) de Edouard Manet*, April 3–10, 1987, p. 38.

NOTES
1. "Il existe à Bellevue un établissement hydrothérapique, bâti dans une partie du parc de l'ancien château. Les eaux, amenées des sources du Montalais, sont limpides, sans odeur, d'une saveur agréable et d'une assimilati on facile." *La Grande Encyclopédie, inventaire raisonné des sciences, des lettres et des arts*, s.v. "Bellevue."

2. Etienne Moreau-Nélaton, *Manet raconté par lui-même* (Paris, 1926), vol. 2, p. 72. The *Portrait of Emilie Ambre as Carmen* is in the Philadelphia Museum of Art.

3. "Décidément, la campagne n'a de charmes que pour ceux qui ne sont pas forcés d'y rester," Manet wrote to his friend Zacharie Astruc at the beginning of his Bellevue sojourn; quoted in ibid., p. 68. See Adolphe Tabarant, *Manet et ses oeuvres*, 8th ed. (Paris, 1947), pp. 385, 394; and Antonin Proust, *Edouard Manet: Souvenirs* (Paris, 1913), pp. 129–30.

4. The letter, which is undated, is reprinted in Moreau-Nélaton, 1926, vol. 2, p. 73.

5. Manet to Emile Zola, October 15, 1880, published in Françoise Cachin, Charles S. Moffett, and Michel Melot, *Manet, 1832–1883* (New York, 1983), p. 528.

6. Ibid., pp. 423-25.

7. Denis Rouart and Daniel Wildenstein, *Edouard Manet: Catalogue raisonné* (Lausanne, 1975), vol. 2, no. 599 (repro.).

8. This was formerly in the collection of Curtis O. Baer; ibid., no. 409 (repro.).

9. Ibid., no. 425 (repro.).

10. "Album de Photographie," vol. 2, no. 41, The Pierpont Morgan Library, New York, Tabarant Collection.

11. Rouart and Wildenstein, 1975, vol. 2, no. 346; Théodore Duret, *Histoire d'Edouard Manet et de son oeuvre* (Paris, 1902), no. 188 (repro.).

12. The date of sale of this last portrait remains speculative. From an entry in Mme Manet's account book, it is possible that the painting left her personal collection in 1897, fourteen years after the artist's death: "Vendu février 1897 six mille cinq cents francs/le vieux musicien à Camentran [sic]/pour Durand-Ruel/le vieux musicien avec la femme au chapeau de Bellevue"; then two years later, "1 février 1899/Reçu 7 mille francs pour le vieux musicien et l'esquisse Bellevue," "Carnet de comptes de Madame Manet," fols. 11, 31, The Pierpont Morgan Library, New York, Tabarant Collection. Tabarant, 1947, p. 384; and Rouart and Wildenstein, 1975, vol. 2, p. 344, have assumed the Bellevue sketch to be the *Young Woman in the Garden* (location unknown), but the extremely unfinished nature of that work raises the question whether Mme Manet would have been able to sell it at that time. The entries in her account book are too cursory to support either identification categorically, but it is worth pointing out that she had begun selling several of Manet's portraits of her by the mid-1890s.

13. See Cachin et al., 1983, pp. 258–60; Duret, 1902, pp. 38-39; Moreau-Nélaton, 1926, vol. 1, pp. 52-53, 94, and *passim*.

14. One example among many: "sous le toit paternel, elle fut chargée de lui apprendre à promener ses mains sur les touches d'un piano." Moreau-Nélaton, 1926, vol. 1, p. 52.

15. Quoted in ibid., p. 53 (author's trans.).

16. See Georges Jeanniot's account of his visit to Mme Manet in the company of John Singer Sargent, reprinted in Moreau-Nélaton, 1926, vol. 2, p. 107.

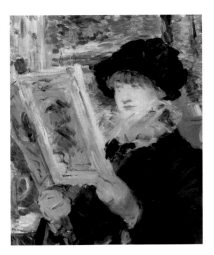

FIG. 10 Edouard Manet (French, 1832–1883), *Reading L'Illustré*, 1879, oil on canvas, 24¼ x 19⅞″ (61.2 x 50.7 cm), The Art Institute of Chicago, Mr. and Mrs. Lewis Larned Coburn Memorial Collection

FIG. 11 Edouard Manet, sketch of Mme Manet in a letter to Henri Guérard, 1880, watercolor and ink, private collection, Paris (courtesy Wildenstein and Co.)

FIG. 12 Edouard Manet, *Mme Manet*, 1880, wash on graph paper, 6⅝ x 5″ (16.8 x 12.7 cm), private collection, Paris (courtesy Wildenstein and Co.)

FIG. 13 Edouard Manet, *Heads of Women*, 1880, ink on paper, 7¹¹⁄₁₆ x 4¾″ (19.5 x 12 cm), Staatliche Graphische Sammlung, Munich

FIG. 14 Edouard Manet, *Sketch of Mme Manet at Bellevue*, 1880, oil on canvas, location unknown (courtesy The Pierpont Morgan Library, New York, Tabarant Collection)

FIG. 15 Edouard Manet, *Portrait of Manet's Mother*, 1880, oil on canvas, 32¼ x 25⁹⁄₁₆″ (82 x 65 cm), location unknown

FIG. 16 Carte de visite of Suzanne Manet, The Pierpont Morgan Library, New York, Tabarant Collection

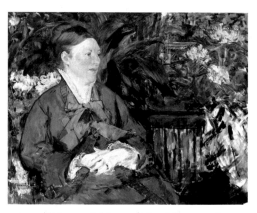

FIG. 17 Edouard Manet, *Mme Manet in the Conservatory*, 1879, oil on canvas, 31⅞ x 39⅜″ (81 x 100 cm), Nasjonalgalleriet, Oslo

EDGAR DEGAS
French, 1834–1917
Italian Woman, 1856–57
Watercolor and pencil on paper, 8¼ x 4⅛″ (20.8 x 10.4 cm)

PROVENANCE: Wildenstein and Co., New York; Mrs. Ira Haupt, New York.

EXHIBITIONS: Wildenstein and Co., New York, "The Great Tradition of French Painting," June–October 1939, no. 59; Wildenstein and Co., New York, "An Exhibition of French XIX Century Drawings," December 10, 1947–January 10, 1948, no. 12; Wildenstein and Co., New York, "A Loan Exhibition of Degas," April 7–May 14, 1949, no. 3.

LITERATURE: Camille Mauclair, *Degas* (New York, 1941), pl. 23; Philippe Brame, Theodore Reff, and Arlene Reff, *Degas et son oeuvre: A Supplement* (New York and London, 1984), no. 10 (repro.).

NOTES
1. See the introduction by Henri Loyrette to Villa Medici, Rome, *Degas e l'Italia*, December 1, 1984–February 10, 1985, pp. 20–25.
2. Theodore Reff, *The Notebooks of Edgar Degas* (Oxford, 1976), vol. 1, p. 72; quoted in Jean Sutherland Boggs et al., *Degas* (New York, 1988), p. 70.
3. Reff, 1976, vol. 1, p. 54 (author's trans.).
4. See, for example, Boggs et al., 1988, pp. 69–70, no. 11.
5. Reff, 1976, vol. 1, p. 72.
6. Moreau to his parents, March 3, 1858, Musée Gustave Moreau, Paris; quoted in Boggs et al., 1988, p. 65.
7. Villa Medici, 1984–85, pp. 22–24.
8. Both Chapu's illustrated letter and watercolor are in the Musée de Melun.
9. Edmond About, *Rome Contemporaine* (Paris, 1861), p. 81 (author's trans.).

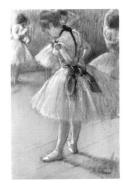

FIG. 18 Edgar Degas (French, 1834–1917), *Italian Peasant Woman*, 1856, pencil and watercolor on paper, Musée du Louvre, Paris, Cabinet des Dessins

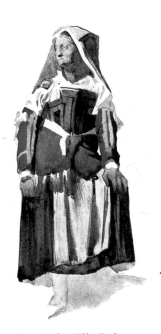

FIG. 19 Jules-Elie Delaunay (French, 1828–1891), *Italian Woman*, 1858, pencil and watercolor on paper, Musée des Beaux-Arts, Nantes

EDGAR DEGAS
French, 1834–1917
The Dancer, c. 1880
Signed lower right: Degas
Pastel, charcoal, and chalk on paper,
12½ x 19¼″ (31.8 x 49 cm)

PROVENANCE: P. Paulin, Paris; Antonio Santamarina, Buenos Aires; sale, Sotheby's, London, April 2, 1974, lot 17.

EXHIBITIONS: Museo Nacional de Bellas Artes, Buenos Aires, "Escuela francesa siglos XIX y XX," October 20–November 5, 1933, no. 30; Galeria Viau, Buenos Aires, "Degas et Lautrec," 1950, no. 4.

LITERATURE: Paul Lafond, *Degas* (Paris, 1919), repro. between pp. 22 and 23; Paul-André Lemoisne, *Degas et son oeuvre* (Paris, 1946), vol. 2, no. 496 (repro.); Fiorella Minervino, *Tout l'oeuvre peint de Degas* (Paris, 1974), no. 515 (repro.); Michel Strauss, ed., *Impressionism and Modern Art: The Season at Sotheby Parke Bernet, 1973–74* (London and New York, 1974), p. 21 (repro.).

NOTES
1. Paul Mantz, "Exposition des oeuvres des artistes indépendants," *Le Temps,* April 14, 1880; quoted in the Fine Arts Museums of San Francisco and the National Gallery of Art, Washington, D.C., *The New Painting: Impressionism, 1874–1886,* January 17–July 6, 1986, p. 324.
2. For discussion of *The Dance Lesson,* see George T. M. Shackelford, *Degas: The Dancers* (Washington, D.C., 1984), pp. 85–91.
3. Ibid., p. 88.
4. Musée d'Orsay, Paris, and The Metropolitan Museum of Art, New York. See Jean Sutherland Boggs et al., *Degas* (New York, 1988), nos. 129 and 130.
5. By George Shackelford in conversation with the author, October 1988. The drawing

is reproduced in Lilian Browse, *Degas Dancers* (Boston, 1949), pl. 121, p. 379. The drawing is dated to c. 1880–83 in her catalogue.

6. Boggs et al., 1988, pp. 405–6. Here, with some reservations, the charcoal drawing is grouped with those made for the later picture.

7. Paul-André Lemoisne, *Degas et son oeuvre* (Paris, 1946; reprint, New York and London, 1984), vol. 3, no. 900.

8. For a similar example, see Richard R. Brettell and Suzanne Folds McCullagh, *Degas in The Art Institute of Chicago* (Chicago, 1984), pp. 92–93.

9. Boggs et al., 1988, nos. 215 and 222.

10. Lillian Moore, "Practice Clothes—Then and Now," *The Ballet Annual*, vol. 14, p. 123.

11. Quoted in George Jeanniot, "Souvenirs sur Degas," *La Revue Universelle*, vol. 55 (October 15, 1933), p. 154 (author's trans.).

12. For example, see the album in the Dance Division of the New York Public Library, *La Danse, vingt dessins de Paul Renouard: Transposés en harmonies de couleurs* (Paris, 1892), in which the publishers announce, rather grandly, "We have tried to capture the special lighting of the theatre and the dance classes of the opera."

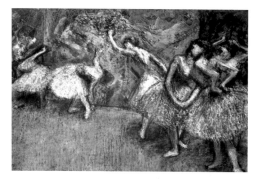

FIG. 20 Edgar Degas (French, 1834–1917), *Ballet Scene*, 1898, pastel on cardboard, 30¼ x 43¾″ (76.8 x 111.2 cm), National Gallery of Art, Washington, D.C., Chester Dale Collection

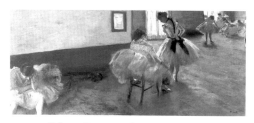

FIG. 21 Edgar Degas, *The Dance Lesson*, 1878–79, oil on canvas, 15 x 34¼″ (38 x 86.3 cm), Collection of Mr. and Mrs. Paul Mellon, Upperville, Va.

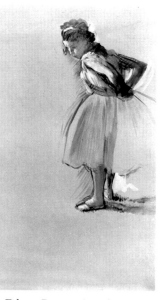

FIG. 22 Edgar Degas, *Standing Dancer Fastening Her Sash*, c. 1873, wash and gouache on paper, 21⅝ x 15″ (55 x 38 cm), private collection, Paris (courtesy Galerie Schmit, Paris)

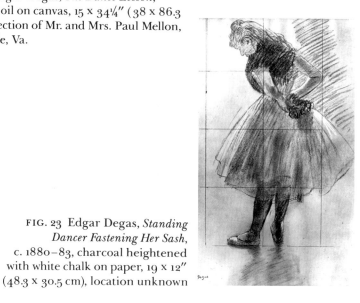

FIG. 23 Edgar Degas, *Standing Dancer Fastening Her Sash*, c. 1880–83, charcoal heightened with white chalk on paper, 19 x 12″ (48.3 x 30.5 cm), location unknown

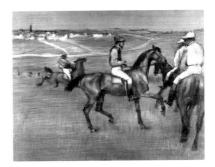

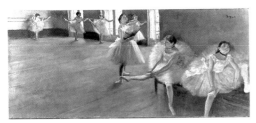

FIG. 24 Edgar Degas *The Dancing Lesson*, 1880, oil on canvas, 15½ x 34¾″ (39.4 x 88.4 cm), Sterling and Francine Clark Art Institute, Williamstown, Mass.

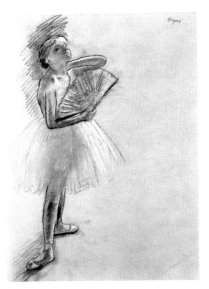

FIG. 25 Edgar Degas, *Dancer with a Fan*, 1880, charcoal and pastel heightened with white chalk on paper, 24 x 16½″ (61 x 41.9 cm), The Metropolitan Museum of Art, New York, Bequest of Mrs. H. O. Havemeyer

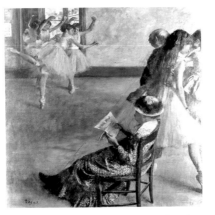

FIG. 26 Edgar Degas, *The Ballet Class*, 1881, oil on canvas, 32⅛ x 30⅛″ (81.6 x 76.5 cm), Philadelphia Museum of Art, The W. P. Wilstach Collection

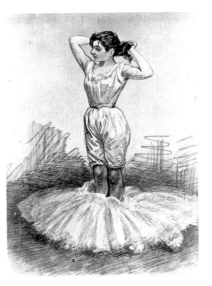

FIG. 27 Paul Renouard (French, 1845–1924), colored lithograph from *La Danse, vingt dessins de Paul Renouard: Transposés en harmonies de couleurs* (Paris, 1892), The New York Public Library, Astor Lenox and Tilden Foundations

EDGAR DEGAS
French, 1834–1917
Race Horses, 1885–88
Pastel on panel, 11⅞ x 16″ (30.2 x 40.5 cm)

PROVENANCE: Théodore Duret, Paris; Duret sale, Galerie Georges Petit, Paris, March 19, 1894, lot 14.

EXHIBITIONS: Wildenstein and Co., New York, "Degas' Racing World," March 21–April 27, 1968, no. 13, introduction, n.p.; The Tate Gallery, London, "The Annenberg Collection," September 2–October 8, 1969, no. 11.

LITERATURE: Paul-André Lemoisne, *Degas et son oeuvre* (Paris, 1946; reprint, New York and London, 1984), vol. 3, no. 852 (repro.); Jean Bouret, *Degas* (New York, 1966), repro. p. 97; Jacques Lassaigne, *Tout l'oeuvre peint de Degas,* translated by Fiorella Minervino (Paris, 1974), no. 706 (repro.); Antoine Terrasse, *Degas* (New York, 1983), repro. pp. 52–53; Jean Sutherland Boggs, "Degas at the Museum: Works in the Philadelphia Museum of Art and John G. Johnson Collection," *Philadelphia Museum of Art Bulletin*, vol. 81, no. 346 (spring 1985), n. 48; Jean Sutherland Boggs et al., *Degas* (New York, 1988), p. 268.

NOTES
1. See Wildenstein and Co., New York, *Degas' Racing World*, March 21–April 27, 1968; Richard Thomson, *The Private Degas* (London, 1987), pp. 92–100; and Denys Sutton, *Edgar Degas: Life and Work* (New York, 1986), pp. 135–60.
2. Paul-André Lemoisne, *Degas et son oeuvre,* 4 vols. (Paris, 1946–49; reprint, New York and London, 1984).
3. Jean Sutherland Boggs et al., *Degas* (New York, 1988), p. 268, where it is mistakenly described as an oil painting on panel.
4. For example, Phillippe Brame and Theodore Reff, *Degas et son oeuvre: A Supplement* (New York, 1984), no. 126: "Jockey, De

Dos," c. 1889, charcoal, pastel, and oil on wood, private collection, Switzerland; and the *Dancer with Raised Arms*, 1891, formerly in the collection of Gisèle Rueff-Béghin (sale, Sotheby's, London, November 29, 1988, lot 4, where it is catalogued as pastel and charcoal on panel); see Douglas W. Druick and Peter Zegers, "Scientific Realism: 1873–1881," in Boggs et al., 1988, pp. 197–211.

5. See Michael Pantazzi's entry on *Race Horses at Longchamp*, Museum of Fine Arts, Boston, in Boggs et al., 1988, pp. 159–60.

6. Thomson, 1987, pp. 93–95; Henri Loyrette in Villa Medici, Rome, *Degas e l'Italia*, December 1, 1984–February 10, 1985, pp. 32–34. It should be noted that the first mutation from the study after Gozzoli to a scene from the track occurs in Degas's fine drawing *At the Races*, c. 1860, in the Sterling and Francine Clark Art Institute, Williamstown, Mass.

7. The sanguine drawing is reproduced in Galerie Georges Petit, Paris, *Catalogue des tableaux, pastels, et dessins par Edgar Degas et provenant de son atelier*, March 8–April 9, 1919, vol. 4, p. 202, no. 237. See Boggs et al., 1988, pp. 266–67.

8. Among them are the erect jockey in profile on the steed after Gozzoli that appears in the center of *Race Horses*, and a rearing horse in the background at an angle to the frieze of jockeys, which occupies a space of its own at the left in *Race Horses*. See Boggs et al., 1988, pp. 101–2. *Race Horses at Longchamp* (Museum of Fine Arts, Boston), painted in 1871 and thought to have been reworked in 1874, developed the striking motif of the paired jockeys, seen from the rear, who step into the composition, which Degas drew upon and rearranged in this pastel (Boggs et al., 1988, pp. 159–60).

9. Boggs et al., 1988, pp. 268–69. *Race Horses* (fig. 32, private collection) was actually painted by 1872, since it was in Ferdinand Bischoffsheim's collection by May 1 of that year when he exchanged it with Durand-Ruel. The baritone and collector Jean-Baptiste Faure returned the painting to Degas,

who reworked it between 1876 and 1878. This information was supplied by Michael Pantazzi from the Durand-Ruel Archives.

10. Theodore Reff, *The Notebooks of Edgar Degas*, 2nd rev. ed. (New York, 1985), vol. 1, p. 143, Notebook 35, fols. 17, 19.

11. Ibid., where the sketches are described as studies for the pastel in Zurich (Lemoisne, 1984, vol. 3, no. 850) and the painting in Providence (Lemoisne, 1984, vol. 3, no. 889); see Ronald Pickvance in Wildenstein and Co., 1968, no. 49. Lepic's noble bearing and full beard are features that are not shared by the squat, ferret-faced jockey in the Zurich pastel, despite the kinship of pose. The drawing of Lepic (fig. 33), which has been dated to 1882, is far closer to a variant of the Zurich composition, *Before the Race*, 1882–88 (oil on paper on panel, Collection of Mrs. John Hay Whitney), which in turn is similar in handling and atmosphere to the Annenberg *Race Horses*.

Even the landscape in *Race Horses* may be related to nature studies Degas had made decades before. The rolling hills and church tower among a cluster of old buildings compare with his views of Exmes (1861, Bibliothèque Nationale, Paris, Notebook 18, p. 169), a medieval village in Normandy near the French stud farm at Haras-du-Pin. Degas made his first visit there in September–October 1861, when he stayed with his friends the Valpinçons at their country house at Ménil-Hubert. See Reff, 1985, vol. 1, p. 98, Notebook 18.

12. Galerie Georges Petit, Paris, *Catalogue des tableaux et pastels composant la collection de M. Théodore Duret*, March 19, 1894, pp. 13–17, nos. 9–16.

13. Lemoisne, 1984, vol. 2, no. 503, vol. 3, nos. 774, 1107, where the provenance to Duret is not recorded.

14. In conversation with the author, Michael Pantazzi noted that Duret acquired a dancer from Durand-Ruel for 2,000 francs, on December 21, probably in 1888 (Durand-Ruel stock no. 1699). The year is not given, but Degas had deposited a dancer with

Durand-Ruel on August 6, 1888.

15. Julie Manet noted in her diary that Manet's portrait of her mother, *Repose*, did not make more than 11,000 francs. See *Journal (1893–1899)* (Paris, 1979), p. 30, where she also noted, "In this collection we also saw *Race Horses* by Degas and *Dancers* so beautifully drawn by this great master" (author's trans.).

Attending the sale at Georges Petit's gallery, Degas is reported to have berated Duret: "You glorify yourself as having been one of our friends. You have pasted up signs all over Paris: *Duret Sale*. I won't shake hands with you. Besides, your auction will fail." Daniel Halévy recorded Degas's acerbic comments in *My Friend Degas*, translated by Mina Curtiss (Middletown, Conn., 1964), p. 94. Three works by Degas were purchased by Durand-Ruel, while the Annenberg pastel, which fell below Duret's reserve of 2,000 francs, nonetheless fetched the decent sum of 1,400 francs. These prices and estimates are taken from the sales catalogue annotated by the Philadelphia collector John G. Johnson, who was present at the Duret sale (John G. Johnson Collection at the Philadelphia Museum of Art).

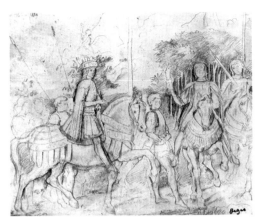

FIG. 28 Edgar Degas (French, 1843–1917), after Benozzo Gozzoli (Italian, c. 1421–1497), *The Journey of the Magi,* 1859–60, pencil on paper, 10⅝₁₆ x 12″ (26.2 x 30.5 cm), The Harvard University Art Museums, Cambridge, Mass., Gift of Henry S. Bowers

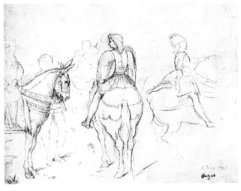

FIG. 30 Edgar Degas, *The Patriarch Joseph of Constantinople and His Attendants,* after Benozzo Gozzoli, *The Journey of the Magi,* 1859–60, pencil on paper, 10 x 12¾″ (25.5 x 32.6 cm), Rijksmuseum, Amsterdam

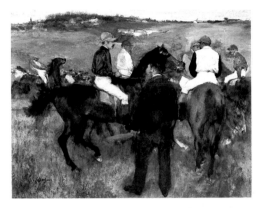

FIG. 32 Edgar Degas, *Race Horses,* 1871–72, reworked 1876–78, oil on panel, 12⅝ x 15⅞″ (32.5 x 40.4 cm), private collection

FIG. 29 Edgar Degas, *Horse,* mid-1860s, sanguine on paper, 7½ x 10¹¹⁄₁₆″ (19 x 27 cm), location unknown (from Galerie Georges Petit, Paris, *Catalogue des tableaux, pastels, et dessins par Edgar Degas et provenant de son atelier,* March 8–April 9, 1919, vol. 4, p. 202, no. 237)

FIG. 31 Edgar Degas, *Three Studies of a Mounted Jockey,* c. 1866–68, pencil on paper, 7½ x 10¼″ (19 x 26 cm), The Harvard University Art Museums, Cambridge, Mass., Grenville L. Winthrop Bequest

FIG. 33 Edgar Degas, *Portrait of Baron Lepic,* 1882, black chalk on paper, 11⅞ x 9″ (30.2 x 22.8 cm), private collection (courtesy Wildenstein and Co.)

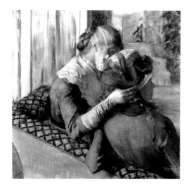

EDGAR DEGAS
French, 1834–1917
At the Milliner's, 1881
Signed lower right: Degas
Pastel on five pieces of wove paper
 joined together, backed onto another
 layer of paper and mounted on linen,
 27¼ x 27¼″ (70 x 70 cm)

PROVENANCE: Delivered by the artist to
Durand-Ruel, Paris, on October 12, 1881;
purchased from Durand-Ruel by Charles
Ephrussi, April 21, 1882; returned on deposit
by Charles Ephrussi to Durand-Ruel on April
24, 1895; purchased by Durand-Ruel, April
7, 1896; Joseph Durand-Ruel Collection;
inherited by his daughter, Mrs. d'Alayer de
Costemore d'Arc, New York.

EXHIBITIONS: Grafton Galleries, London,
"A Selection from the Pictures by Boudin,
Cézanne, Degas, Manet, Monet ... Exhibited
by Messrs. Durand-Ruel," January–February
1905, no. 65; Galeries Georges Petit, Paris,
"Exposition Degas," April 12–May 2, 1924,
no. 150; Galeries Durand-Ruel, Paris, "Quel-
ques oeuvres importantes de Corot à van
Gogh," May 11–June 16, 1934, no. 10; Durand-
Ruel Galleries, New York, "The Four
Great Impressionists: Cézanne, Degas, Ren-
oir, Manet," March 27–April 13, 1940, no. 10;
Durand-Ruel Galleries, New York, "Pastels by
Degas," March 1–31, 1943, no. 7;
Durand-Ruel Galleries, New York, "Degas,"
November 10–29, 1947, no. 8; Philadelphia
Museum of Art, "Exhibition of Philadelphia
Private Collectors," summer 1963 (no cata-
logue); The Tate Gallery, London, "The
Annenberg Collection," September 2–
October 8, 1969, no. 12.

LITERATURE: Georges Grappe, *Edgar
Degas, L'art et le beau*, 3rd year, vol. 1 (Paris,
1908), p. 58; Paul Jamot, *Degas* (Paris, 1924),
no. 68 (repro.); René Huyghe, "Degas ou la
fiction réaliste," *L'Amour de l'art*, no. 7 (July

1931), p. 282, fig. 23; R.H. Wilenski, *Modern
French Painters* (New York, 1940), p. 333; M.
Rebatet, *Degas* (Paris, 1944), pl. 60; Paul-
André Lemoisne, *Degas et son oeuvre* (Paris,
1946; reprint, New York and London, 1984),
vol. 3, no. 827 (repro.); Robert Rey, *Degas*
(Paris, 1952), pl. 52; Pierre Cabanne, *Edgar
Degas* (Paris and New York, 1958), no. 109
(repro.); Jean Bouret, *Degas* (New York,
1965), repro. p. 169; Jacques Lassaigne, *Tout
l'oeuvre peint de Degas*, translated by Fiorella
Minervino (Paris, 1974), no. 637 (repro.);
René Huyghe, *La Relève du réel: Impression-
nisme, symbolisme* (Paris, 1974), fig. 77;
Antoine Terrasse, *Degas* (New York, 1983),
fig. 2; Richard R. Brettell and Suzanne Folds
McCullagh, *Degas in The Art Institute of Chi-
cago* (Chicago and New York, 1984), p. 133;
Robert Gordon and Andrew Forge, *Degas*
(New York, 1988), repro. p. 129; Jean Suther-
land Boggs et al., *Degas* (New York, 1988),
p. 397, fig. 210.

NOTES
1. See Jean Sutherland Boggs et al., *Degas*
(New York, 1988), p. 397, fig. 210.

2. See Gary Tinterow's analysis of the devel-
opment of Degas's style in the 1880s, in ibid.,
pp. 363–74.

3. Ibid., p. 365.

4. Michael Pantazzi, who was responsible for
discovering much of the new information
presented in this entry, first suggested this in
conversation with the author, November
1988.

5. For two related milliners, see Paul-André
Lemoisne, *Degas et son oeuvre* (Paris, 1946;
reprint, New York and London, 1984), vol. 2,
nos. 683 and 693. See Gary Tinterow's dis-
cussion in Boggs et al., 1988, pp. 376–77.

6. Degas's revealing letter to his good friend,
Evariste de Valernes, is in Marcel Guérin, ed.,
Lettres de Degas (Paris, 1945), p. 179, dated to
October 26 [1890] (author's trans.).

7. Mirbeau's extremely interesting text,

"Notes sur l'art: Degas," first published in *La
France*, November 15, 1884, is reprinted in
Gary Tinterow, "Mirbeau on Degas: A Little-
Known Article of 1884," *The Burlington Mag-
azine*, vol. 130 (March 1988), p. 230 (author's
trans.).

8. Degas used this term, in English, in a letter
probably from April/May 1879 to Bracque-
mond. See *Lettres de Degas*, 1945, p. 43.

9. Tinterow's observation that women in the
milliner's series are defined to a "remarkable
degree" by their hats (Boggs et al., 1988, p.
400) does not apply to the Annenberg pas-
tel and serves to emphasize its enigmatic
qualities. In recent literature, it has been
wrongly assumed that Degas is showing a
client and a shop assistant in this pastel; see,
for example, Richard R. Brettell and
Suzanne Folds McCullagh, *Degas in The Art
Institute of Chicago* (Chicago and New York,
1984), p. 133; and, more generally, Eunice
Lipton, *Looking into Degas: Uneasy Images of
Women and Modern Life* (Berkeley, 1986), p.
153, "there is not a single painting of a milli-
nery shop by Degas which does not include
some reference to the milliner."

10. Zola described the large room where
clients tried on the latest fashions as compa-
rable to "the commonplace salon of a hotel,"
in which the shop assistants paraded "with-
out ever sitting down on any of the dozen or
so chairs reserved exclusively for the clients"
(Emile Zola, *Au Bonheur des Dames*, ed. Gar-
nier-Flammarion [Paris, 1971], p. 122). When
the vindictive supervisor Bourdoncle needs
to find reasons to lay off assistants during the
habitually quiet months, being found seated
is a sufficient infraction for dismissal: "You
were sitting down, ... go and pack your bags!"
Ibid., p. 182.

Eugéne Manet informed his wife in a letter
of December 1891 that Degas had ironically
suggested that Charpentier produce a special
edition of *Au Bonheur des Dames* for New
Year's Day with samples of ribbons and lace
trimmings attached. Denis Rouart, ed., *The

Correspondence of Berthe Morisot with Her Friends Manet, Puvis de Chavannes, Degas, Monet, Renoir, and Mallarmé, translated by Betty W. Hubbard (London, 1968), p. 188.

11. For Huysmans's review of the Fifth Impressionist Exhibition of 1880, first published in *L'Art Moderne*, 1883, see J. K. Huysmans, *L'Art moderne: Certains, Fins de Siècles* (Paris, 1975), p. 130.

12. Theodore Reff, *The Notebooks of Edgar Degas* (London, 1976; 2nd rev. ed., New York, 1985), vol. 1, pp. 37, 39.

13. Jacques-Emile Blanche, *Propos de peintre, I, De David à Degas* (Paris, 1919), quoted by Tinterow in Boggs et al., 1988, p. 374.

14. Quoted in Tinterow, 1988, p. 230 (see note 7 above).

15. Charles Ephrussi, "Exposition des Artistes Indépendants," *Gazette des Beaux-Arts*, 22nd year, 2nd period, vol. 21 (May 1, 1880), p. 486 (author's trans.).

16. Ronald Lightbown, *Sandro Botticelli* (Berkeley, 1978), vol. 2, pp. 60–61. The sale was made in February 1882 and Ephrussi published the frescoes in the *Gazette des Beaux-Arts* later that year.

17. With the exception of Boggs et al., 1988, and Robert Gordon and Andrew Forge, *Degas* (New York, 1988), all previous literature has agreed in dating the Annenberg pastel to 1885, the year Durand-Ruel must have assigned to it when *At the Milliner's* was first publicly exhibited in 1905. Gary Tinterow has dated it to between 1882–84 (Boggs et al., 1988, p. 397), and this has been followed by Gordon and Forge.

18. See Philippe Kolb and Jean Adhémar, "Charles Ephrussi (1849–1905), ses secrétaires: Laforgue, A. Renan, Proust," *Gazette des Beaux-Arts*, 126th year, 6th period, vol. 103 (1984), pp. 29–41.

19. Edmond and Jules Goncourt, *Journal: Mémoires de la vie littéraire*, edited by Robert Ricatte (Paris, 1956), vol. 3, p. 116 (author's trans.).

20. *Lettres de Degas*, 1945, pp. 59–60 (author's trans.). The text is not entirely clear: in referring to "le tableau d' Ephrussi" Degas could simply mean Ephrussi's painting, rather than the painting of Ephrussi (i.e. his portrait).

21. The letter is not dated but was presumably written in early June 1880. Ibid., p. 48.

22. Ibid., pp. 66–67; Degas's letter to M. Blanche, dated 1882, concludes, "Write to Ephrussi: he will tell you what to write, he will tell us how to act" (author's trans.).

23. Rouart, ed., 1968, p. 127. The letter is from late March/April 1882, the time of the Seventh Impressionist Exhibition. Compare Boggs et al., 1988, p. 381.

24. Michael Pantazzi has suggested that the unfinished "tableau d'Ephrussi" might relate to the pastel of the *Seated Man Reading*, Lemoisne, 1984, vol. 2, no. 655, which is clearly a portrait. The "Assyrian" profile of the sitter aligns well with the elegantly bearded figure in Léon Bonnat's portrait of him (c. 1895, private collection, Paris); Laforgue remembered Ephrussi as having "a finely trimmed beard"; and Kolb and Adhémar, 1984, p. 29, noted that he used to write during the day in a Chinese dressing gown, which also appears in this pastel.

25. *Oeuvres complètes de Jules Laforgue* (Paris, 1917–30), vol. 4, p. 42, letter dated December 5, 1881.

26. Boggs et al., 1988, pp. 165–66.

27. The point is also made in Kolb and Adhémar, 1984, pp. 31–32.

28. For reference to the Durand-Ruel stock books I am greatly indebted to Michael Pantazzi, who placed this unpublished material at my disposal.

29. Durand-Ruel, Paris, "Livre de Stock," 1880–82, October 12, 1881, "no. 1923, coin de salon"; Durand-Ruel, Paris, Journal, February 2, 1880–November 30, 1881, fol. 125, Durand-Ruel Archives, Paris, "à Degas n[otre] achat de s.[on] pastel, no. 1923."

30. Durand-Ruel, Paris, Journal, December 1,

1881–October 15, 1889, fol. 29, April 21, 1882, "Ephrussi s.[on] achat d'un pastel de Degas, no. 1923, 2,000 f."

31. Durand-Ruel, Paris, "Tableaux Reçus en Depot," July 1893–October 1895, April 24, 1895, "no. 8648, Conversation. Pastel."

32. Durand-Ruel, Paris, Journal, June 1, 1893–January 31, 1899, fol. 311, "7 April, 1896, à Ephrussi, 11 av. d'Iena, acheté *La Conversation/La Conversation* [crossed out] *Chez La Modiste*, payé sa facture de ce jour, 8000 f."; Durand-Ruel, Paris, "Tableaux Existant au 31 Août 1901," "*Chez La Modiste*, 7 April 1896, 40,000 f."

33. Boggs et al., 1988, p. 400. If the Chicago *Millinery Shop* is regarded as the terminus of this series, the Annenberg pastel has claims as its starting point.

34. Ibid., p. 248, n. 5, where the identification of the work exhibited in 1876 with *Mme Jeantaud before a Mirror* (Musée d'Orsay, Paris) is rejected on the basis of Salon criticism.

35. Ibid., pp. 320–22, 337–39, 334–45.

36. See the introduction by Colette Becker to Emile Zola, *Au Bonheur des Dames*, Garnier-Flammarion ed. (Paris, 1971), p. 18.

37. *Lettres de Degas*, 1945, pp. 59–60. Mary Cassatt's famous comment that Degas used her as a model "when he finds the movement difficult, and the model cannot seem to get his idea" could also apply to *At the Milliner's* (see Louisine W. Havemeyer, *Sixteen to Sixty: Memoirs of a Collector* [New York, 1961], p. 258). For Cassatt's portrait of Lydia wearing comparable gloves, see The Fine Arts Museums of San Francisco and the National Gallery of Art, Washington, D.C., *The New Painting: Impressionism, 1874–1886*, January 17–July 6, 1986, p. 358.

38. George Moore, "Memoirs of Degas," *The Burlington Magazine*, vol. 32 (January 1918), p. 64.

39. M. Griffith, "Paris Dressmakers," *The Strand Magazine*, vol. 8 (July–December

1894), pp. 744–51. I am grateful for this reference to Dilys Blum, Curator of Costume and Textiles at the Philadelphia Museum of Art.

40. *Paul Gauguin's Intimate Journals*, translated by Van Wyck Brooks (New York, 1936), p. 133. Joseph Rishel kindly provided this reference.

41. Degas referred to "le jeune et beau Sickert" in a letter to Ludovic Halévy, dated September 1885; see *Lettres de Degas,* 1945, p. 109; Walter Sickert, "Degas," *The Burlington Magazine*, vol. 31 (November 1917), p. 185.

FIG. 34 Edgar Degas (French, 1834–1917), *At the Milliner's*, 1882, pastel on paper, 29⅞ x 33⅜″ (75.9 x 84.8 cm), Thyssen-Bornemisza Collection, Lugano

FIG. 35 The white lines indicate the separate pieces of paper from which Degas built his composition for *At the Milliner's*

FIG. 36 Edgar Degas, *At the Milliner's*, 1882, pastel on paper, 25⅝ x 19⅝″ (65 x 50 cm), location unknown

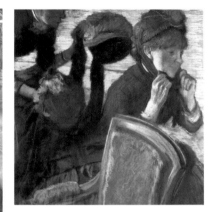

FIG. 37 Edgar Degas, *At the Milliner's*, 1882, pastel on paper, 27⅝ x 27¾″ (70.2 x 70.5 cm), The Museum of Modern Art, N.Y., Gift of Mrs. David M. Levy

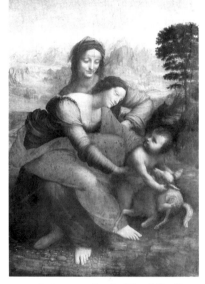

FIG. 38 Leonardo da Vinci (Italian, 1452–1519), *The Virgin and Child with Saint Anne*, c. 1510, oil on panel, 66⅛ x 51⅛″ (168 x 130 cm), Musée du Louvre, Paris

138

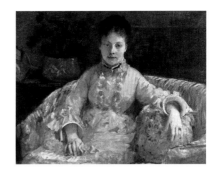

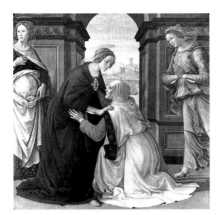

FIG. 39 Domenico Ghirlandaio (Italian, 1449–1494), *The Visitation*, oil on panel, 67¾ x 65″ (172 x 165 cm), Musée du Louvre, Paris

FIG. 41 *The Young Ladies' Room in Mr. Félix's Establishment*, photograph, 1894 (*The Strand Magazine*, vol. 8 [July–December 1894], p. 749)

FIG. 40 Mary Cassatt (American, 1844–1926), *Lydia in the Garden*, 1880, oil on canvas, 26 x 37″ (66 x 94 cm), The Metropolitan Museum of Art, N.Y., Gift of Mrs. Gardner Cassatt

FIG. 42 *The Fashion Hall in Mr. Félix's Establishment*, photograph, 1894 (*The Strand Magazine*, vol. 8 [July–December 1894], p. 749)

BERTHE MORISOT

French, 1841–1895
The Pink Dress, c. 1870
Signed, indistinctly, lower right: Berthe
 Mor…
Oil on canvas, 21½ x 26½″ (54.6 x 67.2 cm)

PROVENANCE: The sitter; Antonio Santa-marina, Buenos Aires, by 1933; [Santamarina Collection] sale, Sotheby's, London, April 2, 1974, lot 13.

EXHIBITIONS: Museo Nacional de Bellas Artes, Buenos Aires, "Escuela francesa siglos XIX y XX," October 20–November 5, 1933, no. 84; Museo Nacional de Bellas Artes, Buenos Aires, "La Pintura Francesa—de David a nuestros días—Oleos, Dibujos y Acuarelas," October–December, 1939, no. 103; Museo Nacional de Bellas Artes, Buenos Aires, "El Impresionismo Frances en las Colecciones Argentinas," September–October, 1962, no. 38.

LITERATURE: Jacques-Emile Blanche, "Les Dames de la Grande-Rue," *Les Ecrits Nou-veaux*, January–February 1920, pp. 19–20; Monique Angoulvent, *Berthe Morisot* (Paris, 1933), p. 120, no. 50; René Huyghe, *La Pein-ture française de 1800 à nos jours* (Paris, 1939), p. 48 (repro.); Marie-Louise Bataille and Georges Wildenstein, *Berthe Morisot: Cata-logue des peintures, pastels, et aquarelles* (Paris, 1961), no. 31, fig. 104; Denis Rouart, ed., *The Correspondence of Berthe Morisot with Her Friends Manet, Puvis de Chavannes, Degas, Monet, Renoir, and Mallarmé* (London, 1986), p. 216, n. 46; The Fine Arts Museums of San Francisco and the National Gallery of Art, Washington, D.C., *The New Painting: Impres-sionism, 1874–1886*, January 17–July 6, 1986, p. 354, n. 58; Charles F. Stuckey, William P. Scott, and Suzanne G. Lindsay, *Berthe Morisot: Impressionist* (New York, 1987), pp. 26–27.

NOTES

1. See Charles F. Stuckey, William P. Scott, and Suzanne G. Lindsay, *Berthe Morisot: Impressionist* (New York, 1987), p. 16; Stéphane Mallarmé, preface, in Durand-Ruel, Paris, *Berthe Morisot (Madame Eugène Manet): Exposition de son oeuvre*, March 5–21, 1896, p. 7. Bill Scott, Suzanne Lindsay, and Chittima Amornpichetkul have generously shared both ideas and unpublished material on Morisot with me.

2. Denys Sutton, "Jacques-Emile Blanche: Painter, Critic, and Memorialist," *Gazette des Beaux-Arts*, 130th year, 4th period, vol. 111 (January–February 1988), pp. 159–72.

3. Jacques-Emile Blanche, "Les Dames de la Grande-Rue: Berthe Morisot," *Les Ecrits Nouveaux*, January–February 1920, pp. 16–24; Jacques-Emile Blanche, *Passy* (Paris, 1928), especially chapter 4, "La Villa Fodor," pp. 50–51; see also Monique Angoulvent, *Berthe Morisot* (Paris, 1933), pp. 42–44.

4. Blanche, 1920, p. 19.

5. Ibid., pp. 19–20.

6. Ibid., p. 20.

7. Mallarmé, in Durand-Ruel, 1896, p. 6.

8. Blanche, 1920, p. 18; Blanche, 1928, p. 52.

9. Blanche, 1920, p. 18.

10. Ibid., p. 20.

11. "Certain jour de 1867, Mlle Marguerite me ramenant par la rue Franklin, ... présenta le tout petit garçon que j'étais à 'mademoiselle Berthe,' qui, assise sur un pliant, peignait un pastel en plein air." Ibid., p. 19.

12. In the notes by Kathleen Adler and Tamar Garb accompanying the most recent English edition of Morisot's correspondence the authors stated incorrectly that Mlle Valentine posed for *The Pink Dress*. Denis Rouart, ed., *The Correspondence of Berthe Morisot with Her Family and Her Friends Manet, Puvis de Chavannes, Degas, Monet, Renoir, and Mallarmé* (London, 1986), p. 219, n. 46. For Valentine's brief career as Manet's model see ibid., pp. 51–52; and Charles S. Moffett's

entry on *In the Garden* in Françoise Cachin, Charles S. Moffett, and Michel Melot, *Manet, 1832–1883* (New York, 1983), pp. 318–20.

13. "Mairie du 16ᵉ Arrondissement de Paris, Acte de Mariage," Paris, November 10, 1897, "Himmes et Carré," p. 879.

14. "Les dits futurs, alliés au degré de beau-frère et belle-soeur, munis d'une dispense obtenue du Governement, à la date du 12 Octobre dernier." Ibid. Louise-Valentine Carré had died on August 25, 1896, age forty-nine. This information was very kindly supplied by Bill Scott, who checked the records of the Passy Cemetery.

15. Julie Manet, *Journal (1893–1899): Sa jeunesse parmi les peintres impressionnistes et les hommes de lettres* (Paris, 1979), p. 138, entry dated October 25, 1897 (author's trans.). Compare her comments following the wedding ceremony: "Le mariage Himmes-Carré m'a produit une triste impression, je plaignais les conjoints; puis j'ai pensé à l'émotion que me produiraient les mariages de Paule et de Jeannie." Ibid., p. 140, entry dated November 11, 1897.

16. Mme Rouart-Valéry's mother, Jeanne Gobillard (Morisot's niece), recorded Mme Himmes's consternation in a journal entry for March 6, 1919; letter of Mme Rouart-Valéry to the author, June 28, 1988.

17. "Mairie du 16ᵉ Arrondissement de Paris, Acte de Décès," Paris, January 31, 1935, "Carré, Veuve Himmes"; ibid., "Himmes," August 31, 1917.

18. "Ne croyez pas, chère madame, que je fusse si monstrueux que d'avoir noté ces détails à l'âge que j'avais sous l'Empire." Blanche, 1920, p. 20.

19. Stuckey, Scott, and Lindsay, 1987, pp. 26–27; Cachin et al., 1983, pp. 258–60.

20. Rouart, ed., 1986, p. 30.

21. See Cachin et al., 1983, pp. 258–60.

22. For Mme Morisot's letter to her daughter Edma, see Rouart, ed., 1986, p. 34. The issue is complicated by the vagueness of the com-

ment: Mme Morisot might be referring to Manet's *Mme Manet at the Piano* (Musée d'Orsay, Paris), though this has been dated by Cachin to 1867/68.

23. Cachin et al, 1983, p. 315.

24. Stuckey, Scott, and Lindsay, 1987, pp. 31–33.

25. Blanche, 1920, pp. 18, 20.

26. "Do you want to send the pastels you did in London? You might add the one of Marguerite Carré." Rouart, ed., 1986, p. 109. In the end Eugène Manet read the stipulations more carefully: only paintings were accepted. This pastel was last recorded by Angoulvent in the collection of the Galerie L. Dru, Paris. See Angoulvent, 1933, no. 51, p. 120.

27. Angoulvent, 1933, no. 88, p. 122; Manet, 1979, p. 85, where Julie described the painting as "Mlle Carré en blanc, très gentille." The best reproduction is found in Wildenstein, New York, *Loan Exhibition of Paintings: Berthe Morisot*, November 3–December 10, 1960, no. 8. The identity of the young woman as Marguerite Carré is confirmed with absolute certainty by an entry in one of Julie Manet's unpublished notebooks (private collection, Paris), which lists the painting as representing "Mme Himmes alors Marguerite Carré." Information graciously supplied by Chittima Amornpichetkul.

28. See Rouart, ed., 1986, p. 116, where the traditional view is stated. Reservations were first made in the annotations to the Sixth Impressionist Exhibition catalogue reprinted in The Fine Arts Museums of San Francisco and the National Gallery of Art, Washington, D.C., *The New Painting: Impressionism, 1874–1886*, January 17–July 6, 1986, p. 354.

29. Nina de Villars, "Variétés: Exposition des artistes indépendants," *Le Courrier du Soir*, April 23, 1881, "Mme Berthe Morisot envoie une délicieuse *Femme en rose*, blonde, vaporeuse, les yeux aussi bleus que les turquoises qui ornent ses mignonnes oreilles." I am

grateful to Suzanne Lindsay for bringing this passage to my attention.

30. Galerie Durand-Ruel, Paris, "Exposition Berthe Morisot," April 23–May 10, 1902, no. 46; Bernheim-Jeune, Paris, "Cent oeuvres de Berthe Morisot (1841–1895)," November 7–22, 1919, no. 59. For Mme Hubbard see Stuckey, Scott, and Lindsay, 1987, pp. 62–64; *The Portrait of Mme Heude* is reproduced in Marie-Louise Bataille and George Wildenstein, *Berthe Morisot: Catalogue des peintures, pastels, et aquarelles* (Paris, 1961), no. 21, fig. 105.

FIG. 44 Edouard Manet, *Reading*, 1865–73, oil on canvas, 24 x 29¼″ (61 x 74 cm), Musée d'Orsay, Paris

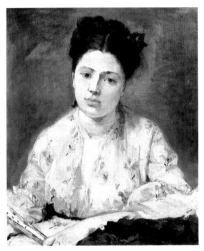

FIG. 46 Berthe Morisot, *Portrait of Jeanne-Marie*, 1871, oil on canvas, 21⅝ x 17⅜″ (55 x 54 cm), private collection, Paris (courtesy Robert Schmit, Paris)

FIG. 43 Edouard Manet (French, 1832–1883), *In the Garden*, 1870, oil on canvas, 17½ x 21¼″ (44.5 x 54 cm), The Shelburne Museum, Vt.

FIG. 45 Berthe Morisot (French, 1841–1895), *Two Seated Women (The Sisters)*, c. 1869–75, oil on canvas, 20½ x 32″ (52.1 x 81.3 cm), National Gallery of Art, Washington, D.C., Gift of Mrs. Charles S. Carstairs

FIG. 47 Berthe Morisot, *Young Woman in a Ballgown*, 1873, oil on canvas, 14½ x 12¼″ (36.8 x 31.8 cm), private collection, Paris (courtesy Wildenstein and Co.)

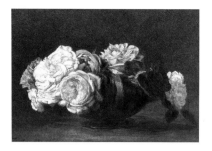

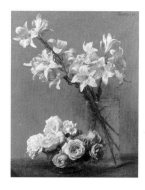

HENRI FANTIN-LATOUR
French, 1836–1904
Roses in a Bowl, 1883
Signed and dated lower left: Fantin 83
Oil on canvas, 11¾ x 16⅜″ (29.9 x 41.6 cm)

PROVENANCE: Mrs. Edwin Edwards, London; Carlos Guinle, Rio de Janeiro.

EXHIBITION: The Tate Gallery, London, "The Annenberg Collection," September 2–October 8, 1969, no. 13.

LITERATURE: Mme Fantin-Latour, ed., *Catalogue de l'oeuvre complet (1849–1904) de Fantin-Latour* (Paris, 1911), no. 1126.

NOTES
1. Frederick Wedmore, *Whistler and Others* (New York, 1906), pp. 36–37.
2. Douglas Druick and Michel Hoog, *Fantin-Latour* (Ottawa, 1983), pp. 13, 18, 113–18, and *passim*.
3. Ibid., pp. 256–57.
4. Jacques-Emile Blanche, "Fantin-Latour," *Revue de Paris*, May 15, 1906, p. 311; cited in ibid., p. 265.
5. Ibid., p. 266, This telling comment from a letter Fantin wrote to Edwards on May 26, 1875, is pertinent in connection with *Roses in a Bowl*.
6. As recalled by Paul Poujaud. See Marcel Guérin, ed., *Lettres de Degas* (Paris, 1945), p. 256 (author's trans.).
7. Blanche, 1906; cited in Michel Faré, *La Nature morte en France* (Geneva, 1962), vol. 1, p. 269.
8. John W. McCoubrey, "The Revival of Chardin in French Still-Life Painting, 1850–1870," *The Art Bulletin*, vol. 46, no. 1 (March 1964), pp. 48–49.

FIG. 48 Henri Fantin-Latour (French, 1836–1904), *Portrait of Mr. and Mrs. Edwin Edwards*, 1875, oil on canvas, 51½ x 38⅝″ (130.5 x 98 cm), The Tate Gallery, London

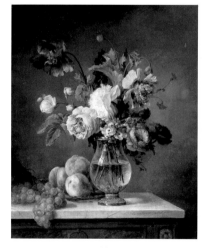

FIG. 49 Anne Vallayer-Coster (French, 1744–1818), *Bouquet of Flowers*, 1803, oil on canvas, 25¾ x 21¾″ (65.4 x 55.2 cm), Collection of Mr. and Mrs. Stewart Resnick

HENRI FANTIN-LATOUR
French, 1836–1904
Roses and Lilies, 1888
Signed upper right: Fantin 88
Oil on canvas, 23½ x 18″ (59.7 x 45.9 cm)

PROVENANCE: Mrs. Edwin Edwards, London; J.P. Heseltine, London; sale, Christie, Manson & Woods, London, May 24, 1918, lot 59; A. Cunningham, London; sale, Christie's, London, July 4, 1933; Faure, Paris; Otto Zieseniss, Paris; Christian Zieseniss, Paris.

EXHIBITIONS: New York World's Fair, Pavillon de la France, Groupe de l'art ancien, New York, "Five Centuries of History Mirrored in Five Centuries of French Art," 1939, no. 357; The Tate Gallery, London, "The Annenberg Collection," September 2–October 8, 1969, no. 14.

LITERATURE: Mme Fantin-Latour, ed., *Catalogue de l'oeuvre complet (1849–1904) de Fantin-Latour* (Paris, 1911), no. 1332.

NOTES
1. Douglas Druick and Michel Hoog, *Fantin-Latour* (Ottawa, 1983), p. 257
2. See Frank Gibson, *The Art of Henri Fantin-Latour: His Life and Work* (London, 1924), p. 111
3. Druick and Hoog, 1983, pp. 234, 256.
4. John Ruskin, *Modern Painters*, 5th ed., rev. (London, 1851), vol. 1, p. xxix.
5. The account was written by Fantin-Latour's new dealer, Gustave Tempelaere, and is cited in Druick and Hoog, 1983, pp. 269–70. It is unlikely that the artist's approach would have changed significantly between 1888 and 1889.
6. See Barbara Ramsay's discussion of Fantin-Latour's technique in ibid., pp. 57–59.
7. Ibid., p. 269.
8. Ernest Chesneau, *The English School of*

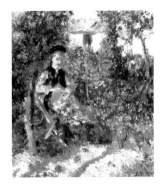

Painting, 2nd ed., translated by Lucy N. Etherington (London, 1885), p. 180.

9. Druick and Hoog, 1983, p. 256.

10. Denys Sutton, *James McNeill Whistler: Paintings, Etchings, Pastels, & Watercolours* (London, 1966), p. 53.

11. Cited in Druick and Hoog, 1983, p. 21.

FIG. 50 Henri Fantin-Latour, *White Lilies*, 1877, oil on canvas, 16⅞ x 11¾″ (43 x 30 cm), Victoria and Albert Museum, London

PIERRE-AUGUSTE RENOIR
French, 1841–1919
Nini in the Garden, 1875–76
Signed lower right: A Renoir
Oil on canvas, 24⅜ x 20″
 (61.8 x 50.7 cm)

PROVENANCE: Julius Elias, Berlin; Edward Molyneux, Paris; Ivor Churchill, London; Paul Rosenberg and Co., New York; Sam Salz Art Gallery, New York.

EXHIBITIONS: Los Angeles Museum, "Five Centuries of European Painting," November 25–December 31, 1933, no. 45; The Art Gallery of Toronto, "Paintings by Renoir and Degas," October 1934, no. 1; Wildenstein and Co., London, "Nineteenth-Century Masterpieces," May 9–June 15, 1935, no. 2; Stedelijk Museum, Amsterdam, "Honderd Jaar Fransche Kunst," July 2–September 25, 1938, no. 204; Galeries Durand-Ruel, Paris, "Quelques maîtres du 18ᵉ et du 19ᵉ siécle," 1938, no. 55; Wildenstein and Co., New York, "The Great Tradition of French Painting," June–October 1939, no. 38; National Gallery, London, "Nineteenth-Century French Paintings," December 1942–January 1943, no. 62; Philadelphia Museum of Art, "Philadelphia Private Collectors," summer 1963 (no catalogue); Wildenstein and Co., New York, "Renoir: In Commemoration of the Fiftieth Anniversary of Renoir's Death," March 27–May 3, 1969, no. 93; The Tate Gallery, London, "The Annenberg Collection," September 2–October 8, 1969, no. 26.

LITERATURE: Ambroise Vollard, *Tableaux, pastels, et dessins de Pierre-Auguste Renoir* (Paris, 1918), vol. 2, repro. p. 113; François Daulte, *Auguste Renoir: Catalogue raisonné de l'oeuvre peint,* vol. 1, *Figures, 1860–1890* (Lausanne, 1971), no. 147; Elda Fezzi, ed., *L'Opera completa di Renoir: Nel periodo impressionista, 1869–1883,* 2nd ed. (Milan, 1981), no. 192.

NOTES

1. Ambroise Vollard, *La Vie et l'oeuvre de Pierre-Auguste Renoir* (Paris, 1919), pp. 72, 75. This chronology is now generally accepted, although Rivière dated the move to the rue Cortot to May 1876. See John House, in Hayward Gallery, London, and Museum of Fine Arts, Boston, *Renoir*, January 30, 1985–January 5, 1986, p. 298; and Georges Rivière, *Renoir et ses amis* (Paris, 1921), p. 129.

2. Jean Renoir, *Renoir, My Father*, 2nd ed., translated by Randolph Weaver and Dorothy Weaver (Boston and Toronto, 1962), p. 201. Renoir's brother Edmond, writing in *La Vie Moderne*, June 19, 1879, noted that the period of gestation for the *Moulin de la Galette* was six months. See Lionello Venturi, *Les Archives de l'impressionnisme*, vol. 2 (Paris and New York, 1939), p. 336.

3. François Daulte, *Auguste Renoir: Catalogue raisonné de l'oeuvre peint,* vol. 1, *Figures, 1860–1890* (Lausanne, 1971), nos. 105, 271.

4. Ibid., no. 148.

5. Rivière, 1921, p. 130 (author's trans.).

6. Barbara Ehrlich White, *Renoir: His Life, Art, and Letters* (New York, 1984), p. 50.

7. Nicholas Wadley, ed., *Renoir: A Retrospective* (New York, 1987), pp. 86–87.

8. Vollard, 1919, p. 72, quotes Renoir as saying, "Je trouvais que, dans Nini, il y avait un peu de la contrefaçon belge."

9. "Les personnages qu'il a peints apparaissent colorés, dans un ensemble clair, plein de combinaisons de tons, ils forment partie d'un tout lumineux." Théodore Duret, *Histoire des peintres impressionnistes* (Paris, 1906), p. 128.

10. Julie Manet, *Journal (1893–1899): Sa jeunesse parmi les peintres impressionnistes et les hommes de lettres* (Paris, 1979), p. 150 (January 20, 1898).

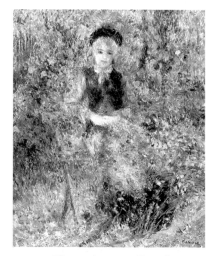

FIG. 51 Pierre-Auguste Renoir
(French, 1841–1919), *Young Girl on
the Beach,* 1875–76, oil on canvas, 24
x 19¹¹⁄₁₆″ (61 x 50 cm), location
unknown

FIG. 52 Pierre-Auguste Renoir,
Departure from the Conservatory,
c. 1877, oil on canvas, 73⅝ x 46⅞″
(187 x 119 cm), The Barnes Founda-
tion, Merion, Pa.

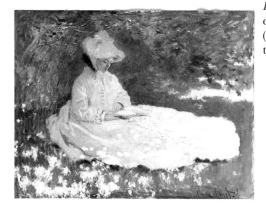

FIG. 53 Claude Monet (French, 1840–1925),
Camille Reading, 1872, oil on canvas, 19¹¹⁄₁₆ x
25⅝″ (50 x 65 cm), Walters Art Gallery,
Baltimore

PIERRE-AUGUSTE RENOIR
French, 1841–1919
Eugène Murer, 1877
Signed upper right: Renoir
Oil on canvas, 18⁹⁄₁₆ x 15½″
 (47.1 x 39.3 cm)

PROVENANCE: Eugène Murer, Paris and
Auvers-sur-Oise; Paul Meunier, Beaulieu;
deposited with Durand-Ruel, Paris, 1906;
returned to Mr. Gachet, 1907; Julius Schmits,
Wuppertal, Basel; Mrs. Ira Haupt, New York.

EXHIBITIONS: Hôtel du Dauphin et
d'Espagne, Rouen, "Exposition de la collec-
tion Murer," May 1896, no. 27; Kunsthalle,
Basel, "Pierre-Auguste Renoir," February 13–
March 14, 1943, no. 126; Waldorf-Astoria
Hotel, New York, "Festival of Art," October
29–November 1, 1957, no. 148; Wildenstein
and Co., New York, "Renoir," April 8–May 10,
1958, no. 12; Wildenstein and Co., New York,
"One Hundred Years of Impressionism:
A Tribute to Durand-Ruel," April 2–May 9,
1970, no. 28.

LITERATURE: Ambroise Vollard, "Le Salon
Charpentier," *L'Art et Les Artistes,* vol. 14,
no. 4 (January 1920), repro. p. 168;
Ambroise Vollard, "La Technique de Ren-
oir," *L'Amour de l'Art,* vol. 2, no. 1 (1921), repro.
p. 53; Julius Meier-Graefe, *Renoir* (Leipzig,
1929), p. 441, fig. 153; M. L. Cahen-Hayem,
"Renoir: Portraitiste," *L'Art et Les Artistes,*
vol. 35, no. 188 (June 1938), pp. 300–301,
repro. p. 302; Hans Graber, *Auguste Renoir:
Nach eigenen und fremden Zeugnissen* (Basel,
1943), p. 64; John Rewald, *The History of
Impressionism* (New York, 1946), repro.
p. 333; Gotthard Jedlicka, *Renoir* (Bern,
1947), pl. 28; Paul Gachet, *Deux Amis des
impressionnistes: Le Docteur Gachet et Murer*
(Paris, 1956), pp. 158, 172, 175, pl. 87; Paul
Gachet, *Lettres impressionnistes...* (Paris,
1957), p. 92, repro. opp. p. 169; E. Hoffman,
"New York Review of Exhibitions," *The Bur-
lington Magazine,* vol. 100 (May 1958), p. 185;

144

John Rewald, *The History of Impressionism*, 4th ed. (New York, 1961), repro. p. 465; Henri Perruchot, *La Vie de Renoir* (Paris, 1964), p. 133; Lawrence Hanson, *Renoir: The Man, the Painter, and His World* (New York, 1968), p. 172; François Daulte, *Auguste Renoir: Catalogue raisonné de l'oeuvre peint*, vol. 1, *Figures, 1860–1890* (Lausanne, 1971), no. 246 (repro.); Elda Fezzi, ed., *L'Opera completa di Renoir: Nel periodo impressionista, 1869–1883* (Milan, 1972), no. 290 (repro.); Marianne Reiley Burt, "Découverte: Le Pâtissier Murer: Un Ami des Impressionnistes," *L'Oeil*, vol. 245 (December 1975), p. 59, pl. 2; *Petit Larousse de la peinture*, s.v. "Auguste Meunier dit Eugène"; Sophie Monneret, *L'Impressionnisme et son époque*, vol. 2 (Paris, 1979), p. 97; Anne Distel, "Renoir's Collectors: The Pâtissier, the Priest, and the Prince," in Hayward Gallery, London, and Museum of Fine Arts, Boston, *Renoir*, January 30, 1985–January 5, 1986, p. 22; Nicholas Wadley, ed., *Renoir: A Retrospective* (New York, 1987), repro. p. 118.

NOTES

1. The biographical literature on Murer is considerable, although an attempt to reconstitute his collection has yet to be made. The starting point for a study of Murer is Paul Gachet, *Deux Amis des impressionnistes: Le Docteur Gachet et Murer* (Paris, 1956) and the same author's *Lettres impressionnistes ...* (Paris, 1957). An article that draws upon Murer's unpublished diary is Marianne Reiley Burt, "Découverte: Le Pâtissier Murer: Un Ami des Impressionnistes," *L'Oeil*, vol. 245 (December 1975), pp. 54–61, 92. See John Rewald's discussion of Murer's collecting in his *History of Impressionism*, 4th ed. (New York, 1961), pp. 413–15; and Sophie Monneret, *L'Impressionnisme et son époque*, vol. 2 (Paris, 1979), pp. 96–98.

2. Choquet's portraits are in the Henry Francis du Pont Winterthur Museum, the Oskar Reinhart Collection, and the Fogg Art Museum, Cambridge, Mass. See François Daulte, *Auguste Renoir: Catalogue raisonné de l'oeuvre peint*, vol. 1, *Figures, 1860–1890* (Lausanne, 1971), nos. 71, 173, 176; and Barbara Ehrlich White, *Renoir: His Life, Art, and Letters* (New York, 1984), p. 79

3. Daulte, 1971, no. 247.

4. Théodore Duret, *Les Peintres impressionnistes* (Paris, 1878), p. 28.

5. Gachet, 1956, pp. 147–50.

6. See ibid., p. 188, for a full listing of Murer's publications.

7. Ibid., pp. 166–87 and passim.

8. Ibid., pp. 156–57. In 1878 Legrand acquired a country house in Conflans-Sainte-Honorine, not far from Anvers, where Murer lived from 1881.

9. Unpublished letter from Renoir to Murer in the Bibliothèque d'Art et d'Archéologie, Paris. The letter is undated but assigned to early 1878 by White, 1984, pp. 51–54.

10. Gachet, 1957, p. 161; the letter is not dated, but is probably a reply to Monet's letter of April 9, 1880 (author's trans.).

11. Apart from the three portraits of Murer and his family by Renoir, there are Pissarro's portrait of *Murer as a Bandit* and a pastel of *Marie Meunier*. See Ludovic Rodo Pissarro and Lionello Venturi, *Camille Pissarro: Son art—son oeuvre* (Paris, 1939), vol. 2, nos. 469, 1537.

12. According to his biography in the *Dictionnaire national des contemporains*, vol. 2 (Paris, 1901), p. 288, which Murer may have helped compile, these articles on the early Impressionist exhibitions appeared in Léon Delboise *Correspondance française*. Renoir, in an undated letter, wrote that he had just read Murer's "charming article" (Gachet, 1957, p. 97). A lengthy passage from Murer's art criticism in *La Correspondance française* (April 16, 1879), where he wrote under the pseudonym Gène Mûr, is published in Janine Bailly-Herzberg, *Correspondance de Camille Pissarro*, vol. 2, *1866–1890* (Paris, 1986), pp. 383–84.

13. The works he loaned were four paintings by Pissarro and one landscape by Monet. See the exhibition catalogue reproduced in National Gallery of Art, Washington, D.C., and The Fine Arts Museums of San Francisco, *The New Painting: Impressionism, 1874–1886*, January 17–July 6, 1986, pp. 265–71.

14. Reproduced in Gachet, 1956, pp. 166–67. Murer acknowledged Renoir as the source for this unwieldy project, which would have divided the salon into four sections, each permitted to exhibit one thousand paintings, with the rejected submissions displayed in separate rooms.

15. Duret, 1878, p. 9.

16. Monneret, 1979, p. 97, gives the paragraph in full.

17. Bailly-Herzberg, 1980, vol. 1, *1865–1885*, nos. 61, 64, undated letter, assigned to 1878.

18. See Gachet, 1956, pp. 168–76, for the text of Alexis's article, written in Parisian slang, and a brief commentary on it.

19. Monet received 200 francs for four paintings in December 1877 and 400 francs for another four paintings, which he had still not delivered in full by April 1880. See Daniel Wildenstein, *Claude Monet: Biographie et catalogue raisonné*, vol. 1, *1840–1881* (Paris, 1974), letter no. 111 (December 20, 1877), letter no. 130 (April 11, 1878), letter no. 175 (April 9, 1880). Sisley reminded Murer that his advance of 100 francs had been for two paintings of a small format (size 8) and that the painting Murer had selected at Legrand's was much larger and therefore worth more. "If you keep this painting, it will be for a price of 100 francs" (February 13, 1878; author's trans.). Sisley also refused to sign the document Murer sent him in October 1878, since it contained clauses he had not seen in one he had signed previously (October 24, 1878). Sisley's letters are published in Gachet, 1957, pp. 124–25. There are many such examples.

20. In June 1879, Pissarro asked Murer to buy five paintings from him for 100 francs

each, or to lend him this sum. Caillebotte came to his aid with a loan of 1,000 francs. Bailly-Herzberg, 1980, vol. 1, p. 78.

21. Gachet, 1957, p. 47, letter of January 29, 1897.

22. Georges Rivière, *Renoir et ses amis* (Paris, 1921), pp. 78–80. See also the equally strident refutation of the slur on Murer's character in Gachet, 1956, pp. 159–60.

23. Burt, 1975, p. 92, quoting from Murer's diary (author's trans.).

24. Wildenstein, 1974, vol. 1, letter no. 137 (September 6, 1878), letter no. 141 (November 28, 1878).

25. Gachet, 1956, pp. 182–83; Gachet, 1957, p. 102.

26. See Gauguin's spirited letter of July 1884 to Pissarro, in which his exasperation at Murer—"quel farceur que ce Murer"—is barely concealed. Victor Merlhes, ed., *Correspondance de Paul Gauguin* (Paris, 1984), pp. 65–67.

27. Gachet, 1957, p. 168.

28. This comment appears in Murer's sketch of Renoir published in Gachet, 1956, p. 192.

29. Burt, 1975, p. 61.

30. Daulte lists twelve Renoirs from the Murer collection. These are: D84, 117, 165, 188, 193, 197, 225, 236, 246, 247, 249, 273.

31. Bailly-Herzberg, 1980, vol. 1, pp. 115–16.

32. The request was made when the two men met at a costume ball given by Henri Cernuschi. See Philippe Kolb and Jean Adhémar, "Charles Ephrussi (1849–1905), ses secrétaires: Laforgue, A. Renan, Proust, 'sa' Gazette des Beaux-Arts," *Gazette des Beaux-Arts*, 126th year, 6th period, vol. 103 (1984), p. 30.

33. Anne Distel, "Renoir's Collectors: The Pâtissier, the Priest, and the Prince," in Hayward Gallery, London, and Museum of Fine Arts, Boston, *Renoir*, January 30, 1985–January 5, 1986, pp. 22, 28, n. 40.

34. Gachet, 1956, p. 187.

FIG. 54 Pierre-Auguste Renoir (French, 1841–1919), *Jacques-Eugène Spuller*, 1877, oil on canvas, 18⅛ x 14¹⁵⁄₁₆″ (46 x 38 cm), Collection of Mr. and Mrs. Charles Wohlstetter

FIG. 55 Pierre-Auguste Renoir, *Paul Meunier (The Child in Velvet)*, 1877-79, oil on canvas, 18⅛ x 14⅜″ (46 x 36 cm), private collection, Baden

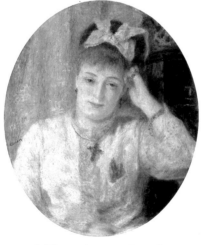

FIG. 56 Pierre-Auguste Renoir, *Marie Murer*, 1877, oil on canvas, 26⅝ x 22½″ (67.6 x 57.1 cm), National Gallery of Art, Washington, D.C., Chester Dale Collection

FIG. 57 Camille Pissarro (French, 1830–1903), *Eugène Murer*, 1878, oil on canvas, 25 x 21″ (64 x 53 cm), Museum of Fine Arts, Springfield, Mass., The James Philip Gray Collection

FIG. 58 Vincent van Gogh (Dutch, 1853–1890), *Dr. Paul Gachet*, 1890, oil on canvas, 26⅜ x 22″ (67 x 56 cm), private collection, New York

PIERRE-AUGUSTE RENOIR
French, 1841–1919
Bouquet of Chrysanthemums, 1881
Signed lower right: Renoir
Oil on canvas, 26 x 21⅞″ (66.2 x 55.5 cm)

PROVENANCE: Purchased from the artist by Durand-Ruel, Paris, 1901; Henry Bernstein, Paris, 1909; Jos Hessel, Paris; Dikran Khan Kélékian, Paris; sale, The American Art Association, New York, January 30–31, 1922, lot 134; bt. in by Durand-Ruel for Kélékian; returned to France; Myran C. Taylor, New York; Wildenstein and Co., New York.

EXHIBITIONS: Galeries Durand-Ruel, Paris, "Exposition Auguste Renoir," May 1892, no. 33; Galeries Durand-Ruel, Paris, "Exposition de natures mortes par Monet, Cézanne, Renoir…," April–May 1908, no. 44; The Metropolitan Museum of Art, New York, "Renoir: A Special Exhibition of His Paintings," May 18–September 12, 1937, no. 31; Marie Harriman Gallery, New York, "Flowers: Fourteen American, Fourteen French Artists," April 8–May 4, 1940, no. 24; Wildenstein and Co., New York, March 23–April 29, 1950, no. 32; Wildenstein and Co., New York, "Magic of Flowers in Painting," April 13–May 15, 1954, no. 62; Philadelphia Museum of Art, "A World of Flowers: Paintings and Prints," May 2–June 9, 1963, no. 148; Wildenstein and Co., New York, "Renoir," March 27–May 3, 1969, no. 94; The Tate Gallery, London, "The Annenberg Collection," September 2–October 8, 1969, no. 27.

LITERATURE: *Collection Kélékian: Tableaux de l'école française moderne* (New York, Paris, and Cairo, 1920), no. 58 (repro.); François Fosca, *Renoir* (Paris, 1923), pl. 30; Peter Mitchell, *Great Flower Painters: Four Centuries of Floral Art* (New York, 1973), no. 304 (repro.); Elda Fezzi, ed., *L'Opera completa di Renoir: Nel periodo impressionista, 1869–1883*, 2nd ed. (Milan, 1981), no. 54 (repro.).

NOTES
1. Georges Rivière, *Renoir et ses amis* (Paris, 1921), p. 81 (author's trans.).

2. Julius Meier-Graefe, *Auguste Renoir* (Paris, 1912), pp. 132–33.

3. Until the appearance of Francois Daulte's forthcoming catalogue raisonné of Renoir's still lifes, this generalization cannot be readily tested, but it is remarkable how many still-life paintings bear similar dimensions—roughly 25 x 21 inches (65 x 53 cm).

4. John House, in Hayward Gallery, London, and Museum of Fine Arts, Boston, *Renoir*, January 30, 1985–January 5, 1986, p. 229.

5. Renoir's handwritten list of his materials, possibly for the use of Jacques-Emile Blanche, now in the Durand-Ruel Archives, Paris, is reproduced in Anthea Callen, *Renoir* (London, 1978), p. 15.

6. Duveen Galleries, New York, *Renoir: Centennial Loan Exhibition, 1841–1941*, November 8–December 6, 1941, no. 18, pp. 40, 126.

7. See the chronology in Hayward Gallery, 1985–86, p. 300.

8. François Daulte, *Auguste Renoir: Catalogue raisonné de l'oeuvre peint*, vol. 1, *Figures, 1860–1890* (Lausanne, 1971), nos. 374, 377.

9. Ibid, no. 360.

10. Paul Hulton and Lawrence Smith, *Flowers in Art from East and West* (London, 1979), pp. 67–68, 111; see H. L. Li, *The Garden Flowers of China* (New York, 1959), pp. 37–47, where he calls the chrysanthemum "probably the most valuable contribution in horticulture from China to the rest of the world." I am indebted to Marjorie Sieger, senior lecturer, Philadelphia Museum of Art, for this reference.

11. H. Baillon, *Dictionnaire de botanique*, vol. 2 (Paris, 1886), p. 34.

12. See Barbara Ehrlich White, *Renoir: His Life, Art, and Letters* (New York, 1984), p. 280.

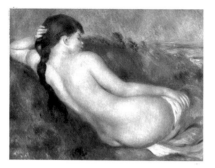

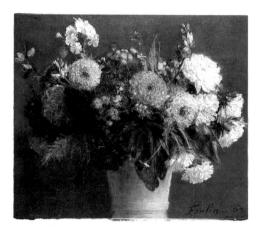

FIG. 59 Henri Fantin-Latour (French, 1836–1904), *Chrysanthemums*, 1862, oil on canvas, 18½ x 22" (46 x 55.9 cm), John G. Johnson Collection at the Philadelphia Museum of Art

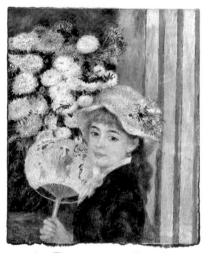

FIG. 60 Pierre-Auguste Renoir (French, 1841–1919), *Girl with a Fan*, 1881, oil on canvas, 25½ x 21¼" (65 x 54 cm), The Sterling and Francine Clark Art Institute, Williamstown, Mass.

PIERRE-AUGUSTE RENOIR
French, 1841–1919
Landscape with Trees, c. 1886
Stamped lower right with initial: R.
Watercolor on paper, 10¼ x 13¼"
 (26.1 x 33.6 cm)

PROVENANCE: Wildenstein and Co., New York; Mrs. Ira Haupt, New York.

NOTES
1. René Gimpel, *Diary of an Art Dealer*, translated by John Rosenberg (New York, 1966), p. 20, recording a visit made on April 23, 1918.

2. University of Maryland Art Gallery, College Park, J. B. Speed Art Museum, Louisville, and University of Michigan Museum of Art, Ann Arbor, *From Delacroix to Cézanne: French Watercolor Landscapes of the Nineteenth Century*, October 26, 1977–May 14, 1978, p. 112 (repro.), pp. 185–86, where it is dated to c. 1878–80. François Daulte has redated this drawing, which will appear in his forthcoming catalogue of Renoir's landscapes. I am grateful to him for providing me with this information.

3. François Daulte, *Auguste Renoir: Catalogue raisonné de l'œuvre de peint*, vol. 1, *Figures, 1860–1890* (Lausanne, 1971), p. 51.

4. Two further watercolors of this series are *Paysage d'effet d'automne* (collection Durand-Ruel, Paris) and *Paysage d'arbres* (collection Victor Annholm, Paris).

PIERRE-AUGUSTE RENOIR
French, 1841–1919
Reclining Nude, 1883
Signed lower left: Renoir
Oil on canvas, 25⅝ x 32" (65.3 x 81.4 cm)

PROVENANCE: Arsène Alexandre, Paris; sale, Galerie Georges Petit, Paris, May 18–19, 1903, lot 53; George Viau, Paris; sale, Galeries Durand-Ruel, Paris, March 4, 1907, lot 54; Bernheim-Jeune, Paris; Durand-Ruel, Paris; Paul Cassirer, Berlin; Max Meirowsky, Berlin; private collection, Germany; Wildenstein and Co., New York; Mrs. Ira Haupt, New York.

EXHIBITIONS: Grand Palais, Paris, "Société du salon d'automne: Catalogue de peinture, dessins, sculpture, gravure, architecture, et arts décoratifs," October 15–November 15, 1904, no. 2; Ausstellungshaus Am Kurfürstendamm, Berlin, "Katalog der XXVI. Ausstellung der Berliner Secession," 1913, no. 283; Musée d'Art et d'Histoire, Geneva, "De Watteau à Cézanne," July 7–September 30, 1951, no. 79; Parke-Bernet Galleries, New York, "Art Treasures Exhibition," June 16–June 30, 1955, no. 357; Wildenstein and Co., New York, "A Loan Exhibition: Nude in Painting," November 1–December 1, 1956, no. 33; Wildenstein and Co., New York, "Loan Exhibition: Renoir," April 8–May 10, 1958, no. 46.

LITERATURE: Vittorio Pica, *Gl'Impressionisti Francesi* (Bergamo, 1908), repro. p. 91; Julius Meier-Graefe, "Renoir," *Kunst und Künstler*, November 1916, repro. p. 51; Paul Georges, "A Painter Looks at a) the Nude, b) Corot," *Artnews*, vol. 55, no. 7 (November 1956), repro. p. 39; Vassily Photiades, *Renoir nus* (Lausanne, 1960), repro. p. 17; François Daulte, *Auguste Renoir: Catalogue raisonné de l'œuvre peint*, vol. 1, *Figures, 1860–1890* (Lausanne, 1971), no. 435, repro. p. 49; Max-Pol Fouchet, *Les nus de Renoir* (Lausanne, 1974).

p. 131, repro. p. 89; Elda Fezzi, ed., *L'Opera completa di Renoir: Nel periodo impressionista, 1869–1883*, 2nd ed. (Milan, 1981), no. 373 (repro.).

NOTES

1. The best discussion is still found in Julius Meier-Graefe, *Auguste Renoir* (Paris, 1912), pp. 103–16; see also Barbara Ehrlich White, "The *Bathers* of 1887 and Renoir's Anti-Impressionism," *The Art Bulletin*, vol. 55, no. 1 (March 1973), pp. 106–26.

2. Meier-Graefe, 1912, p. 116.

3. In a letter from Naples to Paul Durand-Ruel, dated November 21, 1881, Renoir wrote, "Je suis comme les enfants à l'école. La page blanche doit toujours être bien écrite et paf! … un pâté. Je suis encore aux pâtés … et j'ai 40 ans." Quoted in Lionello Venturi, ed., *Les Archives de l'impressionnisme*, vol. 1 (Paris and New York, 1939), p. 116 (author's trans.).

4. Petit Palais, Paris, *Ingres*, October 27, 1967–January 29, 1968, no. 70, pp. 102–4. The image itself was known through several engravings.

5. Meier-Graefe, 1912, pp. 103–4.

6. As Renoir recalled late in life to Albert André, the first protagonists of open-air painting had even reproached Corot for finishing his landscapes in the studio. Not surprisingly, they "detested Ingres." Albert André, *Renoir* (Paris, 1919), p. 34.

7. John House, in Hayward Gallery, London, and Museum of Fine Arts, Boston, *Renoir*, January 30, 1985–January 5, 1986, p. 301.

8. Quoted in Venturi, ed., 1939, vol. 1, pp. 125–26 (author's trans.).

9. François Daulte, *Auguste Renoir: Catalogue raisonné de l'œuvre peint*, vol. 1, *Figures, 1860–1890* (Lausanne, 1971), no. 435; see Michel Hoog and Hélène Guicharnaud, *Catalogue de la collection Jean Walter et Paul Guillaume* (Paris, 1984), pp. 182–83.

10. Barbara Ehrlich White, *Renoir: His Life, Art, and Letters* (New York, 1984), pp. 133–34.

11. Daulte, 1971, no. 623; Albert C. Barnes and Violette de Mazia, *The Art of Renoir* (New York, 1935), no. 216.

12. Galerie Georges Petit, Paris, *Catalogue des tableaux modernes … composant la collection de M. André Alexandre*, May 18–19, 1903, pp. 43–45. In addition to the chalk drawing, Alexandre owned two *Bathers* of 1882 (Daulte, 1971, nos. 398, 399). The full-scale chalk drawing for the Philadelphia Museum of Art's *Bathers* is now in the Cabinet des Dessins, Musée du Louvre, Paris.

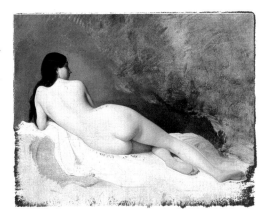

FIG. 62 French School, nineteenth century (formerly attributed to Thomas Couture), *Odalisque*, oil on canvas, 28¼ × 36¼" (71.8 × 92 cm), The Cleveland Museum of Art, Gift of Leonard C. Hanna, Jr.

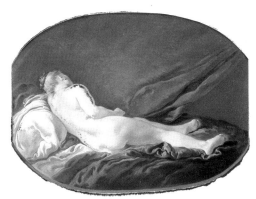

FIG. 61 François van Loo (French, 1708–1732), *Female Nude*, c. 1732, oil on canvas, 27¾ × 35" (70.5 × 89 cm), Hood Museum of Art, Dartmouth College, Hanover, N.H., Purchased through the Mrs. Harvey Hood w'18 Fund

FIG. 63 Jean-Auguste-Dominique Ingres (French, 1780–1867), *Grande Odalisque*, 1814, oil on canvas, 35⅞ × 63¾₆" (91 × 162 cm), Musée du Louvre, Paris

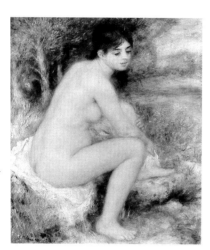

FIG. 64 Pierre-Auguste Renoir (French, 1841–1919), *Nude in a Landscape*, 1883, oil on canvas, 25½ x 21¼″ (65 x 54 cm), Musée de l'Orangerie, Paris, Jean Walter–Paul Guillaume Collection

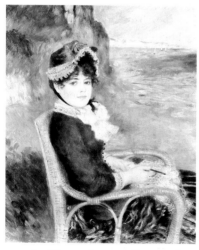

FIG. 65 Pierre-Auguste Renoir, *By the Seashore*, 1883, oil on canvas, 36¼ x 28½″ (92 x 72.4 cm), The Metropolitan Museum of Art, N.Y., The H.O. Havemeyer Collection

PIERRE-AUGUSTE RENOIR
French, 1841–1919
The Daughters of Catulle Mendès, 1888
Signed and dated upper right: Renoir 88
Oil on canvas, 63¾ x 51⅛″ (162 x 130 cm)

PROVENANCE: Catulle Mendès, Paris; Prince de Wagram, Paris; Princesse de la Tour d'Auvergne, Paris; Knoedler and Co., New York; Wildenstein and Co., New York; S. Simon, New York; private collection, Geneva; Wildenstein and Co., New York.

EXHIBITIONS: Galeries Durand-Ruel, Paris, "Impressionnistes," May 25– June 25, 1888, no. 23; Galeries Nationales du Grand Palais, Paris, "Salon de 1890, Société des artistes français, exposition des Beaux-Arts," 1890, no. 2024; Musée de l'Orangerie, Paris, "Exposition Renoir, 1841–1919," June 1933, no. 85; Philadelphia Museum of Art, "Manet and Renoir," December 1933 (no catalogue); Museum of Art, Toledo, "French Impressionists and Post Impressionists," 1934, no. 18; Museum of Fine Arts, Boston, "Independent Painters of Nineteenth-Century Paris," March 15–April 28, 1935, no. 46; Wildenstein and Co., New York, "Great Portraits from Impressionism to Modernism," March 1–29, 1938, no. 38; Stedelijk Museum, Amsterdam, "Honderd Jaar Fransche Kunst," July 2– September 25, 1938, no. 217; Wildenstein and Co., New York, "The Great Tradition of French Painting," June–October, 1939, no. 37; Duveen Galleries, New York, "Centennial Loan Exhibition, 1841–1941, Renoir," November 8–December 6, 1941, no. 59; The Museum of Modern Art, New York, "Art in Progress," 1944, no. 22; California Palace of the Legion of Honor, San Francisco, "Paintings by Pierre Auguste Renoir," November 1–30, 1944, no. 32; Isaac Delgado Museum, New Orleans, "A Loan Exhibition of Masterpieces of French Painting through Five Centuries, 1400–1900," October 17, 1953– January 10, 1954, no. 77; Galerie Beaux-Arts, Paris, "Chefs-d'oeuvre de Renoir dans les collections françaises," June 10–27, 1954, no. 36; Fort Worth Art Center, "Inaugural Exhibition," October 8–31, 1954, no. 83; Wildenstein and Co., New York, "Loan Exhibition: Renoir," April 8–May 10, 1958, no. 49; Palais de Beaulieu, Lausanne, "Chefs-d'oeuvre des collections suisses de Manet à Picasso," 1964, no. 351; Wildenstein and Co., New York, "Renoir," March 27–May 3, 1969, no. 96; The Tate Gallery, London, "The Annenberg Collection," September 2– October 8, 1969, no. 28.

LITERATURE: Gustave Geffroy, *La Vie artistique* (Paris, 1892), vol. 1, pp. 161–63; Arsène Alexandre, introduction, in Galeries Durand-Ruel, Paris, *Exposition: A. Renoir,* May 1892, p. 30; Théodore Duret, *Histoire des peintres impressionnistes: Pissarro, Claude Monet, Sisley, Renoir, Berthe Morisot, Cézanne, Guillaumin* (Paris, 1906), p. 148; Julius Meier-Graefe, *Auguste Renoir* (Munich, 1911), pp. 146–49, 160, repro. p. 147; Julius Meier-Graefe, "Renoir," *Kunst und Künstler,* vol. 15 (November 1916), p. 78; Ambroise Vollard, *Tableux, pastels, et dessins de Pierre-Auguste Renoir,* vol. 1 (Paris, 1918), p. 89, fig. 353; W. Burger, "Auguste Renoir," *Kunst und Künstler,* vol. 19 (February 1920), p. 170; François Fosca, *Renoir* (Paris, 1923), p. 37; Paul Jamot, "Renoir: 1841–1911," *Gazette des Beaux-Arts,* 65th year, 2nd period (1923), p. 342; Théodore Duret, *Renoir* (Paris, 1924), p. 71; Ambroise Vollard, *Renoir: An Intimate Record,* translated by Harold L. Van Doren and Randolph T. Weaver (New York, 1925), p. 242; Julius Meier-Graefe, *Renoir* (Leipzig, 1929), pp. 241–46, pl. 197; R. H. Wilenski, *French Painting* (Boston, 1931), p. 264; Claude Roger-Marx, *Renoir* (Paris, 1933), pp. 45, 88; Pennsylvania Museum (Philadelphia Museum of Art), "Manet and Renoir," *The Pennsylvania Museum Bulletin,* vol. 29, no. 158 (October 1933), p. 20; *Art News,* vol. 32 (December 16, 1933), p. 10 (repro.); Albert C.

150

Barnes and Violette de Mazia, *The Art of Renoir* (New York, 1935), pp. 103–4, 414–15, 458; "Notable Paintings in the Art Market," *Art News,* vol. 36 (December 25, 1937), p. 11; Michel Florisoone, *Renoir,* translated by George Frederic Lees (Paris, 1938), pp. 24–25; Helen Comstock, "The Connoisseur in America," *The Connoisseur,* vol. 101, no. 440 (April 1938), p. 205 (repro.); R. H. Wilenski, *Modern French Painters* (New York, 1940), pp. 117–18, 341; Charles Terrasse, *Cinquante Portraits de Renoir* (Paris, 1941), pl. 26; Hans Graber, *Auguste Renoir, nach eigenen und fremden Zeugnissen* (Basel, 1943), p. 150; Michel Drucker, *Renoir* (Paris, 1944), p. 81, no. 93 (repro.); C. L. Ragghianti, *Impressionnisme,* 2nd ed. (Turin, 1947), p. 74; Gotthard Jedlicka, *Renoir* (Bern, 1947), pl. 35; Germain Bazin, *L'Epoque impressionniste avec notices biographiques et bibliographiques* (Paris, 1947), p. 79; Félix Fénéon, *Oeuvres* (Paris, 1948), p. 138; A. Chamson, *Renoir* (Lausanne, 1949), pl. 35; John Leymarie, *Les Pastels, dessins, et aquarelles de Renoir* (Paris, 1949), n.p.; William Gaunt, *Renoir* (New York, 1952), p. 12, pl. 60; Denis Rouart, *Renoir,* translated by James Emmons (Geneva, 1954), p. 72; Michel Robida, *Renoir enfants* (Paris, 1959), p. 60; François Fosca, *Renoir: His Life and Work* (London, 1961), p. 154, repro. p. 118; Colin Hayet and François Guérard, *Renoir* (Paris, 1963), pl. XXI; Henri Perruchot, *La Vie de Renoir* (Paris, 1964), pp. 234, 364; Barbara Ehrlich White, "An Analysis of Renoir's Development from 1877 to 1887," Ph.D. diss., Columbia University, New York, 1965, pp. 181, 189; Lawrence Hanson, *Renoir: The Man, the Painter, and His World* (New York, 1968), pp. 178, 234, 237; François Daulte, *Auguste Renoir: Catalogue raisonné de l'oeuvre peint,* vol. 1, *Figures, 1860–1890* (Lausanne, 1971), no. 545 (repro.); François Daulte, *Renoir* (London, 1973), p. 54, repro. p. 50; Keith Wheldon, *Renoir and His Art* (London, 1975), p. 97; Bruno F. Schneider, *Renoir,* translated by Desmond Clayton and Camille Clayton (New York,

1977), repro. p. 45; Elda Fezzi, ed., *L'Opera completa di Renoir: Nel periodo impressionista, 1869–1883,* 2nd ed. (Milan, 1981), no. 634 (repro.); Barbara Ehrlich White, *Renoir: His Life, Art, and Letters* (New York, 1984), pp. 178, 184, repro. p. 182; C. L. de Moncade, "La Liberté, Renoir, and the Salon d'Automne, October 15, 1904," in Nicholas Wadley, ed., *Renoir: A Retrospective* (New York, 1987), p. 236 (repro.); M. Berr de Turique, *Renoir* (Paris, n.d.), pl. 60.

NOTES

1. François Daulte, *Auguste Renoir: Catalogue raisonné de l'oeuvre peint,* vol. 1, *Figures, 1860–1890* (Lausanne, 1971), p. 53.

2. Renoir, undated letter, 1888, quoted in Barbara Ehrlich White, *Renoir: His Life, Art, and Letters* (New York, 1984), p. 178.

3. Théodore Duret, *Renoir* (Paris, 1924), p. 71 (author's trans.).

4. Hôtel Drouot, Paris, *Livres, belles reliures, autographes, dessins, et gravures,* June 1–2, 1953, p. 31, lot 410 (author's trans.). It is a pleasure to thank Mrs. Ay-Whang Hsia, of Wildenstein and Co., New York, who obtained a copy of the letter for me. The letter, in the original, is as follows: "Mon cher ami/ Je suis revenu à Paris et je vous prierai de me dire *de suite* si vous voulez les portraits de vos jolis enfants. Je les exposerai chez Petit au mois de mai. Vous voyez que c'est pressé. Voici mes conditions que vous accepterez sans doute. 500 fr. pour les trois, grandeur nature et ensemble./ [Sketch for portrait] L'aîné au piano donne le ton en se retournant vers sa soeur qui cherche le susdit ton sur son violon, la plus petite appuyée sur le piano, écoute comme on doit toujours faire à cet age tendre. Voilà?/ Je ferai les dessins chez vous et la peinture chez moi/ P.S. les 500 fr. payables 100 fr. par mois./ Amitiés et réponse/ Renoir/ 28 rue Bréda."

5. John House, in Hayward Gallery, London, and Museum of Fine Arts, Boston, *Renoir,* January 30, 1985–January 5, 1986,

pp. 244–45.

6. Julius Meier-Graefe, quoted in Nicholas Wadley, ed., *Renoir: A Retrospective* (New York, 1987), p. 251. "For this large, fine commissioned portrait, the artist was grossly underpaid" (François Daulte, *Renoir* [London, 1973], p. 54); see also Daulte, 1971, p. 53.

7. Roy McMullen, *Degas: His Life, Times, and Work* (Boston, 1984), p. 24.

8. "Watch out. You've got to pay up.... If in the meantime you have a 100 franc bill, you'll make me very happy." Renoir, letter of November 27, 1888, quoted in White, 1984, p. 184. Writers from Meier-Graefe on have puzzled over this paltry payment, which could not be explained by Mendès's previous finances; by the mid-1880s he was a relatively prosperous and well-established figure in the Parisian beau monde.

9. Denis Rouart, ed., *The Correspondence of Berthe Morisot with Her Family and Her Friends Manet, Puvis de Chauannes, Degas, Monet, Renoir, and Mallarmé,* translated by Betty W. Hubbard (London, 1986), p. 154.

10. John Rewald, ed. *Camille Pissarro: Letters to His Son Lucien* (New York, 1943), p. 132, letter dated October 1, 1888.

11. Arsène Alexandre, introduction, in Galeries Durand-Ruel, Paris, *Exposition: A. Renoir,* May 1892, p. 30; Renoir's interview with C. L. de Moncade, published in *La Liberté,* October 15, 1904, is reprinted in Barbara Ehrlich White, ed., *Impressionism in Perspective* (Englewood Cliffs, N.J., 1978), pp. 21–22.

12. See the summary of Renoir's development in the 1880s in Hayward Gallery, 1985–86, pp. 241–43.

13. Renoir's letter to Durand-Ruel, in which the portrait of Durand-Ruel's daughter is mentioned, has been correctly redated by John House to the autumn of 1888 (Hayward Gallery, 1985–86, p. 254), and is published in Lionello Venturi, ed., *Les Archives de l'impressionnisme,* vol. 1 (Paris and New York, 1939), pp. 131–32.

14. Félix Fénéon's review was published in *La Cravache*, June 2, 1888, and is reprinted in his *Œuvres* (Paris, 1948), p. 158.

15. Pissarro's approval of Renoir's abandoning his former "romanticism" is expressed in his October 1, 1888, letter to Lucien, in Rewald, ed., 1943, p. 132.

16. See White, 1984, p. 184, and Hayward Gallery 1985–86, pp. 224, 256, 260–262, for the most recent discussions.

17. White, 1984, p. 189 (repro.).

18. Julius Meier-Graefe, *Auguste Renoir* (Munich, 1911), p. 149.

19. Claude Roger-Marx, *Renoir* (Paris, 1937), p. 118.

20. In Venturi, ed., 1939, pp. 131–32.

21. Why Renoir seems to have reacted so enthusiastically to French eighteenth-century painting at this time remains to be examined. Certainly several major exhibitions of French eighteenth-century art were mounted in the 1880s, notably *L'Art du dix-huitième siècle*, at Petit Gallery, 1883–84, and *L'Exposition de l'art français sous Louis XIV et sous Louis XV* at the Hôtel de Chimay, which opened just as Renoir was at work on the Mendès portrait. He ended his important letter to Durand-Ruel (see note 13) by styling himself "Fragonard en moins bien."

22. Gustave Geffroy, *La Vie artistique* (Paris, 1892), vol. 1, pp. 62–63 (author's trans.).

23. The bibliography on these fascinating figures is extensive, although a biography of Camille Mendès remains to be written. On him, see the exhaustive bibliography in Hector Talvart and Joseph Place, *Bibliographie des auteurs modernes de langue française*, 1801–1956, vol. 14 (Paris, 1959), pp. 184–207. On Holmès, see the excellent notice by Hugh MacDonald in Stanley Sadie, ed., *The New Grove Dictionary of Music and Musicians*, vol. 8 (Washington, D.C., 1980), pp. 655–56.

24. See Adrien Bertrand, *Camille Mendès* (Paris, 1908), pp. 11–17 and passim; and the entry on him in the *Dictionnaire national des contemporains*, vol. 1, pp. 237–38.

25. Edmond de Goncourt and Jules de Goncourt, *Journal: Mémoires de la vie littéraire* (Paris, 1956), vol. 3, p. 807 (January 3, 1889), vol. 4, p. 73 (April 12, 1890), pp. 193–94 (February 12, 1892).

26. Letter to John Ingram, November 8, 1885. See Henri Mondor and Lloyd James Austin, eds., *Stéphane Mallarmé: Correspondance*, vol. 2 (Paris, 1959–85), p. 197.

27. Goncourt and Goncourt, 1956, vol. 4, p. 612 (July 9, 1894), noting irreverently, "Mendès has just had his father recognize the children he had with Holmès, which legally makes him their brother" (author's trans.); ibid., vol. 4, p. 782 (April 30, 1895); for his second marriage, see Talvart and Place, 1959, vol. 14, p. 184.

28. R. P. Du Page, "Une Musicienne versaillaise: Augusta Holmès," *Revue de Versailles et de Seine-et-Oise*, 1921, pp. 10–12.

29. Henri Imbert, *Nouveaux profils de musiciens* (Paris, 1892), pp. 138–40.

30. See Ethel Smyth, *A Final Burning of the Boats, Etc.* (London, 1928), pp. 150–35, for an amusing description of her meeting with Holmès in 1899.

31. Jules Renard, *Journal*, 1887–1910 (Paris, 1960), p. 188 (December 1, 1893); the anti-Semitic gloss on such comment is also found in many of the Goncourts' (1956) satires on Mendès.

32. Goncourt and Goncourt, 1956, p. 898 (August 25, 1894).

33. Mondor and Austin, eds., 1959–85, vol. 4, p. 197, letter of July 15, 1895.

34. Annette Vidal, *Henri Barbusse: Soldat de la paix* (Paris, 1953), pp. 40–44, where Barbusse recounts his first visit to Chaton, in celebration of Mendès's having received the Légion d'honneur (author's trans.).

35. In August 1895, Renoir told Julie Manet of the time he had mistaken Mendès's address (rue de Trévise for rue Trévise, and was confused all the more at finding an apart-ment on the same floor with similar "Japonneries" on the window. Before the family had time to leave the table to greet their unexpected visitor, Renoir realized his mistake and bounded down the stairs, four at a time, in escape. Julie Manet, *Journal (1893–1899): Sa jeunesse parmi les peintres impressionnistes et les hommes de lettres* (Paris, 1979), p. 62, entry dated August 24, 1895.

36. For the modernity of the paperbound novel, see Judy Sund, "Favoured Fictions: Women and Books in the Art of Van Gogh," *Art History*, vol. 11, no. 2 (June 1988), p. 258.

FIG. 68 Renoir's sketch of proposed portrait in a letter to Camille Mendès, 1888, location unknown (sale, Hôtel Drouot, Paris, June 1–2, 1933, lot 410)

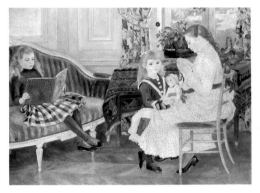

FIG. 67 Pierre-Auguste Renoir (French, 1841–1919), *Children's Afternoon at Wargemont*, 1884, oil on canvas, 50 x 68⅛″ (127 x 173 cm), Staatliche Museen Preussischer Kulturbesitz, Nationalgalerie, Berlin (West)

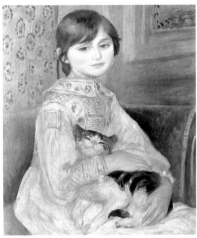

FIG. 68 Pierre-Auguste Renoir, *Julie Manet*, 1887, oil on canvas, 25⁹⁄₁₆ x 21¼″ (65 x 54 cm), private collection, Paris

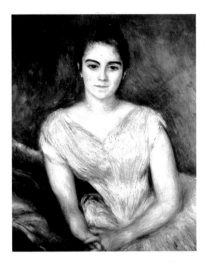

FIG. 69 Pierre-Auguste Renoir, *Marie Durand-Ruel*, 1888, oil on canvas, 28¾ x 23⅝″ (73 x 60 cm), Durand-Ruel Collection, Paris

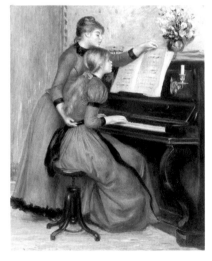

FIG. 70 Pierre-Auguste Renoir, *Young Women at the Piano*, c. 1889, oil on canvas, 22 x 18¼″ (55.9 x 46 cm), Joslyn Art Museum, Omaha

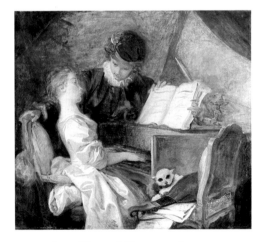

FIG. 71 Jean-Honoré Fragonard (French, 1732–1806), *The Music Lesson*, c. 1765–72, oil on canvas, 43⁵⁄₁₆ x 47¼″ (110 x 120 cm), Musée du Louvre, Paris

FIG. 72 Félix Vallotton (French, 1865–1925), *Catulle Mendès*, 1888, charcoal on paper, 15¾ x 9¹³⁄₁₆″ (40 x 25 cm), private collection, Zurich

153

CLAUDE MONET
French, 1840–1926
Camille Monet on a Garden Bench
 (The Bench), 1873
Signed lower right: Claude Monet
Oil on canvas, 23⅞ x 31⅝"
 (60.6 x 80.3 cm)

PROVENANCE: Bruno and Paul Cassirer, Berlin; Eduard Arnhold, Berlin; Peter Gutzwiller, Basel; Knoedler and Co., New York; Edwin Vogel, New York; Sam Salz Galleries, New York; Henry Ittleson, New York; Acquavella Galleries, New York; Alex Reid and Lefevre, London.

EXHIBITIONS: Paul Cassirer, Berlin, "Siebenten Kunstausstellung der Berliner Secession," 1903, no. 142; The Metropolitan Museum of Art, New York, "New York Collects," July–August 1968, no. 113 (no catalogue).

LITERATURE: Hugo von Tschudi, "Die Sammlung Arnhold," *Kunst und Künstler,* vol. 7 (1909), p. 100; Richard Muther, *Geschichte der Malerei,* vol. 3, *18 and 19 Jahrhundert* (Leipzig, 1909), repro. p. 230; Marie Dormoy, "La Collection Arnhold," *L'Amour de L'Art,* 1926, p. 244, repro. p. 243; John Rewald, *The History of Impressionism,* 4th ed. (New York, 1961), repro. p. 283; Oskar Fischel and Max von Boehn, *Modes and Manners of the Nineteenth Century as Represented in the Pictures and Engravings of the Time,* rev. and enl. ed., vol. 2, translated by M. Edwardes (New York, 1970), repro. p. 122; Gerald Needham, "The Paintings of Claude Monet, 1859–1878," Ph.D. diss., New York University, 1971, pp. 245–48, fig. 73; Daniel Wildenstein, *Claude Monet: Biographie et catalogue raisonné,* vol. 1, *1840–1881* (Lausanne and Paris, 1974), no. 281 (repro.); *Alex Reid and Lefevre, 1926–1976* (London, 1976), p. 52, repro. p. 53; Joel Isaacson, *Observation and Reflection: Claude Monet* (Oxford, 1978),

no. 50, repro. p. 98; Paul Hayes Tucker, *Monet at Argenteuil* (New Haven and London, 1984), pp. 134–35, 139, fig. 109; Robert Gordon and Andrew Forge, *Monet* (New York, 1984), pp. 44, 85–86, repro. pp. 45, 82; T. J. Clark, *The Painting of Modern Life: Paris in the Art of Manet and His Followers* (London, 1985), p. 191, fig. 91; Horst Keller, *Claude Monet* (Munich, 1985), pl. 40; John House, *Monet: Nature into Art* (New Haven and London, 1986), p. 34, fig. 43.

NOTES
1. Daniel Wildenstein, *Claude Monet: Biographie et catalogue raisonné,* vol. 1 *1840–1881* (Lausanne and Paris, 1974), p. 58; Rodolphe Walter, "Les Maisons de Claude Monet à Argenteuil," *Gazette des Beaux-Arts,* 108th year, 6th period, vol. 68 (December 1966), pp. 333–35.
2. Monet's reminiscence as later recorded by the journalist François Thiébault-Sisson; cited in Wildenstein, 1974, vol. 1, p. 58, n. 414.
3. Paul Hayes Tucker, *Monet at Argenteuil* (New Haven and London, 1984), pp. 125–54. For Monet's second house in Argenteuil, see *Camille Monet in the Garden at the House in Argenteuil* (p. 52).
4. An early suggestion that the model for the gentleman caller was Berthe Morisot's husband, Eugène Manet, is intriguing but undocumented; see Hugo von Tschudi, "Die Sammlung Arnhold," *Kunst und Künstler,* vol. 7 (1909), p. 100. Monet's own recollections, in a letter written to Georges Durand-Ruel on July 7, 1921, when he was over eighty, have been overlooked by writers on *The Bench;* the letter is reprinted in Lionello Venturi, ed., *Les Archives de l'impressionnisme,* vol. 1 (Paris and New York, 1939), p. 458, letter no. 397. There Monet dated the painting to 1872, which is a lapse of memory; see note 25.
5. See Wildenstein, 1974, vol. 1, nos. 62, 63, 68, 95. Also related is the enormous *Women in the Garden,* 1866 (Musée d'Orsay, Paris),

for which Camille had posed; see ibid., no. 67.
6. Jean-Paul Bouillon, ed., *Emile Zola: Le bon combat, de Courbet aux impressionnistes* (Paris, 1974), p. 111 (author's trans.). Zola's prescient article first appeared in *L'Evénement Illustré,* May 24, 1868.
7. Much of the following is based on the two studies of Monet's activities in Argenteuil: Tucker, 1984, pp. 125–54, especially chapter 6, and T. J. Clark, *The Painting of Modern Life: Paris in the Art of Manet and His Followers* (London, 1985), pp. 173–97.
8. From a letter to M. Aubry, the mayor of Argenteuil and the proprietor of the Maison Aubry, from a resident of the Porte Sainte-Germaine neighborhood; quoted in Tucker, 1984, p. 38.
9. Ibid., chapter 5, especially pp. 128, 135–37.
10. Ibid., p. 138; see also John House, *Monet: Nature into Art* (New Haven and London, 1986), p. 34.
11. Joel Isaacson, *Observation and Reflection: Claude Monet* (Oxford, 1978), p. 208.
12. Clark, 1985, p. 195. The proprietor, smug or not, was in fact Mme Aubry.
13. See Isaacson, 1978, pp. 20, 205–6, and especially p. 208, no. 50.
14. Monet to Pissarro, September 23, 1873; quoted in Wildenstein, 1974, vol. 1, p. 429, no. 70 (author's trans.).
15. Isaacson, 1978, p. 208, no. 50.
16. I am grateful to Anne Schirrmeister and Dilys Blum for reviewing these issues. For a general introduction to the topic, see Lou Taylor, *Mourning Dress: A Costume and Social History* (London, 1983), pp. 195–96, 303; and Louis Mercier, *Le Deuil: Son observation dans tous les temps et dans tous les pays comparée a son observation de nos jours* (London, 1877), pp. 62–65.
17. Grand Palais, Paris, *Hommage à Claude Monet (1840–1926),* February 8–May 5, 1980, pp. 141–43.
18. For the relationship between Impression-

154

ist subject matter and popular imagery, see the well-documented article by Joel Isaacson, "Impressionism and Journalistic Illustration," *Arts Magazine*, vol. 56, no. 10 (June 1982), pp. 95–115.

19. Eugène Chapus, "La Vie à Paris: Le Caractère de la société parisienne actuelle; les maisons de la campagne," *Le Sport,* September 5, 1860; quoted in Tucker, 1986, p. 125.

20. For an introduction to the topic, see Mark Roskill, "Early Impressionism and the Fashion Print," *The Burlington Magazine,* vol. 112 (June 1970), pp. 391–94; and Valerie Steele, *Paris Fashion: A Cultural History* (New York and Oxford, 1988), pp. 123–32.

21. "Costume en velours et damas de fantaisie," *La Mode Illustrée,* no. 9 (1873), pp. 68–69 (author's trans.). Elaborate instructions for making up this costume, presumably for the client who did not have easy access to the Parisian department store, accompany the illustration.

22. Bouillon, ed., 1979, p. 110, "les maîtres de demain, ceux qui apporteront avec eux une originalité profonde et saisissante, seront nos frères, accompliront en peinture le mouvement qui a amené dans les lettres l'analyse exacte et l'étude curieuse du présent."

23. For a discussion of pendants in French eighteenth-century painting, see Colin B. Bailey, "Conventions of the Eighteenth-Century *Cabinet de tableaux:* Blondel d'Azincourt's *La Première idée de la curiosite,*" *The Art Bulletin,* vol. 69, no. 3 (September 1987), pp. 431–43.

24. Wildenstein, 1974, vol. 1, no. 280.

25. Letter quoted in Venturi, ed., 1939, vol. 1, p. 458, letter no. 397. The relevant section reads: "Les personnages sont ma première femme et amie, l'homme un voisin. Il doit exister deux toiles du même genre."

26. Robert Gordon and Andrew Forge, *Monet* (New York, 1984), p. 85. The authors also point to the momentary confusion we experi-

ence in reading Camille's left hand as holding an object—perhaps a parasol—when in fact the vertical line describes the support of the bench.

27. See Grand Palais, 1980, p. 143–45.

28. Quoted in the National Gallery of Art, Washington, D.C., and The Fine Arts Museums of San Francisco, *The New Painting: Impressionism, 1874–1886,* January 17– July 6, 1986, p. 44.

29. Tucker, 1984, p. 47.

30. For an account of Monet's struggles with his family and their disapproval of Camille, see Wildenstein, 1974, vol. 1, pp. 32, 37–38. Camille is treated harshly throughout: Monet abandons her during her pregnancy to return to his family in Le Havre; their marriage of June 1870 is timed to provide Monet with exemption from military service.

31. See Paul Tucker's account of the conditions surrounding the First Impressionist Exhibition, "The First Exhibition in Context," in the National Gallery of Art, 1986, p. 104.

32. For an account of *Interior,* which Degas called "my genre painting," see Theodore Reff, *Degas: The Artist's Mind* (New York, 1976), pp. 200–238.

33. On this collection see Von Tschudi, 1909, pp. 45–62, 98–109. Contrary to what has been published in Wildenstein, *The Bench* was exhibited in the seventh Berliner Secession exhibition of 1903 (no. 142). A stamp on the back of the painting, "Bruno und Paul Cassirer, Berlin," indicates that *The Bench* was sold by the Cassirer brothers before 1902, as the brothers separated around this time. It has not been possible to establish from whom they acquired *The Bench,* since Paul Cassirer's stock books begin in October 1903, and *The Bench* was already in Arnhold's possession by this time. I am indebted to Marianne and Walter Feilchenfeldt for this information.

34. For a further discussion of Arnold's picture gallery, see Gordon and Forge, 1984, pp. 36–37, 44–45.

FIG. 73 Map of Argenteuil from the train station to the Seine, c. 1875 (from Rodolphe Walter, "Les Maisons de Claude Monet à Argenteuil," *Gazette des Beaux-Arts,* 108th year, 6th period, vol. 68 [December 1966], p. 334)

FIG. 74 Claude Monet (French, 1840–1926), *Boulevard Saint-Denis, Argenteuil, in Winter,* 1875, oil on canvas, 24 x 32⅛" (61 x 81.6 cm), The Museum of Fine Arts, Boston

FIG. 75 Claude Monet, *A Corner of the Garden with Dahlias*, 1873, oil on canvas, 24 x 32½″ (61 x 82.5 cm), private collection, N.Y. (courtesy Wildenstein and Co.)

FIG. 77 Honoré Daumier (French, 1808–1879), *Parisians in the Countryside*, 1857, lithograph, 8⅜ x 10⅚″ (21.2 x 26.2 cm), The Armand Hammer Collection

FIG. 79 Autumn and winter costumes from *La Mode Illustrée*, 1873

FIG. 76 Claude Monet, *Camille in the Garden with Jean and His Nurse*, 1873, oil on canvas, 23¼ x 31⁵⁄₆″ (59 x 79.5 cm), private collection, Switzerland

FIG. 78 Honoré Daumier, *Countryside near Paris*, 1858, lithograph, 10³⁄₆ x 8³⁄₆″ (25.8 x 20.8 cm), The Armand Hammer Collection

FIG. 80 Spring costume from *La Mode Illustrée*, 1873

FIG. 81 James-Jacques-Joseph Tissot (French, 1836–1902), *Reverie*, 1869, oil on canvas, 13 x 16½" (33 x 41.9 cm), private collection, N.Y.

FIG. 83 Photograph of the picture gallery of the Arnhold residence in Berlin (courtesy Robert Gordon)

CLAUDE MONET
French, 1840–1926
Poppy Field, Argenteuil, 1875
Signed lower right: Claude Monet
Oil on canvas, 21⅚₆ x 29"
 (54.1 x 73.6 cm)

PROVENANCE: Gift of the artist to Maître Couteau; Wildenstein and Co., New York, 1967; Mrs. Ira Haupt, New York.

LITERATURE: Daniel Wildenstein, *Claude Monet,* translated by A. Colloridi (Milan, 1971), repro. pp. 36–37; Luigina Rossi Bortolatto, ed., *L'Opera completa di Claude Monet, 1870–1889* (Milan, 1972), no. 119 (repro.); Daniel Wildenstein, *Claude Monet: Biographie et catalogue raisonné,* vol. 1 (Lausanne and Paris, 1974), no. 380 (repro.).

NOTES
1. Daniel Wildenstein, *Claude Monet: Biographie et catalogue raisonné,* vol. 1 (Lausanne and Paris, 1974), nos. 377–80.
2. This line of trees is seen even more clearly in Monet's *Strolling (Argenteuil)* (fig. 85), where it recedes far into the background, with the town of Argenteuil visible beyond the trees.
3. Stéphane Mallarmé, "The Impressionists and Edouard Manet," *The Art Monthly Review and Photographic Portfolio, a Magazine Devoted to the Fine and Industrial Arts and Illustrated by Photography,* vol. 1, no. 9 (September 30, 1876), pp. 117–22; quoted in The Fine Arts Museums of San Francisco and the National Gallery of Art, Washington, D.C., *The New Painting: Impressionism, 1874–1886,* January 17–July 6, 1986, p. 32.
4. Paul Hayes Tucker, *Monet at Argenteuil,* 2nd ed. (New Haven and London, 1984), p. 149.
5. Ibid., pp. 149–53.
6. From the *Mémoire sur l'avant projet de déviation des eaux d'égout de la ville de Paris* (Saint Germain-en-Laye, 1876); quoted in Tucker, 1984, p. 152, p. 199, n. 26.

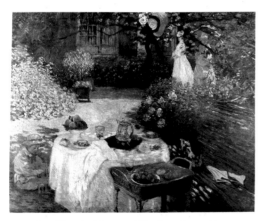

FIG. 82 Claude Monet, *The Luncheon (Argenteuil),* c. 1873, oil on canvas, 63 x 79⅛" (160 x 201 cm), Musée d'Orsay, Paris

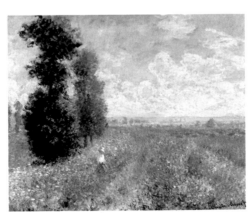

FIG. 84 Claude Monet (French, 1840–1926), *Meadow with Poplars,* 1875, oil on canvas, 21⅞₆ x 25¾" (54.5 x 65.5 cm), Museum of Fine Arts, Boston, Bequest of David P. Kimball in memory of his wife, Clara Bertram Kimball

7. Unlike the grain stacks Monet would later paint at Giverny, these temporary stacks, or "meules temporaires," were dismantled once harvesting was over and threshing had begun. See *La Grande Encyclopédie*, vol. 23, p. 822, s.v. "meule." The Annenberg *Poppy Field*, although much more sketchy than the Boston or New York versions, may in fact have been painted last, after the stacks had been dismantled.

FIG. 85 Claude Monet, *Strolling (Argenteuil)*, 1875, oil on canvas, 23⁷/₁₆ x 31⁷/₁₆" (59.5 x 80 cm), private collection, N.Y. (courtesy Wildenstein and Co.)

FIG. 86 Claude Monet, *Summer: Poppy Fields*, oil on canvas, 23½ x 32" (59.7 x 81 cm), private collection, N.Y. (courtesy Wildenstein and Co.)

CLAUDE MONET
French, 1840–1926
Camille Monet in the Garden at the House in Argenteuil, 1876
Signed lower right: Claude Monet
Oil on canvas, 32⅛ x 23⅝" (81.7 x 60 cm)

PROVENANCE: Possibly Durand-Ruel family, Paris; Wildenstein and Co., New York.

EXHIBITION: The Tate Gallery, London, "The Annenberg Collection," September 2–October 8, 1969, no. 21.

LITERATURE: Daniel Wildenstein, *Monet: Impressions* (Lausanne, 1967), repro. p. 23; Gerald Needham, "The Paintings of Claude Monet, 1859–1878," Ph.D. diss., New York University, 1971, pp. 251–52; Luigina Rossi Bortolatto, *Claude Monet, 1870–1889* (Milan, 1972), no. 123 (repro.); Luigina Rossi Bortolatto, *L'Opera completa di Claude Monet, 1870–1889* (Milan, 1972), no. 123 (repro.); Daniel Wildenstein, *Claude Monet: Biographie et catalogue raisonné*, vol. 1 (Lausanne and Paris, 1974), no. 410 (repro.); Claire Joyes and Andrew Forge, *Monet at Giverny* (New York, 1975) repro. p. 46.

NOTES
1. This house still stands on 21 boulevard Karl-Marx. See the article by Rodolphe Walter, "Les Maisons de Claude Monet à Argenteuil," *Gazette des Beaux-Arts*, 108th year, 6th period, vol. 68 (1966), pp. 333–42.
2. Daniel Wildenstein, *Claude Monet: Biographie et catalogue raisonné*, vol. 2 (Lausanne and Paris, 1974), p. 233, letter no. 393 to Alice Hoschedé, dated January 25, 1884 (author's trans.). See also Monet's letter no. 442 to Durand-Ruel, March 11, 1884, in ibid., p. 243. Wildenstein has noted that *Le Déjeuner sur l'herbe* (ibid., vol. 1, p. 144, no. 63) was left to Flament in 1878 as security against Monet's rent arrears, and remained

rolled up in Flament's cellar for the next six years.
3. In a letter of July 25, 1876, soliciting money from the collector Georges de Bellio, Monet's habitual pleading carried an edge of sincerity when he wrote that he and his family "will be expelled from this lovely little house where I was able to live modestly and work so well"; Wildenstein, 1974, vol. 1, p. 431, letter no. 95.
4. Monet to de Bellio, June 20, 1876, in ibid., p. 430, letter no. 90.
5. Monet to Chocquet, February 4, 1876, in ibid., p. 430, letter no. 86.
6. For a discussion of Monet's style at this time, see John House, *Monet: Nature into Art* (New Haven and London, 1986), p. 34 and *passim*.
7. For example, the orderly *Camille Monet and a Child in the Garden* (private collection, Boston), can be compared to the forestlike *The Artist's Family in the Garden* (private collection, U.S.A.); Wildenstein, 1974, vol. 1, p. 278, nos. 382 and 386, respectively. The proposed reconstruction of Monet's garden is based on fourteen garden paintings (ibid., vol. 1, p. 279, nos. 382 and 384–86; p. 290, nos. 406–9; p. 292, nos. 410–15) and remains open to modification, since the garden has been completely altered.
8. Wildenstein, 1974, vol. 1, p. 292, no. 412.
9. See Paul Hayes Tucker, *Monet at Argenteuil*, 2nd ed. (New Haven and London, 1984), p. 149.
10. As an introduction to this topic, see Alain Corbin, *The Foul and the Fragrant: Odor and the French Social Imagination* (Cambridge, Mass., 1986), pp. 189–94. See also the section on the public and private garden in Los Angeles County Museum of Art, The Art Institute of Chicago, and Galeries Nationales d'Exposition du Grand Palais, Paris, *A Day in the Country: Impressionism and the French Landscape*, June 28, 1984–April 22, 1985, pp. 207–41.

11. In Pierre Boitard's *Nouveau Manuel complet de l'architecte du jardins, ou l'art de les composer et de les décorer*, reprinted as late as 1852, such a garden appeared at the end of his classification, derisively listed as "un potager fleuriste," the sort of garden only those of "mediocre fortune" could afford and one that was commonly the result of "caprice and bad taste." "We will not trouble to mention the rules for laying out such gardens," Boitard concluded, "for there are none" (reprint, Paris, 1852), pp. 76, 116 (author's trans.).

12. Baron A-A. Ernouf and A. Alphand, *L'Art des jardins*, 3rd ed. (1868; Paris, 1886), pp. x–xi. Arthur Mangin, in his *Histoire des jardins anciens et modernes* (1867; Tours, 1887), was even more emphatic. According to him, the great achievement of nineteenth-century reform in garden architecture was to "have restored to the garden its first and essential function—the cultivation of flowers." By definition, Mangin continued, gardens were places planted with flowers, and he observed with approval that in gardens of his day "flowers were gaining ground everywhere" (pp. 265–67 [author's trans.]). Finally, by the end of the century, Vilmorin-Andrieux and Company issued the fourth edition of *Les Fleurs de pleine terre, comprenant la description et la culture des fleurs annuelles, bisannuelles, vivaces, et bulbeuses de pleine terre*, 4th ed. (Paris, 1894), a fifteen-hundred-page compendium of annuals suitable for the private garden, with extensive discussion on how to plant them.

13. "The system of curved lines and surfaces has replaced that of straight lines and flat surfaces. As a result nearly all of our gardens now share a family resemblance that is close to monotonous." Mangin, 1887, p. 268 (author's trans.).

14. In fact, the entry for *hollyhock* ("Rose Trémière) in Vilmorin-Andrieux and Company's 1894 compendium might well describe the flowers as they appear in *Camille in the Gar-*

den: "They are plants of high ornamentation with an effect that is both grandiose and picturesque, and in larger gardens should be planted either in clusters or screens. Since their stems are bare toward the base, it is recommended that they be surrounded by clumps of smaller flowers chosen with discernment" (p. 898 [author's trans.]).

15. Quoted in House, 1986, p. 18. In his garden at the Pavillon Flament, Monet is the Parisian who constructs a nature both ornamental and modish. There is a certain continuity, then, between this group of paintings and the scenes of the Tuileries gardens and the Parc Monceau that he would paint in 1877.

FIG. 88 Claude Monet (French, 1840–1926), *Gladioli*, c. 1876, oil on canvas, 22 x 32½″ (55.9 x 82.5 cm), The Detroit Institute of Arts, City of Detroit Purchase

FIG. 87 Reconstruction of Monet's garden based on Argenteuil paintings

FIG. 89 Photograph of 21 boulevard Karl Marx, by Rodolphe Walter, c. 1965 (courtesy Wildenstein and Co.)

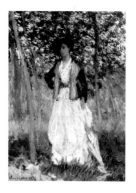

CLAUDE MONET
French, 1840–1926
The Stroller (Suzanne Hoschedé), 1887
Signed lower left: Claude Monet
Oil on canvas, 39⁹/₁₆ x 27³/₄″ (100.5 x 70.5 cm)

PROVENANCE: Suzanne Butler, née Hoschedé; Claude Monet; bequeathed by the artist to his stepdaughter and daughter-in-law, Blanche Hoschedé-Monet; bequeathed to her nephew, Jean-Marie Toulgouat.

EXHIBITIONS: Galerie Georges Petit, Paris, "Claude Monet, A. Rodin," 1889, no. 145; Bernheim-Jeune, Paris, "La Femme: 1800–1930," April–June 1948, no. 63; Philadelphia Museum of Art, "Exhibition of Philadelphia Private Collectors," summer 1963 (no catalogue); The Tate Gallery, London, "The Annenberg Collection," September 2–October 8, 1969, no. 22.

LITERATURE: Roger Terry Dunn, "The Monet-Rodin Exhibition at the Galerie Georges Petit in 1889: A Study of the Significance of the Exhibition and Its Setting, the Work of the Two Artists at Mid-Career, and Their Artistic and Social Relationship," Ph.D. diss., Northwestern University, Evanston, Ill., 1978, pp. 80, 250; Daniel Wildenstein, *Claude Monet: Biographie et catalogue raisonné,* vol. 3 (Lausanne and Paris, 1979), no. 1133 (repro.).

NOTES
1. Daniel Wildenstein, *Claude Monet: Biographie et catalogue raisonné,* vol. 3 (Lausanne and Paris, 1979), nos. 1131–33. See also Claire Joyes, *Claude Monet: Life at Giverny* (New York and Paris, 1985), pp. 29, 35.

2. Wildenstein, 1979, vol. 3, p. 223, letter no. 794 (author's trans.).

3. Wildenstein, 1979, vol. 2, nos. 1075–77,

vol. 3, nos. 1131–32, 1149–53, 1203–4, 1206–7, 1249–50.

4. The year 1887 was an unusual one for Monet, in that he remained almost the entire time at Giverny, not leaving to seek out new motifs for landscape painting until he traveled south to Toulon and Antibes in January 1888.

5. Octave Mirbeau, "Claude Monet," *L'Art dans les deux mondes,* March 7, 1891; quoted in Charles F. Stuckey, ed., *Monet: A Retrospective* (New York, 1985), p. 159.

6. Wildenstein, 1979, vol. 3, p. 223, letter no. 795 (author's trans.).

7. The tentative, exploratory nature of these paintings is also evident in the way Monet discussed and exhibited them. "I've scraped off and destroyed nearly everything I've done ... a superb summer ruined," he wrote to Gustave Caillebotte in early September 1887, at his most dejected (Wildenstein, 1979, vol. 3, p. 298, letter no. 1424 [author's trans.]). Gustave Geffroy had to wait several months before seeing any of Monet's figure paintings (John House, *Monet: Nature into Art* [New Haven and London, 1986], p. 236, n. 92); and Berthe Morisot wrote to Mallarmé the following autumn of "beautiful surprises ... figures in a landscape" that she had missed (Denis Rouart, ed., *The Correspondence of Berthe Morisot with Her Family and Her Friends Manet, Puvis de Chavannes, Degas, Monet, Renoir, and Mallarmé* [London, 1986], p. 161). Furthermore, when *The Stroller* was shown at Georges Petit's exhibition of works by Monet and Rodin in June 1889 (Galerie Georges Petit, Paris, "Claude Monet, A. Rodin," 1889, no. 145), it appeared with three other figure paintings under a separate rubric, "Essais de figures en plein air." Of the 145 works shown by Monet in this exhibition, these were the only 4 paintings to appear in the catalogue undated, thus reinforcing Monet's hesitation to present them as fully realized works.

8. The best recent discussion is William H.

Gerdts, "The Arch-Apostle of the Dab-and-Spot School: John Singer Sargent as an Impressionist," in Patricia Hills, ed., *John Singer Sargent* (New York, 1987), pp. 111–45.

9. Monet informed Rodin that he was seeing Sargent in mid-June 1887 (Wildenstein, 1979, vol. 3, p. 223, letter no. 791). Sargent acquired Monet's *Bennecourt,* in August 1887, presumably from Monet himself (Wildenstein, 1979, vol. 3, p. 88; no. 1126).

10. House, 1986, pp. 36–40.

11. House was the first to suggest that Sargent may have played a greater role than merely absorbing Monet's Impressionism and bringing it to England. See House's discussion of Monet's figure paintings in ibid., p. 39. Monet's letter to Alice is quoted in Hills, 1987, p. 111.

12. As Clement Greenberg noted in an essay on Monet's work at this time, "[Monet] found solutions that permitted him to keep the weight of the picture safely on the surface without ceasing thereby to report Nature." "The Later Monet," in *Art and Culture* (London, 1973), p. 44. For a discussion of Monet and the symbolist context, see Mark Roskill, *Van Gogh, Gauguin, and the Impressionist Circle* (Greenwich, Conn., 1970), chapters 1 and 6; and Roger Terry Dunn, "The Monet-Rodin Exhibition at the Galerie Georges Petit in 1889: A Study of the Significance of the Exhibition and Its Setting, the Work of the Two Artists at Mid-Career, and Their Artistic and Social Relationship," Ph.D. diss., Northwestern University, Evanston, Ill., 1978.

FIG. 90 Claude Monet (French, 1840–1926), *Suzanne Reading and Blanche Painting in the Meadows of Giverny,* 1887, oil on canvas, 36 x 38½" (91.4 x 97.8 cm), Los Angeles County Museum of Art, Mr. and Mrs. George Gard De Sylva Collection

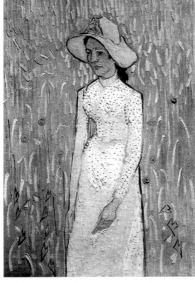

FIG. 92 Vincent van Gogh (Dutch, 1853–1890), *Girl in White,* 1890, oil on canvas, 26⅛ x 17⅞" (66 x 45 cm), National Gallery of Art, Washington, D.C., Chester Dale Collection

FIG. 91 John Singer Sargent (American, 1856–1925), *Claude Monet Painting at the Edge of a Wood,* c. 1887, oil on canvas, 21¼ x 25½" (54 x 64.8 cm), The Tate Gallery, London

CLAUDE MONET
French, 1840–1926
The Path through the Irises, 1914–17
Stamped lower right: Claude Monet
Oil on canvas, 78⅞ x 70⅞" (200.3 x 180 cm)

PROVENANCE: Michel Monet, Sorel-Moussel.

EXHIBITIONS: Galerie Granoff, Paris, "Monet: Nymphéas," 1965; Wildenstein and Co., New York, "Masterpieces in Bloom," April 5–May 5, 1973 (not in catalogue); The Metropolitan Museum of Art, New York, "Monet's Years at Giverny: Beyond Impressionism," 1978, no. 64.

LITERATURE: K. Granoff, *Claude Monet: Quinze nymphéas inèdits. Poèmes* (Paris, 1958), pl. XI; Denis Rouart, Jean-Dominique Rey, and Robert Maillard, *Monet nymphéas ou les miroirs du temps* (Paris, 1972), n.p. (repro.); Daniel Wildenstein, *Claude Monet: Biographie et catalogue raisonné,* vol. 4 (Lausanne and Paris, 1985), no. 1828 (repro.).

NOTES
1. Interview given to the journalist François Thiébault-Sisson and published in "Les Nymphéas de Claude Monet," *Revue de l'Art,* July 1927; translated in Charles F. Stuckey, ed., *Monet: A Retrospective* (New York, 1985), pp. 290–91 (translation slightly revised by author).
2. Cézanne's celebrated appreciation of Monet's powers—"he has muscles"—is translated in Charles F. Stuckey, *Monet: Water Lilies* (New York, 1988), p. 11.
3. Wynford Dewhurst, *Impressionist Painting: Its Genesis and Development* (London, 1904); quoted in Stuckey, 1985, p. 231.
4. The eminent botanist Georges Truffaut admired the "abundant irises of all varieties along the edges of the pond" at Giverny, especially the Japanese iris *(Iris kaempferi)*—

the species in *The Path through the Irises*—which flourished in summer and imparted an "oriental touch" to the gardens. "The Garden of a Great Painter," *Jardinage,* vol. 87 (November 1924); translated in Stuckey, 1985, p. 314. *Iris kaempferi* was already popular with horticulturalists by the 1890s, praised as a plant that was hardy enough to withstand the Parisian climate and easy to grow: "It is said," noted one of the leading French gardening authorities, "that in Japan these flowers are cultivated in land that is not only irrigated but actually submerged in water. However, in Europe, they thrive in ground that is merely moist and gently shaded." Vilmorin-Andrieux and Company, *Les Fleurs de pleine terre,* 4th ed. (Paris, 1894), p. 505 (author's trans.).

5. See also Wildenstein, 1985, vol. 4, p. 196, nos. 1630, 1631, and 1633.

6. For the London painting, see Martin Davies, *National Gallery Catalogues, French School* (London, 1970), pp. 107–8; for the second variant, see Wildenstein, 1985, vol. 4, p. 266, no. 1830.

7. See the reproductions in The Metropolitan Museum of Art, New York, *Monet's Years at Giverny: Beyond Impressionism* (New York, 1978), nos. 62, 63.

8. Commenting on the seasonal variations in Monet's garden, Mirbeau wrote: "The irises raise their strange, curved petals, bedecked with white, mauve, lilac, yellow, and blue, streaked with brown stripes and purplish dots, evoking, in their complicated underparts, mysterious analogies, tempting and perverse dreams...." Quoted in Robert Gordon and Andrew Forge, *Monet* (New York, 1983), p. 204.

9. A 1915 photograph of Monet at work on *Water Lilies* (Portland Art Museum) shows the artist perched on a high stool, protected from the sun by a large umbrella, and with his stepdaughter and housekeeper, Blanche Hoschedé, at hand. See Claire Joyes, *Claude*

Monet: Life at Giverny (New York, 1985), repro. p. 82. Blanche's brother, Jean-Pierre Hoschedé, described how these huge canvases were held in place by a system of ropes attached to pegs and large stones, "to protect [them] from the wind." Jean-Pierre Hoschedé, *Claude Monet: Ce mal connu,* vol. 1 (Geneva, 1960), p. 133.

10. See Gordon and Forge, 1983, pp. 230–31.

11. See also the related *Iris at the Side of the Pool* (The Art Institute of Chicago), reproduced in Joyes, 1985, p. 107.

12. Wildenstein, 1985, p. 331, no. 4d. See also Henri Manuel's photographs of Monet posing with the *Morning* panel: the square segment at the end is clearly visible; ibid., p. 335, photograph no. 3.

13. "If I have regained my sense of color in the large canvases ... it is because I have adapted my working methods to my eyesight and because most of the time I have laid down the color haphazardly, on the one hand trusting solely to the labels on my tubes of paint and, on the other, to force of habit, to the way in which I have always laid out my materials on my palette"; Monet to Thiébault-Sisson (see note 1 above), translated in Stuckey, 1985, p. 293.

14. See Gordon and Forge, 1983, pp. 266–67, for an appraisal of these last paintings; quotation on p. 266.

FIG. 93 Photograph of Monet by the Japanese bridge in his garden, c. 1915, Collection of H. Roger-Viollet, Paris

FIG. 94 Claude Monet (French, 1840–1926), *Lily Pond and Path along the Bank,* 1900, oil on canvas, 35 x 39⅜" (89 x 100 cm), Collection Durand-Ruel, Paris

FIG. 95 Claude Monet, *Irises*, 1914–17, oil on canvas, 31 x 23¼" (79 x 59 cm), National Gallery, London

FIG. 96 Claude Monet, *Iris*, 1914–17, oil on canvas, 78¾ x 59" (200 x 150 cm), Beyeler Collection, Basel

FIG. 97 Claude Monet, *Irises by the Pond*, 1914–17, oil on canvas, 78¾ x 59" (200 x 150 cm), Virginia Museum of Fine Arts, Richmond

CLAUDE MONET
French, 1840–1926
Water Lilies, 1919
Signed and dated lower left: Claude Monet 1919
Oil on canvas, 39¾ x 78¾" (101.1 x 200 cm)

PROVENANCE: Sold to Bernheim-Jeune, Paris, 1919; Bernheim-Jeune and Durand-Ruel, Paris, 1921; Durand-Ruel sold their share in the painting to Bernheim-Jeune, 1922; sold by Bernheim-Jeune to Henri de Canonne, Paris, c. 1928; Garabjol, Paris; Wildenstein and Co., New York.

EXHIBITIONS: Bernheim-Jeune, Paris, 1921, no. 44 or 45; Durand-Ruel Galleries, New York, "Paintings by Claude Monet," January 4–21, 1922, no. 10; Galeries Durand-Ruel, Paris, "Tableaux par Monet," January 6–19, 1928, no. 83; Paul Rosenberg, Paris, "Exposition d'oeuvres de Claude Monet (1840–1927): Oeuvres de 1891 à 1919," April 2–30, 1936, no. 30; The Metropolitan Museum of Art, New York, "Monet's Years at Giverny: Beyond Impressionism," 1978, no. 75.

LITERATURE: François Thiébault-Sisson, "Exposition Claude Monet," *Le Temps,* January 7, 1928, p. 4; Arsène Alexandre, *La Collection Canonne: Une Histoire en action de l'impressionnisme et de ses suites* (Paris, 1930), pp. 47–48, pl. 6; Daniel Wildenstein, *Claude Monet,* translated by A. Colloridi (Milan, 1971), repro. p. 81; Denis Rouart, Jean-Dominique Rey and Robert Maillard, *Monet Nymphéas, ou les miroirs du temps, suivi d'un catalogue raisonné* (Paris, 1972), n.p. (repro.); Charles Moffett, *Monet's Water Lilies* (New York, 1978), p. 7, pl. 15; Robert Gordon and Charles F. Stuckey, "Blossoms and Blunders: Monet and the State," *Art in America,* vol. 67 (January–February 1979), pp. 103, 110, repro. pp. 102–3; Charles F. Stuckey, ed.,

Monet: A Retrospective (New York, 1985), pl. 112; Daniel Wildenstein, *Claude Monet: Biographie et catalogue raisonné,* vol. 4 (Lausanne and Paris, 1985), no. 1891 (repro.); Kunstmuseum, Basel, *Claude Monet: Nymphéas—Impression, Vision* (Basel, 1986), p. 63, n. 169.

NOTES

1. Monet first confided details of this project to the journalist Maurice Guillemot, whom he met in August 1897. In an article published in the *Revue Illustrée* on March 15, 1898, Guillemot reported that Monet was using the lily pond at Giverny "pour une décoration, dont il a déjà commencé les études," and that he had seen "de grands panneaux" in the artist's studio, which would be the elements for a circular room, "dont la cimaise … serait entièrement occupée par un horizon d'eau tâché de ces végétations"; see Daniel Wildenstein, *Claude Monet: Biographie et catalogue raisonné,* vol. 3 (Lausanne and Paris, 1979), pp. 78–79.

2. Robert Gordon, "The Lily Pond at Giverny: The Changing Inspiration of Monet," *The Connoisseur,* vol. 184, no. 741 (November 1973), pp. 154–56. See Horst Keller, *Ein Garten wird Malerei Monets Jahre in Giverny* (Cologne, 1982), p. 145.

3. Wildenstein, 1985, pp. 79–84; for the date of the completion of Monet's third atelier, see his letter to Bernheim-Jeune, October 30, 1915, in which he apologized for postponing a visit to Paris "ayant à m'installer enfin dans mon bel atelier. C'est fait maintenant"; ibid., p. 393, letter no. 2161a.

4. For a summary of this project, see Robert Gordon and Charles F. Stuckey, "Blossoms and Blunders: Monet and the State," *Art in America,* vol. 67 (January–February 1979), pp. 102–17; and Charles F. Stuckey, "Blossoms and Blunders: Monet and the State, [Part] II," ibid. (September 1979), pp. 109–25.

5. For example, Monet's letter to Gustave Gef-froy of December 1, 1914: " Je me suis remis au travail: c'est encore le meilleur moyen de ne pas trop penser aux tristesses actuelles, bien que j'aie un peu honte de penser à de petites recherches de formes et de couleurs pendant que tant de gens souffrent et meurent pour nous"; Wildenstein, 1985, vol. 4, p. 391, letter no. 2135.

6. See Charles S. Moffett, *Monet's Water Lilies* (New York, 1978), p. 7.

7. Wildenstein, 1985, vol. 4, p. 403, letter no. 2319 (author's trans.).

8. Ibid., letter no. 2321.

9. Ibid., p. 89, without noting the source for this information. Although Wildenstein's documentation is extremely thorough, he has connected this *Water Lily* series with a group of canvases of slightly larger dimensions recorded by René Gimpel as measuring "about six feet wide by four feet high" (*Diary of an Art Dealer,* translated by John Rosenberg [New York, 1966], p. 60). Gimpel saw Monet's atelier in August 1918. This celebrated passage, in which Monet spoke of having the canvases brought to him as he worked in front of the motif so that he could "fix the vision definitively," may in fact refer to a group of *Water Lilies* measuring over 4 x 6½ feet (Wildenstein, 1985, p. 264, no. 1823; p. 276, nos. 1856 and 1858; p. 278, nos. 1860, 1861, 1863; p. 286, nos. 1883–85) and probably painted in the summer of 1918, one year before the series of the Annenberg *Water Lilies.*

10. Monet had ordered twenty canvases of approximately 3 x 6½ feet from a Mme Barillon on April 30, 1918; Wildenstein, 1985, vol. 4, pp. 399–400, letter no. 221.

11. The three other signed canvases are Wildenstein, 1985, vol. 4, no. 1890; sold Sotheby Parke Bernet, New York, May 5, 1971, lot 41 (repro.); ibid., no. 1893, cut in half, the left segment reproduced in Kunstmuseum, Basel, *Claude Monet: Nymphéas—Impression, Vision* (Basel, 1986), pl. 47, p. 85; and ibid., no. 1894. The seven unsigned *Water Lilies* are ibid., p. 288, no. 1892; p. 290, nos. 1895–99; and p. 292, no. 1900.

12. See Robert Gordon and Andrew Forge, *Monet* (New York, 1984), repro. p. 277.

13. Quoted in Gimpel, 1966, p. 127.

14. See Charles F. Stuckey, 1979, pp. 114–15; see also the same author's *Monet: Water Lilies* (New York, 1988), pl. 59, pp. 106–7.

15. Roger Marx's article "Les 'Nymphéas' de M. Claude Monet," which appeared in the *Gazette des Beaux-Arts,* 51st year, 1st period, vol. 624 (June 1909), pp. 523–31, is cited in Wildenstein, 1985, vol. 4, pp. 67–68 (author's trans.).

16. For examples of this modernist interpretation, now much revised in the most recent literature, see William Seitz, "Monet and Abstract Painting," and Clement Greenberg, "Claude Monet: The Later Monet," in Charles F. Stuckey, ed., *Monet: A Retrospective* (New York, 1985), pp. 367–82.

17. See Gimpel, 1966, p. 154, for Degas's reactions; ibid., p. 60, for his own. Clemenceau was the first and most committed advocate of the series; see Monet's letter no. 2116 to Geffroy, April 30, 1914, in Wildenstein, 1985, vol. 4, p. 390.

18. See Stuckey, 1979, part II, p. 112. Durand-Ruel had hoped that Monet would then release other paintings unsuited to the government project; this did not happen.

19. A survey of the critical reaction to the exhibitions organized by Bernheim-Jeune in Paris in 1921 and by Durand-Ruel in New York in January 1922 would be revealing. Reactions to the earlier exhibition of *Nymphéas* in 1909 suggest an enthusiastic and comprehending reception; see, for example, Marx, 1909, pp. 523–31; and Jean-Louis Vaudoyer's appraisal from *La Chronique des Arts,* cited in The Metropolitan Museum of Art, New York, *Monet's Years at Giverny: Beyond Impressionism* (New York, 1978), p. 31.

20. Wildenstein, 1985, vol. 4, no. 1893.

21. Arsène Alexandre, *La Collection Canonne:*

Une Histoire en action de l'impressionnisme et de ses suites (Paris, 1930), pp. 47–48 (author's trans.).

FIG. 98 Claude Monet (French, 1840–1926), *Water Lilies*, 1917–19, oil on canvas, 39³/₈ x 79″ (100 x 200 cm), private collection (courtesy Acquavella Galleries)

FIG. 99 Claude Monet, *Water Lilies*, c. 1921, oil on canvas, 79 x 236″ (200 x 600 cm), The Carnegie Museum of Art, Pittsburgh, Acquired through the generosity of Mrs. Alan M. Scaife

HENRI DE TOULOUSE-LAUTREC
French, 1864–1901
The Streetwalker (Casque d'Or), c. 1890–91
Signed lower right: T. Lautrec
Oil on cardboard, 25½ x 21″
 (64.8 x 53.3 cm)

PROVENANCE: Possibly Seré de Rivières; sale, Hôtel Drouot, Paris, April 25, 1901, lot 61; possibly acquired by Meier-Graefe; Heim Collection; sale, Hôtel Drouot, Paris, April 30, 1913, lot 2; possibly Levêque Collection; sale, Galerie Georges Petit, Paris, December 10, 1920, lot 119; Paul Rosenberg, Paris; Wildenstein and Co., New York; Dr. Elias, Sweden; private collection, Switzerland.

EXHIBITIONS: Galerie Durand-Ruel, Paris, "Exposition H. de Toulouse-Lautrec," May 14–31, 1902, no. 37; Galerie Manzi-Joyant, Paris, "Exposition rétrospective de l'oeuvre de H. de Toulouse-Lautrec (1864–1901)," June 15–July 11, 1914, no. 101; The Detroit Institute of Arts, "The Two Sides of the Medal: French Painting from Gérôme to Gauguin," 1954, no. 127; Philadelphia Museum of Art and The Art Institute of Chicago, "Toulouse-Lautrec," October 29, 1955–February 1956, no. 27; Philadelphia Museum of Art, "Exhibition of Philadelphia Private Collectors," summer 1963 (no catalogue); The Tate Gallery, London, "The Annenberg Collection," September 2–October 8, 1969, no. 29.

LITERATURE: Gustave Coquiot, *Lautrec ou quinze ans de moeurs parisiennes, 1885–1900*, 4th ed. (Paris, 1921), pp. 129, 214; Achille Astre, *H. de Toulouse-Lautrec* (Paris, 1925), p. 78; Maurice Joyant, *Henri de Toulouse-Lautrec, 1864–1901: Peintre* (Paris, 1926), pp. 127, 273, repro. p. 38; Gotthard Jedlicka, *Henri de Toulouse-Lautrec* (Berlin, 1929), repro. p. 174; Gerstle Mack, *Toulouse-Lautrec* (New York, 1938), p. 357; Jacques Lassaigne, *Toulouse Lautrec* (Paris, 1939), p. 17, repro. p. 83; R.H. Wilenski, *Modern French Painters* (New York, 1940), p. 127; Pierre Mac Orlan, *Lautrec: Peintre de la lumière froide* (Paris, 1941), p. 821, repro. p. 53; "The Gay Paree of the Nineteenth Century Recorded by Toulouse-Lautrec of the Famous Moulin Rouge and of the Bois de Boulogne," *Illustrated London News*, December 1953, repro. p. 41; François Gauzi, *Lautrec et son temps* (Paris, 1954), p. 84, pl. 6; Hugo Perls, *Warum ist Kamilla schön? Von Kunst, Künstlern, und Kunsthandel* (Munich, 1962), p. 92; Philippe Huisman and M. G. Dortu, *Lautrec by Lautrec* (New York, 1964), p. 64, repro. p. 65; G. M. Sugana, *L'Opera completa di Toulouse-Lautrec* (Milan, 1969), no. 286 (repro.); M. G. Dortu, *Toulouse-Lautrec et son oeuvre* (New York, 1971), vol. 2, no. 407 (repro.); Charles F. Stuckey, *Toulouse-Lautrec: Paintings* (Chicago, 1979), p. 167, pl. 45; Gale Barbara Murray, "Henri de Toulouse-Lautrec: A Checklist of Revised Dates, 1878–1891," *Gazette des Beaux-Arts*, 122nd year, 6th period, vol. 95 (February 1980), pp. 88, 90; G. M. Sugana, *Tout l'oeuvre peint de Toulouse-Lautrec* (Paris, 1986), no. 384 (repro.).

NOTES
1. Fritz Novotny, *Toulouse-Lautrec* (York, 1969), p. 24.
2. See G. M. Sugana, *L'Opera completa di Toulouse-Lautrec* (Milan, 1969), no. 286.
3. Mentioned in the exhibition catalogue for the Tate Gallery, London, *The Annenberg Collection*, September 2–October 8, 1969, no. 29.
4. The few facts surrounding the Casque d'Or are summarized by Naomi E. Maurer in Charles F. Stuckey, *Toulouse-Lautrec: Paintings* (Chicago, 1979), p. 167.
5. Novotny, 1969, p. 10.
6. The Tate Gallery, 1969, no. 29.
7. Maurice Joyant, *Henri de Toulouse-Lautrec, 1864–1901: Peintre* (Paris, 1926), p. 29.

8. Gale Barbara Murray, "Henri de Toulouse-Lautrec: A Checklist of Revised Dates, 1878–1891," *Gazette des Beaux-Arts*, 122nd year, 6th period, vol. 95 (February 1980), p. 90.

9. Ibid., p. 87.

10. A photograph of Lautrec at work on this picture in the garden of Père Forest is illustrated in Stuckey, 1979, p. 4.

11. Joyant, 1926, p. 192 (author's trans.).

FIG. 100 Henri de Toulouse-Lautrec (French, 1864–1901), *Ball at the Moulin Rouge*, 1890, oil on canvas, 45½ x 59″ (115.6 x 149.8 cm), Philadelphia Museum of Art, The Henry P. McIlhenny Collection in memory of Frances P. McIlhenny

FIG. 101 Henri de Toulouse-Lautrec, *La Goulue Entering the Moulin Rouge*, 1891–92, oil on board, 31¼ x 23¼″ (79.4 x 59 cm), The Museum of Modern Art, N.Y., Gift of Mrs. David M. Levy

HENRI DE TOULOUSE-LAUTREC

French, 1864–1901
Henri-Gabriel Ibels, 1893
Signed and inscribed lower right: Pour H.G. Ibels T-Lautrec
Gouache on paper, 20½ x 15½″ (52 x 39.4 cm)

PROVENANCE: Gift of the artist to Henri-Gabriel Ibels; Marquis de Biron; Paul Valloton, Lausanne; Dikran Khan Kélékian, New York; sale, Rains Gallery, New York, January 18, 1935, lot 76; Downtown Galleries, New York; sale, Parke-Bernet Galleries, New York, April 22, 1954, lot 25; Hon. Averell Harriman, New York.

EXHIBITIONS: Musée des Arts Décoratifs, Paris, "Exposition H. de Toulouse-Lautrec," April 9–May 17, 1931, no. 102; Philadelphia Museum of Art, "Exhibition of Philadelphia Private Collectors," summer 1963 (no catalogue); The Tate Gallery, London, "The Annenberg Collection," September 2–October 8, 1969, no. 30.

LITERATURE: Gustave Coquiot, *H. de Toulouse-Lautrec* (Paris, 1913), p. 188; Gustave Coquiot, *Lautrec ou quinze ans de moeurs parisiennes, 1885–1900*, 4th ed. (Paris, 1921), p. 121; Achille Astre, *H. de Toulouse-Lautrec* (Paris, 1925), p. 81; Maurice Joyant, *Henri de Toulouse-Lautrec, 1864–1901: Peintre* (Paris, 1926), p. 277, repro. p. 205; *Art News*, vol. 37 (December 15, 1934), repro. (cover); Emile Schaub-Koch, *Psychanalyse d'un peintre moderne: Henri de Toulouse-Lautrec* (Paris, 1935), p. 211; Gerstle Mack, *Toulouse-Lautrec* (New York, 1938), p. 270; Pierre Mac Orlan, *Lautrec: Peintre de la lumière froide* (Paris, 1941), p. 120; Henri Perruchot, *La Vie de Toulouse-Lautrec* (Paris, 1958), p. 253; G. M. Sugana, *L'Opera completa di Toulouse-Lautrec* (Milan, 1969), no. 326 (repro.); M. G. Dortu, *Toulouse-Lautrec et son oeuvre* (New York,

1971), vol. 2, no. 463 (repro.); G. M. Sugana, *Tout l'oeuvre peint de Toulouse-Lautrec* (Paris, 1986), no. 434 (repro.).

NOTES

1. This apt analogy was first made by Emile Schaub-Koch in *Psychanalyse d'un peintre moderne: Henri de Toulouse-Lautrec* (Paris, 1935), p. 211.

2. See Charles Chasse, *The Nabis and Their Period*, translated by Michael Bullock (New York, 1969).

3. For a general biography and bibliography for Ibels see Phillip Dennis Cate and Patricia Eckert Boyer, *The Circle of Toulouse-Lautrec: An Exhibition of the Work of the Artist and of His Close Associates* (New Brunswick, N.J., 1986), pp. 123–35.

4. The contrast between the two artists is markedly apparent when they portray the same subject, such as the popular actress Yvette Guilbert. See Cate and Boyer, 1986, p. 126.

5. M. G. Dortu, *Toulouse-Lautrec et son oeuvre* (New York, 1971), vol. 2, p. 552, no. D3.336; and Le Musée des Beaux-Arts de Montréal–The Montreal Museum of Fine Arts, *Toulouse-Lautrec, 1864–1901* (Montreal, 1968), no. 10.

FIG. 102 Jean-Antoine Watteau (French, 1684–1721), *Gilles (Pierrot)*, 1717–19?, oil on canvas, 72⅝ x 58⅞" (184.5 x 149.5 cm), Musée du Louvre, Paris

FIG. 104 Henri de Toulouse-Lautrec (French, 1864–1901), *Henri-Gabriel Ibels,* 1893, pen and ink on paper, 16½ x 12½" (42 x 31.7 cm), Smith College Museum of Art, Northampton, Mass., Gift of Mr. and Mrs. Ernest Gottlieb

FIG. 103 Henri Gabriel Ibels (French, 1867–1936), cover for *Le Café-Concert*, by Georges Montorgueil, 1893, lithograph, 16¹⁵⁄₁₆ x 12¾" (43 x 32.5 cm), Collection of Mr. and Mrs. Herbert D. Schimmel

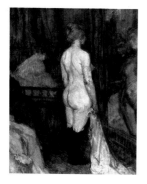

HENRI DE TOULOUSE-LAUTREC
French, 1864–1901
Woman before a Mirror, 1897
Signed and dated upper left: Lautrec '97
Oil on board, 24½ x 18½″ (62 x
 47 cm)

PROVENANCE: Maurice Joyant, Paris; Mme Dortu, Paris; Wildenstein and Co., New York; Mrs. Ira Haupt, New York.

EXHIBITIONS: Grand Palais, Paris, "Société du Salon d'Automne," October 15–November 15, 1904, no. 6?; Galerie Manzi-Joyant, Paris, "Exposition rétrospective de l'oeuvre de H. de Toulouse-Lautrec (1864–1901)," June 15–July 11, 1914, no. 74; Musée des Arts Décoratifs, Paris, "Exposition H. de Toulouse-Lautrec," April 9–May 17, 1931, no. 164; M. Knoedler and Co., London, "Toulouse-Lautrec: Paintings and Drawings," January 19–February 2, 1938, no. 28; Palais des Beaux-Arts, Brussels, "Toulouse-Lautrec (1864–1901)," 1947, no. 49; Wildenstein and Co., New York, "Masterpieces from Museums and Private Collections," November 8–December 15, 1951, no. 60; The Museum of Modern Art, New York, "Paintings from Private Collections," May 31–September 5, 1955, no. 149; The Museum of Modern Art, New York, "Toulouse-Lautrec: Paintings, Drawings, Posters, and Lithographs," March 20–May 6, 1956, no. 26; Wildenstein and Co., New York, "Nude in Painting," November 1–December 1, 1956, no. 37; Waldorf-Astoria Hotel, New York, "Festival of Art," October 29–November 1, 1957, no. 173; Wildenstein and Co., New York, "Toulouse-Lautrec," February 7–March 14, 1964, no. 47; Wildenstein and Co., New York, "Olympia's Progeny," October 28–November 27, 1965, no. 79; M. Knoedler and Co., New York, "Impressionist Treasures from Private Collections in New York," January 12–29, 1966, no. 38.

LITERATURE: Gustave Coquiot, *Lautrec ou quinze ans de moeurs parisiennes, 1885–1900*, 4th ed. (Paris, 1921), p. 210; Maurice Joyant, *Henri de Toulouse-Lautrec* (Paris, 1926), p. 294, repro. p. 48; Emile Schaub-Koch, *Psychanalyse d'un peintre moderne: Henri de Toulouse-Lautrec* (Paris, 1935), p. 191; Jacques Lassaigne, *Toulouse Lautrec* (Paris, 1939), repro. p. 132; R. H. Wilenski, *Modern French Painters* (New York, 1940), p. 359; Pierre Mac Orlan, *Lautrec peintre de la lumière froide* (Paris, 1941), repro. opp. p. 113; "Paintings from Private Collections," *The Museum of Modern Art Bulletin*, vol. 22, no. 4 (summer 1955), p. 35, repro. p. 15; "Current and Forthcoming Exhibitions," *The Burlington Magazine*, vol. 48 (January–December 1956), p. 212; Denys Sutton, *Lautrec* (New York, 1962), pp. 21, 40, pl. 37, repro. (back cover); Jean Bouret, *Toulouse-Lautrec* (Paris, 1963), repro., p. 244; Douglas Cooper, *Henri de Toulouse-Lautrec* (New York, 1966), p. 142, repro. p. 143; Fritz Neugass, "Manets 'Olympia' und ihre Folgen, Gemälde von vier Jahrzehnten bei Wildenstein, New York," *Weltkunst*, vol. 14, no. 1 (January 1966), p. 8 (repro.); G. M. Sugana, *L'Opera completa di Toulouse-Lautrec* (Milan, 1969), no. 471 (repro.); Fritz Novotny, *Toulouse-Lautrec* (York, 1969), p. 193, pl. 91; M. G. Dortu, *Toulouse-Lautrec et son oeuvre* (New York, 1971), vol. 2, no. 637 (repro.); Philippe Huisman and M. G. Dortu, *Toulouse-Lautrec* (London, 1973), repro. p. 80; Matthias Arnold, "Das Theater des Lebens, Zur Ikonographie bei Toulouse-Lautrec," *Weltkunst*, vol. 52, no. 4 (February 1982), p. 305; Matthias Arnold, "Toulouse-Lautrec und die alten Meister," *Weltkunst*, vol. 55, no. 16 (August 1985), pp. 2178–80; G. M. Sugana, *Tout l'oeuvre peint de Toulouse-Lautrec* (Paris, 1986), no. 599 (repro.).

NOTES
1. The erotic implication of bundled bed linen in at least one Lautrec, *The Brothel's Launderer* (Musée d'Albi), is discussed by Charles F. Stuckey, *Toulouse-Lautrec: Paintings* (Chicago, 1979), pp. 224–27.

2. See, for example, Douglas Cooper, *Henri de Toulouse-Lautrec* (New York, 1966), p. 142, who noted: "This is one of the most curious and remarkable paintings in the whole *oeuvre* of Lautrec, for it is almost the only one in which the unpleasantness of the subject is underlined and tinged with bitterness."

3. See Stuckey, 1979, p. 297–98.

4. See Philippe Huisman and M. G. Dortu, *Lautrec by Lautrec* (New York, 1964), p. 162.

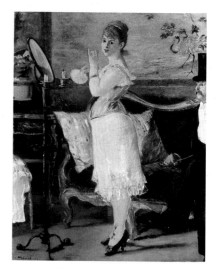

FIG. 105 Edouard Manet (French, 1832–1883), *Nana*, 1877, oil on canvas, 59¹⁄₁₆ x 45⅝″ (150 x 116 cm), Kunsthalle, Hamburg

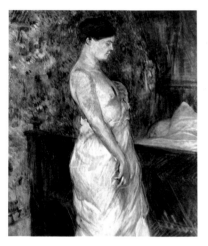

FIG. 106 Henri de Toulouse-
Lautrec (French, 1864–1901),
Woman before a Bed, 1899, oil on
panel, 24 x 19¾″ (61 x 50 cm), The
Phillips Family Collection

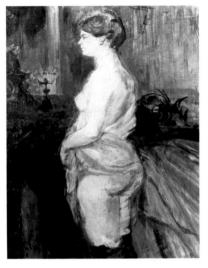

FIG. 107 Henri de Toulouse-
Lautrec, *Woman Adjusting Her Night-
gown,* 1901, oil on panel, 22 x 16⅞″
(56 x 42.2 cm), Albright-Knox Art
Gallery, Buffalo, N.Y., Gift of A.
Conger Goodyear

FIG. 108 Pierre-Auguste Renoir
(French, 1841–1919), *Bather,* c. 1895,
oil on canvas, 32 x 21½″ (82 x 65 cm),
Musée de l'Orangerie, Paris, Collec-
tion Jean Walter–Paul Guillaume

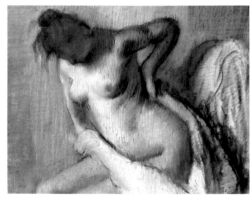

FIG. 109 Edgar Degas (French, 1834–1917),
After the Bath, Woman Drying Herself, c. 1886,
pastel on wove paper, 22¾ x 27¾″ (89 x 116
cm), Philadelphia Museum of Art, The
Henry P. McIlhenny Collection in memory of
Frances P. McIlhenny

FIG. 110 Rembrandt Harmensz.
van Rijn (Dutch, 1606–1669), *A
Woman Bathing,* 1655, oil on canvas,
24⅜ x 18½″ (61.8 x 47 cm),
National Gallery, London

GEORGES SEURAT
French, 1859–1891
Gray Weather, Grande Jatte, c. 1888
Signed lower left: Seurat
Oil on canvas, 27¾ x 34″ (70.5 x 86.4 cm)

PROVENANCE: Alexandre Séon, Paris; Walter Halvorsen, Paris; Gallery Joseph Brummer, New York; John Quinn, New York; Mrs. Thomas F. Conroy-Anderson (niece of Theodore Quinn); Wildenstein and Co., New York.

EXHIBITIONS: Musée d'Art Moderne, Brussels, "Catalogue de la VIᵉ exposition des XX," February 1889, no. 3; Pavillon de la Ville de Paris, "VIᵉ Exposition, Société des Artistes Indépendants," 1890, no. 733; Pavillon de la Ville de Paris, "VIIIᵉ Exposition, Société des Artistes Indépendants, Exposition commemorative Seurat," 1892, no. 1091; La Libre Esthétique, Brussels, "Exposition des peintres impressionnistes," 1904, no. 148; Grandes Serres de la Ville de Paris, XXᵉ Salon, "Exposition rétrospective: Georges Seurat, Société des Artistes Indépendants, Catalogue de la XXIᵉ exposition," 1905, no. 41; Joseph Brummer Gallery, New York, "Paintings and Drawings by George Seurat," December 4–27, 1924, no. 16; Jacques Seligmann and Co., New York, "Exhibition of French Masters from Courbet to Seurat," March 22–April 17, 1937, no. 23.

LITERATURE: Octave Maus, "Le Salon des XX, à Bruxelles," *La Cravache Parisienne*, February 16, 1889, p. 1; Jules Christophe, "Georges Seurat," *Les Hommes d'aujourd'hui*, vol. 8, no. 268 (March–April 1890), p. 3; Georges Lecomte, "Société des Artistes Indépendants," *L'Art Moderne*, March 30, 1890, p. 101; Johan H. Langaard, "Georges Seurat," *Kunst og Kultur*, vol. 9 (1921), repro. p. 37; André Lhote, *Georges Seurat* (Rome, 1922), n.p. (repro.); Walter Pach, *Georges Seurat* (New York, 1923), pl. 9; Walter Pach,

"Georges Seurat (1859–1891)," *The Arts*, vol. 3, no. 3 (March 1923), repro. p. 168; Gustave Coquiot, *Seurat* (Paris, 1924), p. 248, repro. opp. p. 168; *John Quinn, 1870–1925: Collection of Paintings, Water Colors, Drawings, & Sculpture* (New York, 1926), p. 15; Lucie Cousturier, *Seurat* (Paris, 1926), no. 20 (repro.); Bruno E. Werner, "George Seurat," *Die Kunst*, February 1932, repro. p. 150; Daniel Catton Rich, *Seurat and the Evolution of "La Grande Jatte"* (Chicago, 1935), no. 23; Robert J. Goldwater, "Some Aspects of the Development of Seurat's Style," *The Art Bulletin*, vol. 23, no. 1 (March 1941), p. 125, fig. 18; John Rewald, *Georges Seurat* (New York, 1943), no. 85 (repro.); Jacques De Laprade, *Georges Seurat* (Monaco, 1945), repro. p. 47; John Rewald, *Georges Seurat* (New York, 1946), no. 85 (repro.); C. L. Ragghianti, *Impressionnisme*, 2nd ed. (Turin, 1947), repro. p. 51; Paul F. Schmidt, "Georges Seurat," *Die Kunst und das schöne Heim*, July 1949, repro. p. 142; Jacques De Laprade, *Seurat* (Paris, 1951), repro. p. 58; Henri Dorra and John Rewald, *Seurat: L'Oeuvre peint, biographie, et catalogue critique* (Paris, 1959), no. 190 (repro.); C. M. De Hauke, *Seurat et son oeuvre* (Paris, 1961), no. 177 (repro.); B.L. Reid, *The Man from New York: John Quinn and His Friends* (New York, 1968), p. 545; Louis Hautecoeur, *Georges Seurat* (Milan, 1972), repro. p. 47; Fiorella Minervino, *Tout l'oeuvre peint de Seurat* (Paris, 1973), no. 178 (repro.); Judith Zilczer, *"The Noble Buyer": John Quinn, Patron of the Avant-Garde* (Washington, D.C., 1978), p. 185; Richard Thomson, *Seurat* (Oxford, 1985), p. 136.

NOTES

1. This was no. 733 in the exhibition. Seurat had first participated with the society at its creation in 1884, when he showed *The Bathing Place (Asnières)* (fig. 111). The nonjuried group included Seurat's friends Paul Signac, Charles Angrand, and Henri-Edmond Cross.
2. Jules Christophe, "Georges Seurat," *Les Hommes d'aujourd'hui*, vol. 8, no. 268 (March–

April 1890), p. 3 (author's trans.).
3. Georges Lecomte, "Société des Artistes Indépendants," *L'Art Moderne*, March 30, 1890, p. 101, quoted in Henri Dorra and John Rewald, *Seurat: L'Oeuvre peint, biographie, et catalogue critique* (Paris, 1959), p. 238 (author's trans.).
4. Quoted in a letter written by Charles Angrand to Henri-Edmond Cross after the death of Seurat; see Robert Rey, *La Peinture française à la fin du XIXᵉ siècle: La Renaissance du sentiment classique—Degas, Renoir, Gauguin, Cézanne, Seurat* (Paris, 1921), p. 95 (author's trans.).
5. Emile Zola, *Mes Haînes* (Paris, 1879), p. 25.
6. For a history of the evolution of the picture, see Daniel Catton Rich, *Seurat and the Evolution of "La Grande Jatte"* (Chicago, 1935).
7. He visited the ports of the Normandy coast every summer, with the exception of 1887, when he was required to remain in Paris for military service. See Daniel Catton Rich, ed., *Seurat: Paintings and Drawings* (Chicago, 1958), p. 19.
8. Robert J. Goldwater, "Some Aspects of the Development of Seurat's Style," *The Art Bulletin*, vol. 23, no. 1 (March, 1941), p. 125.
9. Quoted in Gustave Coquiot, *Seurat* (Paris, 1924), pp. 39–40 (author's trans.).
10. Three works bear this qualification in their titles: *Grandcamp Evening*, 1885; *The Seine Estuary, Honfleur, Evening*, 1886; and *The Gravelines Canal, Evening*, all at the Museum of Modern Art, New York.
11. Richard Thomson, for example (*Seurat* [Oxford, 1985]), has argued persuasively that Seurat's formulation as an artist was less dependent upon Impressionism than is often thought, and that while he honored their achievement, Seurat's intent and practice often stemmed from quite different theoretical and art-historical sources.
12. See John Rewald, "Seurat: the Meaning of the Dots," in *Studies in Post-Impressionism* (New York, 1986), pp. 161–62.

13. See William Innes Homer, *Seurat and the Science of Painting* (Cambridge, Mass., 1964). Such studies, for all their clarification of Seurat's methods and theoretical foundations, run the fundamental danger of obscuring the artistic complexity of his work. Seurat was, finally, a painter and not a scientist.

14. See Fiorella Minervino, *Tout l'oeuvre peint de Seurat* (Paris, 1973), no. 178, for the observation that the border was added at a later date.

15. Pissarro was describing Seurat painting a colored frame for *The Models* (The Barnes Foundation, Merion, Pa.). Quoted by John Rewald, *Post-Impressionism from Van Gogh to Gauguin* (New York, 1956), p. 112.

16. For a review of the distribution of Seurat's pictures, both during and just after his life, see Dorra and Rewald, 1959, pp. lxxv–lxxvi. Pissarro also commented on the settlement of the estate: see John Rewald, ed., *Camille Pissarro: Letters to His Son Lucien* (New York, 1943), pp. 169, 181.

17. See Judith Zilczer, *"The Noble Buyer": John Quinn, Patron of the Avant-Garde* (Washington, D.C., 1978).

FIG. 112 Georges Seurat, *Sunday Afternoon: Island of the Grande Jatte*, 1886, oil on canvas, 81 x 120⅜″ (206 x 307 cm), The Art Institute of Chicago, Helen Birch Bartlett Memorial Collection

FIG. 114 Georges Seurat, *The Banks of the Seine: Grande Jatte*, c. 1887, oil on canvas, 25⅝ x 31⅞″ (65 x 82 cm), Musée Royaux des Beaux-Arts de Belgique, Brussels

FIG. 113 Georges Seurat, *Bridge at Courbevoie*, 1886–87, oil on canvas, 18 x 21½″ (45.7 x 54.7 cm), The Courtauld Collection, London, The Home House Trustees

FIG. 111 Georges Seurat (French, 1859–1891), *The Bathing Place (Asnières)*, 1884, oil on canvas, 79 x 118½″ (201 x 300 cm), National Gallery, London

PAUL CÉZANNE
French, 1839–1906
Portrait of Uncle Dominique as a Monk,
c. 1866
Oil on canvas, 23¹³⁄₁₆ x 21⁷⁄₁₆"
(60.5 x 54.5 cm)

PROVENANCE: Dominique Aubert; Hugo
Perls, Berlin; H. Wendland, Berlin; Paul
Cassirer, Berlin; Oscar Schmitz, Dresden;
Wildenstein and Co., New York; The Frick
Collection, New York; Wildenstein and Co.,
New York; Mrs. Ira Haupt, New York.

EXHIBITIONS: Dresden, "Internationale
Kunstausstellung Dresden," June–September
1926, no. 78; Berlin, "Französische Malerei
des XIX Jahrhunderts," January–February
1927, no. 6; Kunsthaus, Zurich, "Sammlung
Oscar Schmitz, Französische Malerei des
XIX Jahrhunderts," 1932, no. 27; Wilden-
stein and Co., Paris and New York, "The
Oscar Schmitz Collection: Masterpieces of
French Painting of the Nineteenth Century,"
1936, no. 7; Musée de Lyon, "Centenaire de
Paul Cézanne," 1939, no. 4, repro. fig. 11;
Wildenstein and Co., London, "Homage to
Paul Cézanne (1839–1906)," July 1939, no. 2;
The Metropolitan Museum of Art, New
York, "Summer Loan Exhibition," 1958,
no. 20; National Gallery of Art, Washing-
ton, D.C., "Masterpieces of Impressionist and
Post-Impressionist Painting," April 25–May
24, 1959, no. 26.

LITERATURE: Julius Meier-Graefe, *Cézanne
und sein Kreis, ein Beitrag zur Entwicklungs-
geschichte,* 2nd ed. (Munich, 1920), p. 73, repro.
p. 85; A. Zeisho, *Paul Cézanne* (Tokyo, 1921),
fig. 14; Karl Scheffler, "Die Sammlung
Oskar Schmitz in Dresden," *Kunst und
Künstler,* vol. 19 (1921), p. 188, repro. p. 185;
Georges Rivière, *Le Maître Paul Cézanne*
(Paris, 1923), p. 196; Marie Dormoy, "La Col-

lection Schmitz à Dresde," *L'Amour de l'art,*
vol. 7 (October 1926), pp. 341–42, repro.
p. 340; O. Schürer, "Internationale Kunst-
ausstellung Dresden," *Deutsche Kunst und
Dekoration,* vol. 59 (February 1927), p. 271;
Emil Waldmann, *Die Kunst des Realismus und
des Impressionismus im 19. Jahrhundert,*
2nd ed. (Berlin, 1927), no. 493 (repro.); Emil
Waldmann, "La Collection Schmitz: L'art
français," *Documents,* vol. 2, no. 6 (1930),
p. 320; René Huyghe, *Cézanne* (Paris, 1936),
pp. 29–32; Lionello Venturi, *Cézanne: Son art
—son oeuvre* (Paris, 1936), no. 72 (repro.);
Raymond Cogniat, *Cézanne* (Paris, Amster-
dam, and Leipzig, 1939), fig. 15; "A Cézanne
for the Frick," *Art News* (April 20, 1940), p. 18,
repro. (cover); "The Frick Cézanne," *The Art
Quarterly,* vol. 3, no. 2 (spring 1940), pp. 231–
32; *Magazine of Art,* vol. 33, no. 5 (May 1940),
repro. (cover); "Prophetic Cézanne Acquired
by Frick," *Art Digest,* May 1, 1940, p. 9
(repro.); "A Cézanne Portrait for the Frick
Collection," *The Connoisseur,* vol. 106 (No-
vember 1940), pp. 209–10; Regina Shoolman
and Charles E. Slatkin, *The Enjoyment of Art in
America: A Survey of the Permanent Collections
of Painting, Sculpture, Ceramics, and Decorative
Arts in American and Canadian Museums*
(Philadelphia and New York, 1942), fig. 560;
Edward Alden Jewell, *Paul Cézanne* (New
York, 1944), repro. p. 15; *The Frick Collection
Handbook* (New York, 1947), p. 18; Bernard
Dorival, *Cézanne* (Paris, 1948), pp. 25, 133;
John Rewald, *Paul Cézanne: A Biography*
(New York, 1948), pp. 45–46; "Frick Anni-
versary and Controversy," *Art News,* vol. 48,
no. 9 (January 1950), repro. p. 18; Lionello
Venturi, *Impressionists and Symbolists: Manet,
Degas, Monet, Pissarro, Sisley, Renoir, Cézanne,
Seurat, Gauguin, Van Gogh, Toulouse-Lautrec,*
translated by Francis Steegmuller (New York
and London, 1950), pp. 120–21, 126, fig. 117;
Meyer Schapiro, *Paul Cézanne* (New York,
1952), p. 32, repro. p. 33; Georg Schmidt,
Water-Colours by Paul Cézanne (New York,
1953), p. 11; Theodore Rousseau, Jr., *Paul

Cézanne (1839–1906)* (New York, 1953), fig. 9;
Rudolph Arnheim, *Art and Visual Perception*
(Berkeley and Los Angeles, 1954), p. 59;
Lionello Venturi, *Four Steps toward Modern
Art: Giorgione, Caravaggio, Manet, Cézanne*
(New York, 1956), pp. 67, 70, fig. 25;
Ralph T. Coe, "Impressionist and Post-
Impressionist Paintings in Washington," *The
Burlington Magazine,* vol. 101 (June 1959),
p. 242; Fritz Novotny, *Painting and Sculpture
in Europe, 1780 to 1880* (Baltimore, 1960),
p. 206; Melvin Waldfogel, "The Bathers of
Paul Cézanne," Ph.D., diss., Harvard Univer-
sity, Cambridge, Mass., 1961, p. 30; Liliane
Brion-Guerry, "Esthétique du Portrait
Cézannien," *Revue d'Esthétique,* vol. 14,
no. 1 (1961), p. 2; Yvon Taillandier, *P. Cézanne*
(Paris, 1961), p. 28; Hugo Perls, *Warum ist
Kamilla schön? Von Kunst, Künstlern und
Kunsthandel* (Munich, 1962), n.p. (repro.);
Theodore Reff, "Cézanne, Flaubert, St.
Anthony, and the Queen of Sheba," *The Art
Bulletin,* vol. 44, no. 2 (June 1962), p. 114;
Kurt Badt, *The Art of Cézanne,* translated by
Sheila Ann Ogilvie (Berkeley and Los
Angeles, 1965), p. 300; Liliane Brion-
Guerry, *Cézanne et l'expression de l'espace*
(Paris, 1966), p. 40; H. H. Arnason, *History of
Modern Art: Painting, Sculpture, Architecture*
(New York, 1968), p. 44, fig. 42; Chuji Ike-
gami, *Cézanne* (Tokyo, 1969), fig. 5; Jack
Lindsay, *Cézanne: His Life and Art* (New York,
1969), p. 116; René Huyghe, *La Relève du réel:
Impressionnisme, symbolisme* (Paris, 1974),
pp. 201, 434; A. Barskaya, *Paul Cézanne*
(Leningrad, 1975), p. 13 (repro.); Frank
Elgar, *Cézanne* (New York and Washington,
D.C., 1975), p. 32, fig. 16; Sandra Orienti,
Tout l'oeuvre peint de Cézanne (Paris, 1975),
no. 63 (repro.); F. L. Graham, *Three Centuries
of French Art* (San Francisco, 1975), vol. 2,
p. 102; Nicholas Wadley, *Cézanne and His Art*
(London, New York, Sydney, and Toronto,
1975), p. 19, fig. 97; Theodore Reff, "Paint-
ing and Theory in the Final Decade," in
Cézanne: The Late Work (New York, 1977),

p. 21; Sidney Geist, "What Makes *The Black Clock* Run?" *Art International*, vol. 22, no. 2 (February 1978), p. 10; Sandra Orienti, *L'Opera completa di Cézanne* (Milan, 1979), no. 63 (repro.); Jutta Hülsewig, *Das Bildnis in der Kunst Paul Cézannes* (Bochum, 1981), p. 237; John Rewald, *Cézanne: A Biography* (New York, 1986), repro. p. 44; Lawrence Gowing, *Cézanne: The Early Years, 1859–1872* (London, 1988), p. 112, repro. p. 104; Sidney Geist, *Interpreting Cézanne* (Cambridge, Mass., and London, 1988), pp. 3, 5, 64–65, pl. 2.

NOTES

1. Antoine Guillemet to Francisco Oller, September 1866; quoted in John Rewald, *Cézanne: A Biography* (New York, 1986), p. 64.

2. Lawrence Gowing, *Cézanne: The Early Years, 1859–1872* (London, 1988), p. 10.

3. Ibid., p. 10.

4. Antony Valabrègue to Emile Zola; quoted in Rewald, 1986, p. 82.

5. Gowing, 1988, p. 9. See Lionello Venturi, *Cézanne: Son art—son oeuvre* (Paris, 1936), nos. 72–77, 79–80, 82.

6. Valabrègue to Zola; quoted in Rewald, 1986, p. 81.

7. Meyer Schapiro, *Paul Cézanne* (New York, 1952), p. 32.

8. See *The Catholic Encyclopedia*, s.v. "Lacordaire."

9. For example, in the watercolor of *Mme Cézanne with a Hortensia* (Venturi, 1936, no. 1100) of c. 1875. See Sidney Geist, "What Makes *The Black Clock* Run?" *Art International*, vol. 22, no. 2 (February 1978), pp. 8–14, wherein the author has built a series of complex arguments for Cézanne's pleasure in improbable word associations as well as visual paradoxes.

10. Gowing, 1988, p. 10.

11. "The Frick Cézanne," *The Art Quarterly*, vol. 3, no. 2 (spring 1940), pp. 231–32.

12. *The Frick Collection Handbook* (New York, 1947), p. 18.

13. "Frick Anniversary and Controversy," *Art News*, vol. 48, no. 9 (January 1950), pp. 18, 59.

14. Rewald, 1986, p. 213.

FIG. 116 Paul Cézanne, *Man with Folded Arms*, c. 1899, oil on canvas, 36¼ x 28⅝″ (92.1 x 72.7 cm), private collection, N.Y.

FIG. 115 Paul Cézanne (French, 1839–1906), *The Advocate*, c. 1866, oil on canvas, 24⅜ x 20½″ (62 x 52 cm), private collection

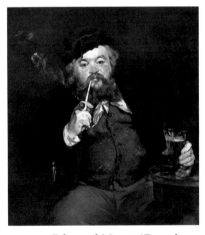

FIG. 117 Edouard Manet (French, 1832–1883), *The Bon Bock*, 1873, oil on canvas, 37¼ x 32½″ (94.6 x 83 cm), Philadelphia Museum of Art, Mr. and Mrs. Carroll S. Tyson Collection

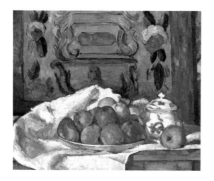

PAUL CÉZANNE
French, 1839–1906
Dish of Apples, 1875–80
Signed lower right: P Cézanne
Oil on canvas, 18⅛ x 21¾"
 (46.1 x 55.2 cm)

PROVENANCE: Victor Chocquet, Paris;
Mme Veuve Choquet sale, Galerie Georges
Petit, Paris, July 1, 3–4, 1899, no. 3; Galeries
Durand-Ruel, Paris; Pierre Durand-Ruel,
Paris, 1913; deposited with Durand-Ruel
Galleries, New York, 1936.

EXHIBITIONS: Paris, "Troisième Exposition
des Impressionnistes," 1877; Grand Palais,
Paris, "Société du Salon d'Automne,"
October 15–November 15, 1904, no. 21;
Galeries Durand-Ruel, Paris, "Exposition
de natures mortes par Monet, Cézanne,
Renoir…," April–May 1908, no. 14;
Chambre Syndicale de la Curiosité et des
Beaux-Arts, Paris, "Exposition d'oeuvres
d'art des XVIIIe, XIXe, et XXe siècles," April
25–May 15, 1923, no. 164; Galerie Bernheim-
Jeune, Paris, "Exposition rétrospective Paul
Cézanne (1839–1906)," June 1–30, 1926,
no. 11; Galerien Thannhauser, Berlin, "Erste
Sonderausstellung in Berlin," January.9–mid-
February 1927, no. 16; Galeries Durand-Ruel,
Paris, "Quelques oeuvres importantes de
Manet à Van Gogh," February–March 1932,
no. 4; Durand-Ruel Galleries, New York,
"Cézanne, Intimate Exhibition," 1938, no. 3;
Durand-Ruel Galleries, New York, "The
Four Great Impressionists: Cézanne, Degas,
Renoir, Manet," March 27–April 13, 1940,
no. 4; Paul Rosenberg and Co., New York,
"Loan Exhibition of Paintings by Cézanne
(1839–1906)," November 19–December 19,
1942, no. 2; Durand-Ruel Galleries, New
York, "Still Life, Manet to Picasso," March 8
–31, 1944, no. 4; Kunsthaus, Zurich,
"Paul Cézanne, 1839–1906," August 22–
October 7, 1956, no. 19; The Tate Gallery,

London, "The Annenberg Collection," Sep-
tember 2–October 8, 1969, no. 5.

LITERATURE: Jean Royère, "Paul Cézanne:
Erinnerungen," *Kunst und Künstler,* vol. 10
(1912), repro. p. 486; Ambroise Vollard, *Paul
Cézanne* (Paris, 1914), fig. 45; A. Zeisho, *Paul
Cézanne* (Tokyo, 1921), fig. 8?; Georges
Rivière, *Le Maître Paul Cézanne* (Paris, 1923),
p. 211; Paul Bernard, *Sur Paul Cézanne* (Paris,
1925), repro. opp. p. 69; E. Tériade, "Jeun-
esse," *Cahiers d'Art,* 6th year (1931), repro.
p. 15; Lionello Venturi, *Cézanne: Son art—son
oeuvre* (Paris, 1936), no. 207 (repro.); G.
Besson, *Cézanne* (Paris, 1936), fig. 25; Elie
Faure, *Cézanne* (Paris, 1936), fig. 25; Alfred
M. Frankfurter, "Cézanne: Intimate Exhibi-
tion: Forty-One Paintings Shown for the
Benefit of Hope Farm," *Art News,* March 26,
1938, repro. p. 11; Fritz Novotny, *Cézanne und
das Ende der wissenschaftlichen Perspektive*
(Vienna, 1938), p. 78, no. 70; R. H. Wilenski,
Modern French Painters (New York, 1940),
p. 371; Robert William Ratcliffe, "Cézanne's
Working Methods and Their Theoretical
Background," Ph.D. diss., University of Lon-
don, 1960, pp. 50–52; Yvon Taillandier,
P. Cézanne (Paris, 1961), p. 56, repro. p. 20;
Kurt Badt, *The Art of Cézanne,* translated by
Sheila Ann Ogilvie (Berkeley and Los
Angeles, 1965), p. 331; John Rewald, "Choc-
quet and Cézanne," *Gazette des Beaux-Arts,*
11th year, 6th period, vol. 74 (July–August
1969), p. 84, no. 31, repro. p. 55, fig. 15; Wally
Findlay Galleries, New York, *Les Environs
d'Aix-en-Provence* (New York, 1974); Sandra
Orienti, *Tout l'oeuvre peint de Cézanne* (Paris,
1975), no. 206 (repro.); Meyer Schapiro, *Paul
Cézanne* (Paris, 1975), fig. 15; Theodore Reff,
"The Pictures within Cézanne's Pictures,"
Arts Magazine, vol. 53, no. 10 (June 1979),
p. 95, fig. 16; John Rewald, *Cézanne: A Biog-
raphy* (New York, 1986), fig. 118; Sidney
Geist, *Interpreting Cézanne* (Cambridge,
Mass., and London, 1988), pp. 96–97, pl. 77;
John Rewald, *Cézanne and America: Dealers,*

Collectors, Artist, and Critics, 1891–1921
(Princeton, N.J., and London, 1989), pp. 122,
128 n. 36, pp. 134, 152 n. 23.

NOTES
1. Maurice Denis, *Theories, 1880–1910* (Paris,
1912), p. 242; quoted in John Rewald, *The
History of Impressionism,* rev. ed. (New York,
1961), p. 412.
2. Quoted in John Rewald, *Cézanne: A Biogra-
phy* (New York, 1986), p. 113.
3. Robert William Ratcliffe, "Cézanne's Work-
ing Methods and Their Theoretical Back-
ground," Ph.D. diss., University of London,
1960, pp. 50–52.
4. Theodore Reff, "The Pictures within
Cézanne's Pictures," *Arts Magazine,* vol. 53,
no. 10 (June 1979), pp. 95–97.
5. Exhibited at Wally Findlay Galleries, New
York, "Les Environs d'Aix-en-Provence,"
October 24–November 26, 1974.
6. The painting is signed in red at the lower
right. This is a rare occurrence for Cézanne,
who signed very few of his pictures, and is an
aid in dating the painting, since many of the
works owned by his early patron, Victor
Chocquet, are signed in this manner.
Chocquet was one of the first articulate
spokesmen for the Impressionists, whose
work he collected with thoughtfulness and
method. At the time of the sale following the
death of Chocquet's widow in 1899, his collec-
tion included this picture, among 36 or 37
Cézannes, as well as numerous works by
Monet, Pissarro, and Renoir. However, there
is no evidence as to when this picture entered
Chocquet's collection. See Mme Veuve Choc-
quet sale, Galerie Georges Petit, Paris, July
1, 3–4, 1899. For information on the Choc-
quet collection, see John Rewald, "Chocquet
and Cézanne," *Gazette des Beaux Arts,* 111th
year, 6th period, vol. 74 (July–August 1969),
pp. 33–96.

FIG. 118 Paul Cézanne (French, 1839–1906), detail of one panel from six-paneled folding screen, which was once attached to the reverse of *Arcadian Scene,* location unknown

PAUL CÉZANNE
French, 1839–1906
The Bathers, c. 1888
Watercolor and pencil on paper,
4⅞ x 7⅞″ (12.6 x 20 cm)

PROVENANCE: Pierre-Auguste Renoir, Cagnes; Jean Renoir, Paris and Marlotte; Wildenstein and Co., New York.

EXHIBITIONS: Galerie Flechtheim, Berlin, "Aquarelle: Cézanne," May 1927; Wildenstein and Co., London, "Homage to Paul Cézanne (1839–1906)," July 1939, no. 54; Philadelphia Museum of Art, "Exhibition of Philadelphia Private Collectors," summer 1963 (no catalogue); The Tate Gallery, London, "The Annenberg Collection," September 2–October 8, 1969, no. 6.

LITERATURE: Ambroise Vollard, *La Vie et l'oeuvre de Pierre-Auguste Renoir* (Paris, 1919), p. 114; Georges Rivière, *Le Maître Paul Cézanne* (Paris, 1923), p. 217; "Berliner Austellungen," *Der Cicerone,* vol. 19, no. 9 (1927), repro. p. 288; Ambroise Vollard, *En écoutant Cézanne, Degas, Renoir* (Paris, 1938), pp. 206–7; Lionello Venturi, *Cézanne: Son art– son oeuvre* (Paris, 1936), no. 902 (repro.); Alfred Neumeyer, *Cézanne Drawings* (New York and London, 1958), no. 20 (repro.); Alfred Neumeyer, *Paul Cézanne: Die Badenden* (Stuttgart, 1959), p. 8, pl. 4; Melvin Waldfogel, "The Bathers of Paul Cézanne," Ph.D. diss., Harvard University, Cambridge, Mass., 1961, pp. 112, 159, pl. 64; Barbara Ehrlich White, "The Bathers of 1887 and Renoir's Anti-Impressionism," *The Art Bulletin,* vol. 55, no. 1 (March 1973), p. 119, n. 47; John Rewald, *Paul Cézanne: The Watercolors, A Catalogue Raisonné* (Boston, 1983), no. 132 (repro.).

NOTES
1. The other oil is *Bathers,* oil on canvas, Pushkin State Museum of Fine Arts, Moscow;

see Lionello Venturi, *Cézanne: Son art—son oeuvre* (Paris, 1936), nos. 580, 581, 588.

2. Maurice Denis, *Theories, 1880–1910* (Paris, 1912), p. 242; quoted in John Rewald, *The History of Impressionism,* rev. ed. (New York, 1961), p. 412.

3. Ambroise Vollard, *La Vie et l'oeuvre de Pierre-Auguste Renoir* (Paris, 1919), p. 114.

4. John Rewald, *Paul Cézanne: The Watercolors, A Catalogue Raisonné* (Boston, 1983), pp. 157–58, no. 298.

5. Vollard, 1919, p. 114, places it as 1882; see Venturi, 1936, no. 902.

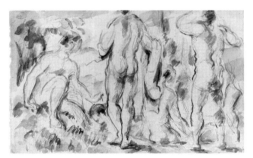

FIG. 119 Paul Cézanne (French, 1839–1906), *Bathers,* 1885–90, pencil and watercolor on leaf from a sketchbook, 5 x 8⅛″ (12.7 x 20.6 cm), The Museum of Modern Art, N.Y., Lillie P. Bliss Collection

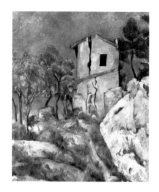

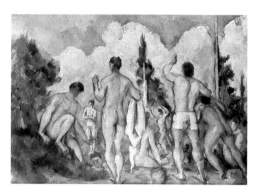

FIG. 120 Paul Cézanne, *Bathers*, c. 1894, oil on canvas, 23⅝ x 31⅞″ (60 x 80 cm), Musée d'Orsay, Paris

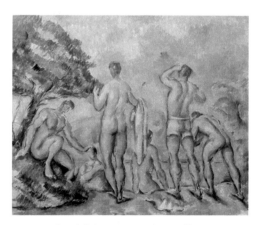

FIG. 121 Paul Cézanne, *Bathers*, oil on canvas, 20¾ x 25¼ (52 x 63 cm), The Saint Louis Art Museum, Gift of Mrs. Mark C. Steinberg

PAUL CÉZANNE
French, 1839–1906
The House with the Cracked Walls, 1892–94
Oil on canvas, 31½ x 23¾″
(80 x 60.4 cm)

PROVENANCE: Ambroise Vollard, Paris; Paul Cassirer, Berlin; Adolph Rothermundt, Dresden; Paul Cassirer, Berlin; Hugo Perls, Berlin, and Georg Caspari, Munich; Prince Matsukata, Paris; private collection, Germany; Mrs. Ira Haupt, New York.

EXHIBITIONS: Galerie Vollard, Paris, "Paul Cézanne," 1899, no. 3; Wildenstein and Co., New York, "Masterpieces from Museums and Private Collections," November 8–December 15, 1951, no. 51; The Museum of Modern Art, New York, "Paintings from Private Collections," May 31–September 5, 1955, no. 22; The Metropolitan Museum of Art, New York, "Summer Loan Exhibition," summer 1958, no. 21; National Gallery of Art, Washington, D.C., "Masterpieces of Impressionist and Post-Impressionist Painting," April 25–May 24, 1959, no. 28; The Phillips Collection, Washington, D.C., The Art Institute of Chicago, and the Museum of Fine Arts, Boston, "Cézanne, An Exhibition in Honor of the Fiftieth Anniversary of The Phillips Collection," February 27–March 28, 1971, no. 22.

LITERATURE: "Confiscation de tableaux," *Le Bulletin de la vie artistique*, vol. 1, no. 26 (December 15, 1920), repro. p. 750; Julius Meier-Graefe, *Cézanne und sein Kreis*, 2nd ed. (Munich, 1920), p. 129 (repro.); Georges Rivière, *Le Maître Paul Cézanne* (Paris, 1923), p. 204; Julius Meier-Graefe, *Cézanne*, translated by J. Holroyd-Reece (London and New York, 1927), pl. 36; Kurt Pfister, *Cézanne, Gestalt, Werk, Mythos* (Potsdam, 1927), pl. 44; Lionello Venturi, *Cézanne: Son art—son oeuvre* (Paris, 1936), no. 657 (repro.); Georges Rivière, *Cézanne: Le Peintre solitaire* (Paris, 1936), p. 119, repro. p. 70; E. Schenck, "Girl with the Doll," *Honolulu Academy of Arts Bulletin,* March 1937, fig. 5; Raymond Cogniat, *Cézanne* (Paris, Amsterdam, and Leipzig, 1939), no. 95 (repro.); Bernard Dorival, *Cézanne* (Paris, 1948), p. 80, no. 140 (repro.); Gotthard Jedlicka, *Cézanne* (Bern, 1948), no. 42 (repro.); "Fifty Years for Wildenstein," *Art News,* vol. 50, no. 7 (November 1951), repro. p. 27; Meyer Schapiro, *Paul Cézanne* (New York, 1952), pp. 106–7 (repro.); Theodore Rousseau, *Paul Cézanne (1839–1906)* (New York, 1953), pl. 23; John Rewald, *Cézanne: Paysages* (Paris, 1958), pl. 10; Ralph T. Coe, "Impressionist and Post-Impressionist Paintings in Washington," *The Burlington Magazine,* vol. 101 (June 1959), p. 242; Hugo Perls, *Warum is Kamilla schön?, Von Kunst, Künstlern und Kunsthandel* (Munich, 1962), n.p. (repro.); Liliane Brion-Guerry, *Cézanne et l'expression de l'espace* (Paris, 1966), p. 120; Jack Lindsay, *Cézanne: His Life and Art* (New York, 1969), repro. p. 168; Yasushi Inoue and Shuji Takashina, *Cézanne* (Tokyo, 1972), no. 47 (repro.); Marcel Brion, *Paul Cézanne* (Milan, 1972), repro. p. 79; Yusuke Nakahara, *Cézanne* (Tokyo, 1974), no. 21 (repro.); Sandra Orienti, *Tout l'oeuvre peint de Cézanne* (Paris, 1975), no. 686 (repro.); Frank Elgar, *Cézanne* (New York, 1975), p. 189, pl. 111; Theodore Reff, "Painting and Theory in the Final Decade," in The Museum of Modern Art, New York, *Cézanne: The Late Work* (New York, 1977), p. 24 (repro.); Matthias Arnold, "Cézanne und van Gogh—Die beiden grossen Post-impressionisten: Ein Vergleich II," *Weltkunst,* vol. 56, no. 2 (January 15, 1986), repro. p. 133.

NOTES
1. Nearly all those who have written about this justly famous picture have felt the need to set it aside from much else Cézanne produced in the final phase of his career, noting the essentially subjective and evocative nature of the image as opposed to the more analytical and objective quality of his late landscapes. To Ralph T. Coe it presents a complete para-

dox within the overall work: "a feeling of loneliness ... showing a romantic aspect of Cézanne's sensibility, notwithstanding his primary search for structural forms" ("Impressionist and Post-Impressionist Paintings in Washington," *The Burlington Magazine*, vol. 101 [June 1959], p. 242). For Theodore Reff, it hints at the reemergence of earlier romantic obsessions in the old Cézanne, "after being banished from his more objective and impersonal art in the intervening years" ("Painting and Theory in the Final Decade," in The Museum of Modern Art, New York, *Cézanne: The Late Work* [New York, 1977], pp. 24–25). Liliane Brion-Guerry places it in the critical moment in Cézanne's career when, having brought his art to a point of complete equilibrium and solidity through a balance of observation and abstraction, just through the intensity and hardness ("durci") required to bring painting to such a fruitful and prophetic point, this "very solidity ['durcissement même'] creates a tension that provokes an impression of malaise." This is prophetic: "the entire universe seems on the verge of a cataclysm that will destroy it." The picture becomes a premonition of the "precariousness of this world of abstraction, a precursor of its destruction" (*Cézanne et l'expression de l'espace* [Paris, 1966], p. 120) (author's trans.).

2. Meyer Schapiro, *Paul Cézanne* (New York, 1952), p. 106; the Saint Anthony reference is to the fraught scenes of Anthony's temptations that Cézanne did in the late 1860s and early 1870s.

3. Reff, 1977, pp. 24–25.

4. Lionello Venturi, *Cézanne: Son art—son oeuvre* (Paris, 1936), no. 133. Number 35 boulevard des Capucines, Paris "Exposition de la société anonyme des artistes, peintres, sculpteurs, et gravures," April 15–May 15, 1874, no. 42; Palais du Champ de Mars, Paris, "Exposition centennale de l'art français, Exposition Universelle," 1899–1900, no. 124.

5. There is also a painting of the late 1870s called the *Abandoned House* (private collection, Boston) to which parallels have been drawn (Reff, 1977, p. 25). However, we do know, in that case, that the title seems not to have been Cézanne's, and, in point of fact, the structure could just as easily be closed up as abandoned and bears little of the sinister nature of the Annenberg picture, which has borne the descriptive title "Maison Lézardée" since first shown by Vollard in 1899, although it is listed in his account books as "Maison du Pendu."

6. John Rewald, *Cézanne: A Biography* (New York, 1986), pp. 193, 240–44.

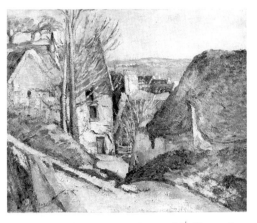

FIG. 123 Paul Cézanne, *House of the Hanged Man, Auvers-sur-Oise*, c. 1873, oil on canvas, 21⅝ x 26″ (55 x 66 cm), Musée d'Orsay, Paris

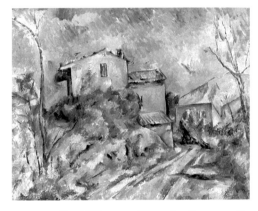

FIG. 122 Paul Cézanne (French, 1839–1906), *Maison Maria with a View of Château Noir*, oil on canvas, 25⅝ x 31⅞″ (65 x 81 cm), Kimbell Art Museum, Fort Worth

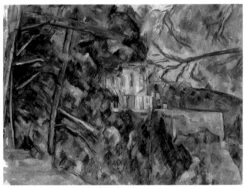

FIG. 124 Paul Cézanne, *Château Noir*, oil on canvas, 29 x 38″ (73.7 x 96.6 cm), National Gallery of Art, Washington, D.C., Gift of Eugene and Agnes Meyer

177

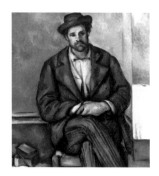

FIG. 125 Paul Cézanne, *Millstone in the Park of the Château Noir*, 1898–1900, oil on canvas, 29 x 36⅜" (73.7 x 92.4 cm), Philadelphia Museum of Art, Mr. and Mrs. Carroll S. Tyson, Jr., Collection

FIG. 126 Paul Cézanne, *The Red Rock*, oil on canvas, 35⅞ x 26" (91 x 66 cm), Musée de l'Orangerie, Jean Walter—Paul Guillaume Collection

PAUL CÉZANNE
French, 1839–1906
Seated Peasant, 1895–1900
Oil on canvas, 21½ x 17¾"
(54.6 x 45.1 cm)

PROVENANCE: Jos Hessel, Paris; Christian Mustad, Norway; private collection, Switzerland; Mrs. Ira Haupt, New York.

EXHIBITIONS: Kunstnerforbundet, Kristiana, Oslo, "Den franske Utstilling," 1918, no. 10.

LITERATURE: Elie Faure, "Toujours Cézanne," *L'Amour de l'art*, December 20, 1920, repro. p. 268; Paul Jamot, "L'Art français en Norvège," *La Renaissance de l'art*, vol. 12, no. 2 (February 1929), p. 104, repro. p. 86; Lionello Venturi, *Cézanne: Son art—son oeuvre* (Paris, 1936), no. 691 (repro.); Marcel Brion, *Paul Cézanne* (Milan, 1972), fig. 3, p. 156; Sandra Orienti, *Tout l'oeuvre peint de Cézanne* (Paris, 1975), no. 605 (repro.); John Rewald, *Cézanne: A Biography* (New York, 1986), repro. p. 206.

NOTES
1. For the cardplayers series, see Lionello Venturi, *Cézanne: Son art—son oeuvre* (Paris, 1936), no. 556–60.

2. See ibid., nos. 561, 563–68, 684–90.

3. Ambroise Vollard, *Paul Cézanne* (Paris, 1919), p. 124.

4. Theodore Reff, "Cézanne's 'Cardplayers' and Their Sources," *Arts Magazine*, vol. 55, no. 3 (November 1980), p. 114.

5. Cézanne noted when walking in the street late in his life: "Look at the old café proprietor seated before his doorway. What style!" See Theodore Reff, "Painting and Theory in the Final Decade," in *The Museum of Modern Art, New York, Cézanne: The Late Work* (New York, 1977), p. 22.

6. See John Rewald, "The Last Motifs at Aix," in The Museum of Modern Art, 1977, p. 99. See also John Rewald, *Cézanne: A Biography* (New York, 1986), pp. 258–59.

7. See Rewald, 1986, p. 220.

8. Venturi, 1936, no. 691, assigns the work to 1895–1900.

9. John Rewald, *The Paintings of Cézanne: A Catalogue Raisonné* (forthcoming).

10. See Venturi, 1936, nos. 685, 689.

FIG. 127 Paul Cézanne (French, 1839–1906), *The Cardplayers*, 1890–92, oil on canvas, 52⅜ x 70½" (133 x 179 cm), The Barnes Foundation, Merion, Pa.

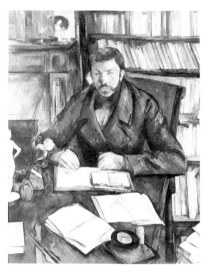

FIG. 128 Paul Cézanne, *Gustave Geffroy*, 1895, oil on canvas, 45¾ x 35⅜″ (116.2 x 89.9 cm), Musée du Louvre, Paris

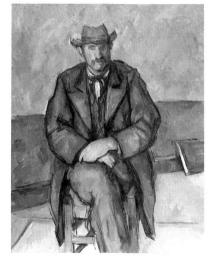

FIG. 130 Paul Cézanne, *Portrait of a Peasant*, oil on canvas, 36¼ x 28¾″ (92 x 73 cm), National Gallery of Canada, Ottawa

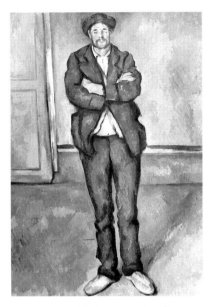

FIG. 129 Paul Cézanne, *Standing Peasant*, oil on canvas, 31½ x 22½″ (80 x 57.1 cm), The Barnes Foundation, Merion, Pa.

PAUL CÉZANNE
French, 1839–1906
Still Life with Watermelon and Pomegranates, 1900–1906
Watercolor and pencil on paper, 12 x 18½″ (30.5 x 47 cm)

PROVENANCE: Galerie Bernheim-Jeune, Paris; Percy Moore Turner, London; Galerie Matthiesen, Berlin; Christian Tetzenlund, Copenhagen; Otto Wacker, Berlin; possibly Bernheim-Jeune; possibly Reid and Lefevre Gallery, London; Mrs. A. Chester Beatty, London; Paul Rosenberg, New York.

EXHIBITIONS: Montross Gallery, New York, "Cézanne," through January 1916, no. 8; Galerie Alfred Flechtheim, Berlin, "Cézanne," 1927, no. 35; Reid and Lefevre Gallery, London, "Cézanne," 1937, no. 32; Wildenstein and Co., London, "Homage to Paul Cézanne (1839–1906)," July 1939, no. 66; The Tate Gallery, London, Museum and Art Gallery, Leicester, and Graves Art Gallery, Sheffield, "Paul Cézanne: An Exhibition of Watercolours," 1946, no. 28; Philadelphia Museum of Art, "Philadelphia Private Collectors," summer 1963 (no catalogue); The Tate Gallery, London, "The Annenberg Collection," September 2–October 8, 1969, no. 7.

LITERATURE: Willard Huntington Wright, "Paul Cézanne," *The International Studio*, vol. 57 (February 1916), p. 130; Julius Meier-Graefe, ed., *Cézanne und seine Ahnen, Faksimiles nach Aquarellen, Feder—und anderen Zeichnungen von Tintoretto, Greco, Poussin, Corot, Delacroix, Cézanne* (Munich, 1921), pl. XVII; Georges Rivière, *Le Maître Paul Cézanne* (Paris, 1923), p. 221; Lionello Venturi, *Cézanne: Son art—son oeuvre* (Paris, 1936), no. 1145 (repro.); Alfred Neumeyer, *Cézanne Drawings* (New York and London, 1958), p. 26, pl. 55; John Rewald, *Paul Cézanne: The Watercolors, A Catalogue Raisonné* (Boston, 1983), no. 561 (repro).

NOTES

1. "Le dessin et la couleur ne sont point distincts; au fur et à mesure que l'on peint, on dessine; plus la couleur s'harmonise, plus le dessin se précise. Quand la couleur est sa richesse, la forme est sa plénitude. Les contrastes et les rapports de tons, voilà le secret du dessin et du modelé." Emile Bernard, *Souvenirs sur Paul Cézanne: Une Conversation avec Cézanne, la méthode de Cézanne* (Paris, 1925), p. 37 (author's trans.).

2. This object may be the sugar bowl with handles that appears in some of the late still lifes; see Lionello Venturi, *Cézanne: Son art—son oeuvre* (Paris, 1936), no. 624.

3. See Alfred Neumeyer, *Cézanne Drawings* (New York and London, 1958), pp. 26, 51.

4. John Rewald, *Paul Cézanne: The Watercolors, A Catalogue Raisonné* (Boston, 1983), p. 229.

FIG. 132 Paul Cézanne, *Still Life with Cut Melon*, c. 1900, pencil and watercolor on paper, 12⅝ x 18¾″ (31.5 x 47.6 cm), private collection

PAUL CÉZANNE
French, 1839–1906
Mont Sainte-Victoire, 1904
Watercolor on paper, 12⅝ x 9¾″ (32.1 x 24.8 cm)

PROVENANCE: Emile Bernard; Michel-Ange Bernard; Wildenstein and Co., New York.

EXHIBITIONS: Philadelphia Museum of Art "Philadelphia Private Collectors," summer 1963 (no catalogue); The Tate Gallery, London, "The Annenberg Collection," September 2–October 8, 1969, no. 8.

LITERATURE: "Lettres inédites du peintre Emile Bernard à sa femme à propos de la mort de son ami Paul Cézanne," *Art-Documents* (Geneva), no. 33 (June 1953), repro. p. 13; François Daulte, *Le Dessin français de Manet à Cézanne* (Lausanne, 1954), p. 66, no. 46, pl. 46.

NOTES

1. "Lettres inédites du peintre Emile Bernard à sa femme à propos de la mort de son ami Paul Cézanne," *Art-Documents* (Geneva), no. 33 (June 1953), repro. p. 13.

2. François Daulte, *Le Dessin français de Manet à Cézanne* (Lausanne, 1954), p. 66, no. 46 (image reversed).

3. See Emile Bernard, *Souvenirs sur Paul Cézanne* (Paris, 1926).

4. Jean-Jacques Luthi, *Emile Bernard: Catalogue raisonné de l'oeuvre peint* (Paris, 1982), pp. 98–99, nos. 663, 666.

5. "Lettres inédites," *Art-Documents*, 1953, p. 13 (author's trans.).

FIG. 131 Paul Cézanne (French, 1839–1906), *Still Life with Pomegranates, Carafe, Sugar Bowl, Bottle, and Melon*, 1900–1906, pencil and watercolor on paper, 11¾ x 15¾″ (30 x 40 cm), private collection, Switzerland

PAUL CÉZANNE
French, 1839–1906
Mont Sainte-Victoire, 1902–6
Oil on canvas, 22¼ x 38⅛"
 (56.6 x 96.8 cm)

PROVENANCE: Paul Cézanne fils; Ambroise Vollard and Bernheim-Jeune, Paris, 1907; Montag, Switzerland.

EXHIBITIONS: The Tate Gallery, London, "The Annenberg Collection," September 2–October 8, 1969, no. 9.

LITERATURE: John Rewald and Leo Marschutz, "Cézanne et la Provence," *Le Point*, vol. 4 (August 1936), repro. p. 22; Lionello Venturi, *Cézanne: Son art—son oeuvre* (Paris, 1936), no. 804 (repro.); Fritz Novotny, *Cézanne und das Ende der wissenschaftlichen Perspektive* (Vienna, 1938), pp. 11, 204, no. 94; Kurt Badt, *The Art of Cézanne*, translated by Sheila Ann Ogilvie (Berkeley and Los Angeles, 1965), p. 163; Charles Ferdinand Ramuz, *Cézanne: Formes* (Lausanne, 1968), fig. 28; A. Barskaya, *Paul Cézanne*, translated by N. Johnstone (Leningrad, 1975), repro. p. 191; Sandra Orienti, *Tout l'oeuvre peint de Cézanne* (Paris, 1975), no. 765 (repro.); Lawrence Gowing, "The Logic of Organized Sensations," in The Museum of Modern Art, New York, *Cézanne: The Late Work* (New York, 1977), p. 68, fig. 125; Geneviève Monnier, "Aquarelles de la dernière période (1895–1906)," in Grand Palais, Paris, *Cézanne: Les dernières années (1895–1906)* (Paris, 1978), p. 45; Sandra Orienti, *L'Opera completa di Cézanne*, 2nd ed. (Milan, 1979), no. 765 (repro.); Jean Arrouye, "Le Dépassement de la nostalgie," in *Cézanne: Ou la peinture en jeu* (Limoges, 1982), p. 131; Robert Tiers, "Le Testament de Paul Cézanne et l'inventaire des tableaux de sa succession, rue Boulegon à Aix, en 1906," *Gazette des Beaux-Arts*, 127th year, 6th period, vol. 106 (November 1985), p. 178.

NOTES

1. Two pictures in this exhibition are intimately related to the Jas de Bouffan: *Portrait of Uncle Dominique as a Monk* (p. 71), documented as having been done in the house, and *Seated Peasant* (p. 80), which shows one of the farm workers from the grounds and, in all likelihood, was also done there.

2. Earlier images of the mountain were done by François Granet (1775–1849) and Emile Loubon (1809–1863).

3. Among his works, only the occurrences of the bather motif exceed in number those of Mont Sainte-Victoire.

4. This summary of the variety of views is from John Rewald, *Paul Cézanne: The Watercolors* (Boston, 1983), p. 240, no. 595.

5. Lionello Venturi, *Paul Cézanne—Water Colours* (London, 1943), p. 37; quoted in Rewald, 1983, p. 237, no. 587.

6. Joachim Gasquet, *Cézanne* (Paris, 1926), p. 135 (author's trans.).

7. Rewald, 1983, p. 239, no. 593.

8. See ibid., no. 593.

9. See ibid., no. 594.

10. Lionello Venturi, *Cézanne: Son art—son oeuvre* (Paris, 1936), no. 804.

11. This speculation on the additions to the painting and the state of any one section during these transitions was established by a close physical examination of the painting with Mark Tucker, Philadelphia Museum of Art.

12. See Emile Bernard, "Les Aquarelles de Cézanne," *L'Amour de l'art*, no. 2 (February 1924), p. 34.

13. This size canvas is a "no. 15, Marine," listed in an inventory of commercially available canvases numbered 0 to 120 and divided into three categories—figures, landscapes, and marines—by Galerie Stiebel, 5 Faubourg Saint-Honoré, Paris.

14. Allowing for possibly cut tacking edges, fourteen of the late Mont Sainte-Victoires are within one or two centimeters of standard sizes, ranging upward from a no. 25 "figure" (six of the fourteen are this size). Only those in Venturi, 1936, nos. 664, 666, and 801, do not match any listed size.

15. Jean Sutherland Boggs et al., *Degas* (New York, 1988), p. 202.

16. The addition is somewhat evident in the c. 1935 photograph and is also clear upon examination of the picture.

17. See Adrien Chappuis, *The Drawings of Paul Cézanne: A Catalogue Raisonné* (Greenwich, Conn., 1973), nos. 765, 768, 784.

18. *The Cutting* is in the Bayerische Staatsgemäldesammlungen, Munich. See also Venturi, 1936, nos. 50, 315.

19. See ibid., nos. 583, 584; see also John Rewald, "Chocquet and Cézanne," in *Studies in Post-Impressionism*, edited by Irene Gordon and Frances Weitzenhoffer (New York, 1985), pp. 166, 185, no. 84.

20. Quoted in The Museum of Modern Art, New York, *Cézanne: The Late Work* (New York, 1977), p. 405, no. 61.

21. John Rewald, ed., *Paul Cézanne: Letters* (London, 1941), p. 234, no. 147.

FIG. 133 Photograph of Mont Sainte-Victoire seen from Les Lauves, by John Rewald, c. 1935, John Rewald Collection

FIG. 134 Paul Cézanne (French,
1839–1906), *Mont Sainte-Victoire Seen from Les
Lauves*, 1902–6, pencil and watercolor on
paper, 18¹¹/₁₆ x 21¹/₁₆″ (47.5 x 53.5 cm:), Peter
Nathan Collection, Zurich

FIG. 135 Paul Cézanne, *Mont Sainte-Victoire
Seen from Les Lauves*, 1902–6, pencil and
watercolor on paper, 13 x 28³/₈″ (33 x 72 cm),
private collection, N.Y.

FIG. 136 A c. 1935 photograph of *Mont
Sainte-Victoire* published in Lionello Venturi,
Cézanne: Son art—son oeuvre (Paris, 1936)
(courtesy John Rewald)

FIG. 137 The white lines clarify the artist's
additions to *Mont Sainte-Victoire*

FIG. 138 Paul Cézanne, *Mont Sainte-Victoire
Seen from Les Lauves*, 1902–6, pencil and
watercolor on paper, 18¹¹/₁₆ x 24³/₁₆″ (47.5 x
61.5 cm), National Gallery of Ireland, Dublin

PAUL GAUGUIN
French, 1848–1903
The Siesta, 1892–94
Oil on canvas, 34¼ x 45¹¹⁄₁₆″ (87 x 116 cm)

PROVENANCE: Ambroise Vollard, Paris; Wilhelm Hansen, Copenhagen; Alphonse Kann, Paris; Prince Matsukata, Paris; Wildenstein and Co., New York; Mrs. Ira Haupt, New York.

EXHIBITIONS: Kunsthaus, Zurich, "Französische Kunst des XIX und XX Jahrhunderts," October 5–November 14, 1917, no. 103; The Museum of Modern Art, New York, "Paintings from Private Collections," May 31–September 5, 1955, p. 10; Wildenstein and Co., New York, "Loan Exhibition: Gauguin," April 5–May 5, 1956, no. 38; The Art Institute of Chicago and The Metropolitan Museum of Art, New York, "Gauguin: Paintings, Drawings, Prints, Sculpture," February 12–May 31, 1959, no. 50; Wildenstein and Co., New York, "Masterpieces: A Memorial Exhibition for Adèle R. Levy," April 6–May 7, 1961, no. 44; National Gallery of Art, Washington, D.C., and The Art Institute of Chicago, "The Art of Paul Gauguin," May 1, 1988–December 11, 1988, no. 128.

LITERATURE: Marius-Ary Leblond, *Peintres de races* (Brussels, 1909), repro. opp. p. 214; K. Madsen, *Catalogue de la collection Wilhelm Hansen* (1918), no. 141; Ernest Dumonthier, "La Collection Wilhelm Hansen," *Revue de l'Art Ancien et Moderne,* December 1922, repro. p. 342; Maurice Malingue, *Gauguin* (Paris, 1943), p. 155, pl. 107; Maurice Malingue, *Gauguin: Le Peintre et son oeuvre* (Paris, 1948), no. 187 (repro.); Lee van Dovski, *Paul Gauguin, oder die Flucht von der Zivilisation* (Zurich, 1950), p. 350, no. 302; J. Taralon, *Gauguin* (Paris, 1953), repro. p. 7, fig. 38; Bernard Dorival, ed., *Paul Gauguin: Carnet de Tahiti* (Paris, 1954), vol. 1, pp. 19–20, 28; "The Museum of Modern Art: Paintings

FIG. 139 Paul Cézanne, *Mont Sainte-Victoire Seen from Les Lauves*, c. 1906, oil on canvas, 23⅝ x 28¾″ (60 x 73 cm), Pushkin State Museum of Fine Arts, Moscow

FIG. 140 Paul Cézanne, *View of L'Estaque from the Sea*, 1878–83, oil on canvas, 17⁵⁄₁₆ x 30⁵⁄₁₆″ (44 x 77 cm), The Barnes Foundation, Merion, Pa.

FIG. 141 Paul Cézanne, *Landscape*, graphite on paper from two pages of a sketchbook, 4⁹⁄₁₆ x 14³⁄₈″ (11.6 x 36.4 cm), Philadelphia Museum of Art, Gift of Mr. and Mrs. Walter H. Annenberg

from Private Collections," *The Museum of Modern Art Bulletin,* vol. 22, no. 4 (summer 1955), no. 44, repro. p. 121; Herbert Read, "Gauguin: Return to Symbolism," *Art News,* November 1956, repro. p. 129 (detail on cover); *Gazette des Beaux-Arts,* 98th year, 6th period, vol. 47 (1956), repro. opp. p. 160; B. H. Friedman, "Current and Forthcoming Exhibitions," *The Burlington Magazine,* vol. 98 (June 1956), p. 212; John Rewald, *Post-Impressionism from Van Gogh to Gauguin* (New York, 1956), p. 532, repro. p. 533; Raymond Cogniat, *Gauguin* (Paris, 1957), repro. p. 64; John Rewald, *Gauguin Drawings* (New York and London, 1958), p. 28; René Huyghe, *Gauguin,* translated by Helen C. Slonim (New York, 1959), repro. p. 64; Georges Boudaille, *Gauguin* (Paris, 1963), p. 175, repro. p. 176; Georges Wildenstein, *Gauguin,* vol. 1, *Catalogue* (Paris, 1964), no. 515 (repro.); Charles Chassé, *Gauguin sans légendes* (Paris, 1965), repro. pp. 128–29; "Gauguin: The Hidden Tradition," *Art News,* vol. 65, no. 4 (summer 1966), repro. p. 26; Marilyn Hunt, "Gauguin and His Circle," in *Gauguin and the Decorative Style* (New York, 1966), n.p. (repro.); Paul C. Nicholls, *Gauguin* (New York, 1967), pp. 29–30, pl. 60; Françoise Cachin, *Gauguin: Biographie* (Paris, 1968), pp. 221, 286, 375, fig. 160, repro. (back cover); Ronald Pickvance, *The Drawings of Gauguin* (London, New York, Sydney, and Toronto, 1970), p. 33; Daniel Wildenstein and Raymond Cogniat, *Paul Gauguin,* translated by Maria Paola De Benedetti (Milan, 1972), repro. p. 59; Lee van Dovski, *Die Wahrheit über Gauguin* (Darmstadt, 1973), no. 302; Richard S. Field, *Paul Gauguin: Monotypes* (Philadelphia, 1973), p. 25; Linnea Stonesifer Dietrich, "A Study of Symbolism in the Tahitian Painting of Paul Gauguin: 1891–1893," Ph.D. diss., University of Delaware, Newark, 1973, pp. 142, 146–49, 210; Richard Sampson Field, *Paul Gauguin: The Paintings of the First Voyage to Tahiti* (New York and London, 1977) pp. 136–41, 273–74, 327;

G. M. Sugana, *L'Opera completa di Gauguin,* 2nd ed. (Milan, 1981) no. 340 (repro.); Michel Hoog, *Paul Gauguin: Life and Work,* translated by Constance Devanthéry-Lewis (New York, 1987), pp. 241–42, pl. 135; Françoise Cachin, *Gauguin* (Paris, 1988), pp. 155, 158, pl. 164.

NOTES

1. The painting was first reproduced in 1909 under the title "Dans la case" in Marius-Ary Leblond, *Peintres de races* (Brussels, 1909), repro. opp. p. 214. It was exhibited at the Kunsthaus, Zurich, in the exhibition "Französische Kunst des XIX und XX Jahrhunderts," October 5–November 14, 1917, no. 103, and in 1918 in Frankfurt as "Scène des îles océaniques." A description of the work four years later, then in the Wilhelm Hansen Collection in Copenhagen, entitled it "Souvenir des îles de la Mer du Sud"; Ernest Dumonthier, "La Collection Wilhelm Hansen," *Revue de l'Art Ancien et Moderne,* December 1922, p. 342.

2. Richard Brettell et al., *The Art of Paul Gauguin* (Washington, D.C., and Chicago, 1988), p. 232.

3. For information on the little-known Alsatian photographer Charles Spitz, see Marilyn S. Kushner, *The Lure of Tahiti: Gauguin, His Predecessors and Followers* (New Brunswick, N. J., 1988), pp. 10–12.

4. Paul Gauguin, *Noa Noa,* edited by Jean Loize (Paris, 1966), p. 24.

5. John Rewald, *Post-Impressionism from Van Gogh to Gauguin* (New York, 1956), p. 532.

6. See *Paul Gauguin's Intimate Journals,* translated by Van Wyck Brooks (New York, 1936), pp. 56–57, 115–16; and Brettell et al., 1988, pp. 214–15.

7. *The Dream,* 1897, Courtauld Institute Galleries, London; see Georges Wildenstein, *Gauguin,* vol. 1, *Catalogue* (Paris, 1964), no. 557.

8. Michel Hoog, *Paul Gauguin: Life and Work,* translated by Constance Devanthéry-Lewis

(New York, 1987), pp. 241, 244.

9. Gauguin explicitly mentioned the striking perspective of the floor pattern of Degas's *Harlequin,* of which he owned a reproduction during his stay in Tahiti. See *Paul Gauguin's Intimate Journals,* 1936, p. 146.

10. Brettell et al., 1988, p. 233.

11. David Bull has graciously made available his documentation on the conservation of this picture.

12. Wildenstein, 1964, no. 434.

13. Ibid., no. 502.

14. These observations were made while examining the painting with David Bull.

15. See Brettell et al., 1988, p. 233.

FIG. 142 Charles Spitz, *Tahitian Women,* 1880–90, photograph (from *Autour du Monde,* Paris, 1895)

FIG. 143 Ukiyo-e School (Japan, Edo Period, c. 1600–1868), *Ceremony for the Harvest Moon*, colored engraving on panel, 10⅜ x 14½" (26.3 x 36.8 cm), National Museum, Tokyo

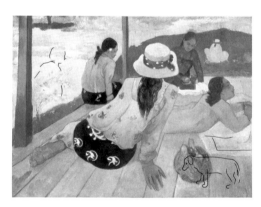

FIG. 144 Location of early elements in *The Siesta*

PAUL GAUGUIN
French, 1848–1903
Still Life with Teapot and Fruit, 1896
Signed and dated lower right:
 P Gauguin 96
Oil on canvas, 18¾ x 26" (47.6 x 66 cm)

PROVENANCE: Private collection, Paris; Wildenstein and Co., New York.

EXHIBITIONS: Galerie Kleber, Paris, "Gauguin et ses amis," January 1949, no. 44; Philadelphia Museum of Art, "Exhibition of Philadelphia Private Collectors," summer 1963 (no catalogue); National Gallery of Art, Washington, D.C., and The Art Institute of Chicago, "The Art of Paul Gauguin," May 1, 1988–December 11, 1988, no. 217.

LITERATURE: Victor Segalen, ed., *Lettres de Paul Gauguin à Georges-Daniel de Monfreid* (Paris and Zurich, 1918), p. 164; Maurice Malingue, *Gauguin* (Paris, 1943), fig. 7; Raymond Cogniat, *Gauguin* (Paris, 1947), fig. 107; Maurice Malingue, *Gauguin: Le peintre et son oeuvre* (Paris and London, 1948), repro. between nos. 200 and 201; Lee van Dovski, *Paul Gauguin oder die Flucht von die Zivilisation* (Zurich, 1950), p. 352, no. 340; J. Taralon, *Gauguin* (Paris, 1954), fig. 50; Georges Wildenstein, *Gauguin*, vol. 1, *Catalogue* (Paris, 1964), no. 554 (repro.); Charles Chassé, *Gauguin sans légendes* (Paris, 1965), repro. pp. 134–35; Daniel Wildenstein and Raymond Cogniat, *Paul Gauguin*, translated by Maria Paola De Benedetti (Milan, 1972), repro. p. 79; G. M. Sugana, *L'Opera completa di Gauguin*, 2nd ed. (Milan, 1981), no. 358 (repro.).

NOTES
1. Pissarro reported a conversation with Gauguin in a letter to his son, November 23, 1893; in John Rewald, ed., *Camille Pissarro: Letters to His Son Lucien*, translated by Lionel Abel (New York, 1943), p. 221.

2. See Octave Mirbeau, preface, in *Cézanne* (Paris, 1914); quoted in Richard Brettell et al., *The Art of Paul Gauguin* (Washington, D.C., and Chicago, 1988), p. 193.

3. Merete Bodelsen, "Gauguin, the Collector," *The Burlington Magazine*, vol. 112 (September 1970), pp. 590–615; and Merete Bodelsen, "Gauguin's Cézannes," *The Burlington Magazine*, vol. 104 (May 1962), pp. 204–11. In a letter to Vollard written from Tahiti, Gauguin claimed to have owned twelve Cézannes. This unpublished information was kindly given to me by John Rewald.

4. See Lionello Venturi, *Cézanne: Son art—son oeuvre* (Paris, 1936), vol. 2, no. 341.

5. See Georges Wildenstein, *Gauguin*, vol. 1., *Catalogue* (Paris, 1964), nos. 401, 403, 404.

6. Ambroise Vollard, *Souvenirs d'un marchand de tableaux* (Paris, 1937), p. 184; cited in Brettell et al., 1988, p. 193.

7. See Gustave Geffroy, *Claude Monet: Sa vie, son temps, son oeuvre* (Paris, 1922), p. 198; and Emile Bernard, "Souvenirs sur Paul Cézanne et lettres inédites," *Mercure de France*, vol. 69 (October 1, 1907), p. 400.

8. For a photograph of the wooden spoons made by Gauguin, see Georges Wildenstein et al., *Gauguin: Sa vie, son oeuvre* (Paris, 1958), p. 178, fig. 4.

9. Brettell et al., 1988, p. 403.

10. Ibid., p. 402.

11. Wildenstein, 1964, no. 603.

12. Ibid., no. 457.

13. *Avant et après*, ms. p. 31; quoted in Bodelsen, 1970, p. 606 (author's trans.).

PAUL GAUGUIN
French, 1848–1903
Three Tahitian Women, 1896
Signed and dated lower right:
 P. Gauguin 96
Oil on panel, 9¹¹⁄₁₆ x 17″ (24.6 x 43.2 cm)

PROVENANCE: Dr. Nolet, Nantes; Wildenstein and Co., New York; Knoedler and Co., New York; Mrs. Ira Haupt, New York.

EXHIBITION: Wildenstein and Co., New York, "Loan Exhibition: Gauguin," April 5–May 5, 1956, no. 46.

LITERATURE: *Lettres de Paul Gauguin à Georges-Daniel de Monfreid* (Paris, 1946), p. 209; John Rewald, *Gauguin: Drawings* (New York and London, 1958), p. 36, no. 98; Georges Wildenstein, *Gauguin*, vol. 1, *Catalogue* (Paris, 1964), no. 539 (repro.); Ronald Pickvance, *The Drawings of Gauguin* (London, New York, Sydney, and Toronto, 1970), p. 36, fig. 83; G. M. Sugana, *L'Opera completa di Gauguin*, 2nd ed. (Milan, 1981), no. 366 (repro.).

NOTES
1. John Rewald, *Gauguin: Drawings* (New York and London, 1958), p. 36, no. 98.
2. *Food of the Gods*, The Art Institute of Chicago. The image was anticipated in a woodcut in Papeete in 1891. See Marcel Guérin, *L'Oeuvre gravé de Gauguin*, rev. ed. (San Francisco, 1980), no. 43.
3. John Rewald, *Studies in Post-Impressionism* (New York, 1986), p. 178. See also Victor Segalen, ed., *Lettres de Paul Gauguin à Georges-Daniel de Monfreid* (Paris and Zurich, 1918).
4. For example, *The Day of the God*, 1894; see Georges Wildenstein, *Gauguin*, vol. 1, *Catalogue* (Paris, 1964), no. 513.
5. Quoted in Wildenstein, 1964, p. 222.

6. Ibid., p. 222, no. 539. Little is known of Dr. Nolet, whom Gauguin may have met during his internment in the hospital in Papeete in July 1896 (where he was placed in a ward for indigents), or during October of the following year, when his physical degeneration (which also included severe eye infection, eczema, and syphilis) culminated in a heart attack. Nolet seems to have found no buyers, although he must certainly have tried. Given Monfreid's knowledge of the picture, Nolet must have approached him. Thwarted, Nolet took the painting with him to Nantes, where it remained with his descendants until Wildenstein purchased it.
7. See Wildenstein, 1964, nos. 564, 569.
8. Among Gauguin's reproductions of the works of artists he admired were photographs of paintings by Puvis de Chavannes.
9. *Paul Gauguin's Intimate Journals*, translated by Van Wyck Brooks (New York, 1936), p. 41.
10. Ibid., p. 241.

FIG. 145 Paul Cézanne (French, 1839–1906), *Still Life with Apples in a Compote*, 1879–80, oil on canvas, 18⅛ x 21⅝″ (46 x 54.9 cm), private collection

FIG. 146 Paul Gauguin (French, 1848–1903), *Portrait of a Woman, with Still Life by Cézanne*, 1890, oil on canvas, 24¹⁵⁄₁₆ x 21⅝″ (63.3 x 54.9 cm), The Art Institute of Chicago, The Joseph Winterbotham Collection

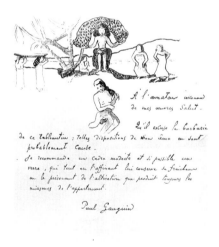

FIG. 147 Paul Gauguin (French, 1848–1903), letter to an unknown collector, Collection of Mrs. Alex M. Lewyt, N.Y.

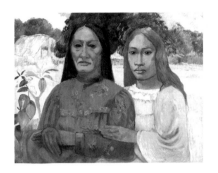

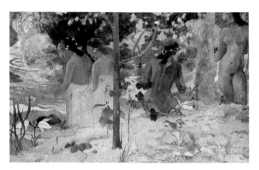

FIG. 148 Paul Gauguin, *The Bathers*, 1898, oil on canvas, 23¾ x 36¾" (60.4 x 93.4 cm), National Gallery of Art, Washington, D.C., Gift of Sam A. Lewisohn

PAUL GAUGUIN
French, 1848–1903
Portrait of Women (Mother and Daughter), 1901 or 1902
Oil on canvas, 29 x 36¼" (73.7 x 92.1 cm)

PROVENANCE: Ambroise Vollard, Paris; Galerie Barbazanges, Paris, 1920–21; Prince Matsukata, Paris; private collection, Germany; Oscar Homolka, New York; Wildenstein and Co., New York.

EXHIBITIONS: Galerie Vollard, Paris, "Gauguin," November 1903, no. 6 or 49; Galerie Thannhauser, Munich, and Arnold Kunst Salon, Dresden, "Collection Vollard," 1910; L'Institut Français, St. Petersburg, "Exposition centennale de l'art français," 1912, no. 116; Prague, "French Art: Nineteenth and Twentieth Centuries," 1923, no. 185; California Palace of the Legion of Honor, San Francisco, "Inaugural Exposition of French Art, in the California Palace of the Legion of Honor," 1924–25, no. 27; Wildenstein and Co., New York, "Loan Exhibition: Gauguin," April 5–May 5, 1956, no. 50; The Art Institute of Chicago and The Metropolitan Museum of Art, New York, "Gauguin: Paintings, Drawings, Prints, Sculpture," February 12–May 31, 1959, no. 65; Philadelphia Museum of Art, "Exhibition of Philadelphia Private Collectors," summer 1963 (no catalogue); The Tate Gallery, London, "The Annenberg Collection," September 2–October 8, 1969, no. 18; National Gallery of Art, Washington, D.C., and The Art Institute of Chicago, "The Art of Paul Gauguin," May 1, 1988–December 11, 1988, no. 231.

LITERATURE: "Gauguin," *Mir Iskousstva*, 6th year, nos. 8–9 (1904), repro. p. 222; Rudolf Meyer-Riefstahl, "Paul Gauguin," *Deutsche Kunst und Dekoration*, vol. 27 (November 1910), repro. p. 113; Charles Morice, *Paul Gauguin* (Paris, 1919), repro. opp. p. 236; Charles Morice, *Paul Gauguin*, 2nd ed.

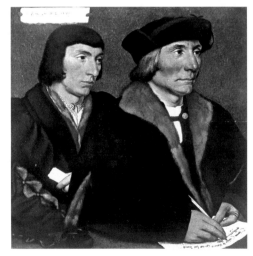

FIG. 149 Jules Agostini or Henri Lamasson, *Two Women*, c. 1894, photograph, O'Reilly Collection, Papeete Museum

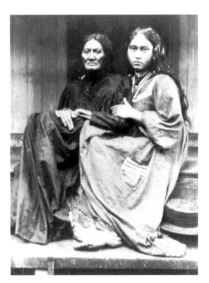

FIG. 150 Hans Holbein the Younger (German, 1497/98–1543), *Thomas Godsalve and His Son John*, 1528, oil on panel, 13¾ x 14³⁄₁₆" (35 x 36 cm), Staatliche Gemäldegalerie, Dresden

(Paris, 1920), repro. opp. p. 112; John Gould Fletcher, *Paul Gauguin: His Life and Art* (New York, 1921), repro. opp. p. 95; "Gauguin," *L'Art et les Artistes,* n.s., 20th year, vol. 61 (November 1925), repro. (cover); Arsène Alexandre, *Paul Gauguin: Sa vie et le sens de son oeuvre* (Paris, 1930), repro. p. 105; Lee van Dovski, *Gauguin, der Meister von Tahiti* (Basel, 1947), pl. 20; Lee van Dovski, *Paul Gauguin oder die Flucht von die Zivilisation* (Zurich, 1950), p. 353, no. 368; Herbert Read, "Gauguin: Return to Symbolism," *Art News,* November 1956, repro. p. 139; John Richardson, "Gauguin at Chicago and New York," *The Burlington Magazine,* vol. 101 (May 1959), p. 191; Georges Wildenstein, *Gauguin,* vol. 1, *Catalogue* (Paris, 1964), no. 610 (repro.); P. O'Reilly, *Catalogue du Musée Gauguin, Tahiti* (Paris, 1965), p. 63; Bengt Danielsson, *Gauguin in the South Seas,* translated by Reginald Spink (London, 1965), fig. 37; Merete Bodelsen, "The Gauguin Catalogue (Wildenstein-Cogniat)," *The Burlington Magazine,* vol. 108 (January 1966), p. 38; Paul Gauguin, *Noa Noa,* edited by Jean Loize (Paris, 1966), pp. 122–23, 192–93, repro. opp. p. 25; Françoise Cachin, *Gauguin: Biographie* (Paris, 1968), pp. 313, 376, fig. 180; Daniel Wildenstein and Raymond Cogniat, *Paul Gauguin,* translated by Maria Paola De Benedetti (Milan, 1972), repro. p. 70; G. M. Sugana, *L'Opera completa di Gauguin,* 2nd ed. (Milan, 1981), no. 434 (repro.); Yann le Pichon, *Gauguin: Life, Art, Inspiration,* translated by I. Mark Paris (New York, 1986), pp. 242–43; Françoise Cachin, *Gauguin* (Paris, 1988), p. 248, pl. 669.

NOTES

1. Galerie Vollard, Paris, "Gauguin," November 1903, no. 6 or 49.

2. Arsène Alexandre, *Paul Gauguin: Sa vie et le sens de son oeuvre* (Paris, 1930), p. 105.

3. See Richard Brettell et al., *The Art of Paul Gauguin* (Washington, D.C., and Chicago, 1988), no. 231.

4. Compare, for example, *Apple Trees in the Hermitage, Neighborhood of Pontoise,* Aargauer Kunsthaus, Aarau (see Georges Wildenstein, *Gauguin,* vol. 1, *Catalogue* [Paris, 1964], no. 33).

5. Bengt Danielsson, *Gauguin in the South Seas,* translated by Reginald Spink (London, 1965), pp. 180, 286, no. 153.

6. These are *Pape Moe* of 1893, private collection, and *Girl with a Fan* of 1902, Museum Folkwang, Essen.

7. Two women in union, although never with this difference in age, was a recurring motif in Gauguin's oeuvre. One thinks of the hushed figures in *Nevermore* (Courtauld Institute Galleries, London), or *Two Tahitian Women* of 1899 at the Metropolitan Museum of Art, New York, or, more relevant here, the late transfer drawings done in the Marquesas; however, the Annenberg picture purges its relationship of any immediate narrative or sensuous interaction, moving onto a more general and profound level. The title *Mother and Daughter* applied to this picture has little cause other than to satisfy our desire to make it more concrete and explicit. The identities of the figures now seem to be resolved: Richard Brettell et al. convey that, according to an interview with Mme Manhard, the younger woman is her grandmother, Teahu A Raatairi, and the older figure Teahu's aunt by marriage (Brettell et al., 1988, p. 426).

8. Holbein's London was centuries and miles from Gauguin's Tahiti; the powerful English lord in a different realm from that of Teahu A Raatairi and her elderly aunt. Yet the Tahitian women lose none of their dignity by the comparison, and Gauguin's examination of the cycle of life is made no less compelling or uplifting by the grounded simplicity of his Tahitian portrait.

VINCENT VAN GOGH
Dutch, 1853–1890
The Bouquet, c. 1886
Oil on canvas, 25½ x 21⅛" (65 x 53.8 cm)

PROVENANCE: Jules Andorko, Paris; Druet Art Gallery, Paris; Mr. and Mrs. Charles Vildrac Gallery, Paris; Baron Frans Havatny, Budapest; Marie Harriman Gallery, New York; Governor and Mrs. W. Averell Harriman, New York.

EXHIBITIONS: Galerie Bernheim-Jeune, Paris, "Vincent van Gogh, L'Epoque française," June 20–July 2, 1927; Stedelijk Museum, Amsterdam, "Stedelijke tentoonstelling, Vincent Van Gogh en zijn tijdgenooten," September 6–November 2, 1930, no. 73; Albright Art Gallery, Buffalo, "Nineteenth-Century French Art: Paintings, Watercolors, Drawings, Prints, Sculpture," November 1–30, 1932, no. 61; Pennsylvania Museum (Philadelphia Museum of Art), "Flowers in Art," April 1–May 1, 1933; California Palace of the Legion of Honor, San Francisco, "French Painting," June 8–July 8, 1934, no. 158; The William Rockhill Nelson Gallery of Art and The Mary Atkins Museum of Fine Arts, Kansas City, "One Hundred Years: French Painting, 1820–1920," March 31–April 28, 1935, no. 63; The Museum of Modern Art, New York, "Vincent van Gogh," December 1935–January 1936, no. 47; Marie Harriman Gallery, New York, "Paul Cézanne, André Derain, Walt Kuhn, Henri Matisse, Pablo Picasso, Auguste Renoir, Vincent Van Gogh," February 17–March 14, 1936, no. 16; City Art Museum, Saint Louis, "The Development of Flower Painting from the Seventeenth Century to the Present," May 1937, no. 38; The Museum of Modern Art Gallery, Washington, D.C., "Flowers and Fruits," 1938, no. 20; Marie Harriman Gallery, New York, "Flowers, Fourteen American, Fourteen French Artists," April 8—May 4, 1940, no. 27; The Detroit Institute of Arts, "Exhi-

bition of Flower Paintings," May 15–June 23, 1940, no. 47; Los Angeles County Museum, "Aspects of French Painting from Cézanne to Picasso," January 15–March 2, 1941, no. 55; Museum of Fine Arts, Montreal, "Exposition de chefs-d'oeuvre de la peinture," February 5–March 8, 1942, no. 22; Wildenstein and Co., New York, "The Art and Life of Vincent Van Gogh," October 6–November 7, 1943, no. 43; Wildenstein and Co., New York, "Loan Exhibition: Van Gogh," March 24–April 30, 1955, no. 43; Corcoran Gallery of Art, Washington, D.C., "Visionaries and Dreamers," April 7–May 27, 1956, no. 38; Philadelphia Museum of Art, "A World of Flowers: Paintings and Prints," May 2–June 9, 1963, no. 148.

LITERATURE: J.-B. de la Faille, *L'Oeuvre de Vincent van Gogh: Catalogue raisonné* (Paris and Brussels, 1928), no. 588 (repro.); Henri Marceau and Horace H.F. Jayne, "Flowers in Art: An Exhibition," *The Pennsylvania Museum Bulletin* (Philadelphia Museum of Art), vol. 28, no. 154 (March 1933), repro. p. 62; Alfred H. Barr, Jr., ed., *Vincent van Gogh* (New York, 1935), no. 47 (repro.); A.M. Frankfurter, "Cézanne, …Van Gogh in an Informal Show," *Art News*, vol. 34, no. 21 (February 22, 1936), p. 5 (repro.); W. Scherjon and Joseph de Gruyter, *Vincent van Gogh's Great Period: Arles, St. Rémy, and Auvers sur Oise* (Amsterdam, 1937), no. 193 (repro.); Louis Hautecoeur, *Van Gogh* (Monaco and Geneva, 1946), repro. p. 95; *Art News*, vol. 54, no. 2 (April 1955), repro. (cover); J.-B. de la Faille, *The Works of Vincent van Gogh: His Paintings and Drawings* (Amsterdam, 1970), no. 588 (repro.); Paolo Lecaldano, *L'Opera pittorica completa di van Gogh e i suoi nessi grafici* (Milan, 1971), vol. 2, no. 551 (repro.); Jacques Lassaigne, *Vincent van Gogh* (Milan, 1972), repro. p. 45; Peter Mitchell, *Great Flower Painters: Four Centuries of Floral Art* (New York, 1973), no. 304 (repro.); Jan Hulsker, *The Complete Van Gogh: Paintings, Drawings, Sketches* (New York, 1980), no. 1335 (repro.).

NOTES

1. Translated in Jan Hulsker, *The Complete Van Gogh: Paintings, Drawings, Sketches* (New York, 1980), p. 234.

2. See ibid., nos. 1091–94, 1125–50.

3. Van Gogh had lived twice before in Paris working for the art dealer Goupil, briefly in 1874 and again from May 1, 1875, to April 1, 1876, when he was dismissed.

4. See Musée d'Orsay, Paris, "Van Gogh à Paris," February 2–May 15, 1988.

5. Hulsker, 1980, p. 300.

6. J.-B. de la Faille, *L'Oeuvre de Vincent van Gogh: Catalogue raisonné* (Paris and Brussels, 1928), no. 588; this placement of the picture in the Arles period has been followed in most of the later literature.

7. J.-B. de la Faille, *The Works of Vincent Van Gogh: His Paintings and Drawings* (Amsterdam, 1970), p. 242, no. 588.

8. See John Rewald, "Theo Van Gogh, Goupil, and the Impressionists," *Gazette des Beaux-Arts*, 115th year, 6th period, vol. 81 (January 1973), pp. 8, 9.

9. For a summation of Van Gogh's interest in Monticelli, and a review of his mention of the artist in his letters, see Aaron Sheon, *Monticelli: His Contemporaries, His Influence* (Pittsburgh, 1978), pp. 82–88.

10. Hulsker, 1980, no. 1140. Assigned by the author to July–September 1886.

FIG. 151 Edgar Degas (French, 1834–1917), *Woman with Chrysanthemums*, 1865, oil on paper applied to canvas, 29 x 36½" (73.7 x 92.7 cm), The Metropolitan Museum of Art, N.Y., The H.O. Havemeyer Collection

FIG. 152 Adolphe Monticelli (French, 1824–1886), *Vase of Flowers*, c. 1875, oil on panel, 20 x 15⅜ (51 x 39 cm), Stedelijk Museum, Amsterdam

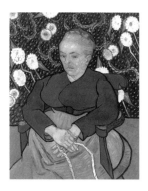

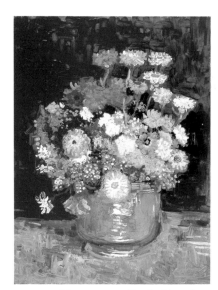

FIG. 153 Vincent van Gogh (Dutch, 1853–1890), *Bowl with Zinnias*, 1886, oil on canvas, 24 x 18⅛″ (61 x 45.5 cm), Mr. and Mrs. David Lloyd Kreeger Collection, Washington, D.C.

VINCENT VAN GOGH
Dutch, 1853–1890
La Berceuse (Woman Rocking a Cradle), 1889
Signed on the arm of the chair: Vincent Arles 89; inscribed lower right: La Berceuse
Oil on canvas, 36½ x 29″ (92.8 x 73.7 cm)

PROVENANCE: Augustine Roulin, Marseille; Joseph Roulin, Marseille; Ambroise Vollard Art Gallery, Paris, 1895; Amédée Schuffenecker, Saint-Maur; Léon Marseille Art Gallery, Paris; Tanner Art Gallery, Zurich; Rudolf Staechelin, Basel; Wildenstein and Co., New York.

EXHIBITIONS: Paris, "Exposition Rétrospective Vincent van Gogh, Société des Artistes Indépendants: Catalogue de la 21ieme exposition 1905," 1905, no. 39; Kunsthalle, Basel, "Vincent van Gogh," March–April 1924, no. 38; Kunsthalle, Bern, "Französische Meister des 19. Jahrhunderts und Van Gogh," February–April 1934, no. 61; Palais de Tokyo, Paris, "Van Gogh: Exposition internationale de 1937, Group I, Classe III," 1937, no. 36; Galerie M. Schulthess, Basel, "Zwei Ausstellungen aus Privatbesitz in der Schweiz—Meisterwerke Holländischer Malerei des 16. bis 18. Jahrhunderts im Kunstmuseum: 25 Werke von Vincent van Gogh," June 23–August 19, 1945, no. 13; Kunstmuseum Basel, "Sammlung Rudolf Staechelin: Gedächtnis-Ausstellung zum 10. Todesjahr des Sammlers," May 13–June 17, 1956, no. 38; Musée National d'Art Moderne, Paris, "Fondation Rodolphe Staechelin, de Corot à Picasso," April 10–June 28, 1964, no. 32; The Tate Gallery, London, "The Annenberg Collection," September 2–October 8, 1969, no. 19.

LITERATURE: *Oeuvres posthumes de G.-Albert Aurier, avec un autographe de l'auteur et un portrait gravé a l'eau-forte par A.-M. Lauzet…* (Paris, 1893), p. 263; Ambroise Vollard, ed., *Lettres de Vincent van Gogh à Emile Bernard* (Paris, 1911), p. 145, repro. p. 157; Théodore Duret, *Van Gogh, Vincent, édition définitive* (Paris, 1919), p. 53; Gustave Coquiot, *Vincent van Gogh* (Paris, 1923), repro. opp. p. 288; Louis Piérard, *The Tragic Life of Vincent van Gogh,* translated by Herbert Garland (London, 1925), fig. 98; Paul Colin, *Van Gogh,* translated by Beatrice Moggridge (New York, 1926), fig. 23; Florent Fels, *Vincent van Gogh* (Paris, 1928), repro. p. 207; J.-B. de la Faille, *L'Oeuvre de Vincent van Gogh: Catalogue raisonné* (Paris and Brussels, 1928), vol. 1, no. 505 (repro.); R. H. Wilenski, *French Painting* (Boston, 1931), p. 297, n. 1; Charles Terrasse, *Van Gogh: Peintre* (Paris, 1935), repro. between pp. 122 and 129; W. Scherjon and Joseph de Gruyter, *Vincent van Gogh's Great Period: Arles, St. Rémy, and Auvers sur Oise* (Amsterdam, 1937), no. 149 (repro.); Douglas Lord, ed. and trans., *Vincent van Gogh: Letters to Emile Bernard* (New York, 1938), pp. 97, 102, n. 7; J.-B. de la Faille, *Vincent van Gogh,* translated by Prudence Montagu-Pollock (New York and Paris, 1939), repro. opp. p. 432; R. H. Wilenski, *Modern French Painters* (New York, 1940), p. 214; Edward Alden Jewell, *Vincent van Gogh* (New York, 1946), pp. 79–80, repro. p. 72; Georg Schmidt, *Van Gogh* (Bern, 1947), pl. 26; Maurice Raynal and Jean Leymarie, *History of Modern Painting from Baudelaire to Bonnard* (Geneva, 1949), repro. p. 68; Werner Weisbach, *Vincent van Gogh: Kunst und Schicksal,* vol. 2, *Künstlerischer Aufstieg und Ende* (Basel, 1951), pp. 130–34, fig. 58; Paul Gachet, *Vincent van Gogh aux "Indépendants"* (Paris, 1953); Frank Elgar, *Van Gogh: Leben und Werk* (Munich and Zurich, 1958), pp. 161–62; August Kuhn-Foelix, *Vincent van Gogh: Eine Psychographie* (Bergen, 1958), p. 138, fig. 28; J. G. van Gelder, *A Detailed Catalogue with Full Documentation of 272 Works by Vincent van Gogh Belonging to the Collection of the State*

Museum Kröller-Muller, with an Essay on Van Gogh's Childhood Drawings (Otterlo, 1959), p. 80; Pierre Cabanne, Van Gogh (Paris, 1961), pp. 181, 188; H. R. Graetz, The Symbolic Language of Vincent van Gogh (New York, Toronto, and London, 1963), pp. 165–67, 174–75; J.-B. de la Faille, The Works of Vincent van Gogh: His Paintings and Drawings (Amsterdam, 1970), no. 505 (repro.); Mark Roskill, Van Gogh, Gauguin, and French Painting of the 1880s: A Catalogue Raisonné of Key Works (Ann Arbor, Mich., 1970), pp. 83–85; Paolo Lecaldano, L'Opera pittorica completa di Van Gogh, e i suoi nessi grafici (Milan, 1971), vol. 2, no. 637 (repro.); Jacques Lassaigne, Vincent van Gogh (Milan, 1972), fig. 3; Matthias Arnold, "Duktus und Bildform bei Vincent van Gogh," Ph.D. diss., Ruprecht-Karl University, Heidelberg, 1973, p. 173; Brian Petrie, Van Gogh: Paintings, Drawings, and Prints (London, 1974), no. 83 (repro.); Marcel Heiman, "Psychoanalytic Observations on the Last Painting and Suicide of Vincent van Gogh," The International Journal of Psycho-Analysis, vol. 57 (1976), pp. 71–73, 78; Arthur F. Valenstein and Anne Stiles Wylie, "A Discussion of the Paper by Marcel Heiman on 'Psychoanalytic Observations on the Last Painting and Suicide of Vincent van Gogh,'" The International Journal of Psycho-Analysis, vol. 57 (1976), pp. 82–83; Nicolai Cikovsky, Jr., "Van Gogh and a Photograph: A Note on 'La Berceuse,'" New Mexico Studies in the Fine Arts, vol. 3 (1978), pp. 23–28; Hope B. Werness, Vincent van Gogh: The Influences of Nineteenth-Century Illustrations (Tallahassee, 1980), p. 12; Jan Hulsker, The Complete Van Gogh: Paintings, Drawings, Sketches (New York, 1980), pp. 380, 386–87, 484, no. 1669 (repro.); Evert van Uitert, "Vincent van Gogh and Paul Gauguin in Competition: Vincent's Original Contribution," Simiolus, vol. 11, no. 2 (1980), pp. 83–86; Bogomila Welsh-Ovcharov, Vincent van Gogh and the Birth of Cloisonism (Toronto, 1981), pp. 148–49; Evert van Uitert, "Van Gogh's Concept of His Oeuvre," Simiolus, vol. 12, no. 4 (1981–82), pp. 233–34, 242; Ronald Pickvance, Van Gogh in Arles (New York, 1984), pp. 246, 248; Naomi E. Maurer, "The Pursuit of Spiritual Knowledge: The Philosophical Meaning and Origins of Symbolist Theory and Its Expression in the Thought and Art of Odilon Redon, Vincent van Gogh, and Paul Gauguin," Ph.D. diss., University of Chicago, 1985, vol. 1, pp. 783–88; Susan Alyson Stein, ed., Van Gogh: A Retrospective (New York, 1986), repro. p. 192; Philippe Huisman, Van Gogh Portraits, translated by Diana Imber (New York, n.d.), pp. 50, 52, fig. 20.

NOTES

1. See Jan Hulsker, The Complete Van Gogh: Paintings, Drawings, Sketches (New York, 1980), nos. 1665, 1669, 1670, 1671, 1672. The baby in the cradle is Marcelle Roulin, born July 31, 1888.

2. Oeuvres posthumes de G.-Albert Aurier, avec un autographe de l'auteur et un portrait gravé a l'eau-forte par A.-M. Lauzet … (Paris, 1893), p. 263 (author's trans.).

3. See Hulsker, 1980, no. 1652 (The Dance Hall, Musée d'Orsay, Paris) and no. 1653 (Spectators in the Arena, The Hermitage, Leningrad).

4. The Complete Letters of Vincent van Gogh, 2nd ed., translated by Johanna van Gogh-Bonger and C. de Drood (Greenwich, Conn., 1959), vol. 3, p. 101, no. 560.

5. Ibid., p. 128, no. 573.

6. Ibid., vol. 3, p. 182, no. 595; see also vol. 2, p. 591, no. 501.

7. J.-N. Priou, "Van Gogh et la Famille Roulin," Revue des P.T.T. de France, vol. 10, no. 3 (May–June 1955), p. 32.

8. The Complete Letters, 1959, vol. 3, p. 129, no. 574.

9. Ibid., p. 97, no. 558b.

10. Ibid., pp. 171–72, no. 592.

11. Ibid., p. 129, no. 574.

12. Ibid., p. 127, no. 573.

13. Ibid., p. 129, no. 574.

14. Ibid., pp. 123–24, no. 571a.

15. See Mark Roskill, Van Gogh, Gauguin, and French Painting of the 1880s: A Catalogue Raisonné of Key Works (Ann Arbor, Mich., 1970), pp. 83–85.

16. The Complete Letters, 1959, vol. 3, p. 137, no. 578.

17. John Rewald, Post-Impressionism from Van Gogh to Gauguin (New York, 1956), p. 240, n. 52.

18. Mme Roulin, The Saint Louis Art Museum, Gift of Mrs. Mark C. Steinberg. See Ronald Pickvance, Van Gogh in Arles (New York, 1984), no. 137 (repro.).

19. Roskill, 1970, pp. 83–85.

20. For various psychological interpretations, see Arthur F. Valenstein and Anne Stiles Wylie, "A Discussion of the Paper by Marcel Heiman on 'Psychoanalytic Observations on the Last Painting and Suicide of Vincent van Gogh,'" The International Journal of Psycho-Analysis, vol. 57 (1976), pp. 82–83.

21. The Complete Letters, 1959, vol. 3, p. 133, no. 576.

22. Ibid., p. 137, no. 578.

23. Ibid., p. 133, no. 575.

FIG. 154 Vincent van Gogh (Dutch, 1853–1890), *Mme Roulin and Her Baby, Marcelle*, 1888/89, oil on canvas, 36¼ x 28¾" (92 x 73 cm), Philadelphia Museum of Art, Bequest of Lisa Norris Elkins

FIG. 156 Vincent van Gogh, sketch of *La Berceuse* flanked by "Sunflowers," in a letter to his brother Theo, May 25, 1889, Rijksmuseum Vincent van Gogh, Amsterdam

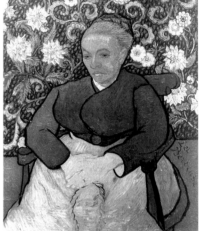

FIG. 158 Vincent van Gogh, *La Berceuse (Woman Rocking a Cradle)*, 1889, oil on canvas, 36¼ x 28¾" (92 x 73 cm), Rijksmuseum Kröller-Müller, Otterlo

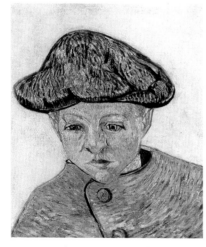

FIG. 155 Vincent van Gogh, *Camille Roulin*, 1888, oil on canvas, 17 x 13¾" (43.2 x 35 cm), Philadelphia Museum of Art, Gift of Mrs. Rodolphe Meyer de Schauensee

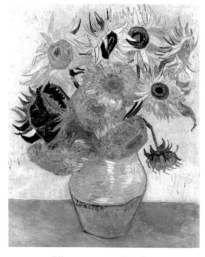

FIG. 157 Vincent van Gogh, *Sunflowers*, 1888/89, oil on canvas, 36¼ x 28⁹⁄₁₆" (92 x 72.5 cm), Philadelphia Museum of Art, Mr. and Mrs. Carroll S. Tyson Collection

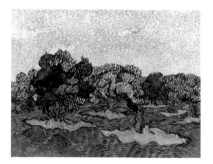

VINCENT VAN GOGH
Dutch, 1853–1890
Olive Trees: Pale Blue Sky, 1889
Oil on canvas, 28⅝ x 36¼″ (72.7 x 92 cm)

PROVENANCE: Mme Johanna van Gogh-Bonger, Amsterdam; Paul Rosenberg Art Gallery, Paris; Victor Schuster, London; Wildenstein and Co., New York; sale, Sotheby's, London, July 26, 1939, lot 76; W. Feilchenfeldt Art Gallery, Zurich; private collection; Reid and Lefevre Art Gallery, London; Sam Salz Art Gallery, New York.

EXHIBITIONS: Stedelijk Museum, Amsterdam, "Vincent Van Gogh," July–August, 1905, no. 202; Montross Gallery, New York, "Vincent van Gogh," October 23, 1920, no. 49; Wildenstein and Co., New York, "French Masters of the XIXth Century," March–April 1927 (no catalogue); City Art Museum, Saint Louis, "An Exhibition of Paintings & Prints by the Masters of Post-Impressionism," April 4–26, 1931, no. 36; The Detroit Institute of Arts, "Modern French Painting," May 22–June 30, 1931, no. 47; Los Angeles Museum, "European Paintings by Old and Modern Masters: An Exhibition Arranged by Wildenstein and Company, Paris, London, New York," June 13–August 5, 1934, no. 17; Los Angeles Municipal Art Gallery, "Vincent van Gogh: A Loan Exhibition of Paintings and Drawings," July 3–August 1957, no. 16; Philadelphia Museum of Art, "Exhibition of Philadelphia Private Collectors," summer 1963 (no catalogue); The Tate Gallery, London, "The Annenberg Collection," September 2–October 8, 1969, no. 20.

LITERATURE: Emile Bernard, *Lettres de Vincent van Gogh*, edited by Ambroise Vollard (Paris, 1911), pp. 141, 145; J.-B. de la Faille, *L'Oeuvre de Vincent van Gogh: Catalogue raisonné* (Paris and Brussels, 1928), vol. 1, no. 708 (repro.); W. Scherjon, *Catalogue des tableaux par Vincent van Gogh, décrits dans ses lettres. Périodes: St. Rémy et Auvers sur Oise* (Utrecht, 1932), no. 8 (repro.); W. Scherjon and Joseph de Gruyter, *Vincent van Gogh's Great Period: Arles, St. Rémy, and Auvers sur Oise* (Amsterdam, 1937), pp. 210, 268, 271 (repro.); J.-B. de la Faille, *The Works of Vincent van Gogh: His Paintings and Drawings* (Amsterdam and New York, 1970), no. 708 (repro.); Paolo Lecaldano, *L'Opera pittorica completa di Van Gogh e i suoi nessi grafici* (Milan, 1971), vol. 2, no. 738 (repro.); Jan Hulsker, *The Complete Van Gogh: Paintings, Drawings, Sketches* (New York, 1980), no. 1855 (repro.); Evert van Uitert, "Vincent van Gogh and Paul Gauguin in Competition: Vincent's Original Contribution," *Simiolus*, vol. 11, no. 2 (1980), n. 83; Naomi E. Maurer, "The Pursuit of Spiritual Knowledge: The Philosophical Meaning and Origins of Symbolist Theory and Its Expression in the Thought and Art of Odilon Redon, Vincent van Gogh, and Paul Gauguin," Ph.D. diss., University of Chicago, 1985, vol. 1, pp. 790–92; Ronald Pickvance, *Van Gogh in Saint-Rémy and Auvers* (New York, 1986), p. 43, fig. 37.

NOTES
1. See Jan Hulsker, *The Complete Van Gogh: Paintings, Drawings, Sketches* (New York, 1980), p. 400, nos. 1758, 1759, 1760.
2. *The Complete Letters of Vincent van Gogh*, 2nd ed., translated by Johanna van Gogh-Bonger and C. de Drood (Greenwich, Conn., 1959), vol. 3, p. 233, no. 615. In addition to the Annenberg *Olive Trees*, the other four are at the Rijksmuseum Vincent van Gogh, Amsterdam; The Minneapolis Institute of Arts; Rijksmuseum Kröller-Müller, Otterlo; Göteborgs Konstmuseum, Sweden; respectively, J.-B. de la Faille, *The Works of Vincent van Gogh: His Paintings and Drawings* (Amsterdam, 1970), nos. 708, 707, 710, 587, and 586. See Ronald Pickvance, *Van Gogh in Saint-Rémy and Auvers* (New York, 1986), p. 161.
3. See Pickvance, 1986, pp. 52–53.

4. Ibid., p. 52.
5. *The Complete Letters*, 1959, vol. 3, p. 233, no. 615.
6. Ibid., p. 220, no. 608.
7. See ibid., p. 82, no. 553.
8. Ibid., p. 234, no. 615.

FIG. 159 Emile Bernard (French, 1868–1941), *Christ in the Garden of Olives*, 1889, oil on canvas, location unknown

FIG. 160 Paul Gauguin (French, 1848–1903), sketch for *Christ in the Garden of Olives* in a letter to Vincent van Gogh, November 1889, Rijksmuseum Vincent van Gogh, Amsterdam

FIG. 161 Vincent van Gogh (Dutch, 1853–1890), *The Starry Night*, 1889, oil on canvas, 29 x 36¼″ (73.7 x 92.1 cm), The Museum of Modern Art, N.Y., Acquired through the Lillie P. Bliss Bequest

FIG. 162 Vincent van Gogh, *Olive Trees: Pale Blue Sky,* 1889, oil on canvas, 28⅝ x 36¼″ (72.7 x 92 cm), The Minneapolis Institute of Arts, The William Hood Dunwoody Fund

VINCENT VAN GOGH
Dutch, 1853–1890
Women Picking Olives, 1889–90
Oil on canvas, 28½ x 35¹³/₁₆″ (72.5 x 91 cm)

PROVENANCE: Bernard Goudchaux, Paris; Dikran Khan Kélékian, Paris; sale, American Art Galleries, New York, January 24, 1922, lot 157; Wildenstein and Co., New York; Mrs. Ira Haupt, New York; Basil P. Goulandris, Lausanne.

EXHIBITIONS: Brooklyn Museum, "Paintings by Modern French Masters," 1921, no. 216; Wildenstein and Co., New York, "A Loan Exhibition: Six Masters of Post-Impressionism," April 8–May 8, 1948, no. 68; The Cleveland Museum of Art, "Work by Vincent van Gogh," November 3–December 12, 1948, no. 27; Wildenstein and Co., New York, "Loan Exhibition: Van Gogh," March 24–April 30, 1955, no. 60; Parke-Bernet Galleries, New York, "Art Treasures Exhibition," June 16–30, 1955, no. 356; The Solomon R. Guggenheim Foundation, New York, "Van Gogh and Expressionism," 1964; Knoedler and Co., New York, "Impressionist Treasures from Private Collections in New York," January 12–29, 1966, no. 12.

LITERATURE: *Collection Kélékian: Tableaux de l'école française moderne* (Paris and New York, 1920), pl. 69; J.-B. de la Faille, *L'Oeuvre de Vincent van Gogh: Catalogue raisonné* (Paris and Brussels, 1928), vol. 1, no. 655 (repro.); Louis Pierard, *Vincent van Gogh* (Paris, 1936), no. 45, repro.; W. Scherjon, *Catalogue des tableaux par Vincent van Gogh, décrits dans ses lettres. Périodes: St. Rémy et Auvers sur Oise* (Utrecht, 1932), no. 70 (repro.); W. Scherjon and Joseph de Gruyter, *Vincent van Gogh's Great Period: Arles, St. Rémy, and Auvers sur Oise* (Amsterdam, 1937), no. 70 (repro.); Louis Hautecoeur, *Van Gogh* (Geneva, 1946), repro. between pp. 80 and 81; Fernando

Puma, *Modern Art Looks Ahead* (New York, 1947), n.p. (repro.); Werner Weisbach, *Vincent van Gogh: Kunst und Schicksal* (Basel, 1951), vol. 2, pp. 162–63; M. E. Tralbaut, "Twee onuitgegeven documenten," *De Tafelronde,* vol. 2, nos. 8–9 (1955), pp. 7–8; "Art in Antiques," *Art News,* vol. 54, no. 4 (summer 1955), repro. p. 10; John Rewald, *Post-Impressionism from Van Gogh to Gauguin* (New York, 1956), p. 358; H. R. Graetz, *The Symbolic Language of Vincent van Gogh* (New York, Toronto, and London, 1963), fig. 86; Charles Sterling and Margaretta M. Salinger, *French Paintings: A Catalogue of the Collection of the Metropolitan Museum of Art* (Greenwich, Conn., 1967), vol. 3, p. 190; J.-B. de la Faille, *The Works of Vincent van Gogh: His Paintings and Drawings* (Amsterdam and New York, 1970), no. 655 (repro.); Paolo Lecaldano, *L'Opera pittorica completa di Van Gogh e i suoi nessi grafici* (Milan, 1971), vol. 2, no. 744 (repro.); John Rewald, "Should Hoving Be De-accessioned?" *Art in America,* vol. 61, no. 1 (January–February 1973), p.28, repro. p. 29; Matthias Arnold, "Duktus und Bildform bei Vincent van Gogh," Ph.D. diss., Ruprecht-Karl University, Heidelberg, 1973, n. 305; Jan Hulsker, *The Complete Van Gogh: Paintings, Drawings, Sketches* (New York, 1980), no. 1869 (repro.); Ronald Pickvance, *Van Gogh in Saint-Rémy and Auvers* (New York, 1986), p. 304, repro. p. 306.

NOTES

1. *The Complete Letters of Vincent van Gogh,* 2nd ed., translated by Johanna van Gogh-Bonger and C. de Drood (Greenwich, Conn., 1959), vol. 3, p. 232, no. 614a.

2. Ibid.

3. Ibid., pp. 232–33, no. 614a.

4. *Woman Picking Olives,* 1889, Collection of Mr. and Mrs. Basil P. Goulandris, Lausanne. See J.-B. de la Faille, *The Works of Vincent van Gogh: His Paintings and Drawings* (Amsterdam and New York, 1970), nos. 654, 655, and

656. See Ronald Pickvance, *Van Gogh in Saint-Rémy and Auvers* (New York, 1986), pp. 304, 306.

5. *The Complete Letters*, 1959, vol. 3, pp. 236–37, no. 617 (c. December 15, 1889).

6. Ibid., p. 240, no. 619.

7. Ibid., p. 464, no. w18.

8. Ibid., p. 243, no. 621.

9. Ibid., p. 464, no. w17.

10. See Pickvance, 1986, p. 161.

11. *The Complete Letters*, 1959, vol. 3, p. 232, no. 614a.

12. Ibid., p. 237, no. 617.

13. Ibid., p. 240, no. 619.

14. Ibid., p. 465, no. w19. The drawing sent to Gauguin seems to be lost. A sketchbook drawing has been argued to be Van Gogh's recording of the picture done after he had reached Auvers, for the purpose of doing a lithograph on the subject. See Johannes van der Wolk, *The Seven Sketchbooks of Vincent van Gogh* (New York, 1987), pp. 216, 308.

15. *The Complete Letters*, 1959, vol. 3, p. 243, no. 621.

16. Ibid., p. 237, no. 617. His pervading calm during the winter of 1889–90 in Saint-Rémy is discussed by John Rewald, *Post-Impressionism from Van Gogh to Gauguin* (New York, 1956), p. 364.

FIG. 163 Vincent van Gogh (Dutch, 1853–1890), *Women Picking Olives (The Olive Orchard)*, 1889, oil on canvas, 28¾ x 36¼" (73 x 92 cm), National Gallery of Art, Washington, D.C., Chester Dale Collection

VINCENT VAN GOGH
Dutch, 1853–1890
Vase of Roses, 1890
Oil on canvas, 36⅝ x 29⅛" (93 x 74 cm)

PROVENANCE: Anna van Gogh-Carbentus, Leyden; Paul Cassirer Art Gallery, Berlin; Fritz Oppenheim, Berlin; G. Hirschland, Essen; M. Frank Art Gallery, New York; Wildenstein and Co., New York; Mrs. Albert D. Lasker, New York; Harriman Gallery, New York; Alex Reid and Lefevre Gallery, London.

EXHIBITIONS: Stedelijk Museum, Amsterdam, "Vincent van Gogh," July–August 1905, no. 157; Galerie Bernheim-Jeune, Paris, "Cent tableaux de Vincent van Gogh," January 1908, no. 86; Paul Cassirer Art Gallery, Berlin, "VII. Austellung," March 5–22, 1908, no. 19; Paul Cassirer Art Gallery, Berlin, "Vincent van Gogh," May–June 1914, no. 134; Paul Cassirer Art Gallery, Berlin, "Vincent van Gogh: Gemälde," January 1928, no. 71; Wildenstein and Co., New York, "Masterpieces from Museums and Private Collections," November 8–December 15, 1951, no. 55; Orangerie des Tuileries, Paris, "La Nature morte de l'antiquité a nos jours," 1952, no. 102; Dallas Museum of Fine Arts, "An Exhibition of Sixty-Nine Paintings from the Collection of Mrs. Albert D. Lasker," March 6–29, 1953, no. 37; The Metropolitan Museum of Art, New York, "Paintings from Private Collections: Summer Loan Exhibition," 1959, no. 54; Wildenstein and Co., New York, "Olympia's Progeny: French Impressionist and Post-Impressionist Paintings (1865–1905)," October 28–November 27, 1965, no. 60; Wildenstein and Co., New York, "Masterpieces in Bloom," April 5–May 5, 1973, no. 27.

LITERATURE: Emile Bernard, *Lettres de Vincent van Gogh à Emile Bernard* (Paris, 1911),

fig. 93; Julius Meier-Graefe, *Vincent van Gogh: A Biographical Study*, translated by J. H. Reece (New York, 1928), fig. 15; J.-B. de la Faille, *L'Oeuvre de Vincent van Gogh: Catalogue raisonné* (Paris and Brussels, 1928), no. 682, fig. 192; Fritz Knapp, *Vincent van Gogh* (Bielefeld and Leipzig, 1930), p. 56, fig. 33; W. Scherjon, *Catalogue des tableaux par Vincent van Gogh, décrits dans ses lettres. Périodes: St. Rémy et Auvers sur Oise* (Utrecht, 1932), no. 113 (repro.); Walter Pach, *Vincent van Gogh, 1853–1890: A Study of the Artist and His Work in Relation to His Times* (New York, 1936), repro. p. 6; W. Scherjon and Joseph de Gruyter, *Vincent van Gogh's Great Period: Arles, St. Rémy, and Auvers sur Oise* (Amsterdam, 1937), no. 113 (repro.); Alexander Dorner, *Vincent van Gogh: Blumen und Landschaften* (Berlin, 1937), p. 16, fig. 5: John E. Cross, *Vincent van Gogh* (New York, 1947), no. 22 (repro.); Wallace Brockway, *The Albert D. Lasker Collection, Renoir to Matisse* (New York, 1958), p. 27, repro. p. 28; W. Sandberg, "Rembrandt, Hokousaï Van Gogh," *Verve*, vol. 7, nos. 27, 28 (1962), repro. p. 56; Charles Sterling, *Still Life Painting from Antiquity to the Present Time*, rev. ed. (New York and Paris, 1959), translated by James Emmons, pp. 114–15, fig. 100; J.-B. de la Faille, *The Works of Vincent van Gogh: His Paintings and Drawings* (Amsterdam and New York, 1970), no. 682 (repro.); Paolo Lecaldano, *L'Opera pittorica completa di Van Gogh e i suoi nessi grafici* (Milan, 1971), vol. 2, no. 793 (repro.); Matthias Arnold, "Duktus und Bildform bei Vincent van Gogh," Ph.D. diss., Ruprecht-Karl University, Heidelberg, 1973, nn. 215, 219; Peter Mitchell, *Great Flower Painters: Four Centuries of Floral Art* (New York, 1973), p. 124; Jan Hulsker, *The Complete Van Gogh: Paintings, Drawings, Sketches* (New York, 1980), p. 450, no. 1979 (repro.); Ronald Pickvance, *Van Gogh in Saint-Rémy and Auvers* (New York, 1986), p. 187, fig. 46; Walter Feilchenfeldt, *Vincent van Gogh and Paul Cassirer, Berlin: The Reception of Van Gogh in Germany from 1911 to*

1914 (Zwolle, 1988), pp. 29, 112 (repro.).

NOTES

1. *The Complete Letters of Vincent van Gogh*, 2nd ed., translated by Johanna van Gogh-Bonger and C. de Drood (Greenwich, Conn., 1959), vol. 3, p. 270, no. 634.

2. Release register, archives of the asylum of Saint-Paul-de Mausole, Saint-Rémy; quoted in Ronald Pickvance, *Van Gogh in Saint-Rémy and Auvers* (New York, 1986), p. 73 (with a reproduction of the original register).

3. See Charles Sterling and Margaretta M. Salinger, *French Paintings: A Catalogue of the Collection of the Metropolitan Museum of Art* (New York, 1967), vol. 3, p. 181, cat. no. 49.41.

4. See Pickvance, 1986, p. 17.

5. *The Complete Letters*, 1959, vol. 3, p. 469, no. W21.

6. See Jan Hulsker, *The Complete Van Gogh: Paintings, Drawings, Sketches* (New York, 1980), p. 452.

7. Ibid., p. 450.

8. See J.-B de la Faille, *The Works of Vincent van Gogh: His Paintings and Drawings* (New York, 1970), nos., 678, 680, 681, and 682.

9. Pickvance, 1986, no. 53 (repro.).

10. *The Complete Letters*, 1959, vol. 3, p. 269, no. 633.

11. Ibid., vol. 3, p. 270, no. 634.

12. Paul Cassirer Art Gallery, Berlin, "VII. Austellung," March 5–22, 1908, no. 19.

13. *The Complete Letters*, 1959, vol. 3, p. 269, no. 633.

EDOUARD VUILLARD
French, 1868–1940
The Album, 1895
Signed lower left: E. Vuillard
Oil on canvas, 26¹¹⁄₁₆ x 80½"
 (67.8 x 204.4 cm)

PROVENANCE: Thadée Natanson, Paris; sale, Hôtel Drouot, Paris, June 13, 1908, lot 51; Viennot.

EXHIBITION: Kunstverein, Hamburg, and Kunsthaus, Zurich, "Vuillard: Gemälde, Pastelle, Aquarelle, Zeichnungen, Druckgraphik," June 6–July 26, 1964, no. 88, pl. 94.

LITERATURE: Achille Segard, *Peintres d'aujourd'hui: Les Décorateurs* (Paris, 1914), vol. 2, p. 320; André Chastel, *Vuillard, 1868–1940* (Paris, 1946), pp. 53. 115; Rosaline Bacou, "Décors d'appartements au temps des Nabis," in Pierre Berès and André Chastel, eds., *Art de France: Etudes et chroniques sur l'art ancien et moderne* (Paris, 1964), p. 196; James Dugdale, "Vuillard the Decorator, I. The First Phase: the 1890s," *Apollo*, vol. 81, no. 36 (February 1965), p. 97; Jan Lauts and Werner Zimmermann, *Katalog Neuere Meister, 19. und 20. Jahrhundert* (Karlsruhe, 1972), vol. 2, no. 2520; Claire Frèches-Thory, "Jardins Publics de Vuillard," *La Revue du Louvre et des Musées de France*, vol. 29 (1979), p. 312, n. 18; Wildenstein and Co., New York, *La Revue Blanche: Paris in the Days of Post-Impressionism and Symbolism* (New York, 1983), p. 9 (repro.).

NOTES

1. *Collection Thadée Natanson: Catalogue de la vente publique* (Paris, 1908), no. 51 (author's trans.).

2. John Russell, *Edouard Vuillard, 1868–1940* (London, 1971), p. 53.

3. Albert Aurier, "Le Symbolisme en Peinture," *Mercure de France*, March 15, 1891, pp.

155–65; quoted in Andrew Carnduff Ritchie, *Edouard Vuillard* (New York, 1954), p. 19.

4. Quoted in Ritchie, 1954, pp. 19–20.

5. For information on the actor, playwright, and producer Aurélien Lugné-Poe, see Patricia Eckert Boyer, "The Nabis, Parisian Vanguard Humorous Illustrators, and the Circle of the Chat Noir," in Patricia Eckert Boyer, ed., *The Nabis and the Parisian Avant-Garde* (New Brunswick and London, 1988), pp. 33, 96; and Belinda Thomson, *Vuillard* (New York, 1988), p. 84.

6. See Rosaline Bacou, "Décors d'appartements au temps des Nabis," in Pierre Berès and André Chastel, eds., *Art de France: Etudes et chroniques sur l'art ancien et moderne* (Paris, 1964), pp. 193–96.

7. Thomson, 1988, pp. 36–39.

8. Quoted in John Rewald, *The John Hay Whitney Collection* (Washington, D.C., 1983), p. 81.

9. The other two are *Conversation (Pot de grès)*, oil on canvas, 25⁹⁄₁₆ x 45¹¹⁄₁₆", in a private collection, and *Dressing Table (Dans les fleurs)*, oil on canvas, 25⁹⁄₁₆ x 46⁷⁄₈", also in a private collection. They are reproduced in Claude Roger Marx, *Vuillard: His Life and Work*, translated by E. B. d'Auvergne (London, 1946), p. 133.

10. These unpublished notes are in the possession of Antoine Salomon, who is preparing the definitive work on Vuillard. They were graciously shared with me by Elizabeth Easton.

11. See A. Gold and R. Fizcale, *The Life of Misia Sert* (New York and London, 1980).

12. Russell, 1971, p. 55.

13. The photograph is reproduced in the exhibition catalogue from Wildenstein and Co., *La Revue Blanche: Paris in the Days of Post-Impressionism and Symbolism* (New York, 1983), p. 13.

14. Reproduced in ibid., p. 9. Antoine Salomon has identified this billiard room as being not in the Paris apartment, but, rather, in the summer house, Le Relais, at Villeneuve-sur-Yonne, which Thadée and Misia rented from 1897. This information was kindly relayed by Elizabeth Easton.

15. André Gide, "Promenade au Salon d'Automne," *Gazette des Beaux-Arts*, 47th year, 3rd period, vol. 34 (December 1905), p. 480; quoted in Stuart Preston, *Edouard Vuillard* (London, 1985), p. 37.

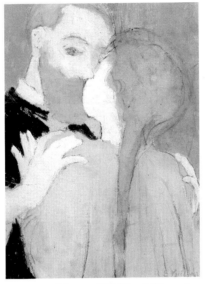

FIG. 164 Edouard Vuillard (French, 1868–1940), *Self-Portrait with Sister*, c. 1892, oil on paper on cardboard, 9 x 6½" (23 x 16.5 cm), Philadelphia Museum of Art, The Louis E. Stern Collection

FIG. 165 Edouard Vuillard, *Under the Trees*, from the series "The Public Gardens," 1894, tempera on canvas, 84½ x 38³⁄₈" (214.6 x 97.5 cm), The Cleveland Museum of Art, Gift of the Hanna Fund

FIG. 166 Edouard Vuillard, *Embroidering by the Window*, from the Thadée Natanson series, oil on canvas, 69⅜ x 25⁹⁄₁₆″ (176 x 65 cm), The Museum of Modern Art, N.Y., Estate of John Hay Whitney

FIG. 167 Edouard Vuillard, *Woman in a Striped Dress*, from the Thadée Natanson series, 1895, oil on canvas, 27⅞ x 23⅛″ (65.7 x 58.7 cm), National Gallery of Art, Washington, D.C., Collection of Mr. and Mrs. Paul Mellon

FIG. 168 Edouard Vuillard, *The Room with the Three Lamps*, 1899, tempera on canvas, 22⅞ x 37″ (58 x 94 cm), Gustav Zumsteg Collection, Zurich

FIG. 169 Edouard Vuillard, *Misia, Vallotton, and Thadée Natanson*, 1899, oil on board, 27⅜ x 20¹⁄₁₆″ (69 x 51 cm), William Kelly Simpson Collection, Katonah, N.Y.

FIG. 170 Edouard Vuillard, *Misia Playing the Piano and Cipa Listening*, c. 1897, oil on board, 25 x 22¹⁄₁₆″ (63.5 x 56 cm), Staatliche Kunsthalle, Karlsruhe

FIG. 171 Photograph of Thadée Natanson playing billiards with Ida Godebska (courtesy Antoine Salomon)

EDOUARD VUILLARD
French, 1868–1940
Romain Coolus and Mme Hessel,
 1900–1905
Signed lower right: E Vuillard
Oil on cardboard affixed to canvas,
 14½ x 22⅜″ (36.8 x 56.8 cm)

EXHIBITIONS: Philadelphia Museum of Art, "Exhibition of Philadelphia Private Collectors," summer 1963 (no catalogue); The Tate Gallery, London, "The Annenberg Collection," September 2–October 8, 1969, no. 32.

NOTES
1. Claude Roger Marx, *Vuillard: His Life and Work*, translated by E. B. d'Auvergne (London, 1946), p. 90.
2. See Evelyn Nattier-Natanson, *Les Amitiés de la Revue Blanche et quelques autres* (Vincennes, 1959), p. 116.
3. See *Dictionnaire de biographie française*, vol. 9, s.v. "Coolus."
4. Annette Vaillant, *Autour de la Revue Blanche* (Paris, 1966), p. 121; quoted in John Russell, *Edouard Vuillard, 1868–1940* (London, 1971), p. 121.

FIG. 172 Edouard Vuillard (French, 1868–1940), *Mme Hessel*, c. 1905, oil on cardboard, 42½ x 30¾″ (106.2 x 78 cm), private collection

FIG. 173 Henri de Toulouse-Lautrec (French, 1864–1901), *Romain Coolus*, 1899, oil on cardboard, 21⅝ x 13¾″ (55 x 35 cm), Musée Toulouse-Lautrec, Albi

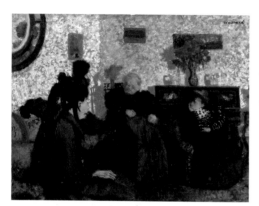

FIG. 174 Edouard Vuillard, *The Widow's Visit*, 1899, oil on paper on panel, 19¾ x 24¾" (50.2 x 62.9 cm), The Art Gallery of Ontario, Toronto

GEORGES BRAQUE
French, 1882–1963
Boats on the Beach at L'Estaque, 1906
Signed and dated lower right: G Braque 06
Oil on canvas, 15 x 18⅛" (38.2 x 46.1 cm)

PROVENANCE: G. P. Curran, Dublin; Mrs. Ira Haupt, New York.

EXHIBITIONS: Royal Scottish Academy, Edinburgh, and The Tate Gallery, London, "G. Braque," August 18–November 11, 1956, no. 7; Saidenberg Gallery, New York, "Georges Braque, 1882–1963: An American Tribute," April 7–May 2, 1964, no. 5.

LITERATURE: John Richardson, ed., *Georges Braque, 1882–1963: An American Tribute* (New York, 1964), no. 5 (repro.).

NOTES
1. In contrast to all other accounts, John Elderfield insists that this moment of revelation occurred at the 1906 Salon d'Automne, in *The "Wild Beasts": Fauvism and Its Affinities* (New York, 1976), p. 83.
2. Quoted in Henry R. Hope, *Georges Braque* (New York, 1949), p. 21.
3. Braque stayed at L'hôtel Maurin, according to Nadine Pouillon and Isabelle Monod-Fontaine in *Braque: Oeuvres de Georges Braque (1882–1963)* (Paris, 1982), p. 20.
4. Elderfield (1976, p. 83) proposed that Derain probably suggested Braque's trip to L'Estaque, although most accounts of Braque's life record that he did not meet Derain until the 1907 Salon des Indépendants. When asked whether the inspiration for the trip to L'Estaque was Cézanne, Braque agreed (Pouillon and Monod-Fontaine, 1982, p. 18).
5. The French quotation is cited in Pouillon and Monod-Fontaine, 1982, p. 18. The English translation is from Youngna Kim,

"The Early Works of Georges Braque, Raoul Dufy, and Othon Friesz: Le Havre Group of Painters," Ph.D. diss., Ohio State University, Columbus, 1980, p. 151.
6. Pouillon and Monod-Fontaine, 1982, p. 24. Virtually none of the paintings of this period are dated, and no firm chronology of the L'Estaque canvases exists.
7. The use of an accentuated boat structure can be seen as early as *Ship in Harbor, Le Havre*, 1902 (Marie-Louise Jeanneret Collection, Geneva) or *The Barges*, 1906 (Fridart Foundation, Geneva), and has been discussed by Kim, 1980, pp. 112–13. The pier was used in *The Bay of Antwerp*, 1906 (private collection, Liechtenstein).

FIG. 175 Georges Braque (French, 1882–1963), *L'Estaque*, 1906, oil on canvas, 19⅝ x 23¾" (50 x 60 cm), Musée National d'Art Moderne, Paris

PIERRE BONNARD
French, 1867–1947
Meadow in Bloom, c. 1935
Studio stamp lower right: Bonnard
Oil on canvas, 35½ x 35⅝″ (90.2 x 90.5 cm)

EXHIBITIONS: Royal Academy of Arts, London, "Pierre Bonnard, 1867–1947," winter 1966, no. 229; The Tate Gallery, London, "The Annenberg Collection," September 2–October 8, 1969, no. 1.

LITERATURE: Jean Bouret, *Bonnard Seductions* (Lausanne, 1967), p. 43, no. 20 (repro.); Jean and Henry Dauberville, *Bonnard* (1920–39; Paris, 1973), vol. 3, no. 1530 (repro.), as "Le Jardin."

NOTES
1. The painting is titled "Le Jardin" in the catalogue raisonné; see Jean and Henry Dauberville, *Bonnard* (1920–39; Paris, 1973), vol. 3, no. 1530.
2. Reproduced in Sasha M. Newman, ed., *Bonnard: The Late Paintings* (London, 1984), no. 51.
3. Jean Clair, *Bonnard* (Paris, 1975), n.p.; quoted in Newman, ed., 1984, p. 172.
4. In 1936; quoted in Newman, ed., 1984, p. 70.
5. Quoted in ibid., p. 69.
6. Ibid.
7. See, for example, Dauberville, 1973, no. 1505.

FIG. 176 Georges Braque, *L'Estaque, Wharf,* 1906, oil on canvas, 15¼ x 18″ (38.5 x 46 cm), Musée National d'Art Moderne, Paris

FIG. 177 Georges Braque, *The Port of Antwerp,* 1906, oil on canvas, 19¾ x 24″ (50 x 61 cm), National Gallery of Canada, Ottawa

FIG. 178 Georges Braque, *The Great Trees, L'Estaque,* 1906–7, oil on canvas, 32⅝ x 28″ (83 x 71 cm), private collection

FIG. 179 Pierre Bonnard (French, 1867–1947), *The Table*, 1925, oil on canvas, 40½ x 29⅜" (103 x 74.3 cm), The Tate Gallery, London

HENRI MATISSE
French, 1869–1954
Odalisque with Gray Trousers, 1927
Signed lower right: Henri Matisse
Oil on canvas, 25⅝ x 32" (65.1 x 81.5 cm)

PROVENANCE: Purchased from the artist by Mrs. Ira Haupt, New York.

EXHIBITIONS: Victoria and Albert Museum, London, "Exhibition of Paintings by Picasso and Matisse," December 1945, no. 7; The Museum of Modern Art, New York, "Henri Matisse," November 13, 1951–January 13, 1952, also shown at The Cleveland Museum of Art, February 5–March 16, 1952, The Art Institute of Chicago, April 1–May 4, 1952, and The San Francisco Museum of Art, May 22–July 6, 1952, no. 61.

LITERATURE: Jean Cassou, *Matisse* (London, 1948), no. 5 (repro.); André Lejard, *Matisse* (Paris, 1952), no. 7 (repro.); Raymond Escholier, *Matisse: A Portrait of the Artist and the Man* (New York, 1960), p. 13, repro. p. 128; Susan Lambert, *Matisse Lithographs* (London, 1972), cited in no. 47; Musée National d'Art Moderne, Paris, *Henri Matisse: Dessins et sculpture* (Paris, 1975), cited in no. 76.

NOTES
1. The screen in *Odalisque with Gray Trousers* can be seen in a photograph of Matisse's studio. See Jack Cowart and Dominique Fourcade, *Henri Matisse: The Early Years in Nice, 1916–1930* (Washington, D.C., 1986), p. 31, fig. 30.

2. First cited in *Verve*, vol. 1, no. 3, p. 125.

3. Pierre Schneider, *Matisse*, translated by Michael Taylor and Bridget Strevens Romer (New York, 1984), pp. 523–28.

4. For example, compare Cowart and Fourcade, 1986, fig. 169; and Jean Cassou, *Matisse* (London, 1948), no. 15.

5. The painting has been dated 1918 (Cassou, 1948, no. 5), 1925 (André Lejard, *Matisse* [Paris, 1952], no. 7), and 1928 (The Museum of Modern Art, New York, *Henri Matisse* [New York, 1951], no. 61).

6. Musée National d'Art Moderne, Paris, *Matisse: Dessins et sculpture* (Paris, 1975), p. 118.

FIG. 180 Photograph of Henri Matisse drawing Henriette Darricarrère, third-floor apartment and studio, 1 place Charles-Félix, Nice, c. 1928 (courtesy The Museum of Modern Art, New York)

FIG. 181 Henri Matisse (French, 1869–1954), *Seated Odalisque, Ornamental Ground, Flowers, and Fruit,* 1927, pen and ink on paper, 10⁵/₈ x 15″ (27.5 x 38 cm), Collection Gèrard Matisse

FIG. 182 Henri Matisse, *Odalisque, Brazier, and Cup of Fruit,* 1929, lithograph, 11 x 14⁷/₈″ (28 x 37.8 cm), Victoria and Albert Museum, London

ACKNOWLEDGMENTS

THE OPPORTUNITY to present the Annenberg Collection at the Philadelphia Museum of Art was both a privilege and a challenge. A privilege, because we came to know the collection very well, having been able to study and examine the paintings in an idyllic environment before research on the catalogue got underway. A challenge, because the collection has been neither exhibited nor published as a whole—in the 1963 Philadelphia Museum of Art exhibition there were thirteen paintings on display, and in the 1969 Tate Gallery exhibition there were thirty-two paintings—and the opportunity to catalogue each work in a rather short period of time was daunting indeed. Given the enormous interest in Impressionist and Post-Impressionist art, and the blossoming of art-historical study in this field, the amount of material to be sifted and considered seemed overwhelming. Although nearly every work in the collection was familiar as a "textbook" example (in that dulling phrase), the paintings had not been studied in depth for many years, with the exception of three Gauguins, which were lent to the Gauguin retrospective of 1988 at the National Gallery of Art, Washington, D.C. Our entries, which sometimes stray rather far from the conventional model of the catalogue entry, bring together as much of the literature as we have been able to discover. Furthermore, by focusing attention on the paintings themselves and taking care to describe and discuss their physical state as well as to consider their art-historical importance, it is our hope that the catalogue will serve as a starting point for future investigation.

Our labors, although concentrated, spanned a relatively short time, and our efforts have depended upon the generosity and assistance of many people. From the beginning, we profited from the sensitive and pertinent insights of Mark Tucker, Conservator of Paintings at the Philadelphia Museum of Art. He helped us look harder and see better: many observations originated in early discussions with him as we surveyed each work in turn together. He also read through the text and clarified several issues for us.

Work on the catalogue itself was a genuinely departmental effort. Veerle Thielemans assisted in the compilation of material and the checking of data. She has proved to be an ideal research assistant: thorough, inventive, and unrelenting in her quest for references and citations. We have benefited from discussions with her during the writing of the text. The herculean task of typing the manuscript, ordering photographs, and coordinating the many departments involved in this project has been supervised efficiently and graciously by Margaret Quigley, Administrative Assistant in the Department of European Painting. Laura Davidheiser began typing and arranging the manuscript text, and her good work was taken over by Lisa Titus, Clerical Assistant in the Department of European Painting, to whom we are particularly indebted for her enthusiasm and capacity to organize in the face of extreme pressure. For nine months we monopolized the Library at the Philadelphia Museum of Art, and we owe a great debt of thanks to all members of the Library staff for their tolerance and support in this enforced takeover. Under the genial supervision of Barbara Sevy, former Librarian, the staff coped with an avalanche of interlibrary-loan requests and research questions. Lilah Mittelstaedt searched far and wide for our references, and Gina Erdreich placed computer systems at our disposal in the checking of bibliographic material and sales history.

The Publications Department, under the caring and exacting eye of George Marcus, coped with a devastating deadline to create a catalogue worthy of the Annenberg Collection. The best of all starting points came in the splendid color photography taken by Graydon Wood, Museum Photographer, who produced color transparencies of the highest quality. We are especially grateful to Jane Watkins, Senior Editor, for her conscientious and untiring supervision of the editing of this catalogue: firm, yet enthusiastic, she clarified our arguments and dignified our prose in many ways. In this she was assisted by Mary Patton and Molly Ruzicka, whose attention to detail and alertness to style were unwavering. Joseph B. Del Valle produced the elegant design for the catalogue.

In the course of writing and undertaking the research for this catalogue we have relied upon many people outside the Museum, who answered increasingly urgent requests with unfailing precision and generosity. We would particularly like to mention the contributions of John Rewald, without whose assistance the entries on Cézanne would be much diminished, and Michael Pantazzi, who shared crucial unpublished material relating to works by Degas. Ay-Wang Hsia and Joseph Baillio at Wildenstein, New York, responded to countless requests and questions and were especially helpful in retrieving photographs. David Bull, Chief Conservator at the National Gallery of Art, arranged for critical X-radiograph photography to be taken of Gauguin's *Siesta*. We are also indebted to the following people for their help in many ways: William Acquavella, Chittima Amornpichetkul, Hortense Anda-Buhrle, Dilys Blum, Jean Sutherland Boggs, Philippe Brame, Harry Brooks, Linda Brooks, Christopher Burge, Françoise Cachin, Beverly Carter, Desmond Corcoran, François Daulte, Mme Ch. Demeulenaere, Anne Distel, Carol Dowd, Elizabeth Easton, Jean Edmonson, Marianne Feilchenfeldt, Walter Feilchenfeldt, Caroline Durand-Ruel Godfrey, Morton J. Gordon, Robert Gordon, Sir Lawrence Gowing, Anne Higonnet, Elizabeth Janus, David Lloyd Kreeger, Ronald de Leeuw, Suzanne Lindsay, Nancy Little, Teresa Longyear, Ann Tzeutschler Lurie, Bronwyn T. Maloney, Daniel Martinez, Paul Mitchell, Charles Moffett, Pierre Mouzay, Alexandra Murphy, Peter Nathan, Anne Norton, Mr. and Mrs. Joseph Pulitzer, Jr., Theodore Reff, Antoine Salomon, Anne Schirrmeister, Robert Schmidt, William Scott, George Shackelford, Innis Howe Shoemaker, William Kelly Simpson, Tone Skedsmo, Charles Stuckey, Irene Taurins, Gary Tinterow, Jayne Warman, Suzanne F. Wells, Barbara Ehrlich White, Michael Wilson, Juliet Wilson-Barreau, Alan P. Wintermute, Michael Zakian, the staff of the New York Public Library, the Pierpont Morgan Library, the staff of the Durand-Ruel Archives, and the Department of Rights and Reproductions at the Philadelphia Museum of Art.